European Connections

edited by
Peter Collier

Volume 8

PETER LANG
Oxford · Bern · Berlin · Bruxelles · Frankfurt am Main · New York · Wien

Walter Redfern

Writing on the Move

Albert Londres and Investigative Journalism

PETER LANG

Oxford · Bern · Berlin · Bruxelles · Frankfurt am Main · New York · Wien

Bibliographic information published by Die Deutsche Bibliothek
Die Deutsche Bibliothek lists this publication in the Deutsche
Nationalbibliografie; detailed bibliographic data is available on the
Internet at ‹http://dnb.ddb.de›.

British Library and Library of Congress Cataloguing-in-Publication Data:
A catalogue record for this book is available from *The British Library,*
Great Britain, and from *The Library of Congress,* USA

ISSN 1424-3792
ISBN 3-03910-157-9
US-ISBN 0-8204-6967-X

© Peter Lang AG, European Academic Publishers, Bern 2004
Hochfeldstrasse 32, Postfach 746, CH-3000 Bern 9
info@peterlang.com, www.peterlang.com, www.peterlang.net

Printed in Germany

Contents

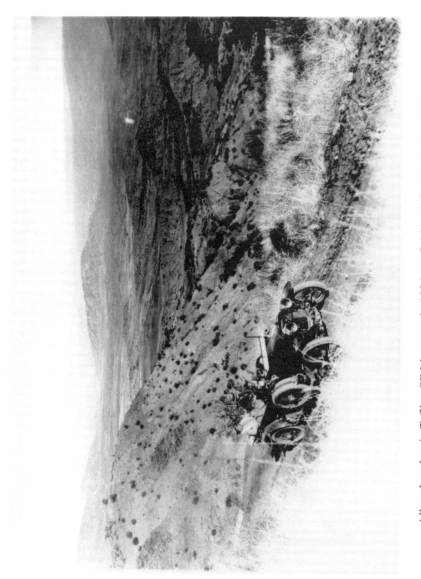

Albert Londres in Tafilet, SE Morocco, in 1924, on fieldwork for *Dante n'avait rien vu.*

Acknowledgements

I gladly doff my virtual trilby to my consistently helpful foreign corres-pondents, those chief champions of Albert Londres: Pierre Assouline and Francis Lacassin.

I am very grateful to the staffs of the Association du Prix Albert Londres, the French National Archives, and the Philby Collection at St. Antony's College, Oxford.

Like any journalist, I am never sure where my ideas come from. This book is dedicated, then, to my forgotten sources across time and space, but, in particular to my wife, Angela, and my invaluable colleague, Mary Bryden, for their encouragement and constructive criticism.

My research in Paris was facilitated by a generous grant from the British Academy, to whom I would like here to express my gratitude.

Abbreviations

(*AB*) *Au Bagne*
(*CR*) *Câbles et Reportages*
(*TB*) *Le Chemin de Buenos Aires / La Traite des Blanches*
(*CF*) *Chez les fous*
(*C*) *Les Comitadjis*
(*CBC*) *Contre le Bourrage de crâne*
(*DA*) *D'Annunzio*
(*DN*) *Dante n'avait rien vu*
(*FR*) *Les Forçats de la route*
(*HS*) *L'Homme qui s'évada*
(*JE*) *Le Juif errant est arrivé*
(*MS*) *Mourir pour Shanghaï*
(*PP*) *Pêcheurs de perles*
(*TN*) *Terre d'ébène / La Traite des Noirs*

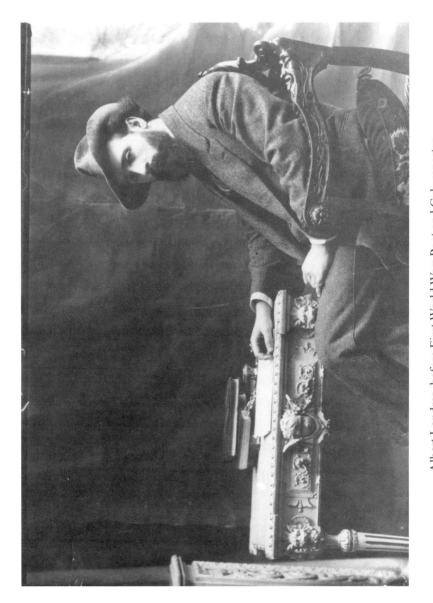

Albert Londres, before First World War: Poet and Cub-reporter.

Preview

One of the many striking photos of Albert Londres shows him dressed in a dark suit with a stiff collar and sporting a splendid fedora. He is standing, elegantly poised alongside a snazzy open tourer which is partly trapped in desert sands. His left hand grips a spade. He did indeed spend his journalistic life digging. Exhuming information by hook or by crook, unearthing abusive practices in all walks of life and across the globe, and digging his readers, of his time or ours, tellingly in the ribs with his challenging finds. And always with a good eye and nose for stylishness.

As roving reporter, Albert Londres lived and wrote for a major part of his life on the move; he garnered his material primarily on the hoof. And yet his most recurrent area of enquiry was closed spaces. His wide-ranging reportages on civil and military penitentiaries; on mental institutions across France; on brothels in Argentina; on the economic slave-trade in the Middle East and in Central Africa (pearl-diving, and road and railway construction); on the convict cyclists ('les forçats de la route') on home territory in the Tour de France; on Gabriele D'Annunzio in his besieged enclave in Fiume; on the atrocious condition of poor Jews in Europe's ghettos; on alien cultures and the end-stopped stereotypes attached to them in Japan, China, and India by Westerners, and the semi-alien cultures in French Indochina; on the chaotic stumblings and deprivations of the isolated early Soviet Russia; on the stand-off collusion between government and terrorists in post-Great War Bulgaria – all of these involved Londres in worming his way into closed societies in the lengthy effort to understand and report on them. His despatches in the First World War, also, entailed his marking time in often stalemate situations on the Western Front or in the Balkans. He

1 Gustave Flaubert: *Dictionnaire des idées reçues,* in *Bouvard et Pécuchet.* Ed. Jacques Suffel. Paris: Garnier-Flammarion, 1966, p.364.

travelled, in short, to grasp enclosure. Variously, in all these contexts, he investigated trade in its multifarious forms: the exploitation, the abuse, and the wanton wastage of human lives in war, commerce, or social organisation: slavery, prostitution, or the oppression of patients' sick minds.

As a result, this book will move between imprisonment and movement – what Yves Le Bohec calls Londres's 'fuite en avant obligée'.[2] In addition to the many instances of physical repressions, it will focus on the congealed mind-sets that humans set up around and against fellow creatures. As an extension, it will study and evaluate the clichés about and within journalistic practice and discourse, including those of Londres himself. Humour, and in particular the revising and twisting of clichés, will be seen as Londres's own brand of irony (he was habitually ironic about the many ironies of existence). Thus his rhetoric and style will be a crucial focus in the totalising study of the Londres phenomenon. He exploits humour in its several modes in order to persuade readers to take his news and views seriously. The poetic elements, both in his young-adult verse and in his mature journalism (especially in what is partly a prose-poem celebrating the exotic hexagonal microcosm of Marseilles), of lyricism, imagery and hyperbole will be viewed as indispensable partners in the various escape-routes of this writer so often thwarted by stasis: the ways in which he modifies, and reacts against, the recurrently appalling universes that he faithfully records. By writing much of the time peripatetically, Londres escaped some if not all of the constraints, impediments and paralyses of the property-owning class of petty bourgeoisie that he took off from.

I set Londres in the context of his times (the historical dimension) and in the world-context of the freemasonry of special correspondents (the sociological, professional dimension) for whom his byline remains a byword and a yardstick. Though many critics, fellow journalists and Internet publicists mention his name reverentially, too few have analysed and judged his writings closely. I would like readers to share with me in this closer reading. Like Gide and Raymond Queneau, I believe that lazy readers should not be encouraged to indulge in their favourite inoccupation. To that end, throughout this book, when I talk of the wider

2 Yves Le Bohec: *Les Mythes professionnels des journalistes: l'état des lieux en France*. Paris: L'Harmattan, 2000, p.163.

world around or beyond Londres, I frequently leave analogies, comparisons or contrasts to the reader. I want her/him to think more widely than Londres, as he did.

My own more specifically personal investment in wanting and needing to write this book dates back over six decades to my primary school. An unsmiling Scottish teacher, who looked to our unpractised eyes about seventy-five, once commented on a short piece of mine, a description of someone we knew that we all had to write: 'You'll be a journalist, my lad'. I had used the phrase – God knows where I picked it up – of 'gimlet eyes' for an aged neighbour. That is now no doubt a dated cliché; to me it was fresh-minted, though I did not know how to pronounce it. Ever since, some significant part of me has wanted to write in journalistic mode: snappy, to the point, amusing. Depending on my editors, I have suffered, and benefited, from this urge.

I have been at times a guttersnipe or a hack academic. Since that childhood, I have written books on various authors who all practised journalism to greater or lesser extents. Jules Vallès, Louis Guilloux and Paul Nizan all supported themselves, for segments of their lives, by journalism. Georges Darien edited three periodicals and contributed to other journals. At a bohemian stage, Raymond Queneau asked his newspaper readers: 'Connaissez-vous Paris?' My books on language matters (*Puns,* and *Clichés and Coinages*) concerned themselves frequently with journalistic aspects of style and rhetoric.

One particular driving-force of this book will be a continuous effort to rehabilitate the very dubious status of journalists, for I am convinced that the best of them, of whom Londres is an outstanding example, do much of the indispensable leg-work for later, sedentary historians. They deal, courageously and innovatively, with history-in-the-making. One way to measure the status of journalism will be to track the shifting borderline, the similarities and differences, between it and literature, and a major subdivision of the latter, committed literature. Politics in a special sense – political correctness – must also be confronted.

As one journalistic commentator wrote: 'All news is views […] There is no fundamentally non-ideological, apolitical, non-partisan, news gathering and reporting system'. Many of us, naturally, confuse news with facts, which should be indisputable and value-free. Whereas French, when it seeks to characterise investigative journalism, favours surgical imagery (probing, or cauterising, a wound), Anglo-American usage pre-

fers the scatological or rustic: muck-raking. French does house 'fouille-merde',[3] shit-stirrer, and various journalists, including Zola, have been likened to dung-beetles ('bousiers'), literal or metaphorical. There is also 'déterreur de scandales', which puts the stress on the disentombing of the buried. In his reportages, Albert Londres wielded an instrument more ponderous than the scalpel but less primitive than the pitchfork. His own chosen metaphor is passably brutal, in this his most often quoted declaration: 'Mon métier n'est pas de faire plaisir ni de faire tort. Il est de porter le fer dans la plaie. Il y a trop de malheur dans le vaste monde pour qu'on se permette de s'asseoir'.[4] This rejection of comfortable ensconcement and the readiness to plunge into painful areas typify his approach to his job.

For Pierre Bonardi, 'Albert Londres a été le type même du voyageur baudelairien':

> Mais les vrais voyageurs sont ceux-là qui partent
> Pour partir, coeurs légers, semblables aux ballons,
> De leur fatalité jamais ils ne s'écartent
> Et, sans savoir pourquoi, disent toujours: Allons![5]

Londres's own version was that he was one of 'ceux qui aiment le voyage pour le voyage, le nouveau pour le nouveau, même si le pays qu'on verra demain ne vaut pas celui de la veille'. More specifically: 'Le reportage n'est qu'une façon de satisfaire mon vice' [i.e. travel], and 'J'aime moins le décor que le mouvement'.[6] He dressed 'internationally', in the separate accessories bought at stop-overs across the world.[7] He travelled not only for his own delight, or because for his raw material he must, but also on behalf of his readers. As well as eye-opening infor-

3 In a letter from André Gill to Jules Vallès, between 15 and 22 February 1880, cited in Gérard Delfau (ed.): *Jules Vallès, l'exil à Londres*. Paris: Bordas, 1971, p.334.
4 Quoted in an unpublished article by his daughter Florise: 'A la mémoire d'Albert Londres vichyssois-journaliste'. See Pierre Assouline: *Albert Londres: vie et mort d'un grand reporter*. Paris: Gallimard, 1990, p.157.
5 Pierre Bonardi: 'Routes et relais d'Albert Londres, voyageur baudelairien'. *La Tribune des Nations,* 29 November 1934. Reprinted in Londres: *Le Juif errant est arrivé*. Ed. Francis Lacassin. Paris: Union Générale d'Editions, 1975, p.264.
6 Quoted in Francis Ambrière: 'Au Pays des grands reporters, Albert Londres'. *Gringoire,* 19 July 1929. [Reprinted ibid., pp.289, 286, 289].
7 Bonardi: 'Routes et relais d'Albert Londres', p.265.

mation and pungently expressed opinions, his accounts offered readers exoticism. They could in reading him live by proxy, enjoy escapism.

He wrote on the move in the sense that, at least in note form, this practice was the unavoidable first stage. Then he sometimes wrote up on the move, on the high seas during the voyage home: the only time in a generally frantic existence he had for peaceful reflection. As a roving reporter, except for investigations into France's mental hospitals, the Tour de France and his celebration of Marseilles, after the First World War on the Western Front he played away, in eastern and southern Europe, the Middle East, Soviet Russia, the Far East, Africa and South America. His protracted absences from France helped to shore up his immunity to the world of values, in its more mercenary and backbiting aspects, practised in the metropolitan press. He thus missed much of the in-house politicking, the corruption and the venality which were endemic in the press of his day, and are still periodically in ours. The financial scandals frequently resulted from the manipulation of French news-papers by foreign governments and business interests.

As most of his reports were sent home from abroad, there was inevitably always a certain distance between despatcher and receivers. His reportages were often like messages in a bottle launched with no more than hope in the heart from various desert or densely populated islands. His fieldwork often took several months. Today, of course, instantaneous transmission of news reports and television pictures of events as they happen mean that journalists rarely have to describe the scene, and in fact often merely duplicate the images in a kind of otiose underlining ('As you can see...'). Londres was a globetrotter, 'un journaliste au long cours', a reporter at large. He favoured leg-work, which of course never ruled out conveyances, animal or mechanical, and was never an armchair or archive journalist. Though not noticeably a sufferer from claustrophobia, he certainly experienced agoraphilia. He had itchy feet and ants in his pants.

Despite his aversion from encumbering paraphernalia or from bourgeois décor when back home after his long trips away, Londres treasured, until he lost them or they fell apart, a travel-rug (a kind of worry-blanket for the man who retained in adulthood the child he had naturally started out as being) and a pigskin suitcase. He could not swim, drive a car, or speak more than a smattering of English. In a basic sense, he was not equipped to be, by analogy with 'médecins sans

frontières', a 'reporter sans frontières', though he always enjoyed himself in 'jeux sans frontières'. As for modes of transport, when all else failed or when it seemed the best way to get the feel of a place or a situation, he strolled or yomped. A stock and clumsily repetitive view is that 'les journalistes sont d'abord des "papillons de l'événement", rebondissant facilement d'un événement sur l'autre, mais avec le défaut complémentaire d'aborder les sujets au gré de l'actualité, un événement chassant l'autre'.[8] By reason of his long stays wherever he ventured, Londres was never that kind of butterfly. If he parachuted in, he generally stayed longer than present-day reporters or their bosses could afford.

Though a salaried staff correspondent in effect in his working life, Londres acted to a large extent as if he were a freelance. He operated in an age when men (always men) in positions of power were readier to be interviewed face to face than they are today, when they did not yet robotically skulk behind a praetorian guard of PR people and other doctors of spin. No doubt, briefings, press conferences and so on have been around a long time, but person-to-person questioning was still easier in his day. Nevertheless, though gifted with patience and stamina, Londres would regularly run up against stonewalling tactics, temporising, incommunicative spokespersons: immovable objects with a very different time-scale and set of priorities from his, and against which he beat his head in vain. The fact that he spent long sessions trying to break down artifices of self-preservation, and yet had to keep on supplying despatches to his home base, meant that his writing contains much padding and other vamping, as in all our existential strategies. Yet the bonus is that he gives us, if *we* are patient, a sense of duration, of things and time being dragged out. Life is not all purple patches, everyone knows, and sound-bites can be toothless.

Londres never subscribed to the cant argument that journalists should present the facts and let the reading public make up its own mind. He knew what his function was: to tell a pointed story. If, then, readers voted with their feet, he accepted this disappointment as part of the rules of the game. He could not, honestly, believe in freedom and deny it to

8 Dominique Wolton: 'Les Journalistes entre l'opinion publique et les hommes politiques', in Marc Martin (ed.): *Histoire et Médias*. Paris: Albin Michel, 1991, p.211.

his readers. He knew, and hoped that his readers did too, that freedom entails the clash of contrary opinions. He could not have been further away from the viewpoint of Richard Salent of CBS News, who stressed the need to cover stories 'from nobody's point of view'.[9] As with 'seeing things' (observing/hallucinating), 'making news' secretes two opposing meanings; recording actuality, and fabricating it. Like any journalist worth his or her salt, Londres does both, the second especially in the artfully composed dialogues he devises after the real-time interviews. Nor does he make any pretence of keeping himself coyly out of the picture. After all, the very word 'journal' in French does double duty: a public news-sheet, and a private diary. Londres was registering himself as well as history in the making.

The resulting admixture of personal and collective has been accurately caught in Denis Ruellan's useful concept of 'le flou': 'La vraie – la seule – richesse du regard journalistique sur les sociétés, voire sur l'histoire, c'est son imprécision, son imprévisibilité, son inconsistance parfois, son adaptabilité surtout: c'est *le professionalisme du flou*'.[10] This 'flou' is to be found in the statutes of professional deontology. Ruellan uses the term in a predominantly meliorative sense. Indeed, the best journalists do escape the rigor mortis to which other colleagues more orthodoxly formed are vulnerable. Journalism has been generally one of the most amateurish of professions. Or, to put it more charitably and possibly more accurately, it has always been a trade you learn on the job, *in medias res*. Though not formally trained, this apparent lone wolf, this solo operator Albert Londres in fact consorted very gladly with other correspondents, French, Italian, English, American. He responded to elective affinities.

'I am always,' wrote the BBC foreign correspondent John Simpson, 'trying to get to places where I'm not wanted, and convincing people to do things they don't want; it's like selling double-glazing'.[11] Such is the rock-bottom experience of the investigative reporter. Like

9 Quoted in Susan Carruthers: *The Media at War.* Basingstoke: Macmillan, 2000, p.17.

10 Denis Ruellan: *Le Professionalisme du flou: Identité et savoir-faire des journalistes français.* Presses Universitaires de Grenoble, 1993, pp.29–30 (my italics).

11 John Simpson: *Strange Places, Questionable People.* Basingstoke: Macmillan, 1998, p.3.

all effective examples of the breed, Londres was expert at the deviousness it takes to gain access to forbidding or forbidden milieux, yet by all accounts his character was very much of a piece: frank, firm, and generally compassionate. But there was more to him than that. For Francis de Tessin,

> cet observateur attentif dont l'apparent nonchaloir cache une tactique d'inquisition philosophique [...] ne se contente pas d'amasser des impressions ou des documents. *Chacune de ses enquêtes est une campagne.* Il captive ses lecteurs. Il les entraîne. Il les oblige, tout en les amusant parfois par son esprit endiablé, à réfléchir sur les grands problèmes du jour.[12]

A snake-charmer, then, but also a great awakener, and never just *un journaliste de salon* or *en chambre*.

Though many governments throughout history have condemned pressmen as enemies of the state, many journalists have argued, on the contrary, and have proved in practice, that properly informed press coverage can be measurably helpful in, for example, assisting the police with their enquiries, running criminals to earth, uncovering plots against public order, or blowing the gaff on occulted injustices. Above all, Londres knew in his bones that, as Robert de Jouvenel maintained, 'un bon journaliste doit savoir s'étonner'.[13] Whatever the temptations to cynicism resulting from witnessing humankind at its worst, the true journalist needs to keep intact this sense of wonderment at the very variousness and quiddity of what we all get up to. How different, indeed, from us readers or from other kinds of newspapermen is the investigative reporter? One view is that

> the investigative reporter is like any other kind of reporter, only more so, more inquisitive, more skeptical, more resourceful and imaginative in knowing where to look for facts, more ingenious in circumventing obstacles, more indefatigable in the pursuit of facts and able to endure drudgery and discomfort.[14]

12 Quoted from *Le Petit Niçois* of 4 May 1927, in Paul Mousset: *Albert Londres, l'aventure du grand reportage.* Paris: Grasset, 1970, p.247 (author's italics).

13 Robert de Jouvenel: *Le Journalisme en vingt leçons.* Paris: Payot, 1920, p.77.

14 Curtis D. MacDougall: *Interpretive Reporting.* New York: Macmillan, 1982, p.227.

Another commentator ups the ante: 'Every good investigative reporter has to be slightly mad. Not only must he manifest the customary skills and characteristics of a journalist, he must do so to excess, and be ever ready to attempt the impossible'.[15]

Such extremism (at least of language) operates, however, in an in-between position. The press is an intermediate zone, somewhere (variably) between literature and everyday discourse (gossip, rumour, opinionating). In addition, it is part-way between literature and politics: inventive like the former, and parasitical like the latter. The journalist, him- or her-self, is a shuttler between the actors and the sufferers of history. The journalist is closer to instant history than the vast majority of readers. 'Newspapers have a double life. On the one hand, they date more quickly than milk and stale more quickly than bread. On the other hand [...], they provide a fascinating dipstick into history'.[16] The American novelist Nicholson Baker has long fought to save newspapers from being junked by libraries, including national ones. As the veteran Alistair Cooke said, 'there is less difference than the intelligentsia would have us believe between the daily grind of the "serious" novelist or biographer in his cloister and the reporter filing his daily dispatch with the wind of the world in his face'.[17] Sartre puts a similar view rather more ponderously:

> Le reportage fait partie des genres littéraires et il peut devenir un des plus importants d'entre eux. La capacité de saisir intuitivement et instantanément les significations, l'habileté à regrouper celles-ci pour offrir au lecteur des ensembles synthétiques immédiatement déchiffrables sont les qualités les plus nécessaires au reporter.[18]

In much present-day journalism, the emphasis on house-style and rewriting militates against overt militancy, or individualism itself. In addition, long practice in journalistic discourse can lead to meretricious devices, dishonest short-cuts, cheapness of effects, unsubstantiated innuendoes, as well as advantages such as sharp focus, dramatic tension and

15 James H. Dygert: *The Investigative Journalist: Folk Heroes of a New Era.* Englewood Cliffs, NJ: Prentice-Hall, 1976, p.146.
16 *Guardian* editorial on the day it inaugurated its archives, 8 June 2002, p.8.
17 Quoted ibid. From Cooke's introduction to the *Bedside Guardian* of 1959.
18 Jean-Paul Sartre: *Situations 2.* Paris: Gallimard, 1948, p.30.

immediacy. As in life, so with Londres: we have to accept the rough with the smooth. When Londres started his habit of constructing books from his newspaper articles, he believed that in this way people who had not read them the first time round would still have a chance of reading them in a book available to all (who could afford it). No doubt this was a recycling operation, opportunistic, milking a body of material for all it was worth, but, more importantly, such a practice shows how much of a literary journalist he was. He wanted to last.

To generalise: most studies of journalism both parochialise and globalise. Albert Londres tends to be assigned the niche of grandfather of French investigative journalism. While he liked fame, and wanted ever more, it was not at any price – especially not at the price of false, exaggerated, or congealed estimation. We need to see him in his various contexts, yet avoid, if humanly possible, stereotyping him. If, on the other hand, I individualise him overmuch, will I say anything of more general validity? The danger lies in turning an idiosyncratic person into a star, an exception, a *monstre sacré*.

Some clichés, and there are very many current or surviving from the earliest days of the press, are energising. The image of the lone-wolf, crusading journalist can invigorate both reporters themselves and the reading public they may on occasion rouse from torpor. One enduring commonplace holds that the French and Anglo-American styles of journalism differ in that the latter is primarily preoccupied with gathering facts, and the former with stylish summations, a kind of sub-literature. Much of the widespread mistrust of pressmen recalls that accorded to politicians. Both sets are credited, in this perspective, with more individual influence than they actually enjoy; and the modus operandi of both is dismissed as manipulative and fishy. In films, on the contrary, the roving reporter is often portrayed as a modern avatar of the knight-errant, rescuing citizens in distress and taking the lid off corruption or other threats to the common weal. Such a stereotype consorts quite happily with a certain raffishness: booze, womanising. Such folklore (fakelore, *fauxclore*) – the French version has a useful connotation of closure – gives rise to classic jokes such as: 'Don't tell my mother I'm a journalist. She thinks I play the piano in a brothel'. Some seek not only to homogenise and belittle the press, but even to terminate it, as the CIA charmingly put it, with extreme prejudice. All in all, 'le journaliste […] n'a jamais eu très bonne presse', or, more

accurately, enjoys a dubious status.[19] Balzac, at his most pugnaciously reactionary, twisted Voltaire's famous maxim: 'Si Dieu n'existait pas il faudrait l'inventer' to 'Si la presse n'existait pas, il faudrait ne pas l'inventer'.[20] The great social historian, the Jack Horner of world literature, should have been the last one to talk of publicists as nefarious. The rotund and orotund Balzac was the pot calling the kettle burnt arse. It is less surprising that Louis Veuillot, far more reactionary again and notably hostile to the free press, should have spoken of newspapers as whores: 'Divertir convenablement les lecteurs distingués des feuilles de joie'.[21] Whores de combat?

The myth of Albert Londres, that is: the unexamined reality, is a kind of shorthand, like 'Hoover' for vacuum-cleaner. For many, he is *the* roving reporter. This book will, in the name of even-handedness, also examine *his* clichés, in the areas of racism, colonialism, Eurocentrism, and sexism.

Why is Londres, virtually alone of all the French *grands reporters* of the twentieth century, the only one whose published journalism is still widely available?[22] He and his valued colleagues were all of them what Philip Knightley called 'professional observers at the peep show of misery'.[23] For a long time, and in some quarters still, journalists in France have been typified as intellectuals, whereas nobody in England, least of all newpapermen, is so esteemed. I will try, unlike the doctor with his rubber hammer, to prevent knee-jerk responses. I hope that, as with a good journalist, the information on Londres and journalism that I have scissored-and-pasted from multiple sources, especially for the biographical elements of this book, will pass muster. After all, I could hardly time-travel back into the past in order to doorstep witnesses.

19 Jean-François Lacan et al.: *Les Journalistes*. Paris: Syros, 1994, p.8.

20 Voltaire: *Epitres*: 'A l'auteur des Trois Impostures'; and Balzac: *Monographie de la presse parisienne*. Paris: Aubry, 1943 [1843], p. 193.

21 Louis Veuillot: *Les Odeurs de Paris*. Paris: Crès, n.d. [1867], p. 81.

22 And not journalists, equally famous in their and his day, such as Edouard Helsey, Henri Béraud, Louis Roubaud, Ludovic Naudeau, or Andrée Viollis, all of whom will crop up in these pages.

23 Philip Knightley: *The First Casualty: From the Crimea to Vietnam: The War Correspondent as Hero, Propagandist and Myth Maker*. London: André Deutsch, 1975, p.44.

As a bridge to the first chapter proper, I want to ask the rhetorical question (are there, at bottom, any other kinds?): apart from the (not always inevitable) process of growing up, of travelling far and wide, of seeing and surviving countless horrors, of experiencing personal tragedy (the loss of his young wife), what else moved Albert Londres beyond the rather vaporous, undistinguished early self and apprentice writings?

Chapter 1
Finding his Feet: Poetry and Parliament

Like everyone, Albert Londres did not come from nowhere. On his father's side he descended from Gascons, the archetypal big-talkers. His paternal grandfather was a pedlar. By all accounts his father was an attractive man but inclined to flare up. Londres's mother came from the Moulins area. Her father, a man of strong republican convictions, was for some years a boiler-maker. Thus, itinerancy and craftsmanship formed a good part of Londres's patrimony.

Londres was born in Vichy in 1884. He made little impact at school, and rarely mentioned in later life his sketchy education or his adolescence. His first job, at Lyon, was in low-grade accountancy, for which he was unqualified, in a mining company. He much preferred spending his leisure time in smoky old bars: provincial Bohemia. He had some connexion with anarchist circles – Lyon was a leading centre – and met Libertad, devotee of Kropotkin and a cripple who used his crutches in street-brawls.[1] Londres's group of friends included Charles Dullin, later to become a leading actor and founder of the Théâtre de l'Atelier in Paris; Henri Béraud, son of a baker, larger than life, later a highly successful novelist and journalist, and 'si plein de talent et de lui-même';[2] the painter and draughtsman Georges Rouquayrol, who would accompany Londres on his fact-finding trips for *Chez les fous* and *Terre d'ébène*; and the café-violinist Achille Berger.

When Londres scooped the group by moving to Paris, a daughter, Florise, was born to his union with Marcelle (Marie) Laforest, in 1904. Londres never got over Marcelle's very early death in 1905. Though later he would be forever 'abandoning' Florise to the care of her grandparents in order to travel for his work, he was devoted to her, his

1 Libertad was the pseudonym of Albert Joseph (1875–1908). He died very possibly as a result of police brutality.
2 Jean Butin, quoting Henri Jeanson: *De la Gerbe d'or au pain noir, la longue marche d'Henri Béraud.* Roanne: Horvath, 1979, p.23. Béraud will reappear several times later in this book.

only child. Globetrotting is an effective means of family planning, although he is reported to have had many affairs on his travels and on brief returns home. From wherever he found himself across the world he wrote very regularly to his parents and daughter, and sent foreign stamps for his father's collection. The letters home were generally franker, even allowing for his natural fear of alarming his ageing parents, than his articles, because of his concerns about censorship, whether official or editorial. Despite the frequent comparison of his face to that of Christ by those who knew him, Londres was catholic mainly in its primary sense of having wide interests and sympathies.

Londres began, and continued all his life, by writing poetry. He was largely an autodidact, with a little help from his friends, in the past or present. He read a good amount of nineteenth-century French poetry, and among his favourites in other literary fields were Stevenson, Barrès, Kipling and Conrad, all in differing degrees migratory. He also cherished Zola, who advised budding novelists to acquire and hone their skills by writing reportages.[3] Barrès, while acknowledged as 'notre maître', was to be used, however, as a trampoline, not as a resting-place.[4] In the same collection, Londres urged other young men and himself to move from self-absorption to 'le besoin de nous extérioriser'.[5] He published *Suivant les heures* (1904), *L'Ame qui vibre* (1908), *Lointaine* (*Le Poème effréné*, 1) (1909), and *La Marche à l'étoile* (*Le Poème effréné*, 2) (1910). According to Assouline, Londres had two volumes of sonnets ready for publication shortly before his death by misadventure.[6]

Suivant les heures, also a collection of sonnets, was prefaced by the minor poet Clovis Hugues. Its vocabulary returns obsessively to words such as 'ma mie', 'catin', 'âme', or 'gueux'. Reviewers, often praising, yet picked on the excessive repetitions, a form of stuttering. Musset and Coppée were often adduced as influences. Londres first met Coppée in 1906. *L'Ame qui vibre* includes a letter to and a brief note from Coppée. It houses a prayer by Londres to be converted and some free verse, for which he apologises to his senior. Other poems are in memory of

3 Though Zola's own *Carnets d'enquêtes* were not published in Londres's lifetime.
4 Londres: *Lointaine*. Paris: Sansot, 1910, p.8.
5 Ibid., p.9.
6 Assouline: *Albert Londres*, p.560. They disappeared with him when the ship went down.

Marcelle, or addressed to Florise or his mother. Londres published a homage on Coppée's death in 1908, in which he recalls being a worshipful regular at his *soirées,* and, in counterbalance, the Lyon bohemian group ritually inaugurating all meetings with the cry of 'A bas Coppée!'[7] As a poet, Londres was, plain to all, 'un Romantique attardé'. His poems have frequent lyrical moments, and often eccentric metaphors, a feature recurrent later in his reportages. His poetic patron saint was Christopher Columbus, the prototypical searcher-traveller. In a poem named after him, Londres writes:

> Seuls, le fécond voyage et l'horizon nouveau
> Pourraient calmer cette âme et nourrir ce cerveau.
> J'essaierais bien ainsi que fit Xavier de Maistre
> De tenter un voyage entre porte et fenêtre.
> Mais mon aile déployée et faite pour l'azur
> Au moindre mouvement se heurterait au mur.

These lines convey Londres's lifelong tension or alternation between unimpeded movement and closed spaces. Much more rarely in the poems, a wry jokiness leavens the intensity, as in these verses for his father's feast-day:

> Plus de trois mille alexandrins
> Sont en ce moment sur ma tête.
> Je suis dans le roi des pétrins.
> Je n'ai pas le coeur à la fête.[8]

La Marche à l'étoile includes a panegyric of pioneering aviators. The peregrinating Londres was never to venture aloft in a plane. That volume's epigraph comes from Victor Hugo: 'Ce n'est pas de toucher le but, c'est d'être en marche', which foreshadows Thom Gunn's more macho 'One is always nearer by not keeping still'.[9]

7 Londres: *La Vérité* (Vichy), 31 May 1908. In Archives.
8 Both poems are in the 'Poèmes inédits' in the Archives.
9 Thom Gunn: 'On the Move', in A. Alvarez (ed.) *The New Poetry*. Harmondsworth: Penguin, 1972, p.157. Before checking, I remembered this line as 'You always get somewhere by not sitting still', which I perversely prefer.

Londres also tried his hand at playwriting.[10] His one-act *comédie* in alexandrines, *Fleurs des eaux, ou Le Joli Rêve*, was performed at the theatre of Vichy's casino in 1911, and was greeted with (no doubt waters-induced) 'chaleureux bravos'.[11] Its essentially static poetry displays a worldly-wise tone about love. Later, Londres dined in 1920 with Firmin Gémier, the director of the first Théâtre National Populaire, and discussed his play on Gambetta, in verse (even the telegrams…) and in five acts. Its use of political material is largely abstract. Londres would live to write far better theatre in the dramatic dialogues he devised for his journalistic interviews.

I am taking Londres's *Marseille, porte du Sud* (1926) out of sequence, because it is in several ways a prose-poem, and because it reveals how at the height of his fame for investigative reporting, his founding urges for poetry, travel, evocation of place and atmosphere, were alive and kicking.

In the opening pages of this report on the most exotic of French cities, Londres acts, like Jules Vallès for Paris, as a barker for Marseilles, and at the same time, comparably too, as a self-publicist. He delivers a spiel outside the multicoloured booth that was and is this great seaport, this gateway to the wide world.[12] 'Ecoutez, c'est moi le port de Marseille, qui vous parle. Je suis le plus merveilleux kaléidoscope des côtes.'[13] Roll up! As often on fairgrounds, the promises are not kept, or are kept differently. Marseilles can only set people off to view the world's wonders, including the globe's female beauties, in their place of origin; she does not house them, except by suggestion. But she can offer her own marvels, her microcosm of the macrocosm. Marseilles lives off, thrives on, export/import: 'Je prends tes tapis, mais reçois mes canons' (p.33). Inevitably it is a multicultural melting-pot, a caravanserai (p.57).

10 And we will see in later chapters how others have adapted his despatches for the stage (*Au Bagne*, *Le Chemin de Buenos Aires*, and various medleys).

11 *L'Argus de la Presse*, 13 September 1911.

12 I will throw several bridges between the journalism of Londres and that of Vallès in the course of this book.

13 Londres: *Marseille porte du Sud*. Paris: Arléa, 1999 [1926]. All references in brackets after quotations are to this edition.

Londres climbs aboard a liner ready for departure, and notes the pampered pooches whose passage costs more than steerage-class humans pay (p.35). A group of ocean-going officers, on whose wavelength Londres homes in, talk about retirement. One has got a straddle post as company inspector: 'Enfin! s'écrie-t-il, mon rêve se réalise, je vais voyager' (p.81). The reformist Londres loves the incorrigible. Equally, he can rehearse in his head and senses the act of setting sail: 'A lui seul, ce hangar est l'Extrême Orient. On en renifle les arômes. Du moins on les imagine' (p.37). Londres, however, never forgets the grass-roots, the human infrastructure to all the romance of travel and trade. Paradoxically, 'un docker est un homme qui travaille durement pour la seule raison qu'il n'a rien à faire' (p.52). It would no doubt surprise stevedores to learn that they lacked a trade, that they were just humpers. Yet Londres is not being thoughtlessly dismissive, for he goes on to describe colliers, the lowest of the low in the wharf pecking-order, doing the dirtiest labour, smelly work, dangerous to skin and lungs, like the pearl-fishers of his report on that Persian Gulf industry five years later.

The year following his Marseilles articles, Londres published *Le Chemin de Buenos Aires* (1927), but here already he interests himself in economic emigrants: 'Les uns désertent les pays trop habités, les autres les terres ingrates. Ils s'en vont, par la grande route d'eau, mendier une patrie […] La leur n'était plus capable de les faire manger' (p.57). In particular, among the self-uprooting ones, he spots the Jews (*Le Juif errant* would follow in 1930): 'Ce sont nos juifs qui, un livre à la main, et se balançant de droite à gauche, ont pris le zinc du comptoir pour le mur des Lamentations' (p.62). This notation both estranges and naturalises the Jews and their idiosyncrasies. While showing compassion for the under-privileged, Londres is never afraid to see comedy in them. To this end, he records a fairly gentle scam concocted by a Marseilles wide boy, by which an advertising film obtained gratis is run for 20 centimes admission to wide-eyed migrants (pp.64–5). Other enterprises include a resourceful operator who removes tattoos with his 'magic' liquid (pp.66ff.).[14]

Londres includes far more serious matters, with which he would deeply involve himself in China just before his death: the opium trade,

14 Tattoos figure significantly in the civil and military prison regimes described in *Au Bagne* and *Dante n'avait rien vu*, both of 1924.

centred on Marseilles, and more up-market than cocaine. He studies the constant guerrilla war between rival gang leaders, and familiarises himself with all the tricks of the trade for smuggling in drugs (pp.84–5). He meets one chief, a Chinese, who allows the French Customs and Excise operatives small successes, in order to keep them happy and at bay from the big stuff. Londres takes in the *maquis,* the criminal-underworld district, a world apart, and which includes the white-slave traffic he would later investigate in *Le Chemin de Buenos Aires*. He is particularly fascinated by the training facilities, e.g. tutoring in burglary (p.94). He finds the local police strangely proud of 'their' criminals: 'Vous ne verrez cela qu'à Marseille' (p.98).

A better testimonial for Marseilles is provided by Londres himself. Marseilles is the Eldorado, magnetic, now frustrating, now fulfilling, for the disinherited. 'Marseille est une ville heureuse où passent beaucoup de malheureux. Il y a de pauvres Arabes, de pauvres nègres, de pauvres blancs' (p.99). He records one such wretch, in pidgin French: 'A cause belles histoires sur le Marseille. Marseille beaucoup magnifiques, beau-coup mensonges' (p.100). With all her howling faults, she acts as a powerful lure. The different races stay largely in their national groups, especially the Armenians. They live in rows of tightly-packed shacks, like horse-boxes: 'On y dort, la tête chez le locataire de droite, les pieds chez le locataire de gauche' (p.105). Such Vallésian inflation of the minimal is both comic and pointed; it drives the inhabitants' very real indigence home to readers. 'A l'étranger, tout le monde devient nationaliste. Question de parler, question de sentir, question de rêver. Au contact, l'internationalisme perd de sa force d'idée' (p.111). Within these ghettos, imposed or chosen, 'à quoi rêvent-ils? […] Moi, je crois que c'est à rien. Ils rêvent par manque de domicile' (p.113). Such enclaves are not home, but just abodes. Yet such stripped-down existences have their own fulness:

> C'est comme lorsqu'ils marchent, ils semblent tourner autour de quelque chose que les autres ne voient pas: ce quelque chose n'est que leur désoeuvrement. Mais, pour des esprits sans calcul, c'est déjà rêver beaucoup que de ne rêver à rien (ibid).

Londres is never a prosaic observer; he intuits the unseen.

Proudly, at the end, he admits what he has *not* supplied: accounts of accountancy, economics, literature, civil engineering projects, urban

reconstruction (pp.115–17). Such negatives or absences matter much less to him than his purpose in composing this kaleidoscopic prose-poem: to jolt the incuriosity peculiar to the French for all to do with the sea and, beyond, the colonies (pp.117–18), a leitmotif of his reporting on places as various as Devil's Island, Indochina, French India, and Central Africa. He might have added that he has not, either, resorted to the omnipresent Marseilles stereotype: the big talker, the spouter of French blarney *(galéjade)*, Pagnol's Marius or his near neighbour, Daudet's Tartarin from Tarascon. Londres preferred to furnish his own hyperbole, for his own ends, which are not solely to amuse.

Just as the Lord Mayor's Show is followed by the muck-cart, so prose follows poetry. The bridge is that it was Coppée who introduced Londres to the team at the major national daily of the day, *Le Matin*, and thus unknowingly set him off on his true calling. After some bitty pieces for his home-town paper in Vichy, Londres had relied on a fellow Lyonnais, Elie-Joseph Bois (later to become the editor-in-chief of the mighty *Le Petit Parisien*, to which Londres contributed the articles that made up *Marseille, porte du Sud*), who was directing at that period the Paris bureau of the Lyons paper, the liberal republican *Le Salut public*.[15]

There, Londres began to learn the trade of parliamentary gossip columnist *(échotier)*: press-cuttings, scissors-and-paste: jackdaw-work, including a good deal of that prime journalistic equipment, plagiarism. To these he added familiarity with the daily workings of the French Chamber of Deputies. It was all desperately low-level labour, invaluable in its way, but unsatisfying to a young man with ambitions. As Assouline comments, Londres in 1912 was 'le type même du journaliste sédentaire dans un quotidien [*Le Matin*] réputé pour sa couverture des grands événements internationaux'.[16] Like many French newpapers of the period, its articles had a persistently literary flavour.

15 Londres also contributed, under the pseudonym 'Aigues-Mortes', some pieces to the leading provincial daily, *Le Petit Marseillais*, and as 'Jacques Couzy' to *La Dépêche*. Later, in 1919, he wrote for the illustrated paper, *Excelsior*, among a great many entirely serious articles, a frothy chronicle 'A Vichy … aux eaux: la Journée du baigneur', about the spa town and what its visitors got up to. In Archives (AS 76/13).

16 Assouline: *Albert Londres*, p.65.

Londres never forgot his first, and lasting, impulse: to be a poet. Generously, he lends a (small-scale) poetic faculty to everyone, for he knew that none of us speaks unremitting prose all our lives.

The First World War was looming up, where Londres would truly find his feet, often encased in mud, as a war correspondent.

Chapter 2
War in West and East

Western Front

In 1906, at the age of twenty-three, Londres was declared unfit for military service, by reason of a weak constitution. Because of a staff shortage, in 1914 his paper, *Le Matin*, appointed him as one of its war correspondents. His initial task was the collecting and transmitting of communiqués from the War Ministry. As Mark Pedelty remarked: 'No journalist becomes a war correspondent without some attraction to war and violence'.[1] Furthermore, whether consciously or not, journalists in any arena must often wish for the situation they are witnessing to get worse, so as to become more newsworthy. Pedelty, in fact, cites one who, in El Salvador, declared: 'You can either be a foreign correspondent, or a human being'.[2] This, no doubt, is the bottom line, but there are many lines above it.

Journalists often cut their teeth as war correspondents, for war, death-dealing as it is, is a continuation of life by other means. The role of war correspondent is customarily held to have been kick-started in the Crimean War, with the growth of the belief that far-flung conflicts were of keen interest to the civilians back home, and were not the exclusive stamping-ground of general staffs or politicians. The American Civil War generated a large increase in such reporting, extensively using the telegraph, and the Boer War fulfilled a similar role in British journalism. Battle photography followed the same pattern, though for a long time photographs were unusable by the press, which relied instead on war-artists for graphic back-up. Over his career, Londres would sometimes

1 Mark Pedelty: *War Stories: The Culture of Foreign Correspondents*. New York and London: Routledge, 1995, p.153.
2 Pedelty, p. 142.

have a photographer in tow, sometimes a sketcher. He himself wrote prose as visualisable as he could make it.

'Covering' a war must always have been like a Shetland stallion trying to cover an elephant: hit-or-miss at best, even if it could reach the crucial centre at all. Comparatively little war reporting is conducted at first hand, at the front line. Reconstruction of what happens must come mainly from variegated sources, including the imagination. News in general is most often, most naturally, and most lazily, conveyed in episodic terms, frequently short-term and regularly violent. Such episodes are newsworthy precisely because of this discontinuity, this discreteness as bounded events. Hence, in the context of war, the use of the pejorative term 'war-tourist'.[3]

Evelyn Waugh, in his novel *Scoop,* provides an excellent example of the Orwellian Newspeak of telegraphese: ' "Request earliest name life story photograph American nurse upblown Adoura". We replied: "Nurse unupblown", and after a few days she disappeared from the news.'[4] Whereas *Scoop* was actually a piece of straight reportage, thinly disguised as a novel to protect the author from libel actions, Londres, as we shall see, habitually melded the resources of fiction with his reportages. As for Rudyard Kipling, one of Londres's favourites, his Gilbert Belling Torpenhow, when war correspondent in the Sudan, describes the qualities of such as himself in these terms: 'The power of glib speech [...], the eye of a horse-coper [dealer], the skill of a cook, the constitution of a bullock, the digestion of an ostrich, and an infinite adaptability to all circumstances'. On stealing his fellow-newsmen's despatches or scoops, he claims that 'all [is] fair in love and war correspondence'.[5] Londres would have countersigned most of this wish-list.

The First World War, on its Western and Eastern Fronts, acted as the site of Londres's apprenticeship as a proactive journalist. His instinct and his realism must have told him that he could best bring the war home to civilian readers not by front-line reporting on armies locked in lethal combat, even if he could have got permission for that close-up, but by writing of the effects of war on the very fabric of French and Balkan life: its villages, towns and buildings, and their denizens, the human and non-

3 See Carruthers: *The Media at War*, pp.231–2.
4 Evelyn Waugh: *Scoop*. Harmondsworth: Penguin, 1948 [1933], pp.160–1.
5 Rudyard Kipling: *The Light that Failed.* New York: Aumont, 1969 [1890], p.23.

human landscapes of war. For his own benefit, his apprenticeship brought home to him his true vocation: to locate, describe and denounce alienations (the chaos produced by war, and later penal, economic or racist alienations). In professional terms, he learnt fast, for example in the unearthing, often from ruined buildings, of eye-witnesses. Quickly his despatches made the front page of *Le Matin*.

As a war correspondent, he strove always to reach the most advanced, the most dangerous positions, and was ever ready to harness any means of locomotion (horse, ox-cart, bicycle, lifts in cars or boats, or Shanks's pony) to get there. He suffered. He slept rough, ate no better than the *poilus*, and exposed himself to the constant risk of being killed, by shelling, sniping, or by disease. It is pointless, however, to picture him as a front-line reporter (probably, in the main, it is only war photographers who are that), because in the 1914–18 War as in any other, and later in the China-Japan conflict, the front line kept shifting, often on an hourly basis, and was topographically dispersed. All we can honestly say is that Londres tried to go everywhere he could possibly get to. In the thick of the horrors of war, he soon learnt to understand what war does to military or civilian human beings, how it forces them to do things, heroic or ignoble, that they would never contemplate doing in peacetime. Where he excels is in passing on to readers something of the very feel of war: the noises, the smells, the catastrophic impact on the non-human world, the plausible attitudes and sentiments of the common soldier or citizen. In this hectic, often hallucinatory atmosphere, Londres tries to keep to the facts he has observed or learned of and checked. He freely acknowledges that much of the time he was writing, quite literally, in the dark. On board a ship in June 1915 near the Dardanelles,

> il m'est défendu de m'éclairer, même le temps de deux allumettes. Je sors cependant mon carnet, mon crayon et, en pleines ténèbres, ne voulant pas oublier tel cri que j'ai entendu, tel coup que j'ai ressenti, une ligne par page, pour être sûr de ne pas en griffonner deux l'une sur l'autre, je me mets à écrire (*CR*, p. 96).

Though he often writes excitedly, emotionally, such prose stays in tune generally with the events described, the mood he wishes to transmit. Amid all the death and destruction, he can evoke joyously an advance in October 1916 by Allied troops near Monastir:

> Les troupes d'avant, les troupes du milieu, les troupes d'arrière, les états-majors, tout déménage, tout est à cheval, en voiture dans les champs et sur les pistes. Tout est plus gai, tout est plus aimable, tout est plus confiant. Tout est plus haut: l'espoir, la tête, la parole; tout est plus léger: l'exil, la souffrance, le coeur. Le cafard est tué. L'avance! (*CR*, p.192).

He knows, of course, that this exaltation will be a brief interlude before further losses and stalemate. Yet even here he is less writing up an event or whistling in the dark than recording a collective dynamism. His essential honesty compels him to register also bafflement, the great and futile why and wherefore that war poses. On one of three trawlers in March 1916, Londres sees another disappear, in seconds: mine, or torpedo?

> Nous avons été les témoins immédiats du drame à vingt mètres, et nous ne savons rien. Tout ce que nous savons c'est que nous sommes partis trois, que nous ne sommes plus que deux et que la nuit, la belle nuit, vient (*CR*, p.156).

War the great obliterator: the sense of horror is unspoken, but audible.

Ever alert to human forgetfulness and war-weariness, on return from the Balkans to the French Front in July 1917, Londres inserts a reminder of his counter-intentions:

> C'est pour tous ceux à qui la guerre ne parle pas que j'écris aujourd'hui. Je débarque de Salonique. Pendant vingt-sept mois j'ai accompagné nos armées en exil [...] Que ceux qui n'aperçoivent plus distinctement le paysage tragique de la guerre parce qu'il leur est trop familier ou qu'ils en sont trop loin, viennent avec moi. Je vous emmène, suivez le nouveau débarqué: nous allons voir (*CR*, p.235).

Like any sane observer, Londres is repeatedly appalled by wanton German destructiveness, with no military point at all, except of course sheer terrorism. The sack of a château in 1917, whose statues in the grounds were smashed because too heavy to loot; all the houses in Douai pillaged in October 1918: 'Ce n'est pas la bataille qui a fait ça, c'est la main tranquille du Boche' (*CR*, pp.241, 361). Londres is unafraid of the most obvious images, the lunar landscape after prolonged shelling (August 1917):

> C'est à la fois un volcan qui aurait mille et mille cratères, une pâte qu'un pâtissier aurait brusquement triturée et un pays d'indéracinable spleen qui, en une nuit, pour le malheur de toute la terre, aurait descendu de la lune (*CR*, p.35).

The homely baking image in the middle is designed to speak to the domestic reader.

His most famous description was also the first piece of journalism he ever signed (21 September 1914) with his own name: on the shelling of Rheims cathedral. This devastation would be later exploited to stigmatise the brutal vandalism of the enemy, either in popular iconography, or in texts by intellectuals such as Romain Rolland, or by artists. This historic building enjoyed a special symbolic value for the French as it had been for long the centre for the coronation of French kings.

> Sur un fond rouge et mouvant comme une tenture que l'on secoue, la cathédrale, étirant ses lignes vers le ciel, prie ardemment. Elle recommande son âme à Dieu […] Rien que pour elle on se serait fait catholique […] Elle n'était pas suppliante comme celle de Chartres, pas à genoux comme celle de Paris, pas puissante comme celle de Laon. C'était la majesté religieuse descendue sur la terre (*CR*, p.23).

Londres was in fact a staunch republican, but such desecration of a traditional religious shrine (and this is virtually the sole instance of any overtly pious sense in all of Londres's writings), spoke to him eloquently, if mainly in aesthetic language. He uses a verbal travelling-camera to match step by step his movements round the site. Such a tactic both draws the reader further in, and establishes the reporter at the centre of the scene. The text is a prose-poem, and an indictment of a war crime, an atrocity against the non-human. Returning to Rheims in April 1918, and seeing its whole centre destroyed, he writes, in the vengeful future tense: 'Qu'aucun de leurs crimes ne se perde […], qu'ils ne comptent plus, à l'ombre de l'émotion nationale, accomplir leur saleté en silence […] Ils ne s'en laveront pas les mains.' Then, in a weirdly phrased sentence: 'La poésie de la destruction ne peut plus contenter nos malheurs' (*CR*, p.310). In his *France at War*, Kipling, with more impetuosity than sane infantrymen display, goes over the top, in denouncing the wrecking of Rheims cathedral 'which is always the favourite mark for the heathen', and: 'We are dealing with animals who have scientifically and philosophically removed themselves inconceivably outside civilisation'.[6]

6 Rudyard Kipling: *France at War*. London: Macmillan, 1915, pp.16, 28.

As well as the black purple patches, Londres never forgets the minutiae of war: 'C'est ce que personne ne racontera, ce que les enfants n'apprendront pas, c'est la marge de la page. Ne bougeons pas, de peur de l'écorner' (*CR*, p.17). A key example of this is the common-or-garden bravery of soldiers: 'C'est une des amertumes de cette guerre de ténacité que l'héroïsme quotidien soit étouffé sous le poids d'une action plus éclatante' (*CR*, p.108). He looks for the nugatory but priceless little consolations that humans resort to in the midst of combat: 'Si la mort arrive en sifflant, c'est en sifflant qu'on la reçoit' (*CR*, p.114): two very different kinds of whistling in the dark.

Atrocities and Propaganda

Reporting in March 1918 on the occupation of Belgium, Londres lends credence to the rumour rampant in the early stages of the war: the Germans' cutting off the hands of Belgian children (*CR*, p.297). After the war, this rumoured atrocity was shown to have been a fabrication of the British press. In general, however, Londres does not choose to monger atrocities; presumably he felt that many enemy excesses had to be kept under wraps or lessened, in order not to create panic in the civil population and indeed the Allied armies. He concentrates, rather, on the massacre of buildings and countrysides. Assouline, therefore, misreads when he declares that threatened architectural masterpieces move Londres more than human agony.[7] In their level-headed study of the issue of German atrocities, Horne and Kramer remind us that 'with war [...], "Kultur" (as it was mockingly spelt) became the very essence of barbarism'. Furthermore, 'the invention of national traditions in the nineteenth century included the redefinition of major historical and architectural monuments as sites of memory which helped constitute the nation'.[8]

7 Assouline: *Albert Londres*, p.87.
8 John Horne and Alan Kramer: *German Atrocities, 1914: A History of Denial*. New Haven: Yale University Press, 2001, p.217. The authors link the aforementioned myth of severed hands with the international scandal in 1903–5 centred on such

Londres had, inevitably, all the stereotypes about the enemy at his command, or at times dictating his responses. The Germans are irrational barbarians. Some of the stereotypes are reciprocally destructive: the German is stupid/fiendishly clever, a coward and a brute. Clichés, of course, are long-life; some of Londres's are still topical, or even endemic widely. Obviously, Londres could not totally escape contamination by the gas of war rhetoric; and very few correspondents ever achieve anything approaching objectivity, let alone sympathy for the foe. In some compensation, Horne and Kramer feature the unfounded Great Fear which swept through the invading German armies and which

> took the form of a collective delusion that enemy civilians engaged in a massive resistance in a franc-tireur war [...] The delusion developed such force that it persuaded one million men of the reality of a chimera.[9]

We should also remember the long-running and automatic French 'imaginary' (as French now puts it) concerning Germany, acute since 1870, which saw it as the hereditary enemy, when England had a much better right to this accolade. Reminiscent of the complaints of English soccer fans about the unjustly superior skills of foreign teams, Londres is not alone in echoing the common grievance that the Germans do not fight fair, as if war were a boxing exhibition. The enemy, naturally, excluding prisoners, was largely invisible to French soldiers or journalists, except at a killing distance, and so Londres could hardly have individualised enemy troops, even if he had wanted to. He collectivised them and made them abstract, mainly as stereotypes. All the same, even when patriotically boosting the Allied war effort, Londres, in contrast with many famous French writers of his day (Barrès, Claudel, etc) never did so inanely.

That he makes little or no mention of German atrocities against humans means either that he accepts them as an unavoidable element in the anarchic insanity of war, or that he dismisses reports of them as yet another aspect of the extensive propaganda cooked up by all parties to the conflict. Though he was shocked by apparent German callousness

alleged practices in the Belgian Congo. They comment: 'What an ironic reversal, then, that Belgian colonial brutality (and Belgian guilt) should supply the dominant motif of victimhood for Belgium in 1914' (p.223).

9 Horne and Kramer, p.419.

towards their own, the burning of dead troops' bodies instead of burial, he later records an equivalent French instance. For him, this was less an atrocity than a harsh embodiment of the pragmatism (here, prophylaxis against epidemics) which rules the waging of any war (*CR*, pp.18, 32). So much false news (rumours, myths, propaganda) proliferated in the Great War that Londres's choice of generally playing it cool and readily admitting ignorance of much that was going on acquires a positive virtue. Marc Bloch cites a witness, for many serving soldiers have always been rudely sceptical about official lines shot to them: 'The prevailing opinion in the trenches was that anything might be true, except what was printed', and adds for himself: 'On the tactical maps, a little behind those interlacing lines which designate the forward positions, it would be possible to hatch in a continuous strip which would be the myth-making zone': especially field-kitchens.[10] The theatre of war spawns and feeds off much ham-acting, hammy speechifying, hambone writing. As newspapers try to reflect public opinion, this often entails further embroidering, distortion and amplification of local legends and bush-telegraph. Hearsay depends for its potency not only on oral transmission, but also on the printed word.

The much-chewed quotation: 'In war, truth is the first casualty' was used as an epigraph to Arthur Ponsonby's *Falsehood in Wartime*.[11] No doubt front-line privates lied, by the sins of omission or commission, in their letters home, for the best of reasons, and lying abounded in the Great War, as in all others, always. Londres was on the look-out for the practice of mendacity and mystification:

> Une expérience professionnelle nous ayant démontré qu'il suffit à un bruit gros comme une grenouille de parcourir quelques kilomètres pour vous arriver gros comme un boeuf, il nous a paru logique que lorsque ce bruit franchissait deux montagnes et une plaine, il nous parvînt gros comme un éléphant (*PP*, p.164).

Here he takes the La Fontaine fable about vainglorious expansion and balloons it further in a new context. He felt only contempt for such

10 Marc Bloch: *The Historian's Craft*. trans. Peter Putnam. Manchester University Press, 1963 [1954], pp.107, 109.

11 Arthur Ponsonby: *Falsehood in Wartime*. London: Allen & Unwin, 1928. It has also been attributed to Senator Hiram Johnson, speaking in the US Senate in 1918, but it is not recorded in the transcript of his speech.

patriotic bombast as this lieutenant-colonel's offering about *poilus*: 'Tous ils vont à la bataille comme à une fête'.[12] Of course, the press was not, even within one paper, monolithic or unchanging. Different phases of the war gave birth to different emphases and moods: triumphalism, fear, boredom, sabre-rattling, and so on. If anything, propaganda was even more pronounced in films than in the papers, because it was far easier to control a film-crew and its bulky equipment than a solo reporter with a notebook. The French Army, in fact, possessed its own film-unit from February 1915. Ponsonby reports that 'in Vienna an enterprising firm supplied atrocity photographs with blanks for the headings, so that they might be used for propaganda by either side'.[13] According to Knightley, 'Britain by the end of [World War 1] had created a propaganda organisation that became the model on which Goebbels based that of the Germans some twenty years later'.[14]

Londres was seldom blindly victorist, unlike much of the French press corps. (In the early 1920s, Marshal Foch vetoed the coinage 'défaitisme' on the grounds that it was an un-French concept.[15] I am reminded of Napoleon's dictum to General Count Lemarois, 9 July 1813: 'Ce n'est pas possible, m'écrivez-vous; cela n'est pas français.') On the other hand, Londres did not write anything which might demoralise the French citizen or soldier. The French press as a whole, in Pierre Albert's view,

> contribua puissamment à anesthésier l'opinion publique et rendit possibles les opérations de propagande. Son rôle essentiel fut d'éviter à un pays fatigué, dont les nerfs étaient tendus à craquer, les émotions fortes que lui auraient données les événements s'il les avait connus dans leur brutale réalité.

Albert goes on to quote Alain's maxim: 'Il ya deux guerres, celle qu'on fait et celle qu'on dit'. As evidence of this verbalised war, he cites Londres's paper, *Le Matin*, on 24 August 1914, which notoriously declared that the Cossacks were only five days from Berlin; and *L'Intransigeant*, on 17 August 1914, maintaining that German bullets

12 Lt. Col. Rousset, in *Le Petit Parisien* of 17 May 1915, cited in Jean Galtier-Boissière: *Mémoires d'un Parisien*. Vol.1. Paris: La Table Ronde, 1961–3, p. 243.
13 Ponsonby: *Falsehood in Wartime*, p.21.
14 Knightley: *The First Casualty*, p.82.
15 See Robert Graves and Alan Hodges: *The Reader Over Your Shoulder*. London: Cape, 1955, p.18.

were harmless; they passed through bodies without tearing any flesh.[16] Londres tried very hard to eschew big talk, if not (generally comic) hyperbole. He maintained that:

> L'abnégation de nos combattants est assez sublime, elle peut se voir à nu.. Elle n'a besoin de nul manteau pompeux pour recouvrir la vérité. Faisant ainsi, nous n'interpréterons pas l'avant avec les imaginations de l'arrière et l'avant piquera une rogne de moins (*CR*, p.291).

Similarly, later in 1918, he wrote: 'Entrons donc simplement dans les vallées de ce monde bouleversé, elles ont connu assez de fracas pour qu'on leur épargne celui des mots' (*CR*, p.342). Exaggeration of the straightforward was obfuscation, and Londres preferred his own brand of hyperbole. Patriotic gore was not his cup of tea.

Censorship

There is a tenacious myth that it is the media, not armies, that lose wars, a case of shooting the messenger, or of 'No news is good news'. Hence military briefings, current already in the 1914–18 War, as an attempt to emasculate the reporting of battlefield news, and thus to spin the reality of the fighting for propagandistic purposes. Propaganda (or the spreading of (mis-)information) and censorship (withholding or doctoring information), intoxication or filtering, are ostensible contraries, but in fact they work hand in glove. Euphemisms for these practices mincing about today include 'press restrictions' or 'guidelines'. Few in the newspaper business actually doubted, in the First World War, the need for censorship, or '(Madame) Anastasie', to give it its long-established nickname. The protesters mainly longed for a more supple and thoughtful variety of communication, and not what was doled out grudgingly by that supreme oxymoron: military intelligence. In Londres's day, the entire press *corps* was more like a platoon in size. While not relenting on censorship,

16 Pierre Albert: 'La Presse dans la guerre (1914–1918)', in: Claude Bellanger et al. (eds): *Histoire générale de la presse française*. Vol.3: *De 1871 à 1940*. Paris: Presses Universitaires de France, 1972, pp.413, 425, 424.

military and government agencies have increasingly, in the last few decades, sought to harness and annex the power of the media for their own ends, instead of conducting a war by other means against the media. General staffs and politicians have always wanted to see for journalists, who are supposed to be professional eye-witnesses. The eternal conflict, clearly, is between secrecy, probably essential for the successful prosecution of a war, and publicity (the very reason for the existence of journalism), though armies themselves require (favourable) publicity. It has to be asked, also, whether newspapermen or women are always as conscious as they should be of the dangers of 'careless talk', which might cost lives. Furthermore, the practice of military disinformation, frequently relayed by the media, can on the right occasion usefully hoodwink the enemy, as well as misleading the common soldier or the folks back home. One command by the brass or bowler hats is that the media should censor any mention of censorship, the attempt to muzzle and domesticate the press. The more insidious and politically crippling kind of censoring is self-censorship, when you make your own what you theoretically should hate. Such airbrushing of awkward or unwanted reality often resorts to the age-old excuse, as does euphemism, of wanting to spare people's feelings.

Euphemism, sleight of tongue or pen, spreads its stifling nets ever wider. We have grown familiar with weasel words such as 'surgical strikes', 'collateral damage', 'friendly fire', or the rather more candid 'incontinent ordnance', 'to terminate with extreme prejudice', and, like all euphemism, 'to be economical with the truth'. This is language dressed to kill, and no mistake. The verbicide in US officialese about Vietnam helped to extend the practice of herbicide to genocide. For his part, while rarely being crude, Londres does not write nude. He is very alive to what can reasonably be put in black and white. Hardly ever euphemistic, he generally calls a spade a spade, and gets down to brass tacks. There is, of course, a thinnish line between allusiveness (giving the reader some work to do) and evasiveness.

We expect soldiers to use camouflage for assault or self-protection, but should we condone verbal fig-leaves, cover-up jobs? Fudging, sugarcoating, pulling punches, all these seek to make the unmentionable also unthinkable, to censor it out of existence. To me, there is invariably something inherently comic in the desperate manoeuvres of attempted whitewashing, that would-be contraceptive rhetoric. 'Mincing' words

and a 'mincing' gait come from the same root: to be over-fastidious, to chop up small, no doubt the better to make statements easier to swallow. With its hidden agendas, its attempts to slant information, euphemism employs implied inverted commas, as if these could be an electrified fence to keep out the undesirable, or a sanitary cordon ensuring a sanitised immunity.

On the whole, Londres evaded *bourrage de crâne* in all its forms. Yet some of his silences surprise. He makes no mention, for example, of the widespread occurrence of shell-shock, or, as we say today, post-traumatic stress disorder. His excuse might be that medical, military and governmental authorities have ever been reluctant to acknowledge that it exists, when malingering, cowardice, financial opportunism and so on are so much more convenient and cheap explanations for psychic or somatic aftermaths. Despite his time spent with British troops, Londres does not refer to British myths such as the Angels of Mons, which derived from a story by Arthur Machen, 'The Bowmen', where there was no mention of angels, but rather ghostly archers from Agincourt rescuing English Tommies miraculously.[17] A rare complaint about the difficulties of his job as war correspondent runs as follows:

> Je répéterai des choses, j'en oublierai d'autres. Au milieu d'événements qui se précipitent, se contredisent et s'enchevêtrent, avec des dépêches qui sont censurées à Salonique, tronquées à Malte, revues à Paris, que peut-on fixer de définitif? Comment aurait-on le temps de tracer le contour des endroits où se passent des drames quand les drames ne font que courir d'endroit en endroit? Tout juste si l'on peut attraper au vol les grands faits qui passent sans savoir toujours d'où ils viennent ni où ils vont (*CR*, p.131).

Yet despite all such fragmentation and interferences, he persists in being realistic:

> La réalité, ce n'est pas un village pris […], la réalité, celle qu'il faut dire – et nous n'apprendrons rien à l'ennemi – c'est que nous sommes dans une impasse, c'est que devant les forces bulgares qui se déploient, devant cinq divisions turques qui marchent en Thrace […], nous ne sommes qu'une poignée (CR, p.133).

17 See Paul Fussell: *The Great War and Modern Memory.* London: Oxford University Press, 1977, p.118.

He complained bitterly to his parents about nineteen of his articles for *Le Petit Parisien* being 'échoppés' (gouged) by the authorities, and a further forty-three spiked.[18] One good effect of censorship, however, was that, incensed by the treatment of his cables, Londres decided to start gathering his articles into a book or two, restoring the excised passages. This would in his later career become his normal practice, sometimes in reverse sequence. A further ironical turnaround was the fact that 'la gravité de la crise morale en 1917 [army mutinies and so on] montra bien les limites de la censure … et de l'influence que les journaux pouvaient encore exercer sur leurs lecteurs'.[19] An extra ploy by Londres was to send secret reports to some French députés, indicting Briand's policies.[20] There is no evidence that they were put to any use.

Eastern Front

In February 1915, Londres decided that the crucial area to cover henceforth was the Dardanelles and the Balkans. When his employer jibbed, he turned to *Le Petit Journal*. As a war correspondent, he would benefit from greater freedom of manoeuvre on the multinational Eastern Front than on the Western; it was more remote from Paris, and the military interference with despatches was patchier.[21] He was beginning to be his own man, shedding the subservience of the staff reporter, which had never been, besides, his forte. In a letter to his parents, he vigorously defended his journalistic practice: 'Un correspondant de guerre n'est pas un pisseur de copie. Pour mon compte personnel, je préfère envoyer un ou deux articles par mois, mais que ces articles soient réellement intéressants'.[22]

18 Letters to parents of 7 January 1914 and 24 March 1917. In Archives.
19 Albert: 'La Presse dans la guerre', p.414.
20 Letter to parents of 24 March 1917. In Archives.
21 Macedonia gave its name, by reason of its extremely diverse racial mix, to the expression 'macédoine de fruits'.
22 Letter to parents, 13 November 1915. In Archives.

'The Balkans apparently enjoy a special exemption from the rules against stereotyping'.[23] In our own day, the perennial danger of disintegration in the Balkan entities remains as urgent as ever. The same volatile mixture of deathly seriousness and black comedy (the latter visible especially in the behaviour of uninvolved but interfering parties in the West) holds true. Militant Kosovans, after being exalted as heroes in their struggle to emancipate their region from Serb domination, now supply the sinister terrorist forces that threaten the precarious unity of Macedonia, the shaky bastion of the West in fragmented Yugoslavia. In the 1914–18 War, regional political goals frequently clashed with the *Realpolitik* of Germany in the area, as Serbia, Turkey, Bulgaria and Romania were to discover to their great cost. German control over Turkey was nicknamed 'Deutschland über Allah'.[24] The war between the Allies and the Central Powers reached its bloody high point at Gallipoli, where the Allies bungled an attempt to seize control of the Dardanelles straits in the face of remarkable resistance by the Ottoman forces. The claustrophobically tight terrain at Gallipoli, with large numbers of troops in very close proximity, produced a high casualty rate, even higher on the victorious Turkish side. Though regarded by the authorities in Paris and London as something of a sideshow, the landing of Allied armies at Salonika (now Thessaloniki) created an Eastern Front. Dissension between the French and British governments and military commands ensured that the whole venture exhibited, in Palmer's words, 'bumbledom'.[25]

Clemenceau joked about 'the gardeners of Salonika', as for a long time the French troops under General Maurice Sarrail did little but dig trenches and fortifications. Londres expressed great admiration for this maverick general, both at Salonika and later in Syria. Sarrail 'cherished the fanciful notion', according to Glenny, 'that his force could link up with the Serbs […] before piercing Hungary, the soft underbelly of the Central Powers, and then driving on triumphantly to Berlin'.[26] Sarrail,

23 Misha Glenny: *The Balkans, 1804–1999*. London: Granta, 1999, p.xxi. 'Balkanisation' has become a commonplace in world politics, applied to any fragmented geopolitical area.
24 Glenny: *The Balkans*, pp.312, 324.
25 Alan Palmer: *The Gardeners of Salonika*. London: Deutsch, 1965, p.59. The British headquarters were divided between Alexandria and Ismailia, midway down the Suez Canal, both of them further from Salonika than London even.
26 Glenny: *The Balkans*, pp.341–2.

however, had to settle for stalemate at Salonika. Londres quickly found that all the opposing belligerents had representatives, all mutually spying, in this one polyglot town; they were so thick on the ground that you almost trod on them (*CR*, pp.141–2), He presents Salonika as a cosmopolitan, sinisterly comic-opera hotchpotch where enemies rubbed not altogether antagonistic shoulders. Though in overall command of the Allied forces there, Sarrail constantly beefed about the treatment of the French expeditionary force as vassals by the British military, and the lack of support, in terms of reinforcements and equipment, from the French government. It can easily be imagined why Londres sided with this bolshy, skilful man. Although in Britain the Macedonian Front became a popular music-hall joke as the favoured destination for skivers in search of a holiday, in fact, despite the provision of plentiful entertainment for the troops, posting to that front was not a soft option. Despite the general impasse, casualties were considerable and malaria widespread.[27] Naturally, Londres experienced the eternal problem of war correspondents: what to write about when no military action is taking place? Assouline's rather flip answer was: 'Le tourisme de guerre'.[28] Londres's exhausting trek through war-torn Serbia was anything but war-tourism. It was the time when the Serbs, 'insolents de fatalisme', were not seen, as many see them today, as war-criminals, but as heroic, outnumbered Allies (*CR*, p.191). For one representative Serb soldier Londres expresses frank admiration: 'La physionomie, le maintien, la résolution me remuèrent jusqu'au fond de l'ame' (*CR*, p.124). As always the size of an event does not concern him: 'A côté de la guerre, ce sera, à Uskub, une double bataille: une petite au milieu de la grande, et la petite sera plus terrible' (*CR*, p.126).

By the spring of 1917, the French troops were beginning to weary of the Balkan campaign, with its forced marches and endless digging of entrenchments, 'and always the feeling that the enemy knew what to expect, that each side had become caught up in a ritual dance of death, purposeless and repetitive'.[29] In France at that time, some infantry regiments were mutinying rather than face yet more senseless loss of life for no gains. In December 1917, Sarrail's arch-enemy, Clemenceau,

27 Glenny, pp.346–7.
28 Assouline: *Albert Londres*, p.98.
29 Palmer: *The Gardeners of Salonika*, p.138.

finally got rid of his troublesome commander (who would subsequently be reinstated as military proconsul in mandated Syria in 1925). Londres left Salonika for a second spell on the Western Front in July 1917, and so missed the eventual military breakthrough in the Balkans in the autumn of 1918.

Before that return to western Europe, Londres switched his close attention to Greece, for which he was not 'suspect de lyrisme' (*CR*, p.169). In 1920, on a second visit there, he caustically remarks: 'Il est bien connu qu'il suffit qu'un homme éternue dans les Balkans pour qu'immédiatement les boutiques se cadenassent' (*CR*, p.526). He freely admits, however, to a kind of jolly bafflement, via a casual classical allusion:

> En politique, la Grèce est le pays du labyrinthe Je suis entré dans le labyrinthe, je n'en suis pas sorti. Ne croyez pas que je m'y aventurais seul. J'ai pris pour guide des ministres, un directeur des affaires politiques, M. Vénizélos et des confrères. Ensemble, tour à tour, nous avons parcouru le dédale. Ils marchaient à côté de moi. Nous allâmes ainsi longtemps. Quand il s'est agi de marcher vers la sortie, que ce fût avec l'un, que ce fût avec l'autre, nous n'avons fait que nous heurter contre les glaces. Je ne me suis pas encore retrouvé (*CR*, p.105).

Eleftherios Venizelos is credited by some commentators with quite considerable diplomatic skills and political intelligence. Though he had grandiose expansionist plans for a Greater Greece (Megali), he greatly contributed to the stark polarisation of the Greek people into two very violently hostile camps: his own and King Constantine's. He was backed by Sarrail's Army of the Orient. In Palmer's account,

> throughout 1916, a powerful lobby comprising General Sarrail and the senior Embassy officials in Athens urged on Paris the policy of establishing a protectorate over Greece, humiliating Constantine with ultimatums, whose conditions he could not possibly fulfil without provoking his own army.

As for Venizelos, the 'old Cretan rebel would never sit as dummy for a French ventriloquist such as Sarrail'.[30] Cross-examining, with no holds barred, the Germanophile Greek general Dousmanis, Londres countered coolly, when the latter plugged the idea of an undivided Greece, with the physical and ideological dichotomy he had seen with his own eyes.

30 Palmer: *The Gardeners of Salonika*, p.95.

Londres had ready access to Venizelos, who carefully explained to him his governmental and diplomatic manoeuvres (*CR*, pp.100–101). Later in 1920, when Constantine's son Paul had succeeded his ousted father, Londres recorded the ongoing Greek dilemma: 'Ou M. Vénizélos ou Constantin. On se croirait revenu quatre ans en arrière. L'époque homérique où déjà s'affrontaient les deux hommes recommence' (*CR*, p.526). Londres's Homeric comparison is undercut a few lines further when a fire-engine rushes up to douse the reciprocally belligerent crowds on the streets of Athens:

> Heureusement, des pompiers, avec une pompe que chauffe un sentimental feu de bois, arrivent à point, et leurs douches rafraîchissent les convictions. Ce n'est évidemment pas Athènes à feu et à sang, mais, à tort, les passions qui, après quatre ans de somnolence, se redressent sur le cadavre d'un petit roi (*CR*, p.526).

Soon, however, Londres was on his home ground, in the thick of street battles, stepping over corpses, after Venizelos had lost a rigged election, which led to riots. In his eyes, it was Venizelos who had been dethroned, and Greece was committing exuberant suicide. In a haywire topical allusion, Londres goes on: 'C'est désopilant pour l'amateur. Il y avait le bolchevisme, les riverains de l'Egée ont inventé le bolchevisme cubiste'. His theme with variations is that the Greeks are inveterate turncoats (*CR*, pp.531, 534).

It was Constantine's apparently pro-German alignment during the First World War and the strong backing of the English general G.F. Phillips that incited Londres to marginalise his journalism for a spell, in order to try to organise the murder of the general. Assouline reads this episode in these terms:

> Contaminé par la fièvre obsidionale qui étreint Salonique depuis le début de cette affaire, il a une réaction assez répandue chez nombre de journalistes au coeur d'un maelström d'événements dont ils aimeraient bien être les acteurs secrets.[31]

In other words, cloak-and-dagger activism occasionally tempts pen-pushing scribes. In addition, a document of 21 May 1917, signed by Londres's colleague on *Le Journal*, Edouard Helsey, Londres himself, J.M.N. Jeffries *(Daily Mail)*, and G.J. Stevens *(Daily Telegraph)*, who all had informants in the enemy camp, was sent to several relevant

31 Assouline: *Albert Londres*, p.132.

authorities in France and Britain, arguing the case for getting rid of Constantine.[32] When the king was forced to abdicate, Helsey claims only coincidence. Londres's project, to contract a Cretan Venizelist, Lambrakis, to kill Phillips, was shelved when news of the king's departure arrived. Helsey maintains that the gang of four had been condemned to death by Greek royalists. The king, he adds, 'ne s'est jamais douté, le digne homme, du service éminent qu'il nous avait rendu'.[33]

A Funny Old War

In the Great War, at different times, Londres covered the Eastern Front, and the French, British and Belgian fronts; his experience as a war correspondent was wide and deep. What sustained him in often dangerous, exhausting or frustrating circumstances was his unkillable sense of humour. As Paul Fussell suggests, 'every war is ironic because every war is worse than expected. Every war constitutes an irony of situation, because its means are so melodramatically disproportionate to its presumed ends.'[34] Londres was constantly alert for the multiple ironies of war, which is so absurdly tragic that 'you have to laugh'.

A French detachment is sent to resupply the hirsute multinational monks on Mount Athos: 'Pour la première fois, nos poilus pâlirent: ils trouvaient plus poilus qu'eux'. In this ferociously all-male community, even 'les puces sont du genre masculin' (CR, pp.211–12). Some of his jokes are at his own expense, as when Luigi Barzini of the Corriere della Sera says to him, as the group of reporters take shelter under heavy shell-fire at Ypres:

32　See Edouard Helsey: *Les Aventures de l'Armée d'Orient.* Paris: La Renaissance du Livre, 1920, pp.216–222. Helsey (1883–1966) was one of the founders of the French equivalent to the Pulitzer prize, le Prix Albert-Londres, after Londres's death.

33　Edouard Helsey: *Envoyé spécial.* Paris: Fayard, 1955, pp.221ff, 196. And Helsey, preface to Londres: *Histoires des Grands Chemins.* Paris: Albin Michel, 1932, p.11. Stevens was killed by a bomb in London in early 1918.

34　Paul Fussell: *The Great War*, p.7.

Croyez-vous, mon ami, que votre col de pardessus pourrait y faire quelque chose? […] Nous l'avions relevé, sans le savoir, au passage de l'obus. Nous nous étions mis un ruban de velours autour de son centre contre plus de quinze kilos de mort! L'instinct est vraiment aussi touchant que l'innocence (*CR*, p.53).

Sometimes, the humour is a nicely-judged conceit: 'Voici le *River Clyde* […] Il fume tout le temps. Il est si fier de lui qu'il ne veut pas se détacher de son panache' (*CR*, p.96). Most of the witticisms are not decorative but pointed, for example this response to the forced abdication of Constantine: 'La tragédie, annoncée par les amis du roi, ne fut qu'une comédie, ajoutons: émouvante' (*CR*, p.221). On the German Army redeployed in late 1918 from the Russian to the Western Front, he slightly alters a set term to good effect: 'Les bataillons fourbus et pelés qui s'en reviennent, sur les genoux, de la *maison de la* retraite que constituait le front russe' (*CR*, p.286, my italics): a black punning reuse of a Napoleonic reference. But Londres's laughter, like that of Jules Vallès, can equally well spring from animal high spirits: 'C'était l'un de ces jours où le soleil de son doigt vous chatouille le menton pour vous faire rire' (*CR*, p.549). In general, he could truthfully say, as he did when he arrived in Düsseldorf with the wrong expectations about the reception of victors by defeated Germans: 'Laissez-moi rire, rire de moi, bien entendu' (*CR*, p.546). We have seen how rarely he was guilty of 'bourrage de crâne' – so effectively combated by the counter-offensive of *Le Canard Enchaîné*: 'le calembourrage de crâne'. His virulent sense of the ridiculous and his constant irreverence guarded him against eyewash and bullshit. He was ever convinced of the tonic potentialities of humour, as every serving soldier or beleaguered citizen, except the most agelastic, always knows in his or her bones.

Just as the French alternately praise and curse English humour, Londres's attitude to English allies (which will resurface later in the section on the British Raj) is by and large marked by amusement but also admiration. Even when reporting English retreats that left French troops exposed, Londres never says a word against them. Rather he prefers to record a serio-comic exploit, when British soldiers swam across a canal wearing life-belts, seized German prisoners, disarmed land-mines, and killed a large number of the enemy, 'et le tout en costume de bain' (*CR*, p.353). He was wearing a British uniform when entering liberated Lille (*CR*, p.240). Some of his best friends were English journalists. In May

1918, stylish as always, Londres spent a few luxurious days in London at the Ritz Hotel. In March 1920, he was awarded an honorary OBE but, as he was in Russia, he had to decline; the offer was renewed in June of that year. He did not get, as many French war correspondents did, the *croix de guerre*. His non-award was a signal honour, for he had been labelled by the French authorities a 'mauvaise tête'.[35] There was, indeed, something stereotypically English about Albert Londres: his dynamic sense of humour, and his self-admitted 'flegme britannique' in the thick of existential harassment.[36]

The title, *Si je t'oublie Constantinople*, of Londres's series of reports from the Balkan Front plays on Psalms 137: 'If I forget thee, O Jerusalem, let my right hand forget its cunning'.[37] Albert Londres's right hand never forgot its cunning, though, like anybody else's, it also occasionally dropped clangers or drummed idly on his page.

What can you say about war that has not already been said for a couple of millennia? After the horror, the pity, the boredom, the bravery, the cowardice (if you dare mention this except as regards the enemy), all that is left is details, and repetition with variations. God, or, the Germans think, the Devil, is in the details. The banality of war is a commonplace itself. It was only with his later social investigations that Londres could find much fresh to say as a commentator/opinionator. In July 1917, he reminded his readers and himself that 'le poilu n'est plus celui de 1914. Remisons les images d'Epinal': let's mothball the pious, gimcrack images (*CR*, p.235). A war is never the same war throughout its duration.

Edouard Helsey read Londres's account of the shelling of Rheims cathedral; he met Londres in Paris, and again in Salonika, then back on the Western Front. In his partial *mea culpa* for his war writings, stressing all kinds of extenuating circumstances, Helsey confesses that 'avant de "bourrer le crâne" à autrui, je me la "bourrais" à moi-même'.[38] In his moving obituary of his friend, Helsey praises in Londres' reporting

35 Assouline: *Albert Londres*, p.144.
36 Letter to parents, 18 July 1917. In Archives
37 The title was chosen by Londres's devoted editor, Francis Lacassin.
38 Edouard Helsey: 'L'Examen de conscience', in *Sous le Brassard vert* (no author given). Paris: Editions de la Sirène, 1919, p.122.

> une aptitude étrange, non pas à déformer, mais à transposer le réel. Il s'asborbait devant un spectacle, s'en pénétrait, se l'amalgamait. Puis il prenait son porte-plume … C'était du Londres. Un objectif photographique qui, au lieu de clichés, vous rendait des eaux-fortes.[39]

A telling twist on *clichés*: photographic and mental. Although Londres urged 'mais passons, passons, ne décrivons pas', in fact he often ignores this self-objurgation (*CR*, p.125). Quite a number of his despatches are in effect non-news (Cf. the ritualistic 'All quiet on the Western Front'): he simply records the waiting-games, the wars of attrition, and tries to guess at the motives for inaction, or bewildering actions. He thus captures that well-attested fact of all wars: that much of the time nothing happens.

Frequently, a brusque, single image focusses the scene: 'Toutes les maisons scalpées' (*CR*, p.21). Or more extended, joky but apt metaphors sum up a complex situation:

> Une route que le coiffeur vient certainement onduler chaque matin […] Plus loin il n'y a plus que des pistes et celles-là ce n'est pas un coiffeur, c'est le diable en personne qui vient les friser […] Le chemin de fer à une jambe, à partir de là, devient cul-de-jatte (*CR*, p.188).

This is how he familiarises for his domestic readers the unfamiliar mountain roads of the Balkans; he brings these home to them.

When do wars begin, or end? There is always overlap, continuum, mess. To move on, after the war, self-evidently, comes the postwar.

39 Helsey: preface to *Histoires des Grands Chemins*, p.9.

Chapter 3
The Postwar: Here and There

Germany, then Spain

Albert Londres wrote best, was most himself, when he could focus on a circumscribed, albeit extensive, topic: one country, one institution or social practice. He was less original, more dutiful, when trying to cope with geopolitics, pan-European problems, in the complex aftermath of the 1914–18 War. I must all the same attempt to cover what he covered, in this large instance, heterogeneously.

As he was always primarily interested in the effects rather than the nature of war, he had logically to move on from Germany as a military enemy to Germany as a defeated nation. He visited it in 1918, 1921, and 1923. In Aix-la-Chapelle, shortly after the Armistice, he was clearly under no illusions about how the German people registered defeat: 'Nous voyons sous nos yeux se dessiner la façon dont [les Allemands] apprendront l'histoire de leur défaite aux petits. Vous croyez que l'Allemagne est diminuée? Allons donc! Elle n'a jamais été si forte' (*CBC*, p.271). Germany has convinced itself that, at its apogee and for unfathomable reasons, it has been forced to give in. But it keeps its head high, feels no humiliation, and broods over its inner rage (*CBC*, p.269). Germany's intentions are to play off the mighty United States against the other Allies:

> Dans sa belle incompréhension de tout ce qui est en dehors de sa race, elle le [le Président Wilson] regarde comme une mère qui ne demande qu'à pardonner à l'enfant qui revient. La guerre, c'est une vieille histoire! La France, l'Angleterre, on n'en parle plus! On les a oubliées! Il n'y a que l'Amérique, les Allemands l'adoptent pour patronne. A elle les invocations! Leur forme de république sera américaine, leurs aspirations américaines, leur vie renaissante américaine. Et leur mentalité, est-ce qu'elle l'est? (*CBC*, p.281)

Given his hostile attitude to the Soviet Revolution, he is clearly troubled by the embryonic 'revolution' in Germany, in which the army and navy are making pressing demands.

Thirty months after his first journey there with the Allied Occupation forces, he went to Düsseldorf and Berlin in March and May 1921. German attitudes seemed to have evolved. 'Est-ce mot d'ordre, est-ce dédain, est-ce résignation? Il y a des trois' (*CR*, p.547). Londres notices how a French general, in full fig, passes apparently unnoticed in the streets of Düsseldorf:

> Le général n'aurait rien fait d'autre dans sa vie que de se promener en uniforme bleu horizon, au nez des statues de bronze de Moltke et de Bismarck, que son footing d'aujourd'hui n'eût pas provoqué plus d'événement. L'on peut donc dire que, dans cette affaire, l'événement, c'est justement qu'il n'en produit aucun (*CR*, p.548).

This is an excellent example of Londres's knack of making a non-event newsworthy, a lesson he absorbed during the interminable war of attrition on Western and Eastern Fronts. He sums up thus the attitude he has encountered in postwar Germany: as long as they don't meddle with our finances, let the Allies occupy whichever cities they like; the occupation will soon fade from memories. Meanwhile, the Germans quite gloat over the biter being bit. It is the occupying troops who have to shell out prodigious sums in the extortionate German shops (*CR*, p.549). More proactively, a German entrepreneur 'allume des hauts-fourneaux comme les musulmans adorent, fanatiquement' (*CR*, p.573). Perhaps not surprisingly, Londres was sacked by *Le Quotidien*, after a short spell in its employ, for 'une vision badine de l'occupation'.[1]

Largely uninterested in postwar political machinations, Londres got himself sent briefly in early 1919 to Spain, where significant events seemed to be boiling up. It was also, possibly, a stand-in for the Soviet Revolution he could not yet get to. Visiting Barcelona, Seville and Madrid, he wrote five articles for *Le Petit Journal*. Unfailingly alert to the price of everything, as well as reporting on the political upheaval in Spain, Londres

1 Assouline: *Albert Londres*, p.300. Londres's friend Helsey wrote far more voluminously and level-headedly, and rather less interestingly, about Germany over a period of ten years.

also commented on the amazingly cheap and cornucopious food, clothes, wine and tobacco on sale there, in stark contrast with the four years of great privation in the Europe he came from. So doing, he conveniently underplays the impoverished, starving Andalusians. He was alarmed by the inroads made by Bolshevism, to which, shortly, he would be full-frontally exposed in Soviet Russia. Always eager to gain access to the power-brokers in any context, Londres was reasonably charmed by King Alfonso XIII. This interview, covering Alfonso's preferred policy over Spanish Morocco, created a storm in the Spanish Parliament; perhaps Londres's first experience of stirring up hornets' nests.

D'Annunzio

Travelling to Trieste, after a series of articles for *Le Petit Journal* on the state of Italy, Londres was treated as a suspect, a probable Bolshevik. His first set of despatches displeased Clemenceau by their impertinent, independent-minded tone, and as a result Londres was dismissed by the paper's director, Stephen Pichon, who was also Minister for Foreign Affairs. Passing to the profusely illustrated daily, *Excelsior*, Londres found a congenial focus in Gabriele D'Annunzio. Londres was not immune to the bliss of basking in reflected glory: 'A Venise, il avait suffi que l'on me vît en sa compagnie pour que, pendant huit jours, on me saluât jusqu'à terre' (*DA*, p.56). This was also, of course, joky hyperbole. His first impressions of D'Annunzio seem to wed, or at least not to mock, the crazy enthusiasm of many Italians for this charismatic figure: 'Les Italiens aiment son éloquence, qui galope comme un quadrige, frappant des images à chaque coup de ses sabots' (*DA*, p.57). Bandwagoning on or sharing the exaltation, Londres renews some ancient images himself: 'S'il avait une baguette, l'Adriatique, se souvenant de la mer Rouge, s'entrouvrirait' (ibid.). Quoting Francesco Nitti, who succeeded Orlando as Prime Minister for a crucial year in 1919: 'C'est une expédition littéraire', on D'Annunzio's triumphal march on Fiume (now Rijeka, in Croatia on the eastern Adriatic coast), Londres comments: 'Je ne dis pas non, mais c'est une littérature dangereuse qui a beaucoup de lecteurs' (*DA*,

p.58). Other staff journalists on *Excelsior* sent in dry, largely impersonal reports, points out Lacassin, the editor of Londres's reportages on Fiume.

The Italian Prime Minister, Vittorio Orlando, in 1918 had to justify half a million war dead and a crippling national debt. His solution: the redemption of Fiume, 'of which few Italians had previously heard, but without which most Italians were now convinced they could not live'.[2] Italy wanted a foothold in the Balkans and wide control over the Adriatic, and was arrogantly uncaring about the knock-on effects of seizing Fiume, for example the damage to Croatia's interests. Italy had in fact virtually no claim on Fiume, but D'Annunzio's alacrity and bravura in spearheading the annexation suited the government's purposes, which explains why, while denouncing the adventurism of the man and his excited supporters, it never seriously tried to end it by force, by a land invasion. Indeed, so many mutinous Italian soldiers wanted to join the venture that they could not all be fed and many had to turned away.[3] It was the blockade by Allied navies that gradually wore down the revolt.

At an early stage, Londres found an offhand but spot-on image for D'Annunzio: 'Déjà coulé en bronze' (*DA*, p.61). The more romantic side of Londres's temperament softened him in the face of such a *beau geste* as that of the Comandante. Flattered, no doubt, when D'Annunzio entrusted him and a colleague, André Tudesq, with the transmission to the French nation of his manifesto, Londres refused to think of him as an egregious politico, and contented himself with describing his ideology as 'du bolchevisme de droite' (*DA*, p.69). Though many have considered D'Annunzio a precursor of fascism, others, such as Ladeen, see in his flamboyant histrionics and passion for grandiose spectacle only the more ritualistic aspects of coming fascism:

> the balcony address, the Roman salute, the cries of 'aia, aia, alala', the dramatic dialogues with the crowd, the use of religious symbols in a new secular setting, the eulogies of the 'martyrs' of the cause and the employment of their 'relics' in political ceremonies.[4]

2 Glenny: *The Balkans*, p.370.
3 See Glenny: *The Balkans*, p.376.
4 Michael A. Ladeen: *The First Duce: D'Annunzio at Fiume*. Baltimore: Johns Hopkins University Press, 1977, pp.vii–viii.

Ladeen goes so far as to make D'Annunzio prophetic of a much wider tendency than fascism: 'D'Annunzio's political style – the politics of mass manipulation, the politics of myth and symbol – have become the norm in the modern world'.[5] As such, D'Annunzio, in Ladeen's interpretation, would never have been able to countenance the creation of a totalitarian state à la Mussolini. From a more aesthetic angle, Jullian claims that 'no other writer, not even Byron, had succeeded in giving History the form of his own fantasies'.[6] Osbert Sitwell, for his part, thought D'Annunzio might provide 'an alternative or escape from the Scylla and Charybdis of modern life, Slum-Bolshevism or Democratic Bungalow-Rash – morbid states of the soul that are of no help to the artist.'[7]

On a return visit, Londres acknowledges that the whole adventure is over, though the dream survives for its believers: 'Aujourd'hui, son pouvoir est éteint – son pouvoir matériel, bien entendu' (*DA*, p.97). After the initial triumphant anthem, the melancholy keening: 'La ville est aphone. L'enthousiasme est décroché' (*DA*, p.100). At their last interview, D'Annunzio had laryngitis and could not speak, except to whisper 'Mum's the word!' (*DA*, p.102). Gradually deserted by his troops, slightly injured by a shell from an Italian warship, the poet/dramatist/aviator and unarguable battlefield hero (he lost an eye in combat in the First World War), had to cave in. Though D'Annunzio had become a living anachronism, for Glenny Mussolini's Fascist movement first began to gather impetus when the future dictator supported the Comandante's occupation of Fiume.[8] In a calculated twist on *mesure*, Assouline suggests that 'dans cette ville dont le prince est un poète, [Londres] se sent tout à fait chez lui. Elle lui convient parfaitement car elle est à sa propre démesure'.[9]

5 Ladeen, p.202.
6 Philippe Jullian: *D'Annunzio*. Trans. S. Hardman. London: Pall Mall, 1972, p.284.
7 Osbert Sitwell: *Noble Essences, or Courteous Revelations*. London: Macmillan, 1950, p.115.
8 Glenny: *The Balkans*, p.376.
9 Assouline: *Albert Londres*, p.170.

Russia

The aversion from Bolshevism which surfaced sporadically in Londres's writings on postwar Spain and Germany was boosted definitively by his trip to Soviet Russia in April and May 1920. In 1917, the same year as his plot with others to have General Phillips assassinated in Athens, Londres also tried to persuade Philippe Berthelot, the French Secretary-General for Foreign Affairs, to send him with secret funds (which of course sloshed about in ministries), firstly to obtain gen denied to the diplomatic service, and secondly to commission direct action against the Bolshevik government; for example, attacks on Lenin and Trotsky, and the sabotage of bridges and railways. It was an unscrupulous, mad and backdoor way of wangling entry to the land of the world-shaking Russian Revolution, otherwise extremely difficult of access. It was not unknown for newspapers (e.g. *The Times*, round the turn of the century) to let their journalists moonlight by combining their own fact-finding with spying for government departments. Londres, a natural hyperbolist in matters of style, here went over the top in terms of action. Still in 1917, he refound his interest in the Great War, and shelved the Russian project for a time.

Around 1920, Londres resurrected his urge to see Soviet Russia for himself. Very few foreign journalists before had got into the new state. Among the few were Arthur Ransome of the *Manchester Guardian* and John Reed of *The Masses*, who maintained sky-high hopes of the Revolution, of which he had been an eye-witness, and who died of typhus in its country. Ransome, later a bestselling novelist, visited Russia twice, and married Trotsky's secretary in 1924. In his book *Six Weeks in Russia in 1919*, Ransome made a very even-handed attempt to be understanding of the chaotic situation he encountered. As well as concerning himself with practicalities such as food availability, transport and industry, he conferred with all the major policy-makers. It is a very knowlegeable book, which succeeds in seeing Russia to a considerable extent from the inside.[10]

10 Arthur Ransome: *Six Weeks in Russia in 1919*. London: Allen & Unwin, 1919. It was revealed in July 2002 that Ransome had spied for the British SIS (Secret Intelligence Service) on top-level Bolsheviks and figures in other political groupings. Though he had obvious left-wing sympathies, of course many Socialists were hostile to the Russian Revolution.

It took Londres 52 long and freezing days to get to and into Soviet Russia, via Berlin, Copenhagen, Sweden and Finland, with which Russia was at war. Determination and physical stamina collided with the first avatar of the iron curtain, Soviet Byzantine bureaucracy, under which, with great effort, like a kid at the circus, he managed to squirm. His account of what must have been a journey from hell is characteristically humorous. His first taste of the new country is a terrified interpreter, a woman on brief parole from prison to perform this job, badly. It is a first sight of the police-state. Though Londres swears to readers that he comes with no preconceived agenda, his manner of describing his impartiality is perceptibly loaded. To the argument that Russia, a huge land-mass, was in a state of utter upheaval that would take a good many years to stabilise, let alone transform, he would no doubt have replied that, if a regime starts off on the wrong foot, it will never subsequently march straight. He locks unforgivingly on to the poverty, the rags, the soup-queues, the decaying buildings of St. Petersburg: 'C'est le dernier degré de la dégradation, ce sont des étables pour hommes, C'est la troisième Internationale. A la quatrième, on marchera à quatre pattes, à la cinquième, on aboiera' (*DA*, p.181). The lack of charity in his reports, the gloating almost, are blatant.

After listing the huge damage done to Russia by the Revolution, he concedes that 'ils ont détruit pour reconstruire', but adds cuttingly: 'Du moins, c'est leur illusion' (*DA*, p.182). More significantly in his eyes, the new Russia is a dictatorship or absolute monarchy. Although he periodically tries to be fair – do not export to Russia your liberal expectations about universal suffrage and parliamentary elections – Russia remains in his view in thrall to the indigestible (read: unread by Londres) *Das Kapital* of Marx, 'cette brique communiste', the foundation-stone, like Peter for Christ, of the new church (*DA*, pp.183–4). 'Il suffit de naître et l'on est tonsuré' (*DA*, p.197). He keeps hammering on the idea that this dictatorship, operating naturally top-down, still tries to persuade each citizen that he is in charge of his own fate and must work for what he lacks. Lenin is not an inventor, but an adapter, an experimenter, with millions of guinea-pigs performing at his behest (*DA*, p.185). As for the peasants, though the land is theirs now, the produce is the state's. As a result, they fight shy and grow only enough for their families. He plays with words to make his point even more down-to-earth: 'Le paysan ne se donne pas la peine de lui [au gouvernement] cultiver les plus chiches des pois chiches' (*DA*, p.189). Going to the top, as he does

whenever feasible, Londres admires an unnamed Commissar for Finances, frank, unself-seeking, non-extremist. Interviewing the equally voluble Tchitcharin, Foreign Minister, Londres delivers this verdict: 'Comme idée, c'est un mélange de bonté, d'incohérence, de rêves mal au point. C'est grotesque et bien intentionné' (*DA*, p.202). The interview sounds, in Soviet terms of course, entirely reasonable, as if Londres has inadvertently allowed his source to escape the stereotype imposed by Londres himself.

However much a moralist, Londres was never idealistic, utopian. The postwar meant something far different in Russia from what it meant in Europe, and for many in Russia and among its few sympathetic observers abroad it encouraged hopefulness. Not a heaven for Londres, but largely a hell on earth. He speaks of 'ce cercle que l'Enfer, pour punir les hommes de vouloir établir leur paradis dans ce monde, appelle la Russie' (*DA*, p.206). In order to characterise Soviet Russia, Londres frequently stresses its Asiatic aspects, as if only the Orient could install despotisms – a none-too-bright Enlightenment hobbyhorse. In this connexion, he also refers several times to the large number of Jews in positions of administrative importance. Old reflexes die hard, though it is true that he does not make racist capital out of this statistical datum.

Because he could not rely on the interpreters laid on to faithfully convey his questions or the officials' answers, and because he wished to capture a local French angle on Soviet Russia, he arranged to meet Pierre Pascal, a product of the Paris Ecole Normale Supérieure who, like Jacques Sadoul, graduated from the French military mission at Petrograd to become an influential Bolshevik. Londres is always ready to listen, and to pass on to readers what he hears, if not to be made to change his mind. He also met René Marchand, ex-correspondent at Petrograd for *Le Figaro* and *Le Petit Journal*. Whereas Pascal strikes him as 'un éclairé doux', Marchand is 'un éclairé fulgurant' (*DA*, pp.207–9). Marchand, indeed, favours shooting French and other Socialists, whom he sees as traitors to the cause of international Socialism. Vandervelde, Kautsky, Longuet, Cachin and Renaudel are far worse than Lloyd George, Clemenceau or Millerand, who are at least logical in their enmity to Soviet Russia. The mere verbal support of supposed fellow-believers in Socialism is totally inadequate; such Socialists should be prepared to abandon their cosy niches and come over whole-hog to the cause. Jaurès is spared Marchand's murderous scorn only by reason of his martyr's death in 1914. Lenin is credited with leading the charge against these tepid Socialists (*DA*,

pp.211–13). Pascal went on serving the Soviets until 1933, after Londres's death, when he recanted. For Kupferman in his excellent survey of French visitors to Soviet Russia, all other accounts of Pascal tally with Londres's thumbnail sketch of this doughty *illuminé*.[11]

Londres interviewed Maxim Gorky: dignified, doing all he could to protect, support and feed the persecuted intelligentsia, but unable to speak out publicly, though he confesses that he is not a Bolshevik (*DA*, p.226). Londres is clearly digusted by the whole atmosphere of spying on and denunciation of those who do not toe the Bolshevik line. Yet he finds time to register that vestiges of former cultural glamour persist: the great Russian bass Chaliapin is still performing before cold, hungry but rapturous audiences (*DA*, p.240).

Understandably, Londres did not get to interview Lenin or Trotsky. He had to study them from some distance, and dig up what facts he could. For Londres, Lenin, with his innumerable brochures, was ever the journalist even when running the country. He is no D'Annunzio: 'Il opère par procédés froids'. Lenin 'vous poursuit de son idée comme l'horloge de son tictac', whereas Trotsky's energy is more freewheeling. Trotsky, nomadic to Lenin's sedentary, also publishes much, but his articles are brutal. All in all, Lenin is forgiven by the Russian people for his chill demands, whereas Trotsky is feared and hated by them (*DA*, pp.241–4). Londres never loses his French predilection for paired opposites, the Cartesian answer in advance to the Marxian dialectic.

In all his journalism, Londres is more often than not confident. On Soviet Russia, he seems over-confident in the rightness of his findings, far too ready to dogmatise rather than to rethink first impressions. To a large extent, it seems his mind was made up before he went there. Lacking, then, in modesty or self-criticism, he settled for being, at best, a meliorist, but not in any way a utopian. Nevertheless, his near-impermeability to Russian newness at least saved him from being taken in by idealising propaganda, which he had a bellyful of, besides, in the Great War, even if it left him seriously short of sympathy for what was being initially and in many ways heroically attempted there. We should remember the opposite of Londres: all the visitors before and after him who were predisposed to excuse, or even to fail to see, what was indis-

11 Fred Kupferman: *Au Pays des Soviets: le voyage français en Union soviétique, 1917–1939.* Paris: Gallimard/Julliard, 1979, pp.38–40.

putably wrong with the great social experiment. Soviet Russia was not officially recognised by France until October 1924, four and a half years after Londres's visit and seven years after the Revolution.

According to Assouline, Londres might well not have survived his trip there, for he learned later that his 1918 overtures to the French government were known to the Soviet secret service, the Cheka.[12] After Londres's death, a journalist on the Paris daily, *L'Intransigeant*, added to the several myths already current about him by claiming that 'lorsque le regretté Albert Londres […] envoyait télégramme sur télégramme à Lénine pour qu'il lui permît l'accès du territoire, Lénine, ayant accepté, fit jeter en prison pour plusieurs mois ce touriste téméraire'.[13]

Poland

In adjacent Poland, Londres spent a few weeks, five years later, in mid-May–early June 1926. (In *Le Juif errant est arrivé* (1930), he would devote a major part of the text to the plight of Jews in Poland). He arrived there just after a military putsch briefly installed Joseph Pilsudski, the main focus of Londres's seven articles for *Le Petit Parisien*. As with his three articles on uprisings in Portugal in February 1927, Londres had not witnessed the events, but blithely reconstituted them on arrival as if he had. Such posthumous eyewitnessing is probably more common than we realise. It was a civil war, though conducted on both sides by separate sections of the army. As so often, Londres chooses to remind readers of peace and normalcy in the middle of chaos and bloodshed. Here, lovers' benches: 'Ces bancs d'amour vont constituer les barricades de la mort et les cadets de dix-sept à vingt ans qui s'y sont souvent assis vont maintenant s'y coucher' (*DA*, pp.133–4). He picks up on this poignant conjunction at the end of his reportage. After the firing finally stops, 'on a rendu les bancs aux amoureux. Tout est réparé, sauf les morts' (*DA*, p.135). Seeking to explain Pilsudski's very mixed fortunes, Londres stresses that, though supported by the Socialists and a good part

12 Assouline: *Albert Londres*, pp.219–20.
13 *L'Intransigeant*, 13 August 1932.

of the army, he had to combat a right-wing majority in the national Assembly. He made the mistake of thinking that his take-over could be bloodless. Hence his hesitations over acting unconstitutionally after his victory. Londres interviewed him on 23 May 1926. Having won the election for the presidency, Pilsudski then refused to accept the appointment, for rather mysterious reasons.

One of the reasons why Londres mostly admires Pilsudski is that he fought for years against the Russians, and was imprisoned three times by them. When he led armed attacks on Russian treasuries, he left receipts for the loot. Despite entering the 1914–18 War on the side of Austria against Russia, he was further incarcerated by the Germans for declining to back them up. He was thus a military hero for the Poles, and a considerable legend attached to him. He later ruled Poland for nine years until his death in 1935. For Londres, he is 'le dictateur manqué', who claimed to have no party (*DA*, p.156). For an academic historian, Pilsudski 'was a born dictator who was much too wise to care to seem to be such', and who granted himself the minimum of powers, for he could 'work his will by agents'.[14] Discontinuously comparable with D'Annunzio, Pilsudski, like General Sarrail, impressed Londres, though the tone of appreciation is never entirely devoid of mockery. Londres always mistrusted – he would have been admiring but sceptical of de Gaulle – saviours of the nation.

Syria

Londres covered Syria in December 1919, February 1920 and November–December 1925. Nevakiki describes thus the fraught relationship of supposed Allies as regards this area. After 1919,

> the British government considered Anglo-French cooperation as the only workable basis for a settlement in Turkey. In order to secure this cooperation it had to satisfy the French claims in Syria. The entente resulted in a partition of interests, in the

14 W.F. Reddaway, et al. (eds): *The Cambridge History of Poland.* Cambridge University Press, 1941, pp.602–4.

manner of the worst pre-war imperialism, and caused endless damage to the reputation of both Britain and France in the Arab world.[15]

They were both partners and intense rivals. I have remarked before, and will again, on Londres's periodic anti-Britishness, which was a fair enough response, given that most British opinion has been, and remains, anti-French. A professional instance of his mistrust is his casual mention that British journalists gladly write any old thing in their reports (*PP*, pp.262–3). A splendidly congealed stereotype of this ancient antagonism is furnished by Lord Cromer, the British soldier, diplomat, and virtual ruler of Egypt for some twenty years:

> The ephemeral attractions of the French are those of a pretty damsel with 'somewhat superficial charms', whereas those of the British belong to a sober, elderly matron of perhaps somewhat greater moral worth, but of less pleasing outward appearance.[16]

Or, more briefly, Gigi and Victoria. The legal foundation of French rule in Syria was a mandate from the League of Nations in 1922. France wanted it for the economic advantage to be gained from French investment in ports, railways, roads and from trade, for the strategic benefit of France's spread eastwards, and 'for a belief in the civilizing mission associated with the protection of Catholic Christians and the extension of educational and missionary activities'. On top of that, Yapp continues, 'it is probably true to say that France took the mandate for prestige and kept it for the same reason'.[17] None of these motives begat any real success. In terms of military presence, there were about one thousand French officers in the Armée du Levant, which was composed mainly of French colonial troops from Africa and Madagascar. According to Londres, Britain continued to suborn the Syrians to be hostile to its ally, France (*PP*, p.213).

In his first stay in the area, mainly in Beirut in 1919, Londres puts the Middle East on parade, through one city, condensed into a paragraph:

15 Jukka Nevakiki: *Britain, France and the Arab Middle East*, 1914–1920. London: Athlone, 1969, p.260.

16 Evelyn Baring, Lord Cromer: *Modern Egypt*. New York: Macmillan, 1908, Vol. 2. pp.237–8.

17 M.E. Yapp: *The Near East since the First World War*. 2nd edition. London: Longman, 1996, p.86.

De la montagne, du désert, de la Cilicie, de la Galilée, en pur costume, envoyés par toutes les sectes, tous les paganismes, toutes les religions, tous les sangs: Bédouins à capuchon blanc, fellahs à tunique bleue, Tcherkess à étroit visage carré, Maronites à barbe radieuse, Malchites à chignon huileux, Druzes du Haman, aux accroche-coeurs de fakir et aux yeux diaboliques, missionnaires immaculés de Jérusalem, Arméniens crucifiés, Libanais exaucés, toutes les couleurs d'étoffe et toutes les couleurs d'âmes, toutes les craintes, tous les espoirs, toutes les attentes répondent: nous voilà (*PP*, p.156).

Conscious of the huge massacre of Armenians by King Faisal's subjects, Londres in the above passage combines the distance of distaste for fanaticism with fellow-feeling, and conjugates the colossal racial mix of the complex region.

In Syria Londres re-encountered General Sarrail, whom he had previously met at Salonika in 1915, after Sarrail was sent there, having been one of the most outstanding generals on the Western Front. Londres's first impression of him at Salonika was close to hero-worship: 'Un homme dont le regard devant les événements les plus sombres est toujours droit, limpide et puissant' (*CR*, p.142). As we have seen, Londres sympathised with Sarrail's dilemma there; he was supplied with only enough troops and equipment to conduct a largely defensive campaign, whereas he was cut out for more expansive aggression against the enemy. A lifelong unbeliever and in politics a radical, Sarrail was an odd man out among mainly Catholic and conservative French generals. He is thought to have aimed at creating a secular state in Syria, whose Muslim or Christian communities figured little in his plans, even though he remained tolerant of all religious beliefs. He was most notorious, however, for his intransigence and temper, which Londres fully recognised and admired. 'C'est un homme magnifique', but 'il organisa sa mauvaise humeur comme de grandes manoeuvres' (*PP*, p.248). The hero-worship grows more nuanced. Londres inserts a telling anecdote: 'Un soir, étant déjà couché, il s'aperçut qu'il ne s'était pas fait un seul ennemi dans la journée, alors il se releva' (ibid). Sarrail's unbending nature could make him stubbornly petty-minded: 'On se croirait dans un salon de dames pincées' (*PP*, p.250): not goosed but uptight ladies. Nevertheless, Londres felt drawn to the general by reason of his upright character and by the fact that Sarrail was periodically the target of official malevolence. When Londres remeets him in Alexandria, en route to Syria, he makes a nice joke about his official telegrams: 'Pour un fantassin comme Sarrail, quelques-uns sont un peu

cavaliers' (*PP*, p.229). Despite his admiration Londres, as always, cross-checks accounts of events and situations between several of Sarrail's staff and the general himself. Like politicians, and Sarrail was fully that as well as a brass hat, the military are to be trusted only as far as you could throw them. In the course of his time in Syria, with his curious blend of authoritarianism and liberalism, Sarrail managed to alienate almost every-body, and in October 1925 he was replaced by Henry de Jouvenel.

In his reports from Syria, Londres includes a regular refrain about the Middle Eastern obsession, like armies throughout the ages, with looting (a leitmotif also of T.E. Lawrence's *Seven Pillars of Wisdom*): 'Ils avaient complètement oublié l'idée nationale. Le pillage seul les passionnait. Nous sommes en Orient' (*PP*, p.234). Even firefighters attending a blaze spend most of their time plundering: 'Au lieu de pomper, ils empilent' (*PP*, p.239). In contrast with Lawrence, Londres is hostile to any pan-Arab movement. Logically enough, for he supports the practice of mandates, and colonialism (properly conducted) in general. At the same time, Londres is prepared to admit his earlier misinterpretation of the situation in Syria, as he now feels much more critical about French actions, or inactions (*PP*, p.236). He generalises against his previous generalisation:

> Il n'y a pas de Syriens. Je dois confesser plus fort: il n'y a pas de Syrie non plus [...] Libanais, Arabes et Druses se haïssent. La religion des Druses leur ordonne d'insulter le Prophète, leur instinct d'égorger le Libanais, leur intérêt de piller les deux. Le libanais maudit le musulman et détale devant le Druse. Le musulman regarde avec joie couler le sang libanais et n'applaudit le Druse qu'autant qu'il en fait libation (*PP*, pp.240–1).

Change around the names, and much the same would be true of inter-necine strife in the Near East today. Also comparable to our own times is the lethal phenomenon of long memories and unforgiveness, here focused on the West: 'Ils vous parlent des croisades comme d'une partie de football qui aurait eu lieu dimanche dernier' (*PP*, p.244).

Unlike the British and their mandate in Iraq, the French are dilatory in granting the inhabitants of Syria a constitution, because they are locked into their colonial past:

> Officiers et fonctionnaires venus en Syrie ignoraient la Syrie. Ils provenaient tous des colonies. Ceux qui arrivaient du Sénégal continuaient comme au Sénégal, ainsi ceux du Congo, du Maroc, de l'Indochine, du Sahara! [...] Le cataplasme qui guérirait en Afrique, provoquerait une plaie dans la Béka! (*PP*, p.243).

66

Despite such drawbacks, the French should not, in Londres's view, withdraw from Syria, as it would signal the decline of their worldwide paternalist mission: 'Il me semble que la plus belle preuve de cette fameuse décadence française, c'est nous-mêmes qui la donnerions aux cent millions de protégés que nous avons par le vaste monde' (*PP*, p.270). Like many Americans today, many Frenchmen (and Englishmen) thought in such condescendingly overlord terms round 1925. Additional reasons for France to stay were that the Syrians wanted them to do so, otherwise Turkey would move in from the north and Britain from the south; weighty French traditions still obtained there; and, of course, investments and trade would suffer badly if France packed up (*PP*, pp.271–3). In short, 'si la France ne doit pas se permettre de faire de projets, alors tirons le rideau sur notre histoire, couchons-nous, et tendons nos poignets aux cordelettes des concurrents!' (*PP*, p.273). It is the quintessential imperialist argument, which Londres had already deployed when visiting French colonies in the Far East in 1922.[18] Finally, and this factor speaks for itself: the question of oil-supplies, even more acute today than then.

Bulgaria: A Cock-and-Bull Story

The last segment of Londres's postwar here-and-there that I want to study at this stage is Bulgaria. He visited it in February–March 1921, after of course analysing its part in the First World War (see Chapter 2), and again in October–November 1931, which was to be his last reportage published in his lifetime. In the 1914–18 War, and almost unavoidably because of its geopolitical position, Bulgaria had constantly and determinedly bargained with the highest bidder. Principally siding with the Central Powers dominated by Germany, Bulgaria had suffered the highest per capita death rate of any belligerent. If there was a difference in tone and stance between Londres's wartime articles on Bulgaria as a German ally and his postwar visit in 1921, he was still trying to provide a fair-minded account of Bulgaria's dilemmas and her attempted solutions.

18 This six-month tour will be examined in Chapter 5.

In 1921, he wrote five articles for *Excelsior*, on the President of the Council, Alexandur Stambouliiski, and on King Boris II, both of whom he interviewed. He treats the former to a calculated hyperbole: 'Massif comme un fort bétonné, mâchoire à broyer du silex, cheveux plantés sur la tête tels tessons de bouteille à l'arête d'un mur' (*CR*, p.533). His very charmlessness and lack of a sense of humour are transfixing. Londres plays astutely on the aesthetic and the theological meanings of *grâce*:

> Quant à la grâce [il ne possède] ni plus ni moins que Lucifer. Si vous êtes à la recherche d'un homme enveloppant, n'allez pas chercher celui-là. Les rides lui viendront, mais ce ne sera pas d'avoir souri (*CR*, pp.533–4).

This awesome man speaks frankly to Londres of Bulgaria's many problems: her dependence, in the postwar situation, on the intentions and actions of the wartime and now very possibly vengeful Allied Powers (*CR*, pp.535–6). Londres carefully explains Bulgaria's well-nigh unavoidable waiting-game. Making a running comparison between Red and Green Internationals, Londres describes Bulgaria's Green one: Stambouliiski's reliance on the majority peasant population, and its 'dictatorship'.

When he wangled an audience with Boris II, Londres wrote to his parents in January 1921: 'Ce soir à 5h.30, je suis reçu par le roi. Cela est plutôt par politesse parce que ce jeune homme ne fait pas grand'chose dans ce pays. Enfin, ça fera un roi de plus'.[19] In general, on this first visit, Londres settles for the stereotype of the Balkans as an indecipherable maze and, in a clever twist on the French idiom, suggests that 'qui dit "balkanique" dit: "où Tacite lui-même perdrait son latin"' (*CR*, p.544). Over three pages, all the same, he puts the Balkan imbroglio in a nutshell for his putably ill-informed readers and, incidentally, blows the gaff knowingly on his habitual trick of coalescing various interviews into one (mythical) informant, so as to produce that thumbnail sketch of the whole situation (*CR*, p.541). This is surely a stock journalistic ploy.

19 Letter to parents, 24 January 1921, in Archives. This has an altogether different ring from Proust's Narrator's star-struck 'C'était ma première Altesse'. (*A la Recherche du temps perdu*. Ed. P. Clarac. Paris: Gallimard, 1954, vol. 1, p.700). Assouline, nevertheless, claims that Londres was less rough with royalty than with political appointees: 'Trop impressionné pour les bousculer, le petit Vichyssois'. *Albert Londres*, p.228.

A historian confesses similar bewilderment: 'If it is legitimate to be baffled by just one historical episode in the Balkans, Bulgaria in the late 1920s and early 1930s must be one of the strongest contenders'.[20] At another point, Glenny emphasises that 'Balkan nationalism evokes such ferocious passion because, paradoxically, it is so labile', that is: so prone to mutating during wartime, after the break-up of a large unit, or when a new state is formed.[21] One particular area given to such lability was Macedonia, which, as Glenny points out, was, and still is, at the crossroads of the peninsula, so much so that even Bismarck, 'with his studied contempt for all Balkan affairs, conceded its vital strategic location'.[22] Londres's last published reportages were devoted to Macedonia and Bulgaria: *Les Comitadjis* (1932). The editor Lacassin's preface draws an analogy between the terrorist, nationalist organisation, the Komitaji, and the PLO or the IRA in our time, because of its structures and its motivations. The founders of the Internal Macedonian Revolution Organisation (ORIM in its French acronym, IMRO or VMRO in its English one) in 1893 set as their goal the liberation of Macedonia, which had been annexed to Turkey since 1371. Their tactics included bombings and sabotage. Two early insurrections in 1898 and 1903 were repressed in a bloodbath by the Turks. After the Balkan Wars of 1912–13, involving Turkey, Bulgaria, Serbia, Greece and Montenegro, Macedonia was split henceforth between Serbia, Bulgaria and Greece. As Bulgaria chose the losing side in the 1914–18 War, Yugoslavia received the major part of Macedonia in 1919 at the treaty of Neuilly, which the IMRO never accepted. As the official Bulgarian government shared the aims of the Komitaji, to regain Yugoslav-held Macedonia, it could not logically quell the IMRO. It differed only (only!) as to the means: diplomacy as against terrorism. 'Komitaji' derives from 'komitas', action-groups.

Londres begins his nineteen despatches to *Le Petit Parisien* in 1931 with a list of the numerous tit-for-tat killings within the two factions of the IMRO: Mihailov and Protoguerov. So there was a civil war as well as the official stand-off with Serbia. When Londres asks after the men he met on his first visit in 1921, he learns that they have all been murdered, including Stambouliiski in 1923. Armed bodyguards, 'archanges en casquette', are

20 Glenny: *The Balkans*, p.438.
21 Glenny, p.158.
22 Glenny, p.156.

consequently an everyday sight on the streets of Sofia (*C*, pp.26–7).[23] The situation sounds like the Wild West. 'Le meurtre, chez nous', he is told, 's'est incorporé à nos moeurs' (p.35). Lest it seem that anarchy reigns, Londres explains that the IMRO possesses its own judicial system, newspapers, police-force, tax-gathering mechanisms, and even a pension scheme for ageing guerrillas (pp.37, 178). He admits the heroic self-sacrifice over the years of its exalted youth, who take to the woods and mountains, and go to ground (p.45). In Macedonia, the Serbs, feeling threatened by a possible invasion of their home territory, have taken over from the Turks as the sworn enemy. Expectably, they try for a policy of denationalisation by imposing Serbo-Croat in public life (p.51). In the middle of all this cacophony, Londres sketches his standpoint: 'Vous me permettrez au préalable de me boucher les oreilles, ensuite de ne m'exprimer qu'à voix basse' (p.47). The competing parties emit such an unforgiving racket that this stance is the only sane one, as it remains today. Macedonia, besides, was multinational and polyglot: Bulgarians, Turks, Greeks, Serbs, Albanians, Jews and gypsies.

The IMRO was in effect a parallel government in Bulgaria. Londres terms the official one 'le gouvernement-redingote' and, alliteratively, the second 'le gouvernement-revolver' (p.50). He makes a patient, lucid exposition of the whole tangled web, despite feeling frequently frustrated by stonewalling interlocutors: 'Je parlais des comitadjis. Il parlait de la neige sur le mont Vitoche' (p.67). As when he wriggled lengthily into Soviet Russia, Londres had to worm his way into the IMRO organisation; in both circumstances, he clearly enjoys the complications and obstacles, which build up narrative suspense, and, naturally, allow him to beef rhetorically. As in Greece, he invites us into a maze.

As well as factions in the rival leaderships, the IMRO houses two separate groups of spear-carriers: the thousands in Bulgarian Macedonia who till the land, but are ready to take up arms at a moment's notice, and the hundreds of conspirators, and apprentice or practised terrorists, living mainly in Sofia, subsidised (lodged, fed and watered) and trained by the organisation. IMRO feeds off a well-oiled protection racket and, like many such organisations, insists on an elaborate ceremony of oath of allegiance. Already, it uses instructional films for training purposes. In all this,

23 All refernces in brackets after quotations are to the 10/18 edition of *Les Comitadjis* (*C*).

Londres is of course acting as a snoop on spies. Describing the complex financing of IMRO operations, Londres does not present it as reasonable, but as having an internal logic, given the muddled political circumstances. He does, however, seem impressed by the thoroughness, which takes a sizeable cut from government taxes on 'reluctant patriots' (p.85). Jews and Armenians are especially targeted for 'donations' (p.86). IMRO can even afford scruples. Its officers are not crooks, even if they are assassins, and often return money unjustifiably exacted from citizens (pp.88–9).

The state police stop up their ears when an IMRO execution of its enemies or dissidents within is imminent (p.97). Murders are highly programmed. Because of ubiquitous bodyguards, targets are shot photographically before ballistically, or are pointed out by scouts ('montreurs'). It is the acceptance of the whole lethal phenomenon by its victims as well as its executants as natural, or at least uneradicable, that most amazes Londres. Murders occur also in prisons, and mistakes are of course made. When Mihailov, promisingly, suggests peace on the streets, Londres comments sceptically: 'La paix ne fait pas le trottoir. C'est une dame hautaine au regard glacial et qui impose aux plus entreprenants' (p.109).

My subheading referred to this text as a 'cock-and-bull' story. This is Londres's own quizzical estimation of his whole reportage: 'Un conte, un conte à dormir debout' (p.115). He recounts a dream, credited to his peasant grandmother, about Macedonia, 'un pays de rêve': a dreamland, or a nightmare? Similarly, he invents a Bulgarian grandfather who tells the children epic tales of the Komitajis' feats (p.156).

When he moves from Sofia to Macedonia, Londres finds himself in the thick of conspiracies. Here, terrorism is fully operational and no longer turned against enemy brothers, as in the capital, but against the enemy, full stop. Here, every Bulgarian family numbers many relatives murdered by the Turks or the Serbs. The Serbs are naturally not the heroic allies of Londres's earlier Balkan despatches. Londres never soft-pedals on the brutality and double-dealing practised by all parties to the overall conflict. Past and present are inextricably entwined both in Bulgaria and Macedonia.

Relating his serious cock-and-bull story, Londres freely confesses his love of mystery and his excitement. At Sofia, 'on goûte une telle ivresse de l'insécurité que l'on est perpétuellement sous le coup délicieux d'un vertige' (p.145). When he talks in one section of an illustrated journal 'trempant la réalité dans le bain de la légende' (p.156), I wonder whether

he does not do the same himself in his very detailed, almost certainly fictional reconstruction of the fateful story of Alexeiev. This man had to undergo a drawn-out, third-degree grilling, then physical torture, and was finally forced to provide false evidence against the real target of the operation (pp.142–50). Also developed at length is a 'métaphore filée' concerning Londres's sense of the Komitajis' *shadow* everywhere present and intimidating everyone in Bulgaria. (Londres's own version of spymania is equally visible in his writings on British India, to be studied in Chapter 5).

In concluding, Londres recalls Belgrade in September 1915 under heavy German shelling, and contrasts that with its prosperous newness in 1931 (pp.160–1). Yet the Orient Express has to be protected by the Yugoslav army throughout its run in Serbia because the Komitajis keep trying to blow it up, in order to play havoc on Serbian territory and to attract worldwide attention to their cause. Little changes in that region. For Londres, however, the future is not rosy for the IMRO. Fewer youths are self-sacrificingly idealistic, the frontier with Serbia is heavily patrolled and the Serbian army on high alert. Mihailov seems inceasingly a Quixotic figure (p.173). 'Tel est le conflit. L'exposer n'est pas le résoudre. Peut-il être résolu?' (p.177). Londres thinks not, as both sides refuse to give an inch. Glenny finds the ruthlessness of IMRO encapsulated in the words of Dame Gruev, a student who helped to found it in Salonika: 'Better an end with horrors, than horrors without end!'[24] The wise compromise would be a confederation of all Southern Slavs, but when were men ever wise? (p.178). In historical fact, IMRO was disarmed and disbanded by the incoming military dictatorship in Bulgaria in 1934, three years after Londres's enquiry.

Today we argue over the definition of a terrorist, and the UN struggles to say what one is. The new cliché is: 'One man's terrorist is another man's freedom fighter'. Can there be good terrorism, as Camus's play *Les Justes* urges us to ponder? For Leonide Zarine, a Balkan expert, Londres 'never permits readability to distract from the value of his book as a serious indictment of an almost medieval tyranny'.[25] For his part, Zarine provides a comprehensive, mind-numbing roster of all the political

24 Glenny, *The Balkans*, p.197.
25 Leonide Zarine, preface to his translation of Londres's *Les Comitadjis*. London: Constable, 1935, p.v.

assassinations in the area. He castigates the harbouring of terrorists, then by Hungary, (today, according to Bush-telegraph, by various 'evil empires'). In 1935, as today, the Balkans are cursed by long memories, by living backwards, and, for Zarine, 'a brigand mentality'.[26]

Londres was unfailingly prepared to talk to the enemy (Japanese officials in invaded China, just after his trip to Bulgaria), to dubious heroes (D'Annunzio), as well as to victims and representative figures, including exiled kings such as Charles IV of Hungary.

The three main stages of his career are (1) the desire for direct action, taking affairs into his own hands or via a hit-man, as with General Phillips in Greece or sabotage in Soviet Russia; (2) diplomatic soundings, which he tried with D'Annunzio on behalf of the Quai d'Orsay; (3) an accceptance of his journalist role, as a researcher, highlighter, revealer and, he hoped, a one-man ginger group. In stages 1 and 2, Londres was fairly clearly indulging in self-mythification, via the aggrandisement of a much smaller actual mission. We must never forget, either, his profound love of mystery and mystification, practical jokes. He undoubtedly needed to outgrow or at least moderate his less justified sense of self-importance.

Assouline suggests that Londres was at a psychological low ebb in this period shortly before his death. A reader of his spirited, witty Bulgarian excursion would never think so.

26 Zarine, p. 241.

Chapter 4
Closed Spaces

Stirring up the Stir: *Au Bagne* (1924)

After his chopping and changing across the various fronts of the First World War and across postwar Europe, Londres must have felt the need, not so much for home comforts, always of relatively little appeal for him, as for travel, but this time travel with a difference, travel within circumscribed, nay claustrophobic limits: prisons of various kinds (civil, military, mental institutions). Travel as burrowing into social issues of criminality and madness. After covering international hostilities, he changes his focus to national systems of one-sided warfare, and resistance struggles.

He dedicates *Au Bagne* to fourteen other French, Italian and English globetrotting journalists.[1] He forgets George Ward Price, whom he had re-met in Shanghai in 1922, after their shared experiences in the Great War. In *La Chine en folie* (1925), Londres lauds roving reporters as 'corbeaux internationaux', who had many a time gathered 'sur les charniers du vaste monde' (*MS*, p.294). He clearly thinks of them as a warm fraternity, rather than as profiteering carrion birds:

> L'équipe des reporters au long cours n'est pas nombreuse. Anglais, Italiens, Français, tout cela remplirait à peine deux wagons. Mais ces hommes sans foyer et sans avenir s'aiment confortablement. Quand, à l'appel d'un événement, l'un d'eux met le pied sur un bateau, il balaye tout de suite le pont du regard dans l'espoir des camarades (ibid.).

Londres would go it alone on his prison visits, where he voyages on the spot, the damned spot, in order to carry out his investigation of abuses.

1 Ludovic Naudeau, André Tudesq, Edouard Helsey, Hubert-Jacques, Henri Béraud, Georges Labourel, Paul Erio (Charles-Louis Minoletti), Ferro Pisani, Luigi Barzini, Civinini (Guelfo), Arnaldo Fracarolli (a slip for Fraccaroli), Luciano Magrini, Perceval Philips, G.J. Stevens.

For Hugo de Burgh, 'it is often said that journalism is the first rough draft of history; by contrast investigative journalism provides the first rough draft of legislation'.[2] This, surely, is not invariably the case. Many investigations lead to nothing concrete or even formulaic. They might inform others better; they might console victims or sympathisers; they might make a name for the journalist, all no mean feats, but not be productive of real change. We should not underestimate, however, the 'shame factor' which exposure can provoke. One occasionally successful area of investigative reporting is the re-opening of legal cases, leading to the correction of miscarriages of justice, as we will see later with respect to Londres's campaign for Eugène Dieudonné. We should not confuse such activities with mere exposure journalism: tabloid scandalmongering about intrinsically unimportant events in which celebrities are allegedly involved.

Starting with *Au Bagne*, his enquiry into the French overseas penal settlement at Cayenne, Londres quickly learned the ropes: the hierarchies and interstices of the *univers concentrationnaire*. Several countries have long had the practice of deporting criminals and other undesirables to distant outposts of empire: Australia, Siberia, Louisiana, French Guiana, New Caledonia. Alfred Dreyfus had been confined on Devil's Island from 1895–9. Being French, of course the region was subjected to profuse bureaucracy, with endless rules, categories and subdivisions of types of convict. Yet the forced labour imposed on prisoners produced little useful. 'La transportation n'était trop souvent qu'une condamnation à mort différée, le travail manuel sous les tropiques faisant office de "guillotine sèche".'[3]

More sober, indeed teetotal, historians than Londres tell us, as he does, of the horrors of 'that tropical gulag'.[4] The convicts suffered very inadequate food, insistent and often arbitrary punishments and even torture, virulent illnesses, a terrible climate and voracious tropical insect life, and generally futile hard labour, such as yanking up grass blade by blade from the street, and solitary confinement for recividists, so that the general apartheid of imprisonment overseas was doubled by local

2 Hugo de Burgh (ed): *Investigative Journalism*. London: Routledge, 2000, p.3.
3 Michel Devèze: *Cayenne: déportés et bagnards*. Paris: Julliard, 1965, p.188.
4 Mark Hunter: 'The Rise of the Fouille-merdes'. *Columbia Journalism Review*. November/December 1995, p.3.

exclusion. Amongst themselves, violence, sexual assaults, gambling, theft and delation were rife. The guards felt themselves as much incarcerated as the detainees. Cayenne was a special world, with its own system of laws, written or tacit.

Londres starts the account of his long field-trip on the boat going there; he records the attitude of returning convicts to visiting reporters like him: 'Si vous allez là-bas pour les journaux, ce sera peut-être intéressant, rapport à la clientèle, mais pas pour nous. Quand on est dans l'enfer c'est pour l'éternité' (*AB*, p.25) – a poignant truism and switch from the literal to the (still highly physical) metaphorical. Elsewhere labelled 'un journaleux' (hack), once in Cayenne Londres overhears this other disabused verdict: 'Le journaliste, c'est de la claque comme les autres' (*AB*, p.88): he's the same shower as everybody else out here. Londres seems to have been largely free to come and go, and to interview prisoners without a warder being present. At the outset, he feigns to be a greenhorn, as so often in his reportages: 'Je ne connaissais rien du bagne. J'étais bête!' (*AB*, p.31). What he probably means is that, no matter how much he has mugged up in advance, he has no initial sense of the reality of prison life. No doubt he was also recycling the Voltairean tactic of making the visitor to a strange place an ignorant, but perceptive, savage or space-traveller, as a way of throwing into relief a society and its ways.

His first encounter on landing in Cayenne was with an ironically misplaced statue to the man who abolished slavery there (*AB*, p.33). His first sight of the inmates latches on to their widespread use of tattoos. No longer marked physically by officialdom, they inscribe on their own flesh their plight and their feelings about themselves. Such tattoos symbolise eloquently their defiance ('Vaincu, non dompté' (*AB*, p.40)), their desire for retaliation, their wry fatalism (the ex-priest with 'Amen' punched into his forehead), their hankering for an image of toughness, and their struggle to be individualised and different – highly desirable when their heads, shaved bald by force, would make them look near-anonymous.[5] Tattooing betrays a complex nucleus of sentiments, which Londres characterises as 'cette littérature sur peau humaine, [...] je "feuilletai" les autres torses'

5 Another visitor, Louis Roubaud, saw a man with a lugubriously funny, Morse-codelike tattoo pricked around his neck, saying: 'Please cut along dotted line'. Roubaud: *Le Voleur et le sphinx*. Paris: Grasset, 1926, p.116.

(*AB*, p.31).[6] Londres observes other graffiti on cell beds, walls or trees, like those of the incorrigible Roussenq: 'Face au soleil, Roussenq crache sur l'humanité' (*AB*, p.89). The relationship of the convicts and the guards is on a constant war-footing: 'On rebiffe, ils rebiffent' (*AB*, p.40). Londres cannot resist turning the tables. He says of a particularly unlovely warder: 'Mes forçats avaient meilleure mine' (*AB*, p.32). If capable of such self-discipline, some guards try to be on their best behaviour when dealing with their charges before Londres's gaze. Though fully aware of their alcoholism, their angry boredom, their sadism, Londres condemns the screws less than the system they serve, its insane regulations and the infamous use of *doublage*, whereby a prisoner repeats his original sentence in a kind of temporal treadmill. How many French juries, asks Londres, know of this small-print rider? The cruel paradox is that 'le bagne commence à la libération' (*AB*, p.42). It is Catch 22, thirty years in advance. 'Le bagne n'est pas une machine à châtiment bien définie, réglée, invariable. [Londres would condone this]. C'est une machine à malheur qui travaille sans plan ni matrice' (*AB*, p.38).

Londres engineers a slowish build-up to the full, detailed horrors of the place; he clearly wants readers to be persuaded of them gradually and cumulatively, rather than to be battered by overstatement. His irony resorts to mock-gentility: 'C'est le cul-de-sac du monde. Encore est-ce moi qui, pour être poli, ajoute: de sac' (*AB*, p.62). Assouline, in a far more in-your-face age, hypes: 'Culs-de-basse-fosse de ce cul-de-sac du cul du monde': the arsehole of the universe.[7] Even so, Londres salvages heart-warming cameos: a guard solicitously helping a convict to cut branches; they go off 'comme de vieux copains' (*AB*, p.37). Amongst the tough recalcitrants, he finds other inmates quite simply and nakedly desperate for home, for affection, for a modicum of freedom.

Long-term gaolbirds develop artifices of self-preservation. One such is 'le plan' (from *planquer*: to stash). Money, officially non-existent, is hidden in a tube rammed up the rectum and defecated when needed (*AB*, p.40). They all have knives. On their sexual practices, Londres remains discreet but realistic: 'Le bagne c'est Sodome et Gomorrhe entre hommes' (*AB*, p.41). He is non-judgemental, like Georges Darien in his *Biribi*, who

6 Cf. Raymond Queneau on graffiti: 'Les graffiti, qu'est-ce que c'est? tout juste de la littérature'. *Les Fleurs bleues*. Paris: Gallimard, 1978, p.98.

7 Assouline: *Albert Londres*, p.322.

shrugs his shoulders with the proverb: 'Faute de grives on prend des merles', which I would convert to 'Buggers can't be choosers'. At the same time, much homosexual activity must have been forced labour of another kind, and intimately tied up with the entire network of rackets, corruption and bullying. One commentator reports a guard murdered by the Arab convict he was raping. His dossier: 'Mort dans l'exercice de ses fonctions'.[8] Young offenders are hijacked by old lags. Londres talks to one beatific sodomist who thinks he is in paradise: hundreds of captives, with fresh batches every year (*AB*, pp.161–2). Though he claims more than once that prisoners do not grass on each other, or collaborate more than lukewarmly in hunting down escapees, at other times Londres acknowledges that informing and ingratiating oneself is the overall name of the game (*AB*, pp.40–1, p.50). In general he meets men who are not only and inevitably institutionalised, but who seem to have come out the other side of humanity into a no-place peopled essentially by themselves alone. In short, he meets all types: the mad, the bad, wanglers, fixers, fatalists, the unvanquished.

Among the last named are a series of rabid individuals. First, Hespel, 'The Jackal', an articulate prisoner who became the camp executioner and who feels himself superior to the notorious state killer, Deibler, in Paris. Londres lets Hespel speak, self-justifyingly, for himself. Hespel ultimately condemns himself along with all his fellows: 'Voilà le cloaque où, [...] comme un pourceau de la sorcière Circé, je me roule dans la fange de l'iniquité' (*AB*, p.49). When he murders a co-detainee, this perfectionist petitions to be allowd to set up his own more efficient guillotine (*AB*, p.53). Second, Ullmo, who has converted to Catholicism and is hell-bent on expiation. Dignified, he still possesses all his marbles; he utters not a word of recrimination, and his motto is: 'Attendre la mort, proprement' (*AB*, p.60). Third: Eugène Dieudonné, whom we will remeet more fully later. Scandalised by the immorality rampant in the settlement, he still recognises the odd windfall of kindness: 'C'est la goutte d'eau dans l'enfer' (*AB*, p.87). He has learned to withstand and indeed to relish solitary confinement.

Fourth: Roussenq ('L'Inco(rrigible)'), who should rather be called 'The Incorruptible', as he never deviates from his self-chosen path. He

8 Marcel Le Clère: *La Vie quotidienne dans les bagnes*. Paris: Hachette, 1973, pp. 202–3.

holds the record for solitary: 3,779 days. He is so set on ever more punishment that the authorities decide to torment him by ceasing to satisfy his masochistic urge for penalisation.[9] Roussenq has lacerated himself many times 'pour embêter les surveillants' (*AB*, p.93). Other inmates, in his eyes, are just vermin. Roussenq provides a link with Londres's account of Biribi, *Dante n'avait rien vu*, in that, prior to Cayenne, where he was sent in 1908, he had endured a long series of military imprisonments in North Africa, culminating in a sentence to twenty years' hard labour. Roussenq is incorrigible but pitiful: 'Je ne puis plus me souffrir. Le bagne est entré en moi. Je ne suis plus un homme, je suis un bagne […] Je ne puis pas croire que j'ai été un petit enfant' (*AB*, p.94). This is probably the most devastating thing, this admission of total internalisation of prisonerhood, that Londres hears during his stay: a man gullotined of his pre-prison life, an ex-man. This gives an acid gloss to the already horrible fact of institutionalisation.

A link with *Chez les fous* is also foreshadowed in *Au Bagne*, in Londres's report on the convicts' frequent madness. He listens to one insane, alternative logic:

> Au temps de ma femme, Jeanne d'Arc, le monde n'était pas si méchant. Je parle de l'année 1904 où j'ai pris Jeanne d'Arc pour femme. Quant à moi, je suis changé en cheval et je viens me plaindre ici que l'on ne me donne pas de foin. Pas même une jument, monsieur. Or, la femme appartient au cheval et non à l'homme, qui n'est qu'un singe (*AB*, p.96).

For many of the mad, it is not All Souls' Day, Le Jour des Morts, just once a year, but year-long (*AB*, p.98). Some of the guards, too, have succumbed, for example one who, in an outlying sector of the settlement, where he is supposed to supply meat to the rest, hangs it up till it rots, at which point he smears camphor on it. Londres finds an excuse for him: he was gassed in the First World War (*AB*, pp.70–1). Throughout his long stay, dozens of inmates shuffle past Londres, for him to inspect or briefly cross-examine: 'Je me sentais égaré dans une immensité de misères' (*AB*, p.103). Not many of them plead innocence; more say: 'Je suis une crapule' (*AB*, p.81). The system itself, of course, is crazy, as is demonstrated by the hardly-existent 'road' through the colony. It is a living, or deathly, proof of

9 I am reminded of the joke definition of a sadist: someone who refuses to flay a masochist.

the wilful negligence of the authorities about developing the area: 24 kilometres have been laid in 50 years (*AB*, p.68). Londres reduces a complex equation to a tellingly simple one: 'La question serait de savoir si l'on veut faire une route ou si l'on veut crever les individus' (*AB*, p.72). The latter seems the likelier, for the chain-gang, badly shod or shoe-less, pick up numerous and often deadly infections. While Londres does not object to penal servitude *per se*, he most certainly does object to accelerated mortality.

Doctors are in fact the bitterest critics of the system, as they are prevented from exercising their proper function by totally deficient medical supplies. Scores of inmates die every year: 'Le médecin voit l'homme. L'administration voit le condamné. Pris entre ces deux visions, le condamné voit la mort' (*AB*, p.120). The local buffalo catch diseases off the prisoners. Londres visits the leper colony: 'Celui-là est classique: faciès léonin en plein, bouffissures, pommettes pendantes, oreilles descendues, nez qui fond. Il a l'air en cuir repoussé'. Courteously, he knows when enough is enough: 'Ses yeux n'étaient plus que deux pétales roses. Nous ne dirons pas davantage, vous permettez?' (*AB*, pp. 142, 144).

Londres can and must speak for himself in his finale:

> Je rêve encore chaque nuit de ce voyage au bagne. C'est un temps que j'ai passé hors la vie. Pendant un mois, j'ai regardé les cent spectacles de cet enfer et maintenant ce sont eux qui me regardent. Je les revois devant mes yeux, un par un, et subitement, tous se rassemblent et grouillent de nouveau comme un affreux nid de vipères. [...] Malheureuses les âmes droites, certaines, dans le domaine du châtiment, de donner à chacun ce qui lui appartient. Ma conscience est moins sûre de ses lumières. Dorénavant, si l'on me demande d'être juré, je répondrai: Non! (*AB*, p.179).

Even when relating grotesque horrors, Londres's reportage maintains tonal gaiety; he will not let misery get him down. Neither will the more obdurate prisoners. He makes a brave pun on the literal and figurative senses of *tête* in the following idiom: 'La loi nous permet de couper la tête, mais non pas de nous la payer' (*AB*, p.38). Much of his customary hyperbole is simply humorous. If the governor had not allotted him a small shack, 'j'aurais été forcé de coucher au marché', like many of the 'freed' men, 'et j'en serais mort sans doute' (*AB*, p.36). On the paucity of nature-descriptions, Londres writes off-handedly: 'Je ne me lance pas dans la description, n'ayant jamais rien compris à la botanique [...] Tout ce qui est joli n'a pas besoin de nom' (*AB*, p.145). For Mousset, *Au Bagne* is wilfully chaotic in

its attempt to keep faith with the messy reality of prison life.[10] Indeed, how should a journalist, or any writer, seek to match confusion, or as some now intone, undecidability?

Earlier I borrowed David Rousset's expressive term, 'l'univers concentrationnaire'. I would adduce also Jules Vallès's leitmotif of 'le forçat'(or 'le galérien'). Vallès envisaged society as an interconnecting set of prisons (school, barracks, gaols, asylums, authoritarian political regimes and, more widely, the paralysing mind-sets created by fashions, fears or sloth). The term embraces 'le forçat du bon mot', the joke-machine (which is how some of Londres's critics belittle him), and, of course, self-imprisonment by reason of one's own automatic responses. 'Le forçat' is a lively but dangerous image, because a universal prison would then be the norm, instead of representing the threat to normality.

An uproarious section of *Au Bagne* is devoted to the (in both senses) camp concert: men performing in drag. In prison, a pecking-order of prices still obtains: 'Au bagne l'égalité n'existe pas' (*AB,* p. 131). The audiences practise film criticism at picture-shows, shouting out 'Du chiqué! Ce n'est pas faisable' at too much cinematic licence (*AB*, p. 152), and, of course, loudly warning screen villains who are about to be nabbed (ibid.).

In 1929 was staged an adaptation of *Au Bagne* by Maurice Prax and Harry Mass, at the Nouvel Ambigu, then at the Cluny. Dieudonné, back in Paris after his release, had a bit part. The performance included the song 'La Belle', with lyrics by Londres and music by Jean Lenoir. In recent years, several compilations of Londres's journalistic pieces have been staged or filmed as documentaries. Adapters have recognised the dramatic flair in his writings. When Jean Vigo died, he had an unrealised project of filming *Au Bagne.*

A supplement to the text of *Au Bagne* (which first appeared as articles in *Le Petit Parisien*) is Londres's letter to Albert Sarraut, the Minister for the Colonies. In it, he raises the crucial human-rights issue, and acts as a one-man Amnesty International *avant la lettre*. His arguments are both economic and ethical. He is categorical: 'Ce n'est pas des réformes qu'il faut en Guyane, c'est un chambardement général' (*AB*,

10 Paul Mousset: *Albert Londres, l'aventure du grand reportage*. Paris: Grasset, 1972, p. 170.

p.180). His indictments and proposals include: too much mixing together of very different kinds of criminal; inadequate health measures (he uses a good capitalist argument: how can sick workers produce anything profitable?); payment for work; the abolition of *doublage* and *résidence perpétuelle* (perhaps the most infernal circles of that hell). Altogether, a far more coherent colonial programme is urgently needed; Londres recognises that any would-be rethinking French government will have to fight the inertia of the penitentiary administration (*AB*, pp.180–2).

Londres signs off baldly: 'J'ai fini. Au gouvernement de commencer' (*AB*, p.180).

A new governor was in fact appointed. Despite the report in Londres's paper *Le Petit Parisien* that Edouard Herriot, the président du Conseil, had decided to abolish the policy of transportation and to introduce repatriation, it became clear that all authorities were dragging their well-shod feet. Those resisting the suppression of the penal regime took a vengeful line on criminality: criminals must suffer severely; or (NIMBY is of some antiquity) dreaded seeing such punitive settlements relocated on metropolitan soil. After the success of *Au Bagne*, a rush of journalists journeyed to Guiana; the serious subject had become modish, and the neologism 'Londrisme' was floated. Londres himself received many letters of gratitude and of support, often begging him to campaign against other injustices, usually visited on the senders. These included a pathetic note from a woman, asking how to get rid of her tattoo. Londres seldom followed up these letters. For one thing, genuine innocents such as Dieudonné were rare. Donet-Vincent underlines Londres's hunger for glory, via such sales gimmicks as allowing the claim on the cover of *Dante n'avait rien vu* that he had abolished the *bagne*.[11]

Of course Londres was not solely responsible for the eventual abandonment of the penal settlement. International opinion, government fact-fining missions and reports, campaigns by the Salvation Army and its installation in Cayenne, all of these played decisive parts. The last convicts were not repatriated till 1953, though reforms were introduced in the years after *Au Bagne*. Pierre describes the impact of this book on a previously under-informed French public: 'L'effet d'une bombe [...] [Le livre]

11 Danielle Donet-Vincent: *La Fin du bagne* (1923–1953). Rennes: Editions Ouest-France, 1992, p.55.

passionna l'opinion et secoua les ministères'.[12] Several of Londres's recommendations were acted upon: abolition of the *cachot,* irons, dry-bread sanctions, and the *camps d'incorrigibles*; work paid for once more, better food and sleeping facilities, and strict instructions aimed at curbing the brutality of the guards (ibid.). Londres's visit lived long in the local memory. All in all, Londres's reportages publicised what had been patchily known but very largely occulted for decades. Other journalists (Louis Raybaud and Georges Le Febvre, for instance) also exerted pressure.

Being largely devoid of cant, Londres sounds, and is, illiberal at times, by our smug contemporary criteria. He accepts that most of the convicts are society's dregs, and he never rejects the concept and practice of hard labour itself. His reportage concerns itself, rather, with promoting a more efficient and humane penal system. Besides, he was un-sectarian and non-militant in (parliamentary) political terms. He saw himself as a would-be setter-to-rights, for convicts and later for the mad, aiming to give practices a hefty nudge or shove in the right direction. Though not taken in by the myriad of sob-stories he heard, Londres saw enough heart-warming evidence of certain prisoners' worth (Ullmo, Dieudonné) not to re-sentence the already convicted.

Conflating Londres with other crusading journalists like Helsey or Alexis Danan, Jean Genet, in his *Miracle de la rose*, accuses all three of misunderstanding the true feelings of prison inmates, in his case youth prisons:

> Ils ne savent pas que, les détruisît-on, ces bagnes, par les enfants, seraient remontés: ces gosses inhumains créeraient des cours de miracles (c'est bien le mot) pour accomplir leurs cultes secrets et compliqués, à la barbe même des journalistes bien intentionnés.[13]

This is Genet at his most preposterous, privileging ritual at the expense of other forms of social life. For half-a-dozen detainees who thought like

12 Michel Pierre: *La Terre de la grande punition*: *Histoire des bagnes de Guyane*. Paris: Ramsay, 1982, p.89. Pierre (p.235) points out one factual error by Londres: the song 'Orapu' 'dont Londres écrit, à tort, qu'il s'agissait du chant que les voisins de cellule d'un condamné à mort entonnaient pour prévenir ce dernier de l'imminence de son exécution', whereas the chant bemoaned the atrocious daily grind. The difference is not great.

13 Jean Genet: *Miracle de la rose*. Paris: Gallimard, 1977 [1947], p.222.

Genet, there must have been hundreds who would want the system of juvenile incarceration smashed, or the regime made more caring. While it is true that prisons provide a home for society's misfits, Genet seems not to have heard of institutionalisation,

Londres's daughter Florise attempted in 1946 to bring a libel case against *Paris-Matin*, for its reporting of the alleged words of a Colonel Sainz, a former doctor in Guiana:

> Albert Londres n'a rien vu, pour la bonne raison que l'Administration Pénitentiaire ne l'a jamais autorisé à visiter le bagne. Le fameux livre du grand reporter 'Le Bagne' qui, aux environs de 1930 [1924, in fact] fit courir un frisson d'horreur dans le public français n'a jamais été que l'affabulation et de la plus déréglée.[14]

In this account, Londres used secondhand material culled from freed convicts. Such a libel did not refute Londres's findings, but rather denied that the so-called eye-witness reporter had ever been *in situ*.

On the Run: *L'Homme qui s'évada*

L'Homme qui s'évada (1928) recounts Londres's courageous and dogged efforts to rescue Eugène Dieudonné from Brazil, wrongly accused of having belonged to the notorious Bonnot gang of anarchist bandits, whereas he had in his youth been at most a fellow-traveller of anarchism. Dieudonné had fled to Brazil from Cayenne, and even more from a French bureaucracy trying to renegue on its pardon. Far more exhilarating and truthful than Henri Carrière's *Papillon* (book or film*)*, *L'Homme qui s'évada* is a splendid yarn of obstinate, repeated escapes, and the determination to become and to stay free.

Many convicts in Cayenne shared a highly understandable obsession with gaol-break, and showed often a desperate inventiveness in their escape methods. Londres's song, 'La Belle', contains these words:

> Même lorsque tu ne viens pas
> C'est toi qu'on adore, la Belle (*AB*, p.199).

14 In dosssier 76/AS/20 in the Archives.

In terms of idiom, and depending on the context, the prison slang term 'la belle' secretes these meanings: going over the wall, killing, the easy life, hard times, luck, arrest, and shopping someone. It is thus polysemous and deeply ambivalent. Londres had mentioned in *Au Bagne* the poignant and crazy action of

> un qui, chaque jour, lançait quelques cailloux dans la mer, à la même pointe de l'île Royale. Comme cela, il créerait une digue d'Amérique du Sud en France. Il n'aurait plus ensuite qu'à marcher dessus pour rentrer chez lui. C'est de cette folie-là que ces tragiques misérables sont fous! (*AB*, p.101).

Londres met a more serious example of the will to escape in Marcheras. This prisoner makes an articulate attack on the crimes of the French penal system, and compares it unfavourably with those of the USA, Britain, Dutch Guyana, and even some Central American republics. It is in fact Marcheras who pronounces what Londres will make his own verdict on the whole sysyem: 'Le bagne n'est qu'une machine à faire le vide. Et cette machine coûte quatorze millions par an à la France' (*AB*, pp.104–5). Marcheras's version of the motives for escape is that 'dégoûtés de notre inutilité, monsieur, on déserte' (*AB*, p.105). He tells an extraordinary tale of his three attempted breakouts, which almost match Dieudonné's. Marcheras accepted living like a wild animal in the jungle, putting up with weird and wonderful jobs in countries he landed in, before being recaptured and sent back to Cayenne. Now a nurse in the infirmary, he is glad to be of some use to his fellows (*AB*, pp.106–9). In an annexe is printed a letter to Londres in 1924: Marcheras has escaped once again.

Dieudonné is an even more impressive embodiment of courage, stamina, and moral consistency. Self-tutored, quite widely-read in political philosophy, he was a homemade intellectual. Though pardoned by Raymond Poincaré, he was sentenced to prison for life, on an unproven charge, eleven years before Londres spoke to him in Cayenne. Londres's editor, Elie-Joseph Bois, sent him to interview Dieudonné, after he had escaped for a third time, in Brazil. Apart from his attempts at flight, Dieudonné was in every way a model prisoner. When Londres catches up with him, he listens to and copies down (a small miracle in the days before tape-recorders) his story of what it feels like to be disbelieved by most others for much of your life. Even amongst the prison population, mutual suspicion and reciprocal informing cage people as effectively as actual

surveillance by the guards or locked doors: 'Au bagne, on ne choisit pas ses amis, on les subit' (*HS*, p.222).

Dieudonné is fully aware of the knockabout aspects of his escape with comrades: trying to paddle a makeshift boat with a carpenter's plane or a saucepan (*HS*, p.230). Likewise, the escapees can find time to joke when wading through waist-high water after their craft sinks, and in imminent danger of being drowned by the rising tide. One calls out: 'Courage Gégène […] t'en fais pas *pour si peu!*' (*HS*, p.236, italics in text). Another in fact dies in the surging waves. To reassure the rest, Dieudonné, the brain-box of the group, pronounces an impromptu lecture on Archimedes' Principle (*HS*, p.241). After multiple hair-raising dangers of all kinds, frequent back-to-square-ones, repeated betrayals and periods of starvation, they reach Brazil, where they encounter oases of calm, windfalls of helpfulness, as well as, of course, much indifference to the plight of these sick, filthy, ragged Martians.

When Dieudonné lands a proper job, all seems set fair, but then he is several times arrested, though gently treated in the main. Gradually, he learns how he is the centre of international haggling between France and Brazil. Eventually, France drops its demand for extradition, and he can enjoy a splendid last supper.

Londres escorted him back to France, after performing miracles of persuasion on the authorities, and earning the salvaged man's undying gratitude. On return to France, Dieudonné remarried his wife; they had divorced for her and their child's protection at the time of his wrongful conviction. Londres revisited him later, when he was comfortably installed in a respectable district of Paris, employing four workers in his cabinet-making business (he had made excellent furniture for his bosses in Cayenne). He tells Londres: 'Eh oui […] je me suis réadapté. Il est plus facile pour un bagnard d'apprendre à vivre en bourgeois que pour un bourgeois d'apprendre à vivre en bagnard' (*HS*, p.312). He had faced in his life both challenges, and met them successfully. After many years marking time, he could now, properly, live his life forwards.[15] Londres later wrote a preface to Dieudonné's *La Vie des forçats*, but he had earlier played a major role in the main text.

15 I think of Nerval's 'L'ignorance ne s'apprend pas': we cannot live backwards. *Aurélia*, in *Sylvie, suivi de Léo Burckart et de Aurélia*. Monaco: Editions du Rocher, 1946, p.78.

With his two books on civil prisons and convicts, Londres learnt that a more profitable way for a journalist to have a perceptible impact on public matters was to campaign against injustices, instead, as earlier in Greece, of offering to have a public figure taken out ballistically. In 1929, he also contrived the release of Paul Roussenq, who had spent 21 years of his adult life first in military prisons and then in Cayenne, mainly in solitary. The catch was that he had to spend three more years there before final freedom.[16]

In the Glasshouse: *Dante n'avait rien vu (Biribi)* (1924)

What does Londres make out through the undoubtedly murky panes of the glasshouse? *Dante n'avait rien vu (Biribi)* updates the novel *Biribi* by Georges Darien of thirty years earlier.[17] Londres finds that little has changed in that timeless hell on earth: 'Biribi n'est pas mort' (*DN*, p.15).

In the 1880s, Darien spent three years of his military service in a disciplinary battalion in Tunisia: a blacklisted expatriate. His *Biribi* (1890) was the virulent product of that brutal ordeal. In later books, he was to exalt the odd-man-out gentleman-burglar in France *(Le Voleur)*, to savage his motherland *(La Belle France)*, and to commit himself voluntarily to linguistic partition by writing in English *Gottlieb Krumm, Made in England.* Double and triple exiles: Darien always piles it on thick. The word 'Biribi' seems to come both from a game of chance involving nutshells, which recalled the stones broken by convicts, and from Barbarie, a traditional name for North Africa. It may be that military prisoners used the gambling term as an ironic reference to their own long-shot chances of emerging alive from their purgatory.

16 Devèze: *Cayenne*, p.201.
17 In a letter to his daughter Florise of 5 September 1917 (in Archives), Londres reveals that he is taking a few days off from the Western Front for a quick trip to Corsica (from where originated most of the NCOs in military prisons), Tunisia and Algeria. He was clearly already thinking of covering the subject, and would do so seven years later.

As in *Au Bagne*, Londres contrasts the regulations (here Livre 57) with the daily practice which flouts them outrageously. Bureaucracy protects noone: 'Ce n'est pas d'une institution que vient le mal; il vient de plus profond: de l'éternelle méchanceté de la race humaine' (*DN*, p.18). Is Londres covering himself against the possible charge of insulting the French Army? If so, does he entirely believe what he says? If he does believe himself, then any reforms he might propose would be largely futile, if behaviour cannot be amended. Or is his attitude simply one of empirical realism; men cause other men's sufferings, visibly, palpably. More positively, whatever the base instincts of many humans, surely these can be held in check by strong supervision, can they not? Londres, like Christ in this respect, devises parables, here a nicely judged fable about Book 57. A Shah of Persia orders a hand-out for his palace staff. By the time the money-bag reaches underlings, it is empty.

> Ainsi du Livre 57. Il partit du ministère. Les généraux le reçurent tout neuf. Puis il arriva aux capitaines. Le capitaine le repassa à l'adjudant, l'adjudant au sergent. Dans le feu de toutes ces lectures, le petit bouquin perdit beaucoup de ses pages. C'est pourquoi le soldat disciplinaire tend encore la main … et le dos (*DN*, p.16).

Like Vallès ironically lauding the Stock Exchange, the more deviously to attack it, Londres presents his accusatory report as a defence of Book 57. As is his wont, and he never pretends that all is black, Londres in this text is not invariably critical of what he encounters, for example a work-party on a road: 'Ils n'avaient pas l'air malheureux. Le puissant syndicat des terrassiers n'auraient rien pu relever, dans ce chantier, qui choquât les lois du travail' (*DN*, p,22). In general, however, conditions are so desperate that even very young prisoners have given up all sense or expectation of normal life: 'Ces gamins, au début de l'existence, ne croyaient déjà plus à rien' (*DN*, p.37). From the men, and differently from the civilian convicts of *Au Bagne*, he meets with a stone wall of non-cooperation, for very good reasons: the fear of reprisals from the guards. Slowly, however, he begins to win the trust of at least certain prisoners, who stop thinking of him as a copper's nark or a joke, because after all he represents 'une vague corde qui leur était enfin lancée au fond de leur trou' (*DN*, p.83). One even takes him for a fact-finding *député*. The men fear above all being sent off 'en détachement', away from the always aleatory protection of a captain.

He listens patiently to life-stories *in parvo*, each tale more horrific than the last. Ivan Vassili swears blind that he has been the victim of

mistaken identity for many years. The authorities remain sceptical. Londres simply presents both sides, not plumping for one version of events. Is Vassili the wrong and wronged man? Was he shanghaied in Marseilles? (*DN*, p.45). Whatever the truth, he is suffering here and now, and it is the suffering imprinted on the man's very flesh that Londres focusses on:

> L'oeuvre des condamnés militaires n'est pas un mythe, elle est écrite sur la terre dure. L'une des bases de l'institution est le relèvement par le travail. Le travail est un fait; quant au relèvement, il se pratique, de préférence, à coups de botte (*DN*, p.46).

Note the quick switch, the swivel of reference, from the moral to the physical senses of 'relèvement', a telling instance of literalisation. As at Cayenne, Londres detects inscription everywhere: on the soil (the shovel and pick-axe marks of the men's hard labours), and on their bodies (torture, and tattoos). One ubiquitously tattooed soldier sports classy motifs, such as Louis XIV hunting-parties. He is dressed, he boasts, even when he is stark naked, and has advertised himself in fairground booths as 'un gobelin vivant'. Not one design is pornographic (*DN*, p.112).

Everywhere Londres finds evidence of the guards' sadism, their obscene fun which has been 'refined' over years, for example slipping fistfuls of salt into soup doled out to famished prisoners (*DN*, p.55). Whereas a halfway-decent sergeant elicits better work out of his charges,

> les actes cruels qui marquent la carrière de beaucoup de sergents sont moins le résultat d'une décision de l'esprit que la conséquence naturelle d'une brutalité qui se croit des droits et se donne des devoirs (*DN*, p.67).

It is this 'natural' cruelty that, paradoxically, goes most against nature, and Londres thus holds them responsible for their acts. This stance helps to explain his mixture of fatalism and reformism: 'On peut dresser des recrues, on ne réforme pas des vieux de la vieille' (*DN*, p.69). Though it is no excuse and leads to violence, the ready availability of plentiful plonk is one of the few consolations of the guards' miserable lives. Faugibier, for one, is a perfect 'monstre': 'Il ne complote pas ses mauvais coups, mais ce qu'il pense est mauvais et il exécute les choses qu'il pense, tout simplement' (*DN*, pp.89–90). As for the moral status or worthlessness of the convicts,

> dans un détachement de cent vingt détenus on peut compter une vingtaine d'hommes à l'instinct monstrueux. Puisqu'il est des personnes qui n'aiment pas que l'on parle

de criminel-né, disons que ces hommes, un jour, ont trouvé le crime, ramassé et bien serré contre leur coeur. S'ils n'étaient dans les pénitenciers militaires, ils seraient à Clairvaux [a major state prison in France]. Les cent autres sont des délinquants de l'armée (*DN*, pp.70–1).

Where does Londres, and the same applies to the 'statistics' of *Chez les fous*, get his (rough) estimates from? They sound plausible enough to this reader, if not perhaps to others.

Altogether, he offers quite a nuanced overview of the different varieties of prisoner personalities:

Les plus mauvais coeurs ne sont pas les plus mauvaises têtes. C'est souvent le contraire. L'homme crapule ne se lance pas à l'aventure, il combine ses coups. Ce n'est pas lui, généralement, qui attire la foudre toujours prête des sergents; c'est l'autre qui, soudain, se dresse et reçoit la décharge. Les moins coupables sont souvent les plus punis (*DN*, p.71).

This awkward fact of life is familiar to schoolteachers and parents: the less slick cop it for the more. Many inmates add self-punishment to sanctions imposed by gaolers, via self-mutilation. With the inventiveness of desperation, they sharpen spoons on rocks with which to lacerate themselves. They provoke conjunctivitis by stuffing snuff in their eyes; failing that, they insert lemon-juice, pepper, mustard, soap or hot cigarette ash, 'qui ne font pas mal non plus', as Londres blackly puns – they do a good job/they don't hurt (as if…). Jaundice or consumption (coughing blood) can be simulated (*DN*, pp.76–82). All such dodges pay a very high price in pain, but are undergone in the hope of avoiding even worse forms of inflicted torture from the guards. Londres remembers his women readers' sensibilities, too, as when he includes in his catalogue of masochistic devices the use of kohl smeared on the face, in order to sham asphyxia, combined with a ribbon pulled tight around the throat (*DN*, p.79).

Some men, 'les volontaires de la folie', also imitate madness, for which they have their method (Method acting), especially the self-made crazy 'hunchback', whose recipe or script for self-transmogrification Londres thoughtfully passes on (very deep breaths and contortion of torso (*DN*, pp.76, 81)). Such corporeal thespians might not hoodwink alienists, but the military superstitiously believe that those who feign madness might become actually mad, and spread their madness contagiously (*DN*, p.82).

A major complaint voiced by Londres is that military 'justice' is random and inconsistent; and a good many prisoners, indeed, give up the ghost, metaphorically and literally, in their pursuit of it, after extensive and homicidal beatings by NCOs. It is haphazard and incredibly petty-minded, for instance long extensions to sentences for not washing your feet (*DN*, p.136). The general run of the detainees is as much under the thrall of the 'caïds', natural leaders, 'king rats', as of the sergeants. Though, as in *Au Bagne*, discreet about homosexuality, Londres notes that *caïds* often force others to dress in drag before assaulting them sexually (*DN*, p.108). The prisoners are not safe anywhere from ill-treatment.

One old lag, Rondier, smart in appearance, claims, however, to be happily adjusted to the regime: a case of chosen institutionalisation, which for others is the ultimate nightmare: 'Le pénitencier et moi cela ne fait plus qu'un' (*DN*, p.110). He would be, he maintains, only a fake ('emprunté') in civil life (ibid). Another more oppositional prisoner, who escapes dressed as a priest, is cornered when celebrating Mass on the ship to Europe. In many parts of his narrative, Londres acts as a recording-machine, a recording angel, intruding himself little, except that he implicitly warms his hands before the sheer diversity of human cussedness and ingenuity. It is a world apart; one prisoner had never heard of the 1914–18 War (*DN*, pp. 125–132).

Hatred is omnipresent: 'Il *fait* haineux dans les pénitenciers comme il fait chaud dans une serre' (*DN*, p.149, author's italics). The guards 'inoculent la rage, et quand le sujet mord, ils l'appellent traître!' (ibid). One detainee plans to match Londres by publicising his bitter experiences. He is energised by 'une haine, monsieur l'agent principal [the chief warder], plus forte que ma douleur' (*DN*, p.150). In a natural bridge back to *Au Bagne*, Londres mentions that many of the convicts in North Africa dream of being transferred to Guiana, of which they have formed false images; greater freedom of movement, permission to smoke, etc. From his own observations in Cayenne, Londres works hard to disabuse such fond daydreams by vivid tableaux of the real, awful situation over there: 'Ils oublient les fers, le ventre vide, l'enlisement. Ils ne voient que la mer, le soleil, le port!' He calls them, as he himself had often been called, 'des littérateurs!' (*DN*, p, 158): these dregs are bookish. He loses the unequal battle. One prisoner, whom he asks why he wants a transfer, responds:

'Pour devenir un bon forçat, c'est mon métier' (*DN*, p.160).[18] On the spot, like the Birdman of Alcatraz, prisoners cling to any vestiges of free life: a sparrow, a rat, even a beetle (*DN*, p.157). At heart, most are fatalistic; like catholics, once a criminal, always one, in the eyes of others, and of themselves: 'Je serai toujours le coupable pour l'avoir été une fois' (*DN*, p,161). Existentialists are turned into essentialists.

At the end, Londres runs through the atrocities of which he has heard, matching the tortures described earlier by Darien: men bound into toad-like postures, or laid between bundles of spiny branches which guards then dance upon; men compelled to carry quicklime on their naked shoulders; warders or dragooned prisoners shitting on prostrate bodies; men tied to the tail of a mule and dragged along, or handed over to colonial soldiers who are instructed to shoot if anyone moves (*DN*, p.162).

Londres fairly catalogues the reasons, if never the justification, for the brutality everywhere rampant: cheap booze, low pay, even lower self-image, lack of effective control by superiors, and a sincere if dire con-viction in many *chaouchs* that their function is to punish their charges pitilessly. Londres categorically believed that he had not only to move and make indignant his citizen readers, but also to incite or shame relevant powers-that-be to take action over flagrant injustices. Such follow-up campaigns sprang from a determination that his newspaper pieces should not remain a dead letter after publication. Assouline neatly terms this practice, which Londres started with *Au Bagne*, his 'after-sales service'.[19] Londres went on to recommend to the Army Minister an all-out pro-gramme of re-education for NCOs, or better, rigorous training of a new, young breed, followed by close inspection of their doings on the spot by officers, doctors and priests. He is ready to use any ploy: the shame-factor (the backwardness of France), or the revelation by antithesis: 'Ce n'est pas la discipline qui règne sur la justice militaire, c'est l'anarchie' (*DN*, p.163). Referring to the shortage of males in France after the murderous Great War, he stresses that she can ill afford to squander thousands more each year by sequestering them. He widens the specific question of military gaols to embrace the whole issue of the proper use of incarceration: 'Le mal est au coeur même de nos méthodes de répression.

18 I am perversely reminded of Heinrich Heine's 'Dieu me pardonnera, c'est son métier'.
19 Assouline: *Albert Londres*, p.424.

Dans ce domaine, nous faisons plus que de manquer d'humanité, nous manquons d'intelligence' (*DN,* p.166): a shrewd blow aimed at French pride in their superior intellect. Ironically, to our eyes, Londres could hold up the United States as a model to follow in penal matters (*DN*, p.167). He asserts there is nothing utopian about his proposals (ibid). However hopeful he made himself, all the same, at the back of his mind must have lurked the memory that governments frequently change policies only or mainly on paper. Darien in his age had found that the 'abolished' *compagnies de discipline* became, euphemistically, in administrative bafflegab, *sections spéciales*, as if the convicts benefited from exceptional treatment.

The most that can be claimed is that Londres gave an impetus to the process of clean-up in the military-prison domain. A debate in the Chamber of Deputies ensued, and a commission of enquiry was set up. On the other hand, a *pied-noir* journalist, Francis Doré, who had been an NCO in North Africa, published a pamphlet, *Albert Londres n'a rien vu*, in 1930. This attacked Londres for dragging the Army in North Africa through the mud. Doré claimed that Londres had never set foot in some of the penitentiaries he included in his reportage, and that he had generalised like mad from a few individual cases.[20] Doré ignored the main, and undeniable, sweep of Londres's indictment: ultimately, 'Biribi doit disparaître' (*DN,* p.164).

Amid all the horrors and the genuine indignation of his response, Londres never forgets his true function as a writer and, above all, preserves his deep-rooted sense of humour, even if he does remark that the prisoners' comic sense is, understandably, more contorted: 'Ce n'est pas le rire qui découvrait leurs dents, c'était le rictus' (*DN*, p.38). Very conceivably he relished Darien's stoical but caustic ludicity, his insistence on the prisoners' dumb insolence, which can of course speak volumes. For his own part, he notes the inmate, who has written to a pastor, a rabbi, and a Catholic-charity lady, and who explains: 'J'assure mes derrières' – a shrewd pirating of military jargon and, in another sense of protecting one's rear, perhaps an elementary precaution in an all-male environment. Londres can humorously but relevantly distance himself from the hypnotising hell he sees all around him. He pictures prisoners, under a baking sun, freezing on command on the spot and in identical postures: 'On eût dit des soldats de plomb abandonnés en désordre par un enfant

20 See Assouline: *Albert Londres*, p.393.

après son jeu' (*DN*, p.32). Indeed, these flesh-and-blood men are treated as discardable toys by their masters. Overlaying currency and character, Londres puts in a good word for an exceptional officer: 'C'est le capitaine Etienne. Il n'est que d'une pièce, mais la pièce est bonne' (*DN*, p.36).

In his preface to his *Biribi*, Darien states: 'Biribi c'est l'armée comme le bagne est la société'. His novel is clearly wider in scope and targeting than Londres's reportage. The big difference between the two is that Darien's protagonist is trapped, until near the end, in Biribi, whereas Albert Londres is a prison visitor.[21] But an understanding, sympathetic and clear-eyed visitor, who turns in a damning report on his stay.

Prisons of the Mind: *Chez les fous*

Chez les fous (1925) extends Londres's encounters with confinement: Cayenne, Biribi, even the 'convict' cyclists of his texts on the Tour de France, a coming attraction in Chapter 6. *Chez les fous*, indeed, is another tour of France, though he does not name any of the abusive asylums he visited. It performs for mental institutions a comparable function to what *Au Bagne* did for civil, and *Dante n'avait rien vu* for military, prisons. The book is composed of twelve articles, published in *Le Petit Parisien*, illustrated by troubling sketches by Georges Rouquayrol. In this text, Londres combats one of the most widespread (after sexism) human pre-judices: the racism turned against the mentally ill. He had earlier, of course, insisted upon the idiocy of war, and of much politics. We need to see whether Londres renewed himself fundamentally when he tacked from reporting historico-political situations to social problems, which are, naturally, still intensely and inherently political.

Around the same date, the Surrealists were romanticising and seeking to appropriate madness. Few such bandwagoners interest themselves in the innocuously insane, which, statistically, most mentally ill patients in fact are. Londres never ceases to keep in focus the severe drawbacks as well as the uniqueness and occasional charms of madness. He does register the

21 Rather like Paul Nizan in *Aden Arabie*, Darien views the French presence in Tunisia as a microcosm, a *reductio ad absurdum* (and *ad nauseam*) of France herself.

picturesqueness, but also the frequently nauseating behaviour and ready violence of some. Nor is he taken in by the hopeless logic of a deranged woman: 'Si j'ai perdu ma raison, je continuerai jusqu'à ce que je perde ma folie' (*CF*, p.212).

Chez les fous opens jovially, with an account of Londres's repeated attempts to procure authorisation for visits to asylums (*CF*, pp.179–80). He distinguishes between the socially acceptable and the forbidden varieties of mental illness. With his writer's instinct, he quickly puts the emphasis on vocabulary, the play of language, terminology:

> Quand une personne tombe malade de la mystérieuse maladie, si cette personne n'a pas le sou, elle est folle. Possède-t-elle un honnête avoir? C'est une malade. Mais si elle a de quoi s'offrir le sanatorium, elle n'est plus qu'une anxieuse (*CF*, p.182).[22]

There is little political correctness in Londres's own lexis. He uses the gamut of colloquial expressions, from 'dingo' to 'une araignée au plafond' [bats in the belfry]. He does not spare himself. His recurrent persona here is less the ignoramus ready to learn than a kind of loony himself. This fits in with his refrain that there are more crazy people outside asylums than inside their walls. He knows that it is a slippery stance, for he moves on from vocabulary to idiom. 'Faire le fou' is both to act the goat and to feign madness: 'Il y a des fous qui font les fous. Il ne leur manque que l'habit de satin, le bonnet à corne retourné et les grelots' (*CF*, p.184). Not only Surrealist opportunists simulate folly. Some acting flair is essential, all the same. Londres has to resort to the subterfuge of disguise: as an internee, or a relative of such, as a warder, even as a dentist's assistant (*CF*, p,191): 'Drapés dans leur manteau couleur d'importance et par surcroît démodé, les fonctionnaires, hauts et bas mandarins de la République, n'ont jamais empêché un journaliste de faire son métier, n'est-ce pas, confrères?' (ibid).

Throughout, Londres fights hard to keep himself tolerant of the extreme schizophrenic cases he witnesses, and to treat them seriously:

22 I am irresistibly reminded of a Jules Feiffer cartoon of 1965 where a down-and-out, successively categorised as 'poor', 'needy', 'deprived', 'underprivileged', 'disadvantaged', ends up by saying: 'I still don't have a dime. But I have a great vocabulary'. Cited in William Safire: *The New Language of Politics*. New York: Random House, 1968, p.112, as an example of official double-talk.

> Une espèce de putois qui, tout en dénouant une corde, là-bas, au fond, s'en prend à la terre entière de je ne sais quel affront que lui inflige un être invisible. Il se fâche comme si son ennemi était devant lui. Son ennemi est bien devant lui, mais seul il le voit (*CF*, p.192).

Many are, he finds, atomised creatures, Leibnizian monads: 'Chacun agit à sa guise. Il ne s'occupe pas de son voisin. Il fait son geste, il pousse son cri en toute indépendance' (ibid). Then, as a way of underlining that madness is an alternative, if frightening, reality, he adds: 'Ils sont des rois solitaires […] Il n'y a pas un peuple de fous; chaque fou forme à lui seul son propre peuple' (*CF*, p.193). Londres cannot fail to spark to this extremist form of individualism. Here, we the alleged sane are the cut-off ones: 'Si leur conversation paraît incohérente, ce n'est que pour nous; eux se comprennent. La rapidité de leur pensée est telle qu'elle dépasse les capacités de traduction de la langue' (ibid): they are, in effect, self-interpreters in a one-seat congress. He goes on to quote a skilful doctor translating plausibly a patient's highly allusive and metaphorical speech, ostensible gibberish (*CF*, pp.193–4).

Londres enjoys the pregnant plays on words of patients, for it is a taste he shares, for example: 'Mâles qui faites du mal', as a distraught woman berates her flummoxed husband and son when they visit her. In spotting this linguistic phenomenon, does Londres help to elasticise more rigid ideas about madness? Punning certainly has several links with madness, though I often wonder who are the barmier, those who practise and champion, or those who sniffily ward off, wordplay, which is demonstrably a potent admixture of logic and absurdity, reason and unreason, gratuitousness and pointedness. Punning stems from, and incites in receivers, mental agility. All true command of language, after all, entails an ability to think laterally, to make meaningful associations, and to see telling connexions between separate words or phrases that sound, or as near as dammit, the same. Puns make sense, in two senses: they stand up to inspection, and they are productive of meaning.

In his enquiry as a whole, Londres keeps switching between observations which encourage in himself and readers some hopefulness, and recognition of psychic or somatic monstrosities, such as the inmate who bites off half of another's tongue, or the astounding resistance to (self-) inflicted pain of the man who saws open his chest, with a beatific smile on his face (*CF*, p.195).

When Londres records stereotypically loopy behaviour, for example that of a man who enacts, with his whistle, the complete role of a station-master, he is playing up to stock human responses by presenting the mad as laughable (cf. the term 'funny-farm'); admitting his own rather troubled merriment at the free show; and recognising the self-circumscribed method in the mad's lunacy: 'Il fait partir des trains que nous ne voyons pas' (*CF*, p.195). He is anxious, presumably, at the thought of the journalist as rapist, committing 'le viol des solitudes'.[23] Yet he consoles himself gradually, as he comes to realise that, by dint of his patient listening and watching, 'il me semble que je deviens sympathique à la foule. J'attire des confidences' (ibid). This is the kinder version of the journalist as father-confessor, psychoanalyst, or simply friendly ear, the reporter as cordial magnet for those starved of compassionate attention. Rather as we might well wonder in a zoo whether we are entertaining the caged animals who stare at us, Londres, tables turned, provides a spectacle, a novelty-turn, for these internees. Similarly two-way is the question of mantras, such as a patient's 'qui va deux va trois', repeated on any old occasion (*CF*, p.198). Londres has his own mantras or ritornelli, such as: aren't very many lunatics harmless? 'Se croire les intestins rouges, est-ce un danger pour soi ou pour la société (loi de [18]38)?' (*CF*, pp.198–9). Londres is especially touched by the sad case of an innocent, none too bright girl, found wandering the streets, homeless and family-less, as a result of the war. If she were released, he realises, she would be a prey to pimps (*CF*, p.199). As it is, when she escapes and is recaptured, she is locked up in a cell; incarceration is the only available form of safety for her (*CF*, pp.214–5).

Crazy women are crazier than crazy men. Or is it just that they externalise their madness more frankly and copiously? Londres is argu-ably, but not indisputably, sexist, if not blithely so like Kingsley Amis in *Jake's Thing*, where women are typecast as barking mad.

> A côté des filles, les fous semblent raisonnables. Ces femmes sont infernales. Toutes ont l'air d'obéir à un ressort qu'elles auraient avalé. Elles se plient, se redressent, gambadent. Elles portent leurs bras en ailes de moulin […] Par temps d'orage, l'intensité de cette diablerie est décuplée (*CF*, p.201).

23 Roger Grenier: *Les Monstres*, Paris: Gallimard, 1953, p.58.

Straitjackets or belts with manacles attached have to be used to immobilise dangerously flying hands. While women – witness any television presenter – may well gesticulate more than men, it may be over-charitable to explain Londres's recourse to robotic imagery by his shock at finding women, whom he loved, in such reduced human form. As for women across the divide, and apart from one or two unspecified hints (see pp.229 and 252, concerning brutal treatment of inmates, including a forcible tooth-extraction without an injection), Londres makes no indictment of the nurses, female or male. In fact, the nuns in one asylum impress him by their stoical endurance of patients' insults and other attempts to humiliate. Because of staff shortages, which do not date from today, some patients are left tied up in bed (*CF*, p.202).

At meal-times in the women's sector, sheer chaos reigns: food and plates whizzing about, or being trampled underfoot. Macaroni is hurled in Londres's face. One automat-like patient has to be 'wound up' in order to eat (perhaps the origins of Londres's image of the swallowed spring) (*CF*, pp.204–6). At night, in lighting worse than a stable's, women dance like maenads round a lavatory-tub, which they knock over: 'C'est le cancan du tout-à-l'égout' (*CF*, pp.213–14). Images spring to mind from the 1949 film, set in a women's mental hospital, *The Snake-Pit*. Londres is particularly sensitised to the plight of patients of either sex who suffer from persecution mania. Anticipating the dramatic presentation of Frantz's delusions in Sartre's *Les Séquestrés d'Altona*, Londres describes the condition in these words:

> Sa folie ne lui laisse pas de répit. Elle le tenaille, le poursuit, le torture. La nuit on le guette, on l'espionne, on l'insulte. 'On' ou 'ils' sont ses ennemis! Ils sont dans le plafond, dans le mur, dans les planches (*CF*, p. 215).

Schizophrenia has modernised itself. Whereas it used to be the Devil who obsessed and possessed the mad, now it is the cinema, phonograph, aeroplane or loudspeaker (*CF*, p.216). The traditional delusions of grandeur follow on from this logic: I am persecuted, therefore I must be important (*CF*, p.218). Manic-depressives, less histrionically, seem to specialise in mute suffering (*CF*, p.217). Making regular comparisons with the world of the reputedly sane, Londres reminds that, whereas 'normal' nightmares have their end, those of the deeply mad rarely let up (*CF*, pp.220–1).

To set against the generally unremitting awfulness described so far, Londres reports glowingly on the exceptional mental institution of Dr Maurice Dide, which is named for once, at Braqueville [i.e. Nutsville], – the only place where, if he were certified, Londres would gladly be interned. Dide's governing idea is that the mentally ill should be left substantially in peace, never aggressed by staff, nor subjected to brutal, ignorant treatment. 'Dans la maison du docteur Dide la folie n'est pas considérée comme un crime' (*CF*, p.222). Mental hospitals are not gaols. For example, a religious 'maniac' should be left to his private ecstasies, for 'cela est son droit de fou' (ibid). Londres always stresses rights as well as wrongs. He agrees with the good doctor that, if we cannot cure the insane, we can at least respect their privacy and dignity in a humane environment. A patient digging in the garden suddenly moves to a wall, and begins tracing on it some invisible message. 'Il serait d'une religion lui ordonnant ces gestes, tout le monde trouverait cela édifiant: bouddhistes, musulmans, catholiques et, à Jérusalem, les juifs devant le mur des lamentations, en font bien davantage à l'heure de la prière!' (*CF*, p.224). Staff should profit from any lucid intervals to encourage patients to regain some more durable sanity (ibid). The success-rate is higher in Dide's establishment than in less enlightened ones. Dide himself is also a proactive experimenter, researching pickled brains kept in chamber-pots, apparently the ideal shape for this purpose (*CF*, pp.227–8).

Fairly, Londres mentions that budgets in asylums are desperately inadequate for decent feeding and proper treatment; there are not enough bath-tubs for soothing balneotherapy. Some patients, inevitably, are beyond recall to any kind of normality: a corpse-woman who has lain supine and motionless for three years (*CF*, pp.239–40). Some positively have to be locked up: homicidal maniacs, like the man who slaughtered his wife and baby at breast, because he thought the infant was eating the mother, even though that disaster houses its own delirious logic (*CF*, p.260). Or the fourteen-year-old boy murderer, who tranquilly declares: 'Il faut bien faire le mal', a grisly double meaning: I just have to do evil/I have to make a proper job of evil' (*CF*, p.261).

Londres shows respect even for paying patients, for whom he putably feels less sympathy: the posh lady, highly articulate, though other examples can have filthy tongues (*CF*, p.245): 'On peut être folle, on sait tenir son rang' (*CF*, p.240). Look at this elegant, shapely, though ultimately childish, diatribe:

J'offre une prime de trois cents vingt ducats à l'homme qui s'en ira là-bas, au cimetière, sur la tombe de feu Parqueret, mon époux, et pendant une nuit entière, alors que hululeront les chouettes lui fera, à la lumière d'une lanterne sourde, de terrifiantes grimaces au fond de sa juste tombe (*CF*, p.242).

Londres himself has a (not so) crazy vision, which picks up on Dr Dide's laissez-faire policy, of an island run by the mad. It functions like a reasonably lubricated social organism, though some ventures go awry. Visiting specialists conclude, fearfully, that the insular ones can be left safely to sort themselves out, without any official ministrations. Several times in *Chez les fous*, Londres makes a pungent joke about how easy it is to mistake patients for staff, or vice versa, culminating in the description of a roomful of psychiatrists that he takes for inmates (*CF*, p.285). Throughout, as in all his writings, Londres celebrates the sheer variousness of human beings, like the 'volunteer fiancée', devotedly in love with a doctor. He repeatedly rips up her love-letters to her face; she never gives up (*CF*, p.247). In the text as a whole, Londres presents illuminating scenes in institutions all over France, hardly ever identified, except for the excellent Dr Dide's place, or the open-house service at Sainte-Anne, instituted by the progressive Edouard Toulouse. It is a thematic rather than a chronological or spatial arrangement of material. Its alternating inclusion of good and bad practice is not governed by some lily-livered fear of being accused of bias, but from an authentic conviction that, to reverse the cliché from economics, good money should be used to drive out the bad.

Adroitly, he uses in fact an economic argument, in telling of the splendid commercial success of Philippe, whose skill at making decorated cushions induces big stores to place bulk orders. Philippe takes on (mad) employees, and the operation is so profitable that he ends up having to pay taxes (*CF*, pp.256–7). Philippe has not regained sanity. He has the delusion that Shackleton is still alive and plotting to arrest the progress of evolution on earth, via a large platinum antenna planted at the South Pole. The apocalyptic result will be that 'la terre ainsi immobilisée ne tournera plus et la moitié de ses habitants surpris alors la tête en bas seront précipités dans le gouffre du néant' (*CF*, p.258). So the mad can be capitalistically useful, while remaining mad. Londres is very aware that not only methods of treatment but also social attitudes towards the mentally sick play an important part in the total equation. A released patient has to ride the punch of a very hostile reception in his village from

neighbours scared of his potentialities (*CF*, p.273). Another is labelled as having a persecution mania because he claims his wife had him locked up so as to freely enjoy her lover. This is a fact, but it does the husband no favours (*CF*, p.277). As in his books on other prisons, Londres expresses heartfelt sympathy for those wrongfully interned: 'Un homme tombé au fond d'un puits donnera de la voix dès qu'il entendra le pas d'un passant' (*CF*, p.276). His mission is palpably to speak up for the gagged ones.

As for future developments, Londres acknowledges that the medical science of psychiatry is still in swaddling-clothes. He prophesies possible cures available by 2100, which effectively puts them off for good. 'Le fou est né trop tôt', he concludes, ironically (*CF*, p.275). What interests him more pressingly is his conviction that present asylums are used as detention centres: 'Une science qui tâtonne s'arroge des prérogatives qui ne devraient appartenir qu'à la justice' (*CF*, p.276). Given his immersion in the whole phenomenon, and possibly yielding to the commonplace that madness is catching, at times he sees it obsessively everywhere, on the streets as well as behind walls. When he tackles the issue of the allegedly caring profession, he concocts a composite figure, an allegory for Londres's time: 'M Psychiatre'. This hunter's catchment area he defines as 'la foire aux puces: on y trouve de vrais fous, d'anciens fous, de *futurs fous*. Il y a l'authentique, le probable, le douteux, le récalcitrant et la victime' (*CF*, p.281 author's italics). As Londres was often turfed out of offices when requesting permission to fulfil his investigative journalist's function, he retaliated by smuggling out inmates' letters. In reprisal, one such inmate was locked in, and forcibly injected so as to stupefy her (*CF*, p.284). 'M Psychiatre' is an arbitrary Fate: 'Cette dame est prisonnière. Aucun jury ne l'a condamnée. Seul M Psychiatre en a décidé ainsi' (ibid). He adds that the staff, in a sadistic refinement, take away inmates' lives without granting them death (*CF*, p.289).

In his final 'Réflexions', Londres goes through his criticisms and his recommendations, as he did in his prison-books. He complains that the mentally ill are treated as a dangerous surplus, like most kittens in a litter (ibid). The living conditions are: prehistoric buildings, and frequently ignorant and savage nursing. He emphasises that, until 1923, the study of mental illness was only optional in medical training. He adduces again and again the still operational law of 1838 ('En matière de loi, on n'en est pas à un siècle près chez nous' (*CF*, p.181). This law authorised families to have undesirable relatives locked away; the formalities were

fairly minimal. It was this law that put Jules Vallès, on his father's instructions, into an asylum for two months. The doctors finally decreed that Vallès had recovered, as miraculously as he was supposed to have succumbed. There is something obscene about medical practitioners prostituting their minds and responsibilities to the squalid work of family discipline. In the 1880s, Vallès visited Sainte-Anne asylum, where he felt both pity and horror at the spectacle of wretched, suffering inmates condemned to the production-line of the factory of madness.[24]

Londres's *envoi* is: 'Notre devoir n'est pas de nous débarrasser du fou, mais de débarrasser le fou de sa folie. Si nous commencions?' (*CF*, p.294). In an appendix, a suppressed chapter, using his old pseudonym, Couzy, (he had to attenuate some of his newspaper articles in the first edition of his book; these are now restored in Lacassin's edition) relates how he was passed from pillar to post through the whole gamut of official agencies (police, Ministry of Health, the president of the civil council, the President of the Republic), all of whom denied him the right to exercise his profession (*CF*, p.298). His strong sense of the public's and his own right to know the reality of asylums ran up against professional secrecy, classified information, and data-protection systems. It was the classic dilemma of any journalist, but he stuck to his guns. He adds a long taxonomy and nomenclature of the umpteen varieties of mental illness (*CF*, pp.303–5). Finally, as in the American feghoot (Spoonerism), he asks, implicitly, the question: 'Who shall be first to stone the cast' of the mad?

As with *Au Bagne* and *Dante n'avait rien vu*, there was an upshot. In the Archives lie scores of letters, stylish or semi-literate, from past or present internees, confirming Londres's findings, and voicing deep gratitude to him for the publicity he had brought to unjust treatment and wrongful imprisonment. Terms like dungeons, *lettres de cachet* and Bastille abound. A few assert that they found his newspaper articles contained too much levity. Most pester him with all sorts of grievances, and calls for help; some seem, in the worst sense, mere attention-seeking. One splendid letter offers meticulous calculations of exactly how much its sender's seven-year internment (unjustified, naturally) has cost the taxpayer. Londres no doubt and justifiably felt that he had done his job by

24 See Jules Vallès: *Le Tableau de Paris*. Paris: Editeurs Français Réunis, 1971, pp.58–75.

writing the newspaper articles, then the book, without getting caught up in individual sad cases. Especially as no mere loco would capture the public's imagination as the adventurer Dieudonné had.

Some of the opinions he expresses in *Chez les fous* might well sound callous to our sensitised but in some ways debilitated sensibilities, but, well before anti-psychiatrists like Laing, Londres was arguing that 'les asiles font les fous […] Ils en ont fait d'abord quelques-uns parmi les aliénistes' (*CF*, p.279). Most asylums, he discovered, are jails or refuse tips for the detritus of society, with straitjackets instead of leg-irons, and in which the cosiness of the staff is bought at the cost of driving the mad further to distraction. He found only one clinic in the whole of France practising imaginative, humane and occasionally successful treatment. Though he makes little mention of the use of drugs to counter mental illnesses, such aids were probably less utilised in his day than in our pharmacopious age.

The obvious link between *Chez les fous*, *Au Bagne* and *Dante n'avait rien vu* is that all three penetrate into and bring into public view systems of internment which yank individuals judged dangerous out of 'normal' society and public view, and dump them in a special, 'safe' place. Londres had a much harder time breaking into the closed space of asylums, however, than into civil or military prisons. *Chez les fous* is another of his books devoted to contemporary France, like *Les Forçats de la route* and *Marseilles, porte du Sud*. Most of his writings took him outside the home hexagon.

Chapter 5
Way out East, and South

Japan

This chapter, and the next, will cover differing aspects of exploitation and oppression. There is probably little to choose between the two. Both damage and exclude people who deserve neither. Chapter 4 studied various forms of oppression. Exploitation adds profiteering to the many crimes of incarcerated oppression. Nobody profits, in an economic or real-life sense, from oppression, except the selfishly powerful who want the bad and the mad – and those falsely accused of being either – safely segregated. But colonialism, like the pearl-fishing industry or prostitution (see Chapter 6) are all profit-centred.

Inconveniently, neither oppression nor exploitation, except in its possibly neutral sense of development, are to the forefront in the first overseas area I want to examine: Japan. They do figure in the coverage of the feudally sexist attitudes to women there, who are put on a pedestal but kept firmly in their place; and in that of the 'defensive' but still oppressive foreign wars waged by Japan on its neighbours.

Londres spent December 1921 and the first quarter of 1922 in this, to him and to many, alien land, as part of a six-months' tour of the Far East, on behalf of *Excelsior*. This tour also took in China, Indo-China and India. His first reports from Japan show a sustained image of Japan jumping all guns in its drive to catch up with the West, and to forge onwards: a nation in full dynamic expansion. The image is that of an Olympic runner surging ahead of the field: 'Il brûle les étapes. Ignorant les routes, il construit des chemins de fer. Les villages connaissent l'électricité sans passer par l'huile et le pétrole' (*CR*, p.590). In this collective onward rush, (and here Londres surrenders to the lazy foreigner's dismissive 'They all look alike'), 'après avoir croisé deux mille Japonais, vous êtes persuadé que vous avez toujours rencontré le même!' (*CR*, p.591). This assumption handily authorises large generalisations about all things

Japanese, so that if you see something once, you then think or make out that you see it everywhere. While admitting that 'dans tout ce pays, pas un homme qui fasse de l'effet [stands out]; la même matrice semble les avoir frappés tous', he suggests that these apparent clones, not without some vanity, do distinguish themselves from each other internally: 'Si chez eux il y a de la pose – et il y en a – elle est en dedans. Pour la découvrir, il faudrait les radiographier' (*CR*, p.591). But then, in a nice slippage from physical to figurative on the word *ressort*, he adds: 'On jurerait de petits hommes magnétiques. Mais quel ressort!' (ibid.).

Londres visited Tokyo, Kyoto and Osaka, the industrial heartland, where Germany, the USA and Britain, unlike France, had secured a foothold. Even when giving in to stereotypes, he remains conscious of these readymades, and he declares that the Western cliché of the fatalistic Oriental is out of place in Japan: 'Avez-vous compris que le Japon déborde quelquefois du cadre de l'estampe?' (*CR*, p.595). In Osaka, 'les Japonais ont changé le cours de leur instinct. Ils bousculent' (*CR*, p.594). Even though the Japanese as a whole people are profoundly ignorant of the wider world, their press is hooked up to everywhere abroad. A rare much-travelled Japanese, who admits to becoming Europeanised when in the West, claims to rebecome totally Japanese on returning home: 'D'un seul bain, le foyer nous décape': the hearth sandblasts us (*CR*, p.597). Home and family are sanctuary, but men can escape that comfortable custody by visiting geishas in a tea-house, the 'second home'. The first home is rarely penetrated, even by close friends (ibid). Londres treats us to a very sensitive, only lightly amused, account of a geisha ceremony (*CR*, p.600). Later, he slips in a more overtly comical description of eating a meal of raw fish, while seated excruciatingly on the floor (*CR*, p.618). While he does recognise that the position of women, whether professional or domestic, is that of adjuncts/servants, he maintains that they are perfectly happy (*CR*, p.597). This is wishful thinking, or reflects his own adoring attitudes to women, or merely records male Japanese self-serving prejudices – or all three.

Despite his partly sincere pose as a 'brute d'étranger' (*CR*, p.606), and his frank and standard refrain that Tokyo is an impenetrable maze with no landmarks, he recognises that it has a secret code he cannot crack. He settles for the plainly visible. Though the 'Mikado' [august door], for his exalted part, is still kept from the sight of ordinary mortals, the regent, Prince Hirohito, parades in an open carriage, saluting his

subjects (*CR*, p.608). Equally on show is the recently appointed French Ambassador, poet and dramatist, the ample Paul Claudel: in full diplomatic togs and a fine carriage escorted by troops of lancers (*CR*, p.610). The poet in Londres is impressed. He explains how a passion for Claudel's work has erupted in Japan: translations and productions of his plays have proliferated. The Japanese certainly know how to worship. Although France enjoyed few trade links with Japan, it did have cultural sway. Claudel projected a Maison de France, where French scholars could come to acquaint themselves with Japanese culture.[1] Japan, a distant ally of the Allies in the Great War, felt it had been outsmarted at the postwar Washington conference. Londres appears to accept that, as a result of such sidelining, Japan was justified in its territorial ambitions in Korea, Manchuria and China, and that its attacks on these countries were principally defensive. He reproduces Claudel's statement, along the same surprising lines, which Claudel gave him for publication in *Excelsior* (*CR*, pp.614–16). Londres dined several times at the embassy and, when he ran out of ready money, Claudel arranged for his articles to be translated and published in a Japanese newspaper at a good rate of pay.[2]

Londres used an interpreter for access to Japanese press reports, and his general informant was the old Japan hand, Charles Laurent. Despite his lack of foreign languages, Londres always takes an interest in their key terms, here: *guiri*:

> Le *guiri* est un sentiment multiple, allant à peu près de la reconnaissance à la vendetta dont vous seriez à la fois le poignard qui frappe et le coeur qu'on transperce. C'est une espèce de morale de l'horreur, effarouchante pour l'Occident. Elle nous paraît tragiquement pittoresque: pour eux, elle n'est que toute simple (*CR*, p.609).

This effort at careful understanding goes some way towards clarifying the alien medley of lethal behaviour towards others and towards oneself in the samurai tradition.

1 Claudel thought of having the leading Indianist, Sylvain Lévy, as director. Londres met Lévy later in India, at Tagore's 'university'/think-tank. Claudel also thought of inviting Bergson and Darius Milhaud. The Maison de France opened in December 1923.

2 Andrée Viollis: 'Albert Londres, prince des reporters'. *Les Nouvelles littéraires*, 5 September 1925, p.1. (Also in Londres: *Le Juif errant est arrivé*, p.277).

Londres's overall response to Japan is that it is very different from Europe, but that its difference sustains it and should be respected. Hence his apparent acquiescence in its expansionist wars. Japan, opening up to the rest of the world since the nineteenth century, takes what it needs from 'Atchira' [over there, abroad], and juxtaposes this with what it already has and already is; there is no real fusion (*CR*, p.587). He does not get round to suggesting that this shotgun marriage between foreign and homegrown breeds deeply neurotic strain. Of course, the recognition of difference as a positive value does not guarantee a refusal of prejudice. The Other can be, and has profusely been, homogenised, even or especially by its champions.

There was a dramatic sequel to Londres's visit to Japan. In Port Said on 20 October 1923 for purposes I have been unable to establish, Londres re-met Captain Cousin of the *André-Lebon*, whom he had known on his long voyage out to Japan nearly two years previously. This ship was moored in Yokohama in September 1923 when an earthquake started. Londres's account of this disaster is entirely secondhand, though he had a minor run-in with earth-tremors when in Japan: his sole security-measure or worry blanket was to put his natty trilby on.[3] He did not witness the full earthquake and the massive fire which destroyed much of the city. Hundreds of refugees clambered aboard the heaving ship, which was tossed about like a toy (*CR*, p.693). At home in apocalypses, Claudel arrived in Yokohama next morning, having walked part of the 36 kilometres from Tokyo in order to find his daughter. Experiencing the catastrophe, then, vicariously, Londres is advised to interview a cabin-stewardess: 'Vous qui auriez voulu voir la catastrophe, vous n'avez qu'à la contempler. Elle a encore l'horreur dans ses deux yeux' (*CR*, p.697). Londres sums up: '*L'André-Lebon* s'est trouvé dans la situation d'un paralytique au centre d'un immeuble en feu' (*CR*, p.699). The whole terrifying episode is of course a prefiguration of Londres's death on a burning ship, on the way back from a later trip to the Orient.

3 Letter to parents of 22 December 1921. In Archives.

Indochina and Colonialism (June–August 1922)

After Japan, after China (to be treated in Chapter 7), Londres sailed to Indo-China: Hue, Hanoi, Haiphong, Pnom-Penh, Saigon and Dalat. Coming from China, Londres passes from a world he finds manic *(La Chine en folie)* into a dopey society. Lethargy assailed even this habitually bustling investigator; the ponderous humidity gets him down: 'Vous êtes-vous revêtus d'une chape de plomb, qui vous prend au-dessous du menton, vous moule les épaules, épouse vos flancs et fait tablier traînant par-devant et derrière?' (*CR*, p.621). Despite this suffocating handicap, he has to try to correct his partly inherited clichés about an uncivilised country, as with Japan. His pose, this time round, is that of the dunce but one trying to do better. Such personae are part of Londres's rhetorical arsenal. He is less alert to the commonly paternalist tone of much French colonial discourse, decking itself as fraternalism: 'Des conquérants? Non! Nous ne sommes que de grands frères [...] Nous avons élevé la ville, eux l'animent' (*CR*, p.623). He seems gratified by the very visible French influence on the streets and parks of Hanoi.

In a succession of interviews, he talks first with (or rather listens to) Kai-Dhin, Emperor of Annam (central part of Vietnam), who expounds noble-sounding puffery about his country's immense debt to France (*CR*, p.620). Conferring with representatives of the 'Jeune Annam' movement, Londres delivers his own interpretation of the colonial situation, for he is ever ready to plug his own message and not just to be a passive receiver, when abroad: if France abandoned Annam, it would collapse, as its people were not yet up to efficient self-government (*CR*, p.629). Their response is to argue that France's self-proclaimed educative mission and grand theories of liberty and equality have awakened a dormant people, which cannot be simply put back to sleep (*CR*, p.630). A servant, fanning them all, and asked by Londres what he thinks of all this, replies: 'Moi [...] pense pas encore' – a well-judged, pointed joke, in slightly substandard French, for the Jeune Annam are perhaps thinking ahead of themselves, in Londres's view, thinking too soon, with very little popular support (*CR*, p.631).

Londres finds Cambodia very different from Annam: a darker-skinned race, very averse to work. Again, Londres conveys his rapid opinion with good-natured humour, which can of course be a way of not

taking people or places seriously enough: 'De même que jamais, jamais, jamais, le tigre n'aura de trompe, le cocotier de branches et Carmen de coeur, jamais le Cambodgien n'aura l'idée de travailler' (*CR*, p.631). In Cambodia he interviews the highly impressive King Sisowath, 83 years old, and holding his own in a court where the young princes speak Parisian slang (corrected, of course, by the French Resident). While palpably charmed by what he briefly sees of the court, Londres remains conscious of the undercurrents: an arrogant grandson wilfully offending the king, ageing but still capable of violence (*CR*, pp. 633, 646–7).

Saigon is 'la sur-colonie de la colonie' (*CR*, p. 635). It is, for Londres, essentially bourgeoisified, 'la colonie en bigoudis' (ibid). All sense of adventure, of risk-taking by the colonists has vanished: 'La colonie, comme nos rêves l'inventaient voilà vingt ans aujourd'hui, est décédée [...] La sublime fantaisie est envolée' (ibid.). A reader inevitably wonders with what previous golden age Londres is comparing the sorry present state. Old-style colonists, 'vous veniez à la colonie pour la faire vivre', whereas presentday successors 'y viennent pour y vivre. Après le feu sacré, le pot-au-feu' (ibid.). That wordplay on *feu* (passion/cooking fire), or elsewhere on *raid* (mission)/*raide* (missions used to be tough and challenging) point up the contrast of a mythical then and an only too prosaic now. Expatriates took particular exception to the mention of hair-curlers *(bigoudis)*, and no doubt to Londres's whole, very literary, premiss of a one-time exciting colonial venture. Londres attempts to generalise his very individualistic approach by distributing, like a born novelist, his own idiosyncratic ideas and language around various people encountered on his travels. He no doubt thought that such a tactic would make his opinions more difficult to contradict. As Napoleon is said to have said, in a different context: 'Les crimes collectifs n'engagent personne'.[4] If locals claimed that they never said that, he could respond that they could have, or that several others did.

On the hill-station, the oasis, of Dalat, Londres lets himself wax lyrical: 'Dalat est la goutte d'eau sur la langue suppliante du pécheur mort sans confession, et qui en serait à sa cent unième année de soif ardente' (*CR*, p.637). Unlike the British at Simla in India, the French have not developed Dalat properly; it remains 'une future station' (*CR*,

4 Napoleon: *Maximes et pensées*, no. 13.

p.639). In those hills, almost needless to say, Londres's account of the Moïs tribe differs greatly from André Malraux's later fictional exploitation of them in *La Voie Royale* (1930). Londres's tribesmen, in a recycling of the idiom 'pas méchant pour un sou', are 'pas méchant pour une sapèque trouée' (*CR*, p.638): a *sapèque* is an old Indo-Chinese coin.

While in the Dalat hill-area, Londres arranged to take part in a tiger-hunt. First, he notes that, 'aux Indes aujourd'hui, les tigres sont numérotés. Leurs extraits de naissance et empreintes digitales sont dans la bibliothèque de chaque maharadjah' (*CR*, p.639). He himself thinks he is hungry to slaughter one of these magnificent beasts, presented here as delinquent and therefore, presumably, fair game for sanctions, however terminal. In his report, there is none of the self-disgust or bitter social commentary (anti-imperialist, but also anti-native) of George Orwell's famous text 'Shooting an Elephant', nor any political correctness. The hunt itself is narrated breathlessly, and features Londres acting, as he must, the utter novice. It is the expert Fernand Millet who in fact kills the tiger while it is tearing at the bait, a dead and putrefying buffalo. Meanwhile Londres gazes transfixed at the tiger, and never fires a shot (*CR*, pp.644–5).

Londres was writing eight years before the brutal repression by the French of the 1930 Yan Bay uprising, the other side of the medal to its 'mission civilisatrice'. The refrain of Nicola Cooper's book, *France in Indochina*, is that France's equivalent of the British 'Jewel in the Crown' attached to India was Indo-China, 'la perle de l'Extrême-Orient'.[5] Londres was by no means alone in celebrating a heroic age, a glorious past in which the subject people gladly accepted its domination by France, for the sake of the good works, moral and material, carried out by the coloniser. Such a myth may well not have derived in his case from self-censorship, the fear of a bad effect on readership or the authorities, but rather from a sincerely held belief in the value of good colonialism, a concept unimaginable to postcolonialists. Other reporters, eight to thirteen years later, said much the same as Londres: Louis Roubaud, or Andrée Viollis, who wrote: 'Je ne veux pas discuter ici le principe de la

5 Nicola Cooper: *France in Indochina: Colonial Encounters*. Oxford: Berg, 2001, *passim*.

colonisation. Il est ce qu'il est'.[6] This truism seeks to silence unwelcome demurrals. It is hardly necessary to highlight the patronising nature of such attitudes. Roubaud and Viollis, too, criticise the deleterious effect of the advent of large numbers of dependants, and contrast such domesticity with a masculine, pioneering epoch. As Cooper comments,

> like many of his period, Malraux, in his articles for *L'Indochine* (1925 onwards), despite his criticisms of the colonial government, believed it would be wrong to deprive the indigenous populationa of Indochina of their chance to acquire the identity within the supranational polity whose centre was France.[7]

During the interwar years, very few groups or individuals in France expressed the desire to see the colonial system entirely overthrown. The only coherent and uncompromising critique of colonialism in that period came from the French Communist Party and certain individuals among the Surrealists. Even so, the Communists' line was an offshoot of their policies in the West, and not specific to colonies. A few Surrealists mounted a counter-exhibition to distract from the massive official Exposition Coloniale at Vincennes in 1931, but it drew paltry attendances compared with the eight million pulled into the government extravaganza. The French Catholic Church had never made a serious indictment of colonial exploitation. How could it when its own goal (in more senses than one) of worldwide evangelisation ran in the same direction?

In our self-professedly more enlightened age, Edward Said has long since become an impassioned if not universally uncontested challenger of the practice and theory of colonialism, or to use his own favoured term Orientalism:

> A representation is *eo ipso* implicated, intertwined, embedded, interwoven with a great many other things besides the 'truth', which is itself a representation. What this must lead us to methodologically is to view representation (or misrepresentation – the distinction is at best a matter of degree) as inhabiting a common field of play defined for them, not by some inherent subject matter alone, but by some common history, tradition, universe of discourse.[8]

6 Andrée Viollis: *Indochine SOS*. Preface by André Malraux. Paris: Gallimard, 1935, p.23; and Louis Roubaud: *Viet-Nam, la tragédie indochinoise.* Paris: Valois, 1931.

7 Cooper: *France in Indochina*, p.92.

8 Edward Said: *Orientalism.* Harmondsworth: Penguin, 1985 [1975], pp. 271–2.

Orientalism is a falsifying way of thinking and talking that he finds guilty of the most lethal kind of cliché. Roland Barthes's more sexy version of this critique runs as follows:

> L'exotisme révèle bien sa justification profonde, qui est de nier toute situation de l'Histoire [...] Face à l'étranger, l'Ordre ne connaît que deux conduites qui sont toutes deux de mutilation: on le reconnaîtra comme guignol ou le désamorcera comme pur reflet de l'Occident.[9]

Thus does Barthes picture the castration of the full-blooded Other.

To what extent was Londres guilty of 'Orientalism', of exoticising the lands east of Suez? He always recognises the otherness of the Other, whether Japanese, Chinese, Indo-Chinese, or as we will later see Indian, African or Arab. He might strongly disrelish much of what he observes in indigenous populations, but he never denies them the right to otherness, the right to be themselves and not just distorted replicas of Westerners. Although he supports colonialism, properly conducted, as a practice, he sees it principally as a means to material improvements in the local infrastructure, rather than as a cultural take-over or make-over of the East or South by the West. While his frequent emphasis on mazes and mysteries, or his inclusion of non-event interviews, might seem to shoot himself in the foot as an explicator – why go all that way only to plead non-understanding as an outcome? – they simply reflect his candour. At the same time, they act as correctives to the folks back home, of whatever educational level, or to Western officials on the colonial spot, not to yield to stereotype, to hasty generalisations, to which he himself is aware of not being immune. Though in Arabia he dressed as one, Londres never claimed to go native. His travelling luggage was light, but his cultural baggage was as heavy as the next man's or woman's. He often uses a kind of shorthand, and not just for note-taking. Altogether, it was really much too early for Londres to hold advanced views on the inherent evils of colonialism. It is probably fair to conclude that he, like many others, believed in the civilising duty of a country such as France. His regret was that this mission was so rarely carried out civilly.

9 Roland Barthes: *Mythologies*. Paris: Seuil, 1957, p.165.

India (October/November 1922)

In 1887–9, Rudyard Kipling, one of Londres's chosen few, had travelled in India, China, Japan and America, from all of which he sent back reports to his newspaper, the Lahore *Civil and Military Gazette.* Londres did not share his passion for India, which appeared to him from the outset to be a police-state in which he was under constant surveillance: 'La police, dans l'Inde, n'est pas une institution: c'est une araignée, vous sentez continuellement ses fils sur votre visage et sur vos mains' (*CR*, p.647). Everywhere, he is 'suivi de mes invisibles et reconnaissables policiers' (*CR*, p.654). At this distance in time and space, it is impossible to say how much neuroticism or likelihood is contained in this refrain. Antagonised, then, Londres vents his amazement that the much publicised rebellion tranquilly fanned by Gandhi, with its two watchwords: non-cooperation and civil disobedience, does not seem to have filtered down to the Indian masses, who are in his view mostly intent on not upsetting the British overlord. He provides factual accounts of that peaceful uprising, and, at the other extreme, of the massacre of many Indians by General Dyer at Amritsar (*CR*, pp.649–51). He singles out Gandhi's attack on the caste system which served British interests so well ('Divide and rule'). With his guide and informant Samul, Londres takes a night stroll through the 'cemetery' (the dormitory pavements) of Calcutta: 'Il pense à tout, Samul, il sait tout, explique tout' (*CR*, p.655). which of course saves Londres a great deal of effort. He has, however, the grace to call himself 'l'étranger, que je ne cesse d'être' (*CR*, p.660).

Expectably, he is astonished by the garish crowdedness of urban India, the masses all chanting the same slogans when they greet Nehru, the unrelenting din, the shrieking colours (*CR*, pp.656–7). Ever observant of grass-roots things such as shop-prices, he pays particular attention to (as he spells it) 'pikketing', and its use of non-violent disobedience, hitting foreign goods where it hurts most, at the point of sale. He is most at ease interviewing the Nobel prizewinner, Rabindranath Tagore, who was attempting to form an intellectual élite at his countryside 'university' in Bengal. There Londres met the French Indianist Sylvain Lévy of the Collège de France, whom Claudel wanted to attract to Japan, as well as Andrews, a highly influential go-between for the Hindus and the English. Londres notes Tagore's rude hostility to

Gandhi, whom he feminises: 'Une cartomancienne vaticinante […] Au lieu de faire appel au génie actif de l'Inde, il s'allia à la magie' (*CR*, p.661). Gandhi's great crime, for Tagore, was to deal far too much in symbols, which were then taken literally by the ignorant majority (*CR*, p.662).

Although Londres's dislike of the English was nowhere near so visceral as that of his old friend Henri Béraud, who lumped Albion in with the Judeo-Bolshevik conspiracy, it seems fair to say with Assouline that 'colonialiste comme la majorité des Français de son temps, il ferait volontiers souffler le vent de la décolonisation sur [l'Inde], à titre exceptionnel'.[10] What appals Londres especially in India is English attitudes towards Indians: 'On dirait que, pour l'Anglais, d'abord il y a l'Anglais, ensuite le cheval, ensuite le Blanc en général, ensuite les poux, les puces et les moustiques et enfin le *native* ou indigène' (*CR*, p.662). He makes no apology for this *reductio ad absurdum*. The status of France as an ally of Britain changes nothing, and denying oneself criticism would entail keeping totally silent about India (*CR*, pp.662–3). It is the insulated insularity of this island race in their Raj that most angers this gregarious Frenchman: 'On dirait que, pour prévenir toute escalade, [l'Anglais] a entouré son âme et son corps de tessons de bouteilles. On peut également l'imaginer s'avançant entouré de paravents' (*CR*, p.663). The Englishman in India is a closed space. At the same time, Londres cannot but acknowledge the material improvements engineered by the British: ports, railways and so on. Admittedly, such advances have been manned by Indian labour, but would any of them have happened without British input and impetus? (ibid.). He could hardly say anything more damning than when he accuses the British, like the Indians themselves, of lacking a sense of humour (*CR*, p.664).

Moving on to the French enclave of Pondichery, he finds that, unlike the British, the French colonial powers have done very little in material terms for the inhabitants. It is a backwater, like Vietnam, and yet the French intruders are popular, whereas the British in India are universally hated (*CR*, p.670). Nevertheless, this French corner of India

10 Assouline: *Albert Londres*, p.272. Béraud published a pamphlet: *Faut-il réduire l'Angleterre en esclavage?* Paris: Editions de France, 1935. His detestation of the English dated from his coverage of the crisis in Ireland in the 1920s, a period, place and subject not tackled by Londres.

is in a time-warp. In conclusion, in both British and French India, Londres deems the Indians capable of passionate nationalism, but not of revolution (*CR*, p.671). When he meets some activists, comparable to the Jeune Annam group in Indo-China, they appear to him to have no concrete ideas for overthrowing or replacing the Raj.

How much importing of Eurocentric prejudices does Londres perpetrate in his texts on the east? At least, he does not demonise alien structures and practices. If travel has not in a major way broadened his mind, neither has it narrowed it. He does not escape the mind-sets of his age, though he offers reasons why these should become more supple.

Africa

In snooker (and racist) terms, Londres could be said, in going to Africa from the Orient, to move from yellow and brown to black. He spent four months in Black Africa, accompanied by his sketcher, Georges Rouquayrol. The tour produced 26 articles for *Le Petit Parisien* in October/November 1928, and the book *Terre d'ébène* in 1929.[11] Londres visited the following countries in French West Africa and French Equatorial Africa (the former ceased to exist as such in 1958, and the latter in 1959): Senegal, Guinea (now Guinea-Bissau), Sudan, Upper Volta, Ivory Coast, Togo, Dahomey (now Benin), Gabon, and Congo/ Zaïre. This whole huge area of Africa was formerly the central supply-centre for the slave-trade.

Londres introduces his account with a proud recapitulation of its hostile reception by critics, readers and officialdom:

> Voici donc un livre qui est une mauvaise action [...] On me l'a dit. Même on me l'a redit. On m'également appris [...] que j'étais un métis, un juif, un menteur, un saltimbanque, un bonhomme pas plus haut qu'une pomme, une canaille, un contempteur de l'oeuvre française, un grippe-sous, un ramasseur de mégots, un

11 I quote from *Terre d'ébène* in the 10/18 edition by Francis Lacassin, published together with *Le Chemin de Buenos Aires*, the whole retitled by him *La Traite des Blanches, La Traite des Noirs*. I use the abbreviation *TN* for the African book and *TB* for the South American one.

petit persifleur, un voyou, un douteux agent d'affaires, un dingo, un ingrat, un vil feuilletoniste (*TN*, p.217).

All lists risk becoming risible simply by being prolonged, and this one is blatantly comic, though with serious underpinnings. This is Londres's tactic here for softening up the reader before the provocative text even starts on its odyssey. In order to counter the charges, Londres lays out his journalistic credo:

> Je demeure convaincu qu'un journaliste n'est pas un enfant de chœur et que son rôle ne consiste pas à précéder les processions, la main plongée dans une corbeille de pétales de roses. Notre métier n'est pas de faire plaisir, non plus de faire tort, il est de porter la plume dans la plaie (*TN*, p.219).[12]

He defines his stance, his objections to abusive colonialism, which grow much more pointed in this book compared with his Far-Eastern reportages, in these terms: 'Ce n'est pas les hommes que je dénonce, mais la méthode' (ibid). We could add 'or the absence of method', particularly as he goes on to say: 'Nous travaillons dans un tunnel. Ni argent, ni plan général, ni idée claire. Nous faisons de la civilisation à tâtons' (*TN*, pp.219–20). In other words: the colonising French stumble about the Dark Continent semi-blindly for want of better enlightenment.

At Dakar in Senegal, Londres picks up on his writings on Indo-China, and the perils of comfortableness, with the same punch-line:

> Qui dit fonctionnaire colonial ne veut plus dire esprit aventureux. La carrière s'est dangereusement embourgeoisée. Finis les enthousiasmes du début, la colonisation romantique, les risques recherchés [...] On s'embarque maintenant avec sa femme, ses enfants et sa belle-mère. C'est la colonie en bigoudis! (*TN*, p.224).

When he sees the fading memorials to French expeditionary forces of the heroic epoch (1880–1900), he comfortably omits the fact that such dashing columns massacred the natives freely (*TN*, pp.262, 266). He shows more compassion when he selects the ubiquitous baobab tree to act an an overarching symbol for a whole suffering continent:

> Le baobab est un géant désespéré. Il est manchot et tordu. Il tend ses moignons face au soleil, comme pour en appeler au Créateur de la méchanceté des bourreaux qui

12 Cf. 'porter le fer dans la plaie', Londres's most widely quoted maxim, discussed in the Preview of this book.

l'ont crucifié. On sent qu'il pousserait des cris déchirants s'il avait la parole et qu'il ferait des gestes de détresse si la nature lui avait donné du mouvement (*TN*, p.230).

This is anthropomorphism kept on a tight leash. This tortured country, though, forces itself on the visitor via its insistent, overpowering smells, particularly of shea-butter. As Londres reminds us, however, this product is also a component of European women's beauty products.[13]

Londres does not confine himself to the victim status of Africans; he wants to present them in their own right: for instance, their ability to walk vast distances, albeit seemingly on often paltry errands. Perhaps it was the example of his pedlar grandfather that elicits some sympathy for these people: 'Six jours de marche pour venir, six pour retourner. On écrira après cela que les nègres sont paresseux!' (*TN*, p.277). Refusing prurient Western obsession with bare-breasted black women (the title of the American translation is *A Very Naked People*), Londres stresses that both female and male nudity possesses 'infiniment de pudeur' (*TN*, p.236). On their beliefs and superstitions (*TN*, pp.323–4), he cannot help finding them primitive, especially in their awe of medicine men and the practice of cannibalism, for which he reports evidence (*TN*, pp.369–70). Dahomey, on the other hand, receives the accolade of being more civilised than other parts of Africa that Londres has seen, though even there the irrational rules. The uprooted Prince Ouanilo, born there but living mainly in Bordeaux where he practised law, felt very ill-at-ease on return to his native country. He died on the boat back to France, convinced that sorcerers had put the hex on him (*TN*, pp.382–9). A white in his motherland, a black in France, this royal personage floats in the limbo world that he unknowingly shares with plebeian, racially mixed children. Londres finds an apt childlike image for these buffeted youngsters:

Ils sont comme ces bateaux-jouets qui voguent dans les bassins municipaux. Dès qu'ils approchent du bord, un bâton les repousse; quand ils gagnent le centre, un jet d'eau les inonde. Il en coule des quantités [...] L'école en fait moralement des Français, la loi les maintient au rang de l'indigène (*TN*, pp.269, 271).

Londres's weightiest indictment of the colonial system centres on modern forms of servitude in this traditional seed-bed of slavery: the

13 Compare the telling contrast of adorned ladies' throats and ruined divers' lungs in *Pêcheurs de perles*, in the next chapter; or the use of kohl both for eye make-up in the West and for simulating asphyxiation in Cayenne in *Au Bagne*.

roadworkers who, for want of any mechanical aids, even a wheelbarrow, are compelled to carry everything on their shoulders or heads (*TN*, p.256). He underlines the heavy cost in human lives exacted by the building of roads and railways through murderous terrain. 'On n'a dépensé que du nègre', he explains, sardonically (*TN*, p.312). Despite the large revenue from taxes paid by natives, the authorities' reserves pile up to millions, which are not invested, as they should be (*TN*, pp.312–13). The 'free' workers are as much slaves as the roadbuilding convicts of Cayenne. A historian, Gilles Sautter, even though criticising Londres's occasional overstatements, and indicating the changes in policy already in effect while Londres was publishing his despatches, finds Londres's account substantially irrefutable. Indeed, like Londres, Sautter finds the tragedy shot through with bitter farce.[14] Londres provides statistics on the large numbers of dragooned men who take flight to neighbouring, less savagely repressive countries, but who even there are pursued and punished by their bosses (*TN*, pp.404–5). The death-rate, on the tracks or elsewhere, was very high. The scandalous practice of *portage* also caused mass exodus to other lands, and equally high mortality. Londres quotes an official report on death-rates which speaks of 'la fragilité inconcevable des indigènes' (*TN*, p.315). This is homicidal litotes and, as in the Great War, language dressed to kill.

In the section on the woodcutting industry, Londres describes graphically the physical endurance involved:

> Dans l'effort, les hommes-chevaux sont tout en muscles. Ils tirent, tête baissée. Une dégelée de coups de manigolo tombe sur leur dos tendu. Les lianes cinglent leur visage. Le sang de leurs pieds marque leur passage (*TN*, p.352).

He records their work-chants, and their sole audible retaliation: to insult the overseer's mother (Cf. American blacks' 'dozens') (*TN*, pp. 352–3). A white foreman seeks to justify what he deems his measured discipline: 'Je suis celui qui fait le moins de morts dans la région' (*TN*, pp.354–5). Londres remains non-judgmental, though the facts speak for themselves: apart from the cruelty to men, the short-term cutting-down of precious trees such as mahogany, through ecological ignorance: 'Les chasseurs d'acajou esquintent la nature et le nègre' (*TN*, p.359). Londres seems to

14 Gilles Sautter: 'Notes sur la construction du chemin de fer Congo-Océan (1921–1934)'. *Cahiers d'études africaines*, 7, 1967, pp.267, 294.

entertain no hopes of any effective system of justice. In the bush, he finds only a parody of it: a French official faces a production-line of patient, uncomplaining plaintiffs, nearly all sent away with an outsize flea in their ear (*TN*, pp.276–7). Londres castigates the official myopia, the missed opportunities for a development profitable to all: 'Sinon par amour du prochain, du moins par égoïsme, nous devrions veiller [sur l'indigène] comme sur un champ de blé' (*TN*, p.314). For once, Londres misjudges his simile: wheat is harvested, and consumed, each year.

As for blacks' treatment of fellow blacks, while Londres recognises the general laws of hospitality: 'Pas de pauvres chez les noirs. Ils pratiquent le vrai communisme. L'homme qui refuserait le couscous serait déshonoré' (*TN*, p.238), elsewhere he notes the endless litigation and petitioning over small areas of property, and the abuse of power by any black placed in a position of authority; they are as harsh as any white man (*TN*, p.246). There is even a homegrown slave-system: 'Ce sont les nègres des nègres' (*TN*, p.257). France has attempted futilely in the Sudan to establish villages of freemen (*TN*, p.258). Inter-tribal antagonism ensures that porters from different areas treat each other brutally (*TN*, p.417). Women are chattels, beasts of burden or traction; their only freedom lies in complaining vociferously (*TN*, pp.322–3). Rather facilely, Londres grants himself the luxury of indignation at the disfigurement, to his European eyes, of women's faces by the insertion of plates into lips: 'Changer leurs femmes en canards!' (*TN*, p.234). All that disgusts him is summed up in his impotent curse: 'Putain d'Afrique!' (*TN*, p.417).

What of Londres's own 'sufferings' on this tour? He has to put up with bats infesting mud huts, and hyenas howling outside all night long. On the other side, his paraphernalia includes a rough sedan chair for him to travel in some style and comfort; he has 27 carriers, 'mes esclaves' (*TN*, pp.407, 412). Nevertheless, he bestirs himself to intervene in order to get injured men sent to hospital, such as it is (*TN*, p.414). Lacking any local language or a lingua franca, 'je fais appel à mon langage international': mime (*TN*, p.350). He gets on well with his 'boy', Birama, whom he took on in that African labour-exchange, prison (*TN*, p.366). Unashamedly, Londres dwells on Birama's prototypical features: 'Sa face semblait résumer si bien toutes les races de noirs qu'à la fin je l'appelai le Nègre-Réuni' (ibid.). Londres, however, individualises him via his quirks. Birama refuses to buy soap with the money his employer gives him for that purpose, because it will just fritter away in the water,

whereas the splendid and unnecessary topee that Birama purchases will last and last. This is unarguable, if somewhat daft, logic (*TN*, p.367).

Londres does not forget to give a (limited) voice to the oppressors. The white foreman of the lumberjacks sounds both fatalist and enterprising; and, after all, his existence in the life-threatening forest is no bed of roses: 'De deux choses l'une: ou la forêt vous enrichit ou elle vous tue. Pile ou face. A la forêt de décider' (*TN*, p.356). The bush has conceivably decided the mysterious joint suicide of a white official and his wife. The sole motive offered is 'l'appel de la plus amère des terres' (*TN*, p.341). A venture-capitalist makes a speech, on behalf of eighteen others. He is fearful of the way things are going (e.g. the enfranchisement of the blacks), and resentful of the lack of vigorous official support for private enterprise (*TN*, p.337). From his angle, and rejuvenating the cliché 'political football', Londres pictures the colonial set-up as a match between two white teams, administrators and businessmen, with the native as the ball (*TN*, p.333). As for the capitalists back home, they under-invest: 'La France est riche […] Les capitaux se défient des affaires coloniales' (*TN*, p.346).

Two individual whites are singled out for laudatory treatment. The first, a perfectly decent, self-made man, Tartass the peripatetic barber, who trumpets ingenuously his trade as the very essence of civilisation, and who therefore feels qualified to stand for parliament (*TN*, pp.248–54). Much less comically distinctive is the second, Dupuis, now called Yacouba, an ex-Carmelite missionary. He has settled comfortably in the caravanserai-town of Timbuctoo, centre of the salt-trade, with his woman and her extended family. He has truly gone native: 'Je suis heureusement décivilisé […] Mon âme jusqu'au fond est nègre'. In spite of his self-defrocked state, Yacouba treasures a brotherly, non-condemnatory letter from the region's vicar apostolic (*TN*, pp.302–4).

The remaining white man who figures in Londres's text is his writerly colleague, the widely-known Paul Morand. Morand was travelling through some of the same areas of Africa as Londres, with his wife and Mme. Edouard Herriot, the wife of the statesman. He and Londres had first met on the boat during the outward journey. They coincided at Bamako and Niafounké, and sailed together on the River Niger for a week. Morand was gathering material for his book *Paris Tomboctou*, in which he registers their encounter: 'Ce grand coureur de globe […] apporte à mon chevet un surplus de vitalité, une précision

d'informations, une intelligence rapide qui me stimulent'. Londres tells him about Bahia and Rio de Janeiro, which he had recently visited in order to collect Dieudonné. He plays Morand records of negro spirituals and blues on his new phonograph, a present from Henri Béraud. Morand feels outclassed as a globetrotter: 'Je me croyais imbattable en matière de voyages, en connaissance des lignes de paquebots, de voies ferrées, etc. [...] J'ai rencontré Londres, et je m'avoue vaincu'.[15] Contrasting Londres's quite leisurely way of getting the feel of a place and its ways with that of the more dandiacal Morand, Assouline writes: 'Le plus rapide des ces hommes de plume n'est pas celui qu'on croit'.[16] Novelists/ travel writers can be more road-hoggish than journalists. Most of Londres's provisions vanished when they separated; Londres does not blame the bearers (*TN*, pp.305–7).

How does Londres's achievement measure up to that of other writers on the colonies: Gide, Malraux, Céline? Gide preceded Londres in French West Africa (1925–6 as against 1928). He dedicated his *Voyage au Congo* (1927) to Joseph Conrad, one of Londres's favoured writers, and who provided Gide with a model, with his *Heart of Darkness*, for a Congo of the mind.[17] Gide was on an ill-defined official mission of observation, together with the film-maker, Marc Allégret, who was ever on the look-out for photo-opportunities to the extent of staging some for his lens. For an aesthete of fifty-six years, Gide revealed an extraordinary vigour, and often walked forty kilometres a day in extremely testing climates and terrains, as well as being carried for stretches in a primitive, open sedan chair. Gide's refrain is the lack of differentiation between landscapes, dwellings and faces; they all look the same. Yet he is hungry to understand the Other, while remaining blinkered by cultural premisses and prefer-ences. He has curious and revelatory recourse to some of the classics of French and European literature (Racine, Goethe) while trekking through the boondocks. They offered a kind of intellectual home comfort, as if he feared being stupefied by local sights and events, needed regular reminders of where he came from, and dreaded being lost in a 'culture-free' environment, that is from a European if not cripplingly Eurocentric perspective. No more than Londres was Gide receptive to native cultures,

15 Paul Morand: *Paris Tomboctou*. Paris: Flammarion, 1928, pp.46, 78, 90, 121.
16 Assouline: *Albert Londres*, p.486.
17 André Gide: *Voyage au Congo*. Paris: Gallimard, 1927.

unless they had been Islamised. On the other hand, his lifelong cults of 'déracinement', 'dépaysement', and 'dépouillement' (note all the negatives; Gide was a fervent stripper) ensured that his curiosity stayed unremitting. This intense curiosity and his vibrating sensibility sustained a fascination with entomology, botany, and humanity. Though Gide's prose in this text is, as always, inclined to the prissy, he does strive to play fair to the African realities he encounters. Time and again he refutes the stereotype of the lazy black. Very aware of colonialist exploitation, he did not set out with the express intention, like Londres, of uncovering the crimes of Europe in Africa. Neither of them wanted to reject the imperialist system as a whole. Both shared the belief that it was the mother country's moral as well as financial duty to exploit colonies in a neutral sense: to develop them efficiently and humanely. While both indicted official abuses and failures, neither attacked the colonial enterprise itself. Both of them at heart seconded the common white man's view of the superior value of Western civilisation.

Henri Béraud, who added to his fame as a journalist and prize-winning novelist by a concerted onslaught on Gide as a cultural icon, said: 'La Nature a horreur du Gide'.[18] A different void, that could induce vertigo, makes its absence felt in Malraux's *La Voie Royale*, and in Londres's *Terre d'ébène*. Londres's version is the more tough-minded and resistant: 'La forêt ne vous donne pas le vertige, ou celui qu'elle procure est le contraire de l'autre: loin de vous attirer, elle vous repousse' (*TN*, p.351). In Malraux's novel (1930), the jungle is described in horror-mongering fashion as an endless prison of proliferating matter, constant disaggregation, viscosity and formlessness – countered only by the forms of art represented by the Khmer statues half-buried in the jungle's rank vegetation. Throughout, nature is 'ce monde ignoble et attirant à la fois comme le regard des idiots'.[19] Both the heroes of this novel are at sea on land.

Céline's *Voyage au bout de la nuit* (1932) displays French colonialism in Africa, after the chapters on the un-Great War, as a war continued by other means. Making no attempt to locate any good in the

18 Quoted in Jean Butin: *De la Gerbe d'or au pain noir, la longue marche d'Henri Béraud*. Roanne: Horvath, 1979, p.210.

19 André Malraux: *La Voie Royale*. Paris: Grasset, 1930. See Note 7 and text for Malraux's articles in *L'Indochine*.

colonial enterprise, Céline plugs the line of all his fiction about the bullying, swindling and rampant egoism built into all forms of trading. *Voyage au bout de la nuit* is powerfully and blatantly anti-realistic, and often switches to nightmare allegory, as when, in a blackly comic turn-around, the white protagonist (more strictly agonist) Bardamu is sold by negroes to a slaver. The dominant image of the African episodes is that of dissolution. All, physical nature or human part-beings, melt. Céline's fixation on putrefaction is sometimes held to be typical of fascist men-talities. He, however, sees rotting as the end of a process, not as offering the promise of regeneration. It is always end-of-the-world, never brave new world. The natives are shown as largely passive, indeed willing, victims of white exploiation.

Photos of African tribal societies, of course, cannot escape exploit-ing, bringing to the fore, bare-breasted women. Didier Folléas discovered Londres's own photos of his trip in a flea-market bookshop in Casablanca, where Londres had called in on his various journeys to Guiana, Buenos Aires, Rio and Black Africa.[20] These photographs corresponded with Londres's reportages. Folléas reminds us of the cult of all things African in 1920s Paris: music (especially jazz), masks, stage-shows, and the keen interest of painters, Surrealists and ethnologists in the whole new-found land. Londres had tried to persuade his newspaper editor, Elie-Joseph Bois, to fund a movie-camera and two operators to film the whole expedition, but ended up taking a standard camera and his painter-friend, Georges Rouquayrol. Whilst interesting, his photos do not improve on his very graphic writing.

Chantal Paisant's critical study of *Terre d'ébène* is often plausible according to its own presuppositions, yet it is based on the pointless wish that Albert Londres had somehow been born later, when he would have benefited from our contemporary right-thinking, right-on hindsight about colonialism. Her essentially reductionist argument suffers from lack of reference to Londres's *oeuvre*. Though she acknowledges that Londres's book is an attempt at a 'contre-exposition', she is in fact playing between the two related senses of *exposition*: (pictorial) exhibition, and exposure/

20 See Didier Folléas: *Putain d'Afrique! Albert Londres en Terre d'ébène*. Paris: Arléa, 1998, pp.7–9. In the Archives is a long, undated presentation of Marrakesh.

exposition.[21] She presents Londres as performing, in effect, a Lobster Quadrille – one step forward, two steps back: 'L'ensemble de l'exposition satirique s'inscrit dans ce mouvement de ressac, de l'intentionnalité critique à la confirmation des préjugés, des images dénoncées aux images reçues'.[22] This interpretation leads her to say that Londres remains implicated in the lazy-minded discourse of empire-builders that he appears to challenge, especially in his stress on the ungratefulness of metropolitan France towards her overseas territories.

His most grievous sin is his 'regard amusé du Pouvoir-Savoir [qui] transforme l'"étranger" en "burlesque", l'illisible en cocasse' (p.415). As we will see, this verdict is both uncharitable and wrong-headed. Paisant seems insulated against the positive charge that can be active in subversive humour. She can see jokiness, like so many people, only as a diminisher of seriousness, and as giveaway complicity with the enemy. In effect, she sees humour merely as light relief (but Comic Relief was a jolly *and* grave undertaking), and as a distraction from the real goal. Her stance is reminiscent of that unjust criticism levelled against the Victorian comic poet and social critic, Thomas Hood: that he evaded the full import of what he discussed, and in so doing either frustrated or spared the reader's emotions. Of course, joking in a serious context can be a facile way of making out that humour solves everything ('So that's all right, then'). Relenting at times, Paisant recognises Londres's good intentions, while making her compliments back-handed: 'Un pathos bien dosé de sourires indulgents d'un côté; de l'autre, une sincère compassion mêlée de quelques frissons, achèvent de conforter le Blanc dans la stabilité de ses valeurs' (p.416). She strains comparisons between Londres and the *doxa* of his period too far when she claims that

Le discours de presse produit ce que le lecteur bourgeois, conservateur et nationaliste de l'époque veut acheter: après l'horreur de la guerre 14–18, la confirmation d'un monde clos [sur?] lui-même dont il ait globalement la maîtrise, et une littérature conventionnelle qui en soit à la fois le miroir et l'écran contre son propre irrationnel. A ce titre, l'avant-scène de Londres joue très exactement le même rôle que la méthode de propagande qu'il dénonce (p.416).

21 Cf. the Surrealists' failed 'counter-exhibition' mentioned earlier.
22 Chantal Paisant: 'Images du pouvoir blanc dans le reportage d'Albert Londres en Afrique noire'. In: J-L. Cabanis and Cl.-G. Dubois (eds): *Images européennes du pouvoir*. Bordeaux: Editions Universitaires du Sud, 1996, p.409.

She tars Londres and his age with the same brush, like the convict in Guiana who put Londres in the same basket as the French powers-that-be. She does, nonetheless, admit that Londres's text has its Conradian moments, when it fastens on to the darker heart of colonialism, although she undercuts this faintish praise when she makes an analogy with Céline:

> La matière première d'un *Voyage au bout de la nuit* est là, diffuse… vigoureuse-ment cadrée entre de solides arguments de bon sens et de fierté nationale, dûment chapeautée de titrages moralistes et rassérénants, maintenue sous la férule de l'unique point de vue du Pouvoir dominant (p.417).

Folléas, in contrast, finds that there is 'jamais de racisme profond ni théorisé dans *Terre d'ébène*'; in it whites are subjected to the same pointed mockery as blacks. His only criticism, in fact, is that revolts broke out in the region shortly after Londres's tour, but that there is no inkling of these in his text.[23] Altogether his view is far more balanced than Paisant's.

Humour is balance, mental equilibrium. It enables Londres to write tellingly of a black ex-soldier who pays good money in order to be eulogised in public by the *griot* (travelling poet/musician/sorcerer). Would not Western generals envy such a custom? The black ends up broke, but honoured (*TN*, pp.239–40). Nearer to home and to the knuckle: does the junk (e.g. reach-me-downs) exported by Europe to African markets betoken native gullibility or white man's rapacity? 'Voici la requimpette de mon grand-père. Je la connais. Il la portait le jour de la première communion de ma mère' (*TN*, p.243). Londres's boy in such shoddy gear looks like a penguin on stilts, though minus the dicky (*TN*, p.244). Others buy by mistake children's left-overs from catalogues for themselves, then burst out of them (*TN*, p.371). Birama takes a feather-duster for a clarinet. West and South misread each other.

Mildly deferential to European monarchs, Londres cannot resist making fun of Zounan, King of the Night, who veils his face to eat or drink, and who processes in a carriage pulled by colossal guards (*TN*, p.375). The last emperor in Africa (up to then) performs each day a farcical routine, in which he makes as if to ride off into battle against a rival chief, but then desists (*TN*, p.327). Perhaps Londres might have been more tolerant of merely symbolic violence. Their interview is a dialogue of silent deaf men, but the interpreter signals the moment for

23 Folléas: *Putain d'Afrique!*, pp.55, 83–5.

Londres's departure in choice French: the white man is buggering off (*TN*, p.332). In Senegal, Londres is unsure whether to laugh at or be impressed by the newfound, strutting dignity of the black electorate, increasingly unwilling to act as white men's dogsbodies.

As a critic of colonialism, Londres was self-evidently no revolutionary – very few thinking people in his day were – but was certainly a reformist. He was disillusioned by the lack of dynamism in French colonial policy and practice. The incurious citizens of the homeland let local administrators off the hook of active responsibilty for developing the economy. Even Belgium's colonies were more advanced, in terms of infrastructure and work-conditions (after surviving earlier scandals). 'Ce n'est pas en cachant ses plaies qu'on les guérit' (*TN*, p.423), and French adults have a right to learn the true facts of what is being done, or not done, in their name. Though he lists the few achievements so far, these do not, in his eyes, go nearly far enough. A proper marriage must be arranged between France and her colonies (*TN*, p.246). To that end, a plentiful dowry is urgently needed:

> Pour sauver le nègre, l'argent est nécessaire. Le moteur à essence doit remplacer le moteur à bananes [i.e.the natives]. Au siècle de l'automobile, un continent se dépeuple parce qu'il en coûte moins cher de se servir d'hommes que de machines! Ce n'est plus de l'économie, c'est de la stupidité (*TN*, p.247).

As for reactions to Londres's pugnacious and eye-opening reportages, the pro-colonialist press predictably accused him of ignorance, prejudice and malevolence, though some debates in parliament did ensue.[24]

There are obvious links between *Terre d'ébène*, colonialism, and the subject of my next chapter: exploitation. Exploitation of sportsmen in the Tour de France, of women's bodies in *Le Chemin de Buenos Aires*, of the lungs and lives of the pearl-divers in *Pêcheurs de perles*, and the tragic, age-old plight of Jews across Europe in *Le Juif errant est arrivé*.

24 See Assouline: *Albert Londres*, pp.492–8, for more details of this upshot.

Chapter 6
Exploitation

Convict Sportsmen: *Les Forçats de la route* (1924)

Londres's paternal grandfather was a pedlar, a 'compagnon du tour de France' (post-apprenticeship journeyman). Londres himself rather more comfortably made a circuit of some of France's town halls, where he quickly felt disillusioned by the lack of dynamism, the petty materialism, and the incessant squabbling between special-interest groups, before he embarked on following the world-famous cycle race. In addition, 'the sporting "tour" was an adult equivalent of the fictional "tour de France" by two orphaned Alsatian children which was familiar to most French boys and girls'.[1] This famous book, *Le Tour de France par deux enfants* by 'G. Bruno' (in fact Mme. Alfred Feuillée) was a huge best-seller, and was recently selected as one of the national 'sites of memory' in the series of books of that title edited by Pierre Nora. It was used extensively by state schoolteachers in order to instil civic virtue and patriotism in the young.

The race itself, of course and from the beginning, was far less edifying than that fictional text-book. As the whole event was multiply money-driven, how could entrants not be corrupted and made ruthless? Skullduggery, dirty tricks of every hue (cf. the sinister concept of the 'professional foul' in football) have always been part and parcel of the tour. Other endurance tests in the 1920s included dance-marathons. The *Schadenfreude* of non-participants witnessing such brutal prize-events bears comparison with crowds at the Tour de France, who went to see aces, even pathetically self-appointed ones, perform wonders of sprinting and climbing, but also to observe from a safe vantage-point their injuries in spills or collapse from exhaustion. Unlike in closed sporting arenas

1 Richard Holt: *Sport and Society in Modern France*. London: Macmillan, 1981, p.100.

with their executive boxes and popular terraces, at the open-air Tour spectators are physically contiguous, a social promiscuity not welcome to all. As it is free entertainment, income must be obtained from other sources (sponsorship, advertising). Probably few who watch cycle themselves, except in the most utilitarian fashion. This spectator sport and its focus, cycling, are thus poles apart. Viewers, besides, see only a brief blur, or an unexciting snail-slow progression, unlike at most other sporting contests when they take in the whole caboodle from start to finish. Nowadays, of course, you can watch the whole race on TV, if you have endless spare time, from your potato-couch.

Albert Londres was very under-prepared for this reportage. According to Assouline, his lady companion of the period persuaded him to desist from foreign travel for a while, while assenting to his circuit of France.[2] Although those whom Londres baptised the 'convicts' of the Tour de France were sentenced to this penal servitude by their own volition, and were therefore oppressed and exploited in a different way from the inmates of *Au Bagne*, *Dante n'avait rien vu* and *Chez les fous*, if comparably to the prostitutes of *Le Chemin de Buenos Aires*, Londres in his reportages on this race wisely confined himself to what he already had ample experience of studying: human suffering. Londres must have been very aware that he was himself making a pretty penny out of other people's travails. As a professional journalist, he was also fully cognizant of the elaborate and costly arrangements made by newspaper owners and editors to get news and results as fast as possible, and before rivals, on to the printed page. In the Twenties, the coverage of the Tour was not in fact placed in the sports section, but nearer to political and international news, on the front page. All in all, it is clear from his reports that he was much less interested in the cycle-race *per se* than in the wider social issue of exploitation.

The first major cycle race in France was pedalled from Rouen to Paris in 1869, soon after the development of the penny-farthing. The modern bicycle was invented in the late 1880s, and by 1900 was in mass-production. By 1926, there were over seven million machines in France, and another leap forward came in the Popular Front period, when the French discovered fresh air. Manufacturers gradually invested large sums in promoting cycling as a spectacle in order to sell more machines

2 Assouline: *Albert Londres*, p.395.

to consumers. The race itself became a massive advertising-campaign with the creation of works teams (as in Grand Prix racing). Though the bicycle, expensive in its earliest versions, remained for some time a middle-class means of locomotion, the advent of cheaper varieties made cycling more readily working-class in symbolism. The aristocracy, naturally, had always ridden horses. The workers had to wait for the invention of production-line models to have at their disposal their 'steeds'; then the nobs switched to motor-cars. A common received idea, especially pre-1914, was that sport could replace war by providing the same moral education as military service.[3] Wrong on both counts.

In his articles, Londres unmistakably wants to cut the Tour, usually treated on the page as epically supernormal, down to size, down to the nitty-gritty. Since he envisages competitors in the race as gaolbirds on wheels, he often identifies only numerically those whom the crowds address familiarly by their first name. The stress throughout the texts falls on suffering, major or minor, periodic or continuous. Riders constantly put on and take off protective glasses against tar-dust: 'Ils ne savent de quelle façon ils souffrent le moins' (FR, p.13). One rider complains stoically: 'Un jour viendra où l'on nous mettra du plomb dans les poches parce qu'on trouvera que Dieu a fait l'homme trop léger' (FR, p.18). Pettifogging legalities add to the overall fatigue and aching limbs; riders must not throw away a jersey when suffocating with heat. The articulate cyclist Henri Pélissier sums up: 'Nous acceptons le tourment, mais nous ne voulons pas de vexations' (FR, pp.17–18). Londres is naturally drawn to mavericks. Among the old lags Pélissier is the most bolshy.

Even though drug-taking has a long history among Tour riders, Londres makes only brief mention of it. Its usage is made to sound entirely practical; cocaine for the eyes and chloroform for the gums, in order to counter the clouds of dust from which Londres, seemingly comfortable in a following car, also suffers. Rapidly listing the qualities of different dusts across France, he makes this wry joke: 'Rien que d'y penser, j'en ai l'eau à la bouche. Pourvu que celle des Landes, lundi, soit aussi bonne!' (FR, p.19). Thus a plague is ironically transformed into a delight. Patently or latently, Londres does not wish to raise the hoary

3 Philippe Gaboriau: *Le Tour de France et le vélo: histoire sociale d'une épopée contemporaine.* Paris: L'Harmattan, 1995, p.24.

spectre of drugs in sport, on the subject of which prevails a large element of hypocrisy. Spectators lust over the results, but sniff at the means.

Throughout the last century, sport has not been, if it ever was, a naïvely pure competition that depends solely on the skills that athletes bring to it. It is an entertainments industry in its own right, and an enormous imbroglio of financial interests. If laypeople want to watch sporting marvels, they have to expect some stars to exploit every means possible, including performance-enhancing drugs, in order to provide the top-flight spectacle hungered for by millions. Nor does it make much sense to demand that bodies governing sporting events should act also as watchdogs and chastisers of the law-breakers. On the other hand, governments attempt to limit the ravages of drug-abuse in everyday life, so why not also in the sporting arena, if only for the sake of the athletes' physical well-being? As Graham Robb points out:

> Drugs will continue to be part of professional cycling, not just because of ingenious chemists and drug smugglers, but also because the sport is essentially self-destructive. The high-speed *danse macabre* that spins down Pyrenean cols in the rain is oblivious to the long-term effects of drug abuse. The helmets worn in time trials are not designed to protect the skull but to decrease wind resistance and thus, in effect, to increase the risk of lethal accident.[4]

Edward Nye focusses on a different kind of intoxication, for which he borrows a Freudian interpretation. From this angle, pleasure segues uncontrollably and masochistically into pain and even fatality: 'Ainsi le coureur satisfait en même temps Eros, la pulsion de vie, et Thanatos, la pulsion de mort'.[5]

Riders themselves often react derisively to efforts to moralise their muscles. In the interwar years, some topped up their urine sample with another person's. One rider was told as a result that his test was negative, but that he was pregnant.[6] That anecdote would have appealed to Londres's sense of humour, as indeed would the passionate addiction of

4 Graham Robb: 'Saddlesore heroes'. *Times Literary Supplement*, 20 July 2001, p.9.
5 Edward Nye (ed.) *A Bicyclette*. Paris: Les Belles Lettres, 2000, p.vi. On the same page, Nye explains how naturally secreted serotonin can counter the effects of pain, such that some doctors prescribe for depressives the use of exercise-bikes instead of Prozac. Appropriately, the series that this book figures in is called 'Sortilèges'.
6 Holt: *Sport and Society*, p.98.

Alfred Jarry to cycling, which included racing against trains. Such feats were obviously associated in the absurdist playwright's mind with record-breaking sexual prowess. In his own accounts of cycling, Londres is strangely less given to joking and ridicule than in his other writings on far weightier topics, perhaps a sign that he did not feel in his element, at the Tour de France, whose near-sacrosanct status would seem to positively invite verbal sabotage.

As ever, Londres keeps his weather-eye open for the everyday, revealing detail. When competitors throw in the towel, they lack street-clothes to go home in; tailors, aware of this possible windfall, hang round every staging-point. As for the machines, punctures are ten a penny: 'Mon ennemi? C'est mes fesses' (*FR*, p.23), which cannot be replaced so easily as an inner-tube. Londres revels in the slang terms: *clochards*, for the also-rans, or *ténébreux*, for those not attached to a team. All the time, he underlines the immense physical expenditure: 'Les muscles de leurs cuisses grincent' (*FR*, p.31). He highlights the falls and collisions with cars or overspilling crowds (ibid). His overall theme is the sheer madness of the whole phenomenon (the next year he was to publish *Chez les fous*): 'Il suffit de suivre le Tour de France pour que la folie vous semble un état de nature' (*FR*, p.44). He himself refuses, via a sneering verb, to be caught up in the spectators' frenzy: 'C'est dix millions de Français qui glapissent de contentement' (*FR*, p.45). In all, he interests himself most in riders' grievances about the agonies of pedal-pushing, the feudal treatment they get from organisers, and their struggle against abusive regulations. Most importantly, he is visibly allergic to the widespread practice of mythologising this sporting ordeal, and regularly mocks the hagiographical cliché, 'les géants de la route'. These 'giants', while not exactly having feet of clay, possess, on hire it often seems, mortal, suffering legs.

Like many another scribe of any level, low or high, of literary skill, Londres could have very easily aggrandised the Tour. One such was its founder, Henri Desgrange, writing it up in *L'Auto*:

> Du geste large et puissant que Zola dans *La Terre* donne à son laboureur, *L'Auto*, journal d'idées et d'actions, va lancer à travers la France, aujourd'hui, ces inconscients et rudes semeurs d'énergie que sont nos grands routiers professionnels [...] Nos hommes vont s'enfuir éperdument, inlassables, rencontrer sur leur route tous ces sommeils qu'ils vont secouer, créer des vigueurs nouvelles, faire

naître des ambitions d'être quelque chose, fût-ce par le muscle seulement, ce qui vaut mieux encore que de n'être rien du tout.[7]

A reader cannot help being struck by the flowery, melodramatic, yet strangely abstract nature of this piece of purple publicity. The event is itself already hyperbolic, extremist, and it tempts commentators into verbal escalation. While ostensibly intent on doing a knocking-job on the clichéic mythology of the Tour, Roland Barthes himself yields to such over-writing in his analysis of this 'épopée': 'Le Tour dispose d'une véritable géographie homérique. Comme dans l'Odyssée, la course est ici à la fois périple d'épreuves et exploration totale des limites terrestres'.[8] Barthes in fact congeals a race which is self-evidently based on movement: 'Le Tour est un conflit incertain d'essences certaines' (p.118). Barthes's 'mythologies' are otherwise called clichés, stereo-types, fixed forms. Ironically, Barthes himself, despite his Marxian terminology, seems to have little sense of historical development; he is interested solely in end-products. He never shows us the genesis or evolution of a myth. Well might he write: 'Le rôle du langage, ici, est immense, c'est lui qui donne à l'événement, insaisissable parce que sans cesse dissous dans une durée, la majoration épique qui permet de le solidifier' (p.116). Had he lived to read such fancy talk on the Tour, Londres might well have declared in mock-pidgin, like Queneau's imaginative but no-nonsense Duc d'Auge: 'Moi pas être un intellectuel'.[9]

Mousset's verdict on *Les Forçats de la route* is that the reading public understood

> que le *Bagne* et *Biribi* ayant consacré en Albert Londres un ennemi des bourreaux, un clinicien des douleurs imméritées, il appartenait à un tel spécialiste de se pencher sur les souffrances, mineures mais réelles, encore qu'acceptées par eux, des coureurs.[10]

7 Henri Desgrange, in *L'Auto*, 1 July 1903, on the occasion of the first Tour de France. After the 1914–18 War, which broke the sequence, *L'Equipe* and *Le Petit Parisien* displaced the leading cycling paper *L'Auto*.

8 Roland Barthes: 'Le Tour de France comme épopée', *Mythologies*. Paris: Seuil, 1957, p.114.

9 Raymond Queneau: *Les Fleurs bleues*. Paris: Gallimard, 1978 [1965], p.25.

10 Mousset: *Albert Londres*, p.207.

Londres himself, round 1932, in a list of his reportages, called his articles on the race 'une idiotie', though no doubt he had the Tour itself more in mind. Most certainly, he did not relish having to follow slavishly a predetermined itinerary, for he had been used to selecting where he went; once there, he could backtrack, digress, take root for a while. The Tour despatches were one form of writing on the move that Londres found hard to take. The bike, for him, had always been a resolutely utilitarian object. Compared with his other subjects, the Tour de France stands out as a highly organised totality, though with its own inner and self-destructive anarchies. His position as a fish out of water ensured that he could not muster the empathy of, say, a Richard Cobb:

> For these somewhat disinherited places, the Tour represents a brief, strident compensation, as the coloured riders flash by, a sort of royal progress that may give a kingfisher sense of importance to some out-of-the-way, dormant *commune*.[11]

The generous Cobb omits the fact that long stretches of the race, like cricket to infidels, is monumentally dull. Finally, Londres was more or less disqualified by one of the racers he had cited:

> Londres était un fameux reporter mais il ne savait grand'chose du cyclisme – dira beaucoup plus tard Francis Pélissier, devenu directeur sportif de l'équipe La Perle. Nous l'avons un peu bluffé avec notre cocaïne et nos pilules! Ça nous amusait d'emmerder [Henri] Desgrange.[12]

If informants misled at the time, can they be trusted any more later on? This lack of certain reliability must be a recurrent handicap to all press-work. Whatever Londres's personal misgivings about the quality of his writings on the Tour, the many current Internet items referring to them as authoritative reveal how influential they have been.

The paradox of spectacles such as the Tour de France is that an event designed to celebrate physical fitness and prowess should end each day of its duration in the total exhaustion of the participants. If one of the intentions of the race was originally to rejuvenate the poor physique of the nation's manhood, this was a counter-productive way of proceeding.

11 Richard Cobb: *Tour de France.* London: Duckworth, 1976, p.212.
12 Pierre Chany: *La Fabuleuse Histoire du cyclisme*. Paris: Office de diffusion international du livre, 1982, p.329.

Sexual Prisoners: *Le Chemin de Buenos Aires* (1927)

In a letter to his parents of August 1917, Londres talked of travelling to Buenos Aires for a book on the white-slave trade which he said was all set up with an (unnamed) publisher. In the same letter he also spoke, alliteratively, of the need for self-renewal: 'Il faut savoir sortir de son sillon'.[13] Thus, as with anticipated fact-finding trips to Soviet Russia and North Africa, he did not always act on impulse, but often planned, or at least visualised, ahead.

During the long voyage out to South America, he sent eight despatches to *Le Petit Parisien*, which were not included in the final book. His boat was full of poor immigrants from all over Europe, destined for Brazil and Argentina. On a stopover at Bahia, he is struck by the famous Brazilian melting-pot; former imported slaves are now the full citizens of this sovereign country: 'Et c'est ce qui fait qu'à Bahia, ville de couleur du grand Brésil blanc, on peut voir, installé dans une auto, un monsieur noir conduit par un chauffeur blanc' (*CR*, p.798). He is much more enchanted by the gaiety and brilliant light of Rio de Janeiro than he will shortly be by Buenos Aires.

What awaited him? Prostitution had been legalised in Buenos Aires in 1875. The authorities clearly saw unchecked prostitution as dangerous to public order. Londres comes from the other direction: the city is dangerous for vulnerable women lured there unwillingly or not, and is itself the originator of urban disorder. For Donna J. Guy,

> the comparison between black slavery and prostitution was first implied by Victor Hugo in 1870, and thereafter distinguished 'voluntary' from 'involuntary' prostitution. The term 'white slavery' was calculated to enlist antislavery activists, many of whom were feminists, in a new moral campaign. The anti-white slavery campaign, in addition to its nationalistic concerns, was explicitly racist. It presumed that all white women found in foreign bordellos had been forced there against their will by immoral men. The possibility that white women chose to engage in sexual commerce with men of different races, even if starvation were the only other 'choice', was inconceivable.[14]

13 Londres, letter to parents of August 1917, in Archives.

14 Donna J. Guy: *Sex and Danger in Buenos Aires*. Lincoln: University of Nebraska Press, 1991, p.25.

136

This interpretation is from a justifiably feminist perspective. Guy plausibly detects a link between prostitution and the question of women's employment. Many observers yielded to stereotyped ideas of women's place, in the home and family; and it took ages for some to accept that there is no inevitable connexion between a woman having a paid job and sexual slavery (p.35).

It was by talking to pimps that Londres introduced himself to the whole issue of the 'white slave trade', the buying and selling of women's bodies. 'Je ne suis, sans doute, qu'un débutant dans le milieu, mais un débutant qui a des dispositions' (*TB*, p.20). That last word teases the reader: natural ability, or readiness to learn. It could also be a sidelong reference to his own visits to brothels. He claims to be following a course, like a medical intern (*TB*, p.22). The journalist, of course, has to doorstep insiders, and keep his eyes peeled. How can he not be some sort of voyeur? Of his informant Armand he says: 'Il est ce qu'il est, mais il l'est. Je sais ce qu'il fait. Il sait ce que je fais. Il a confiance en moi. J'ai confiance en lui. D'homme à homme' (*TB*, p.23). You might scent an excess of male bonding, all-lads-together here. These pimps in Paris bars shuttle between France and Argentina, returning home periodically for 'la remonte': scouting for and stocking up on new 'talent'. In order to cross-check their accounts of how the business works, Londres also interviews the chief of the Paris vice-squad, and comments: 'Quand il s'agit de trouver mon foin, je mange à tous les râteliers': I cash in on all sides (*TB*, p.25).[15] He freely admits that the Parisian prelude is an appetiser, a curtain-raiser (*TB*, p.28). At the start of his long trek through the underworld, he is seeking to win his readers over in advance of his full investigation, by offering close-up snapshots of pimps and coppers, the former all snappily dressed and swimming in money. A rumour circulated in Buenos Aires that Londres was an officer of the French Sûreté detailed to track down the vice-trade. Londres must have achieved the difficult feat of proving a negative. His whole approach deliberately

15 Playing on the idiom 'prendre son bien où on le trouve', Molière said: 'Il m'est permis de *re*prendre mon bien où je le trouve' (See Grimarest: *Vie de Molière*, 1704, p.14). Fittingly, this boastful statement recycles a line from a Spanish play put on by Molière's troupe. Londres would be entirely at home in such shenanigans.

eschews the heavily moralising tone that weighs down so many enquirers into this area of human activity.

On a stopover in Bilbao, Londres meets a couple who seem very attached to each other. Gradually, he reveals that the man is a procurer and the girl a wretched nineteen-year-old whom he has picked up, fed, dressed, and will employ in South America. He has obtained her sister's (a nun's) identity papers: 'Cette servante de l'amour [partait] faire son métier avec l'état civil de la servante de Dieu' (*TB*, p.37). As the man is already married, the girl will be his 'doublard', second woman. This episode prepares for Londres's general thesis that few women go over there totally against their will, though the pressure of cajolement is intense. At the same time, the term 'colis' for a woman posted abroad by a home-based pimp graphically underlines how much of a (sex-)object she is, whatever the initial lovey-doveyness: 'Colis de dix-sept à vingt kilos. C'est-à-dire des femmes de dix-sept à vingt ans' (*TB*, p.38). New girls are smuggled into Argentina in any odd corner of the ships, one, for example, in a goods-hoist purposely stalled between two decks. Thus the very boat out is their first taste of semi-incarceration. Given his own set-tos with immigration officials, Londres confesses his admiration for the astute ways in which the minders wangle their charges through, and flout authority (*TB*, pp.42–3). In fact, on arrival, his own papers (he was travelling, in effect, incognito) are not in order. He responds insolently, saying that his fingerprints are still on the ends of his digits, but it is a quick-thinking pimp who saves his bacon. In such ways does he feel an honorary member of the *demi-monde*.

The streets and cafés of Buenos Aires appear to him populated solely by men, unsmiling and in a mortal hurry. (In an uncollected article, he slips in that he quite likes the idea of men being privileged and pampered (*CR*, p.803)). Always observant of urban spaces, he notes the tedious checkerboard lay-out of the city: 'Décidément, Buenos Aires a juste autant de fantaisie qu'une géométrie: parallèlles, perpendiculaires, diagonales, carrés' (*TB*, p.49). As for illumination, he makes a hyperbolic joke about the plethora of lights, for instance on house fronts: 'Si les Argentins osaient, ils se promèneraient une ampoule électrique au derrière' (*TB*, p.54).

He makes a link with Guiana when he meets Vacabuena, of whose exploits in and out of the penal colony he has heard astonishing stories. In Buenos Aires, unlike Paris, the underworld men are hardly dis-

tinguishable from the bourgeoisie. Londres stresses both the types of pimps, and their variety: 'La gueule d'amour, le beau costaud, l'impérieux petit crevé [a nicely judged oxymoron], le brun et mat méditerranéen, le gros voyou en costume de fin gigolo, [...] le sympathique et le méchant' (*TB*, p.64). They are anarchists but lovers of order: 'En politique, ils aiment les gouvernements sérieux, pondérés qui font le commerce prospère' (*TB*, p.65). They have middle-class tastes and ambitions and, like any *rentier*, are not keen on hard work (ibid). Londres offers some potted biographies. Many start on a life of crime in their early teens by petty thieving. They shack up with a supportive older woman, and persuade a girl to walk their streets for their benefit. In and out of gaol, they make an educational gain from mixing with serious criminals, and end up in the export or import trade of female flesh (*TB*, pp.67–8). Regularly quoting their racy idiolect, Londres wonders mischievously to himself: 'Seuls les poètes et les *caftanes* [pimps] savent créer de jolis mots. Pourquoi l'Académie Française n'a-t-elle reçu, jusqu'ici, que les poètes?' (*TB*, p.67).

Throughout, Londres displays a keen interest in the practical details of pimps' manipulation of their women. One such ups-and-downs story is that of Victor le Victorieux of the hiccuping nickname. In Paris, he scoops up a girl outside a hat factory, and works hard, for once, to win her affections. Taking her to England, when he cannot find a job, she goes on the streets, and they enjoy for a time a comfortable income. Having heard of the riches to be made in South America, but failing to break into the market in Buenos Aires, he settles in Mendoza, far off across the pampas, but makes little money. There he indulges in casual brutality towards a non-compliant, gawky woman: 'Je fus contraint [...] de lui repocher les deux yeux' (*TB*, p.77). After selling the awkward one to a Marseillais, he goes through a succession of women, all failures. Eventually, he marries the girl he first thought of. Now wealthy, he has several girls working for him, and soon will ensconce himself in a bourgeois, if racy, existence in France (*TB*, p.85). In recounting this unsavoury tale, Londres refrains from blatant judgmentalism.

Buenos Aires idolises the golden calf. It is an international crucible of men from all over and attendant women, attracted by the legend of rags-to-riches. Ironically, given the presentday financial catastrophe in Argentina, then many were obsessed with making easy money, some few of them successfully. After all, money *(argent)* is built into the very

name of the country: 'L'argent, dans ce pays, n'est pas fait pour être caressé. On le brutalise, au contraire: on entend lui faire rendre le maximum' (*CR*, p.805). Coming from an old country of largely static capitalism, Londres is not altogether hostile to this unethical ethos, this dynamic entrepreneurialism:

> Une thèse littéraire [Barrès, obviously] soutient qu'une terre qui n'a pas 'ses' morts, ne sait plus conseiller les vivants, et que ces vivants sont alors livrés à toutes sortes de vents qui les déchirent. Amérique [i.e. the Americas] prouve le contraire. Tous ces gens ont préféré se passer de leurs morts. Le bien-être, une existence moins étroite, un horizon plus large, une importance plus grande donnée à l'individu, quel qu'il soit, voilà la thèse positive de ces terres nouvelles (*CR*, p.805).

Londres can be quite soft on bought 'love': a lie, but possibly an attractive lie (*TB*, p.88). Even male chauvinist pigs can place women on pedestals, where most catch cold, and Londres pleads for a statue to women, especially French prostitutes ('las Franchuchas'), who have traditionally been neglected by sculptors. Hardly exemplary, they deserve grateful recognition (*TB*, pp.90–1). He asserts that, statistically (and statistics notoriously exceed even damned lies), 80% of prostitutes are unfortunate, 'des malheureuses', and 20% 'des vicieuses' (*TB*, p.93). He defines le milieu as 'une société d'hommes qui exploitent la femme, simplement, comme d'autres exploitent la forêt, des brevets, des mines ou des sources d'eau minérale' (*TB*, p.96). These men, except for a fishy collusion with the police, who, together with other uniformed officials such as firemen, practise protection rackets, form a self-contained world: 'Ils ont fondé, eux aussi, une ligue des Droits de l'Homme, mais sur la femme' (ibid.). Londres records the telling admission of a woman, Moune: 'Je ne me reconnais pas beaucoup le droit de penser'. After being badgered, charmed and purchased (with food, clothes and accommodation), she feels a great sense of obligation: 'Je paye' (*TB*, pp.106–7).

Brothels provide production-line sex. Londres joins a queue in one, waiting for the sole woman to be free for the next 'trick'. It is entirely conceivable that he was a customer of brothels on his lengthy travels.[16]

16 Cf, his visit with French marines to a Korean-run brothel, in *La Chine en folie*, in Chapter 7.

He could not pose hypocritically as an abolitionist, and he was, after all, a single man from the death of his young wife onwards. He is, besides, often led to call himself a pretty typical French male. Elsewhere, he includes, or incriminates, himself, and of course the male reader, in a Baudelairian apostrophe: 'O mes semblables à moi' (*TB*, p.198). In this Buenos Aires brothel, he resorts to a pseudo-poetic euphemism for the number of clients per day: 'Une femme de casita [a one-woman bordello] délace de trente à trente-cinq fois sa sandale dans une journée' (*TB*, pp.119–20).

Equably, Londres gives some place to pimps' self-valuations, for example the running costs, the qualities and the duties they see as theirs: 'Il nous faut être administrateur, éducateur, consolateur, hygiéniste. Du sang-froid, de la psychologie, du coup d'oeil, de la douceur, de la fermeté, de l'abnégation' (*TB*, p,120). (On the specific question of sexual hygiene, Londres leaves out, unaccountably, the very real problem of communicable diseases). Pimps beef about the present inferior generation of unscrupulous exploiters, and indeed are frequently as moralising as any uptight bourgeois. When Londres tells them, not altogether flatteringly, that they are 'les jockeys de la femme', they are tickled pink (*TB*, p.124). He knows they are all unabashed exploiters, and he says of a prostitute, in a telling image: 'Elle donne sa bourse à son homme comme une mère son sein à son enfant, jusqu'à l'épuisement s'il le faut' (*TB*, p.125). He registers the 'Dear John' letters giving them the brush-off that these women so often receive (ibid). Once he tries to intervene, in order to persuade a young woman to return home to her angst-ridden mother. When she stands firm, he gives up, graciously. This is the nearest he gets to behaving edifyingly.

One special branch of the white-slave trade is that run by 'Polaks', who are in fact not only Poles, but also Russians and Czechs: it is an umbrella-term. Londres had been in Poland the year before, in May 1926, in order to report on Pilsudski, and would revisit it in 1929 for the sake of *Le Juif errant est arrivé*. In Buenos Aires in 1927, he recalls a Jewish 'camp' in the back country of Poland, centuries old, and in effect a ghetto. He tells of his fearful sense of being a totally foreign intruder (*TB*, p.144). In his view, the true white-slave trade is controlled by 'Polaks', working solely with Jewish girls from Poland. He remembers the extreme poverty of the Polish Jews he saw in 1926, which of course counters the often lethal stereotype of the eternal money-grubbing Jew.

In Argentina, the imported young Jewesses are the Third Estate of the profession, and charge lower prices (*TB*, p.146). The 'Polaks' form a closed microcosm within the already closed macrocosm of the underworld, and have little or no contact with other nationalities. While pointing out that not all 'Polaks' are Jews, Londres stresses that those who travel to and inside Poland on round-up missions are. They make deals, sign contracts, with the girls' families; the girls are export goods. Given that Londres puts the spotlight far more on French (goyim) pimps and prostitutes, it seems unbalanced of Guy to assert that 'despite Londres's account, or most likely because of its chauvinistic and sympathetic cast, the French role in white slavery was rarely vilified in the same way as that of Jewish traffickers'.[17]

La Boca is the arsehole of Buenos Aires, and the women who ply their trade there are 'condamnées non à mourir, mais à vivre'(*TB*, p.152). One woman says to him: 'Notre usine à nous est une usine à baisers' (ibid.). They cannot escape once caught in the net of buying and selling. Even when teasing readers, Londres remains pointed, as when he remarks: if you want more details, ladies, please contact me (*TB*, p.154). By the very nature of his subject, he could very easily have fed the prurient appetites of readers of either gender, but he resists the facile temptation.

He does not neglect the legal aspects, and refers several times to the Socialist laws of 1919–20, which, according to Guy, were

> far less benevolent than Socialists imagined. Larger bordellos meant that pimps and madams had to work more clandestinely in Buenos Aires after 1919, or else assume the financial burden of operating one-woman bordellos. They also had to rely more on police corruption. Under-age women needed falsified documents.[18]

Londres turns to his standard metaphor for his enquiries, the maze or the jigsaw: 'La vérité ici n'est pas une vérité d'ensemble [...] Il faut la reconstituer sans énervement comme l'on fait des images d'un puzzle' (*TB*, p.181). This image suggests patience, and a refusal to jump to conclusions. He cites Mme Abslau, who has worked for years to save young ladies from sin, but now confesses failure. Her statistics vary a little from Londres's: 90% of the women will their trade, and 10% are

17 Guy: *Sex and Danger*, p.93.
18 Guy, p.108.

victims of 'une douce violence' (*TB*, p.165), which seems piously hopeful on both counts. Loath to pass judgment, Londres also recognises that he will never best the articulate pimps in argument, as they have an answer for everything (*TB*, p.172).

Amid the horrors, he usually stumbles across some comic relief, as with the pimp who moonlights as a Methodist preacher (*TB*, p.186). He runs a joke about his own extravagant oaths, which are probably a take-off of rich Hispanic cursing: 'Par le cheval blanc d'Henri IV, par la barbe de Léonard de Vinci, par la cigarette tombante de M. Aristide Briand, je ne pourrais jamais, jamais m'habituer à Buenos Aires' (*TB*, p.131). As always, he enjoys playing with language and twisting idioms. Of a man nicknamed 'l'Ours' he comments: 'Cet ours était assez convenablement léché' [This bear of a man was quite a honey] (*TB*, p.198). Invited to dinner by a prostitute and her keeper, he notices that she keeps disappearing to do a 'trick', and then returns unruffled to her pots and pans. The meal is excellent, and the bourgeois soirée charming (and unusually exciting) (*TB*, pp.189–90). Yet he returns inevitably to the servitude of the women. He compares crowds of them at a casino dance to five hundred sheep packed into a little cargo-boat en toute to Algeria (*TB*, p.197). All these vertical women, soon to be horizontal: 'On dirait une colossale botte d'asperges' (Ibid.). Cuttingly, he describes night-clubs, where 'on s'amuse à s'ennuyer' (*TB*, p.90). Nevertheless, he sees in the flesh how fulfilled and cosy some of the men-women relationships are: money is sent regularly to families back home, and some saved for the woman's eventual return to France; the man buys her presents. Such arrangements create a good boss/employee relationship (*TB*, p.200). If prostitution must exist, and Londres sees it as an age-old ('the oldest') and worldwide profession, let it have at least these consolations. The local pimps are in it mainly to pamper themselves and their women. Unlike the Europeans, they blue their earnings, and spend much time stealing women from European pimps (*TB*, pp.201–4). There is little honour between thieves of different races.

Londres sums up his aims in writing this book: 'J'ai voulu descendre dans les fosses où la société se débarrasse de ce qui la menace ou de ce qu'elle ne peut nourrir. Regarder ce que personne ne veut plus regarder. Juger la chose jugée' (*TB*, p.207). As in *Chez les fous*, he wishes to speak up for the silenced or inarticulate ones: 'J'ai pensé qu'il était louable de prêter une voix, si faible fût-elle, à ceux qui n'avaient

plus le droit de parler' (ibid). In this effort, we cannot of course rule out a use of ventriloquism at times. From the women's angle, hunger and poverty are at the root of all prostitution. From the man's: sexual voracity and cash to spare. 'Il y aura toujours des femmes à vendre tant qu'il y aura des hommes pour les acheter. Et l'on verra la fin du monde avant de voir la fin du demi-monde' (*TB*, p.208). Such fatalism or realism precludes any preaching: 'Foin de la belle morale!' (*TB*, p.213). Even the League of Nations in its attempt to get at the true facts of the sex-industry based its findings too much on documentation at the expense of observation *in situ*: 'Les dossiers n'ont jamais été constitués pour combattre la traite des Blanches, mais pour dégager la responsabilité des fonctionnaires chargés de la combattre' (*TB*, p.209). Londres at least went to see for himself, at grass-roots level. Officially, in the USA especially, too much is swept under the carpet: 'La vertu, pour eux, est le vice qui ne se voit pas' (*TB*, p.209). His final statement is: 'La responsabilité est sur nous. Ne nous en déchargeons pas' (*TB*, p.214). What can this mean, in practice? Abolish poverty? Practise brain-surgery or castration on men?

Le Chemin de Buenos Aires, in terms of international recognition, is probably Londres's most famous book, widely translated. The subject-matter played a big part in securing that extensive readership. A play adapted from the text by Yoris Hanswick and Harry Mass received scores of performnces in Paris, and Vichy, theatres, in the period 1928–1932. Apparently, Serge Eisenstein wanted to film it.[19] Before embarking on the *Georges-Philippar*, Londres met Henri Champly, special correspondent of *Le Temps* in Mukden, and encouraged him to make a Chinese equivalent of *Le Chemin de Buenos Aires*.[20] Pierre Mac Orlan, novelist and roving reporter, sometimes referred to his own reportages as documentary films. Late in life he confessed that, if he could have his time over again, he would prefer to have made films rather than books:

19 According to *L'Ami du Peuple* of 7 April 1930. (In Archives, 76/AS/9).
20 According to *Le Journal*, 29 June 1933.

144

La formule la plus émouvante de reportage est celle qui se rapproche le plus, non pas d'un scénario pour film documentaire mais des moyens littéraires et plastiques employés afin de créer une émotion. Le voyage d'Albert Londres à Buenos Aires est un film, un documentaire dont l'adaptation à l'écran serait surprenante et pourrait créer un très sincère sentiment de pitié.[21]

Gauchos, the pampas, corned beef, Evita Perón, the tango (which began its exotic life in bordellos and casinos), football: these are some of the stock images of Argentina. Londres provides a different focus. Today, of course, it is East European prostitutes who immigrate in large numbers to many more prosperous countries. For the first time, with *Le Chemin de Buenos Aires* Londres projected to write a book first and then publish it divided into articles in *Le Petit Parisien* afterwards. He was getting closer to the idea of writing literature rather than despatches.

Le Chemin de Buenos Aires has attracted strong critiques and eulogies. For Guy, 'Albert Londres […] transformed his favourable impressions of French pimps in Buenos Aires into an antifeminist, anti-Semitic, pro-French text. He truly confused Europeans by contradicting the League of Nations observations'.[22] My foregoing close analysis refutes all of these charges, which stem from a preset agenda. Guy is on less shaky ground when she observes that 'in many ways the white slavery debate was the quintessential discourse on how presumed dangers of female immi-gration linked gender and family issues to national identity and international prejudice'.[23] In general largely supportive of Londres's attitudes, his biographer Assouline finds that *Le Chemin de Buenos Aires* elicits conflicting responses: 'La révolte, la nausée, l'incrédulité, le fou rire'.[24]

Theodore Dreiser is more generous, and borrows, in his text on Londres's book, from Norman Douglas's *South Wind*, the criterion of 'readers widely in touch with life'.[25] Dreiser writes sarcastically against

21 Pierre Mac Orlan: 'Les Compagnons de l'aventure: correspondants de guerre et grands reporters'. In: *Le Mystère de la malle no.1* Ed. Francis Lacassin. Paris: Union Générale d'Editions, 1984, p.236.

22 Guy: *Sex and Danger*, p.114.

23 Guy, p.7.

24 Assouline: *Albert Londres*, p.462.

25 Theodore Dreiser, preface to Eric Sutton's translation, *The Road to Buenos Ayres* (London: Constable, 1928). Dreiser wrote this homage when on a factfinding tour of Soviet Russia in 1927–8. At the request of Constable, Dreiser included a

the biblical saw that the wages of sin is death. As his own investigations prove, and now those of Londres, such wages are just a different form of life, often respectworthy. He agrees wholeheartedly with Londres's conclusion about the crying need to reduce or abolish poverty, which will in turn reduce or abolish prostitution. It is a very enthusiastic text, in which Dreiser confesses to having had his eyes opened and his opinions seriously modified. He admits, too, having been seduced by Londres's style and humour. He salutes 'the informed, dispassionate, critical and yet sympathetic and understanding mood and manner in which the whole matter is approached'. The book 'is sui generis'.

Paul Morand, who had met up with Londres in Africa, registers his admiration for his fellow-peregrinator, in particular his refusal of closure or sermonising:

> Ou bien il conclut que les Françaises sont des 'malheureuses', fin tolstoïtienne qui met tout le monde d'accord. Londres n'a pas à être moraliste; il est reporter; il a eu ces renseignements si précis – comme il l'a dit lui-même – parce qu'il est favorablement connu dans le 'milieu' grâce à ses interventions en faveur des bagnards et des gens de Biribi; naturellement il ne saurait charger ses informateurs.

A ship's doctor told Morand that each of eight Frenchwomen travelling to Buenos Aires had in her possession a copy of Londres's book. Morand asked him what had been the reaction to it of Argentinian citizens: "'Le livre", me dit-il, "n'a pas nui aux grands barbeaux [pimps] qui ont des capitaux et des relations, mais il a porté préjudice aux 'maquereautins' [small-time ponces] et aux 'chevaliers de la belote' [cardsharps]'".[26]

One such local respondent, Mariel Soriente, suggests that the image of Buenos Aires as a paradise, or hell (according to taste) of prostitution, of racy perdition, was consolidated by Londres's book. In this view, like the Polish writer Witold Gombrowicz's novel *Trans-Atlantyk*, Londres's text turns its back on the city centre to concentrate on the margins, the areas near the River Plate. Both writers were fascinated by the urban sprawl there and the constant flow of spending, financial or seminal.

footnote explaining the Mann Act of 1910, by which it was a serious federal crime to import women from abroad for immoral purposes, or to transport them across state lines within the USA. Though the motives of the act were unimpeachable, it gave rise to widespread malicious abuse, being often interpreted to embrace voluntary immorality, and used to harass political enemies.

26 Paul Morand: *Paris Tomboctou*. Paris: Flammarion, 1928, pp.259–60.

Both stress the wasteful illuminations and the crowds' electric energy in the popular amusement-areas. Soriente thus puts Londres in unexpected company, especially when Borges is added to the stockpot. Finally, Soriente detects the central element of melodrama and betrayal in both the Pole and the Frenchman, yet also their liberating subversion of stereotypes. Soriente, however, no more than Guy, is sensitive to Londres's serious use of humour to study sexual servitude.[27]

I move now to a different kind of economic slavery: the Persian Gulf pearl-industry.

A Real Choker: *Les Pêcheurs de perles* (1931)

Amongst Londres's several motives for this journey to the Middle East must have been some compulsion, after concentrating on the Jews in *Le Juif errant est arrivé* (1930 in book form, 1929 in newspaper articles), to give some sympathetic attention to a specific group of Arabs. Already, in 1925, Londres had interested himself in the area and in the case of Captain Gabriel Carbillet, who had been nominated in 1924 governor of the Jabal al Druze, one of several autonomous regions in Syria (see Chapter 3). A zealous moderniser, Carbillet managed to alienate certain Druze notables, who protested to General Sarrail. Sarrail supported Carbillet, and arrested the complainants. This led to a general Druze uprising which was later joined by nationalist chieftains from Damascus. The aim of these was 'a curious mixture of holy war, demand for independence from France, and appeals to the principles of the French Revolution and the rights of man'. The Druze area was reconquered in April 1926.[28] Londres, like his hero Sarrail, defended Carbillet on his excellent record

27 Mariel Soriente: 'La Ciudad de la traición; Gombrowicz/Albert Londres: trayectos y apropiaciones en la construcción del espacio urbano porteño'. http://www.filo. uba.ar/Departamentos/letras/teolit/Teolit11/soriente.htm. pp.4–5.

28 M.E. Yapp: *The Near East*, pp.88–92.

of construction of roads, schools, water-supplies, museums; he also put a block on tribal chiefs' rooking of ordinary Arabs.[29]

An investigation of the pearl-fishing industry and of more general slavery practices in the area of the Persian Gulf was a stand-in for, and a come-down from, Londres's keen wish to penetrate Mecca (inevitably) in disguise (cf. his tricking his way in to mental institutions). Sir Richard Burton had smuggled himself into Mecca in 1853 in the guise of an Afghan pilgrim. The nearest Londres could get was Jedda. His constant companion and priceless interpreter throughout the long trek recorded in *Pêcheurs de perles* was Chérif Ibrahim, of whose highly ambivalent status and reputation Londres was fully aware: 'Des rois l'adorent; d'autres le veulent pendre' (*PP*, p.33). Ibrahim is 'le compagnon mystérieux et indispensable' (*PP*, p.53).[30] According to Joseph Kessel, another renowned roving reporter and novelist of the period and later, Ibrahim and others were sending secret reports to the French government about the slave-trade (not banned by the Koran), operating between Abyssinia and Jedda.[31] According to Maurice Larès, however, the government also received adverse reports about Ibrahim, on the grounds of his mythomania and lack of professional conscience. Yet Depui, to give him back his original French name, was the only French Muslim officer in the French Army able to operate anywhere in Arabia and, as such, far too precious not to be entrusted with special missions.[32] Like St John Philby, he doubled up as secret service agent and a trade inter-mediary.[33] After holding out to Londres the exciting project of being spirited into Mecca in fancy dress, Depui backed down and, as a sop, offered Londres photos and pilgrims' accounts on which he could em-broider an imaginary visit to the forbidden city. When Londres refused

29 See *CR*, p.254 (December 1925), and Londres's preface to Captain Gabriel Car-billet: *Au Djebel Druze*. Paris: Argo, 1929, which is dedicated to Londres.
30 In a letter to his parents of 1930 (in Archives), about to embark at Marseilles, Londres mentioned joining up with Ibrahim, and recommneded him as a *poste restante* in Port Said.
31 See Joseph Kessel: *Marchés d'esclaves*. Paris: Union Générale d'Editions, 1984, pp.191–208 for these reports.
32 Maurice Larès: *T.E. Lawrence, la France et les Français*. Service de reproduction des thèses, Université de Lille 111, 2 vols, 1979, vol.1, pp.403–4.
33 See also General Diomède Catroux: *Deux Missions en Orient, 1919–1922*. Paris: Plon, 1958, pp.184–89, about his fluctuating relationship over some years with Depui.

this cop-out, Depui suggested in lieu Djibouti and the pearl-fishing industry.[34]

In Jedda, Londres draws a very unflattering portrait of pilgrims en route to Mecca, *on* the beaten track of the Hajj; the veiled women seem as frightening as the men: 'Une fièvre sacrée anime Djeddah [...] Ces lamentables voyageurs [...] sont comme possédés [...] C'est le champ de foire de la foi' (*PP*, p.37). On the other hand, the houses there are exotic, like (of course) the *Thousand and One Nights*. As Said remarks barbedly, the French pilgrim (he has in mind the lay, literary variety) in the Orient 'came to a place in which France, unlike Britain, had no sovereign presence [...] They ruminated about places that were principally *in their minds*'.[35] Londres was on better ground with his skin than his literary fancy, or rather he constructs a splendid extended conceit about bodily matters, when he homes in on the flies of Jedda: 'Elles vont par millions, toutes conscientes de leur origine. La mouche de Java ne fréquente pas la mouche de Bagdad' (*PP*, p.36). These are personalised flies, in two senses: they dog their hosts, and Londres anthropomorphises them: 'La nuit, quand les pèlerins sont couchés, elles les recouvrent comme d'une résille pour les préserver des insectes. Et les mouches de tous les pays en font autant pour chacun de leurs fortunés compatriotes' (ibid). In Jedda, gateway to 'le pays de la Vertu', Londres composes a long list of Koranic vetoes (*PP*, pp.38–40). The handful of European expatriates he compares, in their version of a ghetto, with convicts he had known in Guiana (*PP*, p.41). They are stranded, cabined/cribbed/confined. As in presentday Saudi Arabia, their mini-revolt smuggles in whisky and phonographs; and the Islamic law of Shari'a, then as now, exerts its savage sanctions on wrongdoers.

At Jedda, Londres succeeds in obtaining an audience with King Ibn Saud, who had taken up the torch of the eighteenth-century founder of the Wahhabite sect, ibn-Abdul Wahhab. Wahhabism is still today the official religion of Saudi Arabia, and is based on a literal interpretation of the Koran. Londres, instinctively hostile to all forms of puritanism, finds in Islam, unlike among the Jews, a 'défense absolue de penser pour

34 Assouline: *Albert Londres*, p.528. Though Depui's papers stated that he came from Morocco, he was in fact born in the Doubs. He converted to Islam, and was four times French consul at Jedda.

35 Said: *Orientalism*, p.169 (author's italics).

soi-même' (*PP*, p.44). (He was hardly to know that in the late 1930s Ibn Saud would initiate modernisation programmes financed by oil revenues). In Londres's time, Ibn Saud expressed undying hatred for Western civilisation. Unsurprisingly, when Londres goes to the audience armed with written questions, the meeting turns out to be another non-event. The next day, Londres receives the official reply: all is explained in the Koran (*PP*, pp.50–51).

The two most charismatic Englishmen of the region, St John Philby and T.E. Lawrence, sworn arch-rivals, supported opposing monarchs, respectively Ibn Saud and Hussein, of whom the former triumphed. In a text of 1925 on the British Intelligence Service, Londres writes of Lawrence:

> Puissance. Allure. Dernier refuge des hardis condottieri modernes. Le colonel Lawrence qui était colonel comme moi mais qui était Anglais, fut, pendant quatre années, le Sforza de cet Orient. Il inventa un royaume, le Hedjaz, et sacra un roi, Hussein [...] Puis Lawrence partit sous d'autres étoiles travailler de son métier de dieu (*PP*, p.267).

They never met. Beneath the sneering sketch quoted above probably lies, given Londres's nostalgia for a mythified French colonial past, a hankering for a French version of Lawrence or Philby. Malraux was too much of a cerebral fantasist to fit the bill.

Still seeking insights into the sources of power in the region, Londres next turns to the larger than life-size figure of Harry St John Bridger Philby, whose fortress-house in Jedda, with its menagerie of tethered dog-faced baboons, he visits in some awe. One day Philby was playing cards with Londres and various French officials when they saw a French pilgrim-ship, *L'Asia*, on fire in the harbour off Jedda. In Londres's cable to his paper, he writes of the horrific scene, where passengers desperate to reach the deck trampled to death all in their way. He hears the same cracking sound of skulls exploding in the intense heat that he had previously heard on funeral-pyres in India. He finds the survivors weirdly blissful and feels tempted to re-stampede them 'pour leur apprendre à s'émouvoir'. It seems that 'ils n'ont rien vu, rien entendu. Pour eux le cauchemar est complètement oublié [...] Ils sont béats'. With apparent callousness, he says of the dead: 'Allah les a pris. Ils revenaient de la Mecque d'où l'on gagne le paradis'. He had written very differently of the stricken ship in Yokohama (see chapter 5). No

150

doubt here his complete aversion from Islam as a faith dictates his coldness of approach.[36] In his version of the disaster, Philby mentions Londres's articles protesting the charges made against the French captain and officers, and suggesting that the shipping company was not keenly interested over the fate of a heavily insured vessel. Another of its ships had burnt out in a French harbour not long before this incident. The *Georges-Philippar*, on which Londres died, was to be the third such catastrophe.[37]

Philby, in Elizabeth Monroe's view, 'relished his role as a mystery man, and was pleased when from time to time it was embellished by European journalists'.[38] At different times, Philby acted as explorer, businessman, and political agent. For Londres, Philby served the British Intelligence Service as a freelance. Londres, it is true, sees British secret agents everywhere, but they probably were. The whole area was under British surveillance and, to some degree, control (*PP*, p.60). With characteristic exaggeration, Londres maintains that Philby knew the provenance of every fly in Jedda (*PP*, p.61), and that he strongly influenced Ibn Saud's policies:

> Philby est l'inventeur d'une nouvelle manière de conquérir: plus de cuirassés, plus d'expéditions, un portier! Un portier géant, génial, qui élèvera une porte à l'entrée du pays convoité, se couchera en travers, en interdira l'accès à tous les curieux et, enfin, le jour venu, quand on y aura trouvé du pétrole par exemple, l'ouvrira aux nobles enfants de son pays. Saluons bien bas Saint-John Philby, c'est un monsieur (*PP*, p.62).

Quite someone.[39] When Londres promises to write about Philby in *Le Petit Parisien* (which he did), Philby said he would return the

36 Londres: 'Devant *l'Asia* en flammes dans le port de Djeddah', *Le Petit Parisien*, 24 May 1930, in *Pêcheurs de perles*, pp.277–82.

37 H. St John Philby: *Arabian Days*. London: Robert Hale, 1948, p.271, 'written entirely from memory' (p.xv). According to Assouline: *Albert Londres*, p.538, Londres, on the contrary, accused the captain of criminal negligence.

38 Elizabeth Monroe: *Philby of Arabia*. London: Faber, 1973, p 154 Philby also met Joseph Kessel.

39 The image of the colossal doorkeeper owes something to the harem, though Philby was no eunuch. According to Monroe (p.153), he had a strong appetite for both Western and Arab women and, like Sir Richard Burton, complemented it by a large collection of erotica. He converted to Islam at a ceremony in Mecca in 1930, in Monroe's eyes, 'not as a faith but as a convenience' (p.164).

complement in *The Near East* (he didn't). They could share jokes. Playing on the French paper's name, Philby asks: 'Est-ce un exemple à donner aux enfants qui n'ont pas encore toutes leurs dents?' (*PP*, p.62). He ends by furnishing Londres with a safe-conduct through Arabia, Yemen and the Faresan Islands.

In the Yemen, Londres is danced and sung to while trying to sleep out of doors because of the suffocating heat (*PP*, p.63). On the Faresan Islands, turning at last to the pearl-fishermen, Londres accepts that they are pursuing a crazy dream of fortunes and, in this sense, are nobody's slaves. Or at least he accepts that they believe this themselves, and it keeps them going (*PP*, p.56). Later he agrees more debonairly with their self-estimate: 'Ah! Poètes superbes et illettrés!' (*PP*, p.70). Most of the time with them, however, he occupies himself with the gruesome reality of their daily labour rather than their dreams. He knows very well that they live in a Catch-22 situation, for they have, as in the American folk-song, sold their soul to the company store. Though they receive advances from shipowners, they can never repay their debts. Indeed, some blind men persist in diving; they feel for the pearl-oysters (*PP*, pp.71–2). Londres thoughtfully supplies readers with a list of types of oysters and of the pearls some rare ones contain. He watches the operation 'occupé par mon propre émerveillement' (*PP*, p.80). I doubt that he ever lost this capacity for asonishment.

The craziness of the searchers is partly due to their consumption of kat, leaves productive, when chewed, of an addictive drug similar to amphetamine, which staves off weariness and hunger. 'La ville entière n'était peuplée que de maniaques échappés le matin même d'un asile d'aliénés' (*PP*, p.81). Offered some kat Londres can hardly refuse. He does not describe its effect on him, possibly because he cannot remember. Most of the little money earned by the working population goes on buying kat.

He then travels by sambucca to the coast of Eritrea. It is a very deviant, digressive odyssey, for the boat takes him in the opposite direction to his destination in the Persian Gulf, but there is habitually something very leisurely about Londres's movements.

After the advent of Ibn Saud, slavery had to become more clandestine. African slaves of both sexes, bought to work in homes or harems, were sold in undercover markets – some of them cheaply as faulty goods, export rejects, Londres add with bitter humour (*PP*, p.94).

152

As in *Le Chemin de Buenos Aires*, Londres tries hard to imagine the compensations of being a slave: the extreme poverty they have escaped back home, whereas in Arabia they enjoy food, a roof, and clothes (*PP*, p.96). Londres takes a photo of a black with a child slave. Later on, the man takes the concerned Londres to see the child happily installed with his 'real' family. It is not the same child (*PP*, p.93). By implication, Londres makes the crucial point, still as urgent today as then, that many are literally born into slavery.

Londres does not hesitate to mention his own less dramatic sufferings in the infernal heat of Djibouti. As in Indochina, the sun crushes mere humans: 'Le nez penche vers les souliers. Personne ne peut la lever. Rien à faire, le soleil pèse trop lourd' (*PP*, p.101). The sun, and the writing, are both hyperbolic. Aden is a hell on earth, another, alien, planet, as in Nizan's *Aden Arabie*. Eventually, in a German cargo-boat, he reaches the Persian Gulf, the Pirate Coast (no sign of them), Dubai, and Bahrain. Londres's journalism always relays to us the lengthy difficulties of simply getting somewhere. Londres has by now donned Arab gear. A photo in the original edition of his book shows him, if not as a dead ringer, at least, to Western eyes, as a passable Arab.

Pearling had long been a mainstay of the economies of the Gulf states, but around 1929, just before Londres's visit, pearling started to collapse as an industry, both because of the world depression and competition from Japanese cultured pearls. Thus Londres was observing a phenomenon in terminal decline. It would soon begin to be replaced throughout the region by oil, which also takes a heavy and ongoing toll on human lives by other means. Neverthless, Bahrain, when Londres saw it, was still totally monopolised by the pearl industry; 15,000 divers were engaged in it. He provides details of how advances, either in kind or in cash, from the employers have to be repaid at very high rates of interest. Above all, the work itself is regularly lethal in the short or long term. Dangers from nature are sharks, swordfish and electric rays. Illnesses include ringworm, conjunctivitis, heart problems, wrecked lungs and ears (deafness, perversely, is valued as a sign of experience) (*PP*, p.135). Lives are shortened. His decriptions of dives, admittedly from the safe vantage-point of the boat deck, are graphic. Here are the gasping men resurfacing:

> Chacun se raccroche à la corde avec un air de souffrance. Ils arrachent la pince. Du pouce et de l'index ils pressent leurs yeux fermés, comme pour en exprimer un mal; ensuite ils passent leur main sur leur visage, par-dessus leur tête, comme un chat qui se nettoie (*PP*, p.141).

Trying to simulate their endurance by holding his breath, Londres manages only 35 seconds, whereas the divers can stay under for 120. They are dead set against modern technology such as diving-suits, for these would entail mass unemployment (ibid.). He watches one diver lose consciousness on resurfacing; another's nose and ears bleed profusely, yet he plunges again (*PP*, pp.142–3). Again, though continuing to call them slaves, Londres cannot help recording their boyish excitement over the hunt and the all too rare success. Slaves but not convicts (*PP*, p.140).

His conclusion is that,

> abîmés par le métier, ces esclaves se laissent éblouir par leur chance – leur chance platonique. Et c'est cela qui me parut merveilleux, bien plus que la perle, bave salée, vain objet de parade, joie puérile pour les femmes, peine inhumaine pour les hommes (*PP*, p.149).

Londres had originally wanted to call *Pêcheurs de perles A ce prix, Mesdames*, but any reader can see for herself or himself the tight connexion between the ruination of the impoverished pearldivers' lungs and ears and the adornment of rich women's throats. After all, pearl necklaces are known as chokers. The last contrasting image if of 'le riche collier pendu au col, le pauvre pêcheur pendu à sa corde' (*PP*, p.150). This is economic colonialism, and he notes the ponderous presence of Parisian jewellers' agents, haggling over the congealed smear called pearls.

Like Nizan's *Aden Arabie* (1931), Londres's text seeks to serve up not a *digestif* for armchair readers' fat and contented bellies as they consume the exoticism, but a tonic *vomitif.*

Ghettos and Peregrinations: *Le Juif errant est arrivé* (1930)

Londres's reportages are not watertight blocks. He enjoyed his memory, and he recycled favoured topics. The world of the 1920s and 1930s was already well on track to becoming the global village McLuhan later wrote of and that we are supposed to inhabit today. Londres first mentioned Jews in his despatches from Salonika during the First World War, then again in obvious relation to Palestine during his tour of Lebanon and Syria in 1920. They reappear in his texts on Soviet Russia the same year. In 1926, he visited Jewish settlements in Poland. In 1927, Jews formed part of his investigations into the vice trade in *Le Chemin de Buenos Aires*. It was therefore natural and logical that he should finally embark on a thorough study of their plight and their possible escape-route, in 1930, in *Le Juif errant est arrivé*. These collected articles narrate his lengthy trek from Whitechapel to the Carpathians, Czechoslovakia, Poland, Romania and Palestine.

On a cross-Channel boat from Calais to Dover, Londres surveys large numbers of suitcases bearing stickers from all over the globe, and thus sets up the worldwide dimensions of his enquiry. Suddenly, a Jew, probably a rabbi off to the East End of London to collect alms, surges out of the crowd of comfortably-off Gentile travellers. His dress, hair and everything else about him render him distinct. On the boat-train to London, Londres spots him again, and shows himself more mocking towards the nosiness of the tourists than towards the singularity of the Jew. He has clearly familiarised himself with the terms for Jewish accoutrements (*JE*, pp.16–19). Yet he does not downplay his own culture shock at the sight of 'his' Jew reading the Talmud while gesticulating vigorously: 'Le Juif s'exprime autant avec les doigts qu'avec la langue. Manchot, il serait certainement demi-muet!' (*JE*, p.20). When he describes the act of reading in these terms; 'Le rabbin broutait son texte, les lèvres actives comme un lapin qui déguste' (ibid.), is he belittling the man and his faith, or acknowledging the nourishment furnished by the book? His words do set up a certain distance, or rather register one that is indisputably there. Later, he writes: 'Leurs doigts dansent comme des marionettes' (*JE*, p.101), which hovers between the charming and the robotic.

Having tailed the rabbi and his small reception committee to Whitechapel, Londres gets himself fixed up with a Yiddish-speaking interpreter, Polish by birth, provided by the Zionist Office. As in Japan, Londres gives full rein to his Frenchness as regards food, especially the bloodless kosher meat. He jokes about ordering a giraffe steak. He allows himself great latitude in parodying the list of taboos in Leviticus.[40] He invents one beast, *le choerogrylle* (*grylle* = monster). Refusing to join in the mockery, for Jews prefer to laugh at themselves, his interpreter challenges him to find, among the restaurant's hetero-geneous clientele, a stereotypical Jewish face. He cannot (*JE*, pp.22–4). These Eastenders are Jews first, English second, but glad to be English (*JE*, p.25). The interpreter maintains that the most virulent opponents of Zionism are the fanatical rabbis of eastern Europe, as Londres will see for himself later in the text (ibid). The particular wandering Jew that Londres has followed so far is indeed a rabbi who, among his largely integrated coreligionists of Whitechapel, stands out 'comme une bouée pittoresque sur une mer indifférente' (*JE*, p.29). The kind openness with which Londres is greeted by East-End Jews, and their readiness to respond to his questions, indicate that he is not felt to be a hostile witness. Before reaching the heartland of Eastern European Jewry, Londres is already strongly aware of the toxic antisemitism rampant there, and the only likely solution to it: escape to Palestine: 'Le problème juif est compliqué, mais je crois qu'il se résume en une question d'air. Respirer ou ne pas respirer. Ni plus ni moins' (*JE*, p.31).

In London, he listens attentively to the thoroughly assimilated daughter of old Murgraff. He is trying to attain a global view of Jewry. The old man himself is deeply grateful for his forty years in England. There are, Londres is finding, many varieties of Zionists and anti-Zionists, just as Jews themselves are intensely variegated. Even if few assimilated Jews are Zionists, they recreate Israel wherever they are: schools for boys, and study of the Torah to which all are faithful: 'C'est leur drapeau national, leur hymne patriotique, leur soldat inconnu' (*JE*, p.34), he says, using cultural terms immediately comprehensible to a French reader.

40 The giraffe is in fact cloven-hooved and a ruminant, and so admissible, except that it is found only in sub-Saharan Africa, far from the Middle East!

They need air; they are hemmed in, denied more than congested space. Londres devotes some pages to international efforts to solve or alleviate the plight of Jews. The key figure is Theodor Herzl, the Hungarian-born journalist and playwright who energised the movement of Zionism to establish a Jewish nation with its own home. Despite his hard work to this end, he had little success in persuading comfortably-off Jews in Europe to emigrate or to subsidise mass-emigration: 'Il est très difficile, même au nom de l'idéal, de faire déménager des gens bien logés' (*JE*, p.41).[41] Though he was acclaimed as leader at the World Jewish Congress in Basle in 1897, and had meetings with Emperor Wilhelm ll and with the Sultan of Constantinople, England proposed only a location alternative to the hungered-for Palestine: Uganda. The San Remo Conference of 1920 mandated Britain to create a Jewish national home in Palestine. For Londres, as for many others, Britain was serving primarily its own interests in the Middle East, and indeed its proposals were a typical British fudge.

Throughout history, Jews have been demonised; it was well known that they munched up Christian babes. Ghettos were at initially chosen for self-protection, and then imposed as a sanitary cordon. The multiple diasporas were 'ghettos ambulants', nomadic closed spaces or prisons (*JE,* pp.51–2). Of course, some few Jews did attain high office in many countries, though often such assimilation was even more provocative to insiders than separatism (*JE*, p.52). In Russia, massacres by Cossacks, pogroms, became routinised. A split gradually opened up between Western (Sephardic) and Eastern (Ashkenazi) Jews. It is on the latter that, after East London, Londres concentrates, not forgetting a third strand, the Hasidic Jews, and their cult of miracle-working rabbis such as Bad Cham Tov. He obviously has less time and sympathy for the extremely long-term perspective of rabbis and orthodox Jews, who await the coming of the true Messiah to put an end to their miseries, than for the prospect of Zionists: Next Year in Jerusalem.

On his long trek to the East, Londres's first encounter is with the Jewry of Prague, where he lights on their hectic cemetery: 'Ce n'est pas un lieu de repos, mais un tumulte macabre' (*JE*, p.56). Of all European countries, only Czechoslovakia makes any attempt to recognise the

41 *Déménager* has the useful other meanings of 'to do a bunk', and 'to be off one's head'.

separate reality of Jews and their right to be Jews. When he makes to take some photos his subjects flee. He had his sketcher Rouquayrol with him again; his sketches appeared only in the *Petit Parisien* articles.[42] In Prague, Londres himself is the target of intense observation. If he finds Jews extraordinary, they repay the compliment (*JE*, pp.59–60). In his eyes, eastern Jews in the Carpathians 'sont Hébreux plus que Déroulède ne fut français' (*JE*, p.63). They are obliged to be, at best, middlemen. In Hungary they have betrayed fellow Jews (*JE*, p.65). The mutually loathing miracle-working rabbis, the *Wunderrabbi*, whose fetishistic cult Londres derides, stir up internecine strife. Unamazingly, (some) Jews hate (some) Jews. Rabbis of a more average kind play multiple roles (medical, legal, marriage-brokering), and thus enjoy powerful influences over the laity (*JE*, p.67).

Londres's two companions/explicators/interpreters in eastern Europe are Ben and Salomon, each speaking several languages and exhibiting sharp intellects. Londres seems most often at least semi-jokey about the religious observances of Jews, though he does admit that their seemingly crazy faith is all that they have in their great poverty to call their own: 'Pour moins grelotter de froid, ils grelottaient de piété sur le Talmud', he says, telescoping the everyday and the otherworldly (*JE*, p.74). Catching up with his title, he eventually meets a wandering Jew, a pedlar, of whom he sneaks ('en traître') a photo when he gives him a lift in his hire car (*JE*, p.79).[43] Mostly, instead of itinerant Jews, he comes across a majority of Jews who, through fear, fatalism, illness, old age, inertia, or extreme poverty, are in fact rooted ineluctably to the spot.

He gives several pages to pogroms (Russian for 'devastation'), which were born in Russia in the nineteenth century. These stemmed mainly from the military and students, though in Londres's eyes Eastern cultures and governments 'l'ont dans le sang' (*JE*, p.86). Pogroms are thus endemic. More widely, the urge to carry out such massacres is due to 'les nôtres, les sauvages européens' (*JE*, p.89). 'Un Polonais, un Russe chassent le Juif du trottoir comme si le Juif, en passant, leur volait une part d'air. Le Juif, pour un Européen central, est l'incarnation du parasite' (*JE*, p.91). Jews invented the scapegoat, but have become

42 Londres mentions him only once (p.202).

43 This photo is reproduced on the cover of the 10/18 edition. I must use a lower-case *w*: Londres makes no reference to the traditional legend.

158

everybody's scapegoat. Antisemitism is an ingrained habit in the region. Londres offers reasons, irrational reasons, how this situation has come about. He accepts the idea of the universal Jew, despite all the variations he sees. Israël, as an idea, an object of unconditional worship, 'n'est plus qu'Israel épars, mais toujours un' (*JE*, p.100). In Romania, he discovers a town full of shipping-offices, mainly for emigration to the West. How well he understands the alllurement of travel, the call of ocean-going ships (*JE,* pp.110–11). His refrain, as elsewhere in his writings (e.g. on Jews in Soviet Russia), is that they are an oriental people: 'La juiverie vit dehors' (*JE*, p.125). In the same Romanian town, in keeping with the stock image of Jewish clothiers, he marvels at a street lined with dozens of secondhand shops: 'Les rues ont l'air d'être les couloirs d'une fantastique armoire vestimentaire dont les vêtements, aidés par le vent, secoueraient leurs puces sur le passant' (*JE*, p.111). This combines stereotypical Jewish dirt and dynamic business-life. He meets some who have tried Palestine and come back disillusioned, 'des sionistes écoeurés' (*JE*, p.112). One couple, small traders, experienced failure there, and have concluded that Palestine is for the very rich or the very poor (*JE*, pp.112–13).

In Galicia (Poland), he sees abject poverty in the ghetto at Lvov: a sewer-cave packed with people of all ages, surviving amidst sewage (*JE*, pp.117–122). Taken for a Jew (not for the first or last time), he is knocked aside by a Pole (*JE*, p.123). He briefly mentions Pilsudski, on whom he had reported in 1926, and who has enough other dilemmas on his plate not to have much time for Jewish problems. Besides, Londres is inclined to guess that to some extent the Jews in Poland bring their woes on themselves (ibid.). Warsaw is the Jewish hub of Europe, but Jews are denied jobs, professions or higher education by the government. Pilsudski strove in vain to bring the whole situation back to the terms of the non-Antisemitic constitution.

Londres conjugates the Warsaw ghetto with real warmth, and is much taken with the inhabitants' vitality in the depths of poverty (*JE*, pp.130–1). Probably the biggest eye-opener of his whole tour is his ubiquitous discovery that Jews, commonly imagined to be as rich as Rothschild, are in fact, in the main, desperately poor. In the ghetto, as in Africa or China, his alert nose registers characteristic smells, here of Orthodox Jews:

> Cette odeur est un mélange d'essence d'oignon, d'essence de hareng salé et d'essence de caftan, en admettant qu'un caftan fume comme fume la robe d'un cheval en nage. Individuellement, peut-être, ne dégagez-vous aucune odeur, je le souhaite, mais groupés en lieu clos, vous empoisonnez, Messieurs! (*JE*, p.134).

While politely put and suggesting a reaction some way short of repulsion, this response to pungent smells is a bit rich coming from a member of the (then) infrequently bathing, garlic-and-Gauloises Gallic race.

More important is Londres's genuinely deep admiration for Jewish fostering of the intellect. He writes excitedly about the cerebral intoxication of rabbinical students. These truly amaze him by their unflagging concentration on learning and argufying: 'Depuis sept heures, ils ne cessaient de boire, de boire la science, la connaissance, le savoir, la découverte' (*JE*, p.135). They are simply insatiable:

> Et ce que ces jeunes acrobates de la pensée, ces fiévreux cérébraux apprennent ici, c'est moins la littérature, l'éthique et la morale juives qu'à devenir plus fins, plus déliés, plus pénétrants, plus prompts. Voilà du beau sport! (*JE*, p.136).

All in all, 'c'était très beau, nullement ridicule, émouvant, empreint de grandeur et respectable comme la folie' (*JE*, p.136). We should keep that last phrase in mind, for Londres's tone when describing certain outlandish Jewish rituals can seem to match the barge-pole tactics of milder antiSemites. *Chez les fous* had taught him respect for what he could not access but did not wish to write off in mockery. Even when he appears to mechanise the students' activities, he puts the stress on their dynamism: 'Cette usine intellectuelle. Les cerveaux tournent à plein rendement. Ces machines humaines [...]' (*JE*, p.138). These young men are concerned little with material things such as food: 'Quand on veut apprendre, il faut souffrir' (*JE*, p.139). As well as having suffering forced upon them, Jews impose it on themselves, for a higher end. The whip-cracking God of the Old Testament would be proud of them. In spite of his very real animation over the astonishing spectacle they provide, Londres more generally believes that this people, at the same time dispersed and compressed (diaspora/ghettos), secretes far too many fatalistic, theologically-minded, *Gottbetrunkener* fanatics for its own good, or even its own survival.

Londres himself, of course, is driven more by inner than outer demons. He makes a pointed joke of his pose as a writer/martyr: 'Ce martyr de grand chemin, ce pauvre voyageur qu'on ne laisse plus dormir

son saoul et que les directeurs de journaux mettent sur les routes par 36 degrés de froid comme s'il était un Esquimau!' (*JE*, p.142). A further self-imposed penance of the researcher is to accompany an agent of the Internal Revenue on his rounds of the Warsaw ghetto (*JE*, pp.143–9). Every tax-payer they meet haggles, laments, or brazenly lies. The tax-man usually settles for compromise, part–payment or postponement. Londres finds ghettos within the ghetto: lodgings with rooms concealed behind floppy wallpaper in which undeclared employees work in the mini-cottage industries of the black economy. Happily, Londres joins in the existential charade, noting that Jews are adept at turning everything round in arguments. The Polish inspector's personal wailing-wall is that 'nous venons exiger une dette, ils s'arrangent pour vous faire un emprunt' (*JE*, p.147). This is one of the few places where Londres makes space for that crucial fact of life: Jewish humour. This is particularly strange, as his own brand of humour has many affinities with it.

In a village near Warsaw, Londres encounters a *Wunderrabbi*, and thus secures his first interview ever with a saint: 'Approcher des rois, d'illustres personnages, confrères, cela n'est rien: mais un saint?' (*JE*, p.152). Each one of these star rabbis is the mortal enemy of the rest. Some specialise in curing mental ailments such as diabolic possession; others treat infertile women. They are fed and generally financed by pious Jews, and are the object of pilgrimages from all over Europe (*JE*, pp.153–4). As so often Londres reacts playfully, irreverently, in the face of such questionable majesty, and threatens to steal a hair of the prophet's beard (*JE*, p.155). In yet another dramatised non-event, a rabbi refuses to answer Londres's questions about his attitude to Palestine, or the poverty of Polish Jews, although his evasionary silence is eloquent (*JE*, p.157).

When Londres says farewell to his surviving interpreter, Ben, he thinks of the firm friendship that has developed on their travels. Ben maintains that what looks like Jewish stasis is anything but: 'Que notre état, momentanément sédentaire, ne vous abuse p*as* […] Nous sommes encore tous en marche vers un pic inaccessible' (*JE*, p.160). Ben divides Jews into four categories: '1. Les Juifs de chez vous: les assimilés; 2. Les Juifs d'ici: les emprisonnés; 3. Les Juifs de Palestine: les illuminés; 4. Les Juifs comme moi. – Les alpinistes?' (*JE*, p.161). Thus, despite Londres's title and its apparent reference to the legendary figure, there is, according to Ben, a wandering Jew, but one who frets on the spot or goes

round in circles, but never (so far) reaches his desired destination. Ben adds that Jews like himself are the true wandering Jews: idealistic but critical (*JE*, p.164). He ends by inviting Londres to write to him from Jerusalem and to tell him whether Zionism has any future. For himself, Londres would favour the Zionist summons to Palestine for those Jews who could not or would not assimilate to European society.

Setting off for Palestine, and quoting Lord Balfour and Winston Churchill, Londres makes clear his own critical stance on the self-contradictory, hypocritical-cum-pragmatic policy of Britain, and, as earlier in Syria, emphasises its hostility towards French interests in the Middle East. In Palestine, Londres is immediately struck by the very different appearance of Jewish pioneers: shaved and in open-neck shirts. Tel-Aviv: 'C'est clair, large, ensoleillé, tout blanc, c'est gai. On y sent la volonté acharnée d'oublier le ghetto' (*JE*, p.172). He had been in Haifa in 1919, and knew very well that the first Zionist settlers had been greeted by Arabs carrying clubs. Some of the archetypal wandering Jews have indeed arrived, but not to the same kind of welcome as 'le beaujolais nouveau'. Londres clearly admires the monumental work of the pioneers, seeking to make something habitable and fertile out of not very much, a truly inhospitable terrain (*JE*, p.179). The Wailing Wall brings back to him the tragic experience, but also the decidedly odd-looking rites, of the Jews (*JE*, pp.184–5). On return to Paris, and hearing of massacres of Jews, he returns to Palestine. Altogether, he gives a fair account of the genuine and extensive Arab grievances (*JE*, pp.206–7). In his view, Zionism is this: 'On ne devient pas sioniste par raisonnement; le sionisme est même, je crois, le contraire de la raison. On est sioniste par instinct' (*JE*, p.215). He finds, at least and at last, some happy Jews (*JE*, pp.216–7).

The book appeared in January 1930, two months after the final newspaper article. His friend Edouard Helsey brought out his account the same year: *L'An dernier à Jérusalem*.[44] Helsey's book is much more patient and detailed, though of course it limits itself to Israel, whereas Londres's straddles Europe. Helsey's too tries to be even-handed between Arabs and Jews; and it bears some strong vestiges, unlike his friend's, of Christianity. Helsey's conclusion is perhaps necessarily wishful thinking, since he admits the mutual visceral loathing between

44 Paris: Editions de France, 1930.

the two parties to the bitter dispute. His proposal is for a Jewish enclave within Palestine, though this would obviously curtail severely the number of Jewish immigrants. Londres and Helsey, in Paris, took part in a major debate on Palestine at the 'Causeries populaires du 20ème', under the aegis of Bernard Lecache and his Ligue contre l'antisémitisme.[45]

Le Juif errant est arrivé cannot be thought of, nevertheless, as playing a positive part in a concerted campaign, except that reminding people of what they should know already, and in the process interesting them with drama, humour, and generally lifting readers out of their own backyards, is a crucial element in investigative journalism. It does, however, ask the recurrent question: Who benefits from racism? Just as *Terre d'ébène*, *Le Chemin de Buenos Aires*, *Les Forçats de la route*, and *Pêcheurs de perles* had asked who profits from colonial exploitation, prostitution, commercialised sport, and a lethal luxury-goods industry. The snide answer in each case is of course: the exploiter and the oppressor. But the asking of the question remains a necessity. We have seen how some of Londres's campaigns, about prisons or asylums for example, did produce tangible results, in the form of alleviation of appalling conditions. His coverage of Antisemitism, on the other hand, could be only a fine but materially ineffective lament over man's infinite capacity for inhumanity. What he proves, however, is that you can be firmly critical of, and joky about, aspects of Jewishness without thereby deserving the label of Antisemite.

The myth of the Wandering Jew derives from the incident in the Gospel narrative in which Christ, staggering under the weight of the cross he is bearing and that will soon bear him, asks a shoemaker if he can rest on a seat. He is refused permission. The Jew is thereafter condemned to roam the world eternally, damned and homeless, in expiation for his sin. Londres makes no reference to this myth, which has evident Christian and anti-Jewish foundations, nor to the two best-known French literary extensions of it, by Edgar Quinet and Eugène Sue (who added Socialism to the already heady brew). Sue also helped to foster the idea, much more palatable to Londres, that Jewry can represent suffering humanity at large.

45 See Assouline: *Albert Londres*, p.522.

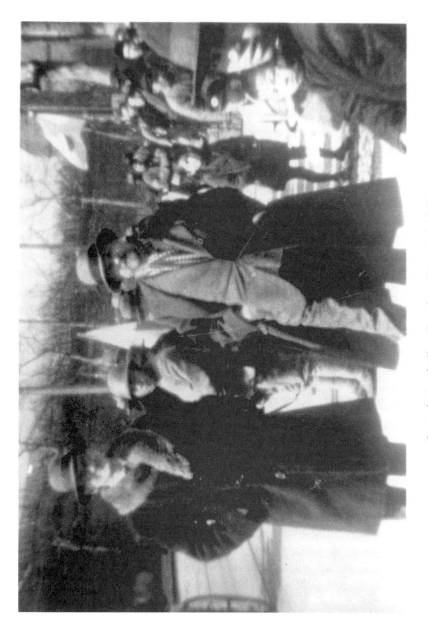

Last photo of Albert Londres, Shanghai, 1932.

Chapter 7
China, and Death

It is not at all surprising that Londres, the incurable traveller, should have been drawn to the wanderings of the Jews. The unattributed epigraph to *La Chine en folie* (1925) runs: '...puis il y a celui qui voyage comme l'oiseau vole, parce que Dieu à l'un donne des ailes, à l'autre inquiétude'.[1] Here Londres recalls his younger admiration for Barrès, who famously made a cult of a rather cosy 'inquiétude'. In the text itself, Londres reverts to his earliest pseudonym, Jean-Pierre d'Aigues-Mortes (used for his tyro articles in *Le Petit Marseillais*), in order to grace and reiterate his feelings about travel:

> Et Jean-Pierre huma le large passionnément.
> S'il voyageait, c'était comme d'autres fument l'opium ou prisent le coco. C'était son vice, à lui. Il était l'intoxiqué des sleepings et des paquebots. Et, après des années de courses inutiles à travers le monde, il pouvait affirmer que, ni le regard d'une femme intelligente, et malgré cela proprement faite, ni l'attrait d'un coffre-fort, n'avaient pour lui le charme diabolique d'un simple et rectangulaire billet de chemin de fer (*MS*, p.143).

This is no doubt the Romantic version of a deeply-entrenched passion. Later, having exclaimed 'Un train, ma seconde patrie!' (*MS*, p.183), and having left behind a delightful and touching Russian lady, met by chance in a hotel, he notes more realistically how, once you are on a train, the past quickly recedes; we live then forwards, as indeed biologically we never fail to do. Then, more measuredly, he offers a jovial, telescoped account of his travels, his infrequent returns home, and his repeated sense on reaching there that nothing has changed, nor probably ever will change. Hence the cyclical urge to be off again. At the outset of this book, I quoted Londres on the point of his travels: 'J'aime moins le

1 *La Chine en folie*, in *Mourir pour Shanghaï*. Ed. Francis Lacassin. Paris: Union Générale d'Editions, 1984, p.134. This edition contains, as well, Londres's articles on the Sino-Japanese conflict of 1932, for *Le Journal*, under the heading *Mourir pour Shanghaï*. The abbreviation *MS* serves for both texts.

décor que le mouvement', and, unusually for a Frenchman; 'Le monde ne tient pas dans la carte de France'.[2] He wanted to be, and to write, on the move; France could not contain him.

Even his friends mythified him. Here is Henri Béraud going over the top: 'Mon vieil Albert Londres, qui serait allé depuis longtemps dans la lune, si le parcours ne lui avait semblé un peu court et par-dessus le marché bien monotone'. Such stalled excitement typifies this poseur, and Béraud later adds: 'Plus les hommes se frottent entre eux, plus ils se ressemblent. Le siècle de la bougeotte sera celui de la banalité'.[3] *Se frotter:* on his many travels and in daily life, Béraud had the twin gift of rubbing up to people, and of rubbing them up the wrong way. Londres could not differ more. Londres has the true globetrotter's credo: 'Sur la grande-route on n'est jamais blasé. Plus les étonnements succèdent aux étonnements, plus ils sont vifs' (*AB*, p.146). More thoughtfully than Béraud, Michel Leiris – ethnographer, poet, lucidly and ludically word-drunk – records his verdict on travelling: 'Le voyage ne nous change que par moments. La plupart du temps vous restez tristement pareil à ce que vous aviez toujours été'.[4] Neither he nor Londres would ever have seconded Béraud's disabused summation of his own life's work:

> Le reporter a pris ses vacances avec sérénité, en homme qui ne confond point son ouvrage avec la tâche de l'historien et moins encore avec la mission du prophète. Il n'a voulu être, il ne sera jamais qu'un flâneur solitaire et amusé.[5]

Despite the endemic travel-bug, that mental malaria never to be fully shaken off, by all accounts Londres loved his home town, Vichy, even in its corniest aspects: concert audiences in full fig; bourgeois valetudinarians supping the whiffy waters, allegedly so good for one; people sitting on café terraces, watching the world go by. Even this stasis Londres termed 'chair travel'.[6] Travel, it is said ad nauseam, broadens the mind – or, we might add, the mindlessness. Travel is escapism (but remember Lucertius on everyone 'trying to get away from where he is,

2 Quoted in Ambrière: 'Au Pays des grands reporters, Albert Londres', p.289.
3 Henri Béraud: *Rendez-vous européens*. Paris: Editions de France, 1928, pp.9, 19.
4 Michel Leiris: *L'Afrique fantôme* (1934), in *Miroir de l'Afrique*. Ed. Jean Jamin. Paris: Gallimard, 1996, p.352.
5 Béraud: *Rendez-vous européens*, p.221.
6 Gaston Chardonnet: 'Albert Londres'. *Bulletin de la Société d'Histoire et d'Archéologie de Vichy et des environs*, 43, 1950, p.250.

as if mere locomotion could throw off the load'.[7] Londres did travel to broaden his mind beyond French umbilicism, to extend his interests and knowledge, to spread his sympathies, and to bring home to readers what they did not, or did not care to, know, before he told them.

In China, first of all he needs to locate himself. *La Chine en folie* gets under way with Londres experiencing that common phenomenon, memorably described by Proust, of waking up and not knowing where you are. Picking up on the epigraph and its voyaging birds, he asks: 'Où étais-je? Au Caire? A Tokio? A New York? Temps délicieux où l'on ne sait pas où l'on vit! La mouette saurait-elle dire sous quel degré de latitude se trouve la vague qui la berce?' (*MS*, p.158). More pressingly: what am I doing in China? Were his readers in France waiting and panting for his despatches on that far-off conflict?

> Un beau crime à Ménilmontant l'emportera toujours sur une guerre dans la province du Tchély, mon ami. De plus ne sais-tu pas que cinq mille cadavres n'ont jamais la même valeur suivant qu'ils pourrissent à cinq cents ou à vingt mille kilomètres de Paris?
> Bah! Un reportage est un reportage (*MS*, p.159).

Even if he could hardly hope to mobilise French opinion on this distant drama, as he did with his reports on social problems in the West, he could at least inform his readers better, and keep on schooling them in the difficult but indispensable skill of maintaining scepticism in the face of official versions of the news.

During what is commonly called the 'Warlord Era', that is, roughly 1916–1931, China was far from being a monolithic country. The lack of any effective central republican government led to a feudalisation of governance. The period was one of virtually continuous civil war. Londres sums up the resulting situation briefly: 'Chine: chaos, éclat de rire devant le droit de l'homme, mises à sac, rançons, viols. Un mobile: l'argent . Un but: l'or. Une adoration: la richesse' (*MS*, p.146). He allows himself some black humour about rape and pillage in the villages: 'Les dames qui ont horreur de l'imprévu dans le plaisir se jettent dans les puits pour échapper au rut déchaîné' (*MS*, p.147). He retells horror stories, only too likely to be true: children tossed out of windows on to

7 Lucretius: *The Nature of the Universe*. Tr. R.E. Latham. Harmondsworth: Penguin, 1957, p.128.

bayonets (*MS*, p.148). The unremittingly sarcastic tone is due firstly to Londres's feeling bewildered amid the chaos, like everyone else he meets, besides, and secondly to his having no manageably-sized group amongst Chinese multitudes for whom he might feel compassion. How could he crusade in a civil war? All he can honestly register is the absolute shambles of the divisions and subdivisions of this vast country, and the largely farcical attempts at central control, either in the north (Peking/Beijing), or the south (Canton/Guangzhou) (*MS*, p.149). This internal situation is exacerbated by rivalry between external powers, such as Japan and the USA, who treat China as the locus for international appropriation. In Mukden (now Shenyang) in Manchuria, Londres keeps up the same, rather forced, jolliness. Everything, everyone, is crazy: 'Le genre humain est complètement toqué' (*MS*, p.153). (1925 was the year also of *Chez les fous*). A key problem for Londres, more acute here than in other contexts, was his lack of the apposite language, though as always he makes virtue of necessity. Asking a coolie to guide him to a hotel, he explains: 'Et comme je parlais le chinois à la manière des sourds-muets, je mis les mains dans la position d'un oreiller et je couchai ma tête dessus' (*MS*, p.153).[8] Reminding readers as always that despatches do not come out of nowhere and take their toll, he brings home to us the freezing hell of the northern Chinese blast, progressively compared to sandpaper, steel wool, and razor-blades (*MS*, pp. 153–5) – a cumulative hyperbole, though no doubt near the knuckle. He had lost his precious travelling-rug in Finland, en route to Russia, after it had gone everywhere with him from Salonika onwards. A very few belongings were ever his movable home.

He provides a potted biography of a warlord, Zhang Zuolin, who, on the run from service in the Sino-Japanese War of 1894, had made a brief stop-off with French nuns, whose short-lived catechumen he became, before turning to banditry (*MS*, pp.160–179). The house rules of his gang of cutpurses were: robbery only on the open road, murder only if necessary, torture if relevant. Gradually, having teamed up with the Hang-Houzes (Red Moustaches), he gained control over a whole province. In the Russo-Japanese War of 1904, Zhang Zuolin acted as a spy and a guerrilla. Taking over all Manchuria, he grew rich. A persistent turncoat, he served successively the Empire and the Republic of

8 Cf. his recourse to mime in *Le Juif errant est arrivé*.

China. Ruthless, he had a rival chief murdered. Eventually, he proclaimed himself viceroy of Manchuria. He was still illiterate. Londres is clearly astounded at this man, who has come to command an army of 300,000 men. Two concentric circles of bodyguards protect him. Of their interview, reached after negotiating innumerable guardrooms and hordes of officials, Londres writes understandably in a state of extreme nervousness, for Zhang Zuolin is an ace decapitator, and Londres is a world away from home and safety. The interpreter could write a book on Londres's gooseflesh. Zhang is as lowslung as Napoleon, and it is impossible to catch his eye, though he looks like a bird of prey. To preserve himself from excess awe, Londres examines for vermin the chair offered him by the apparently half-asleep Zhang. He can even enjoy the display of self-abasement customary on such ritualised encounters in China: 'Appeler Excellence ce vieux forban était pour moi faire un plongeon dans le ravissement' (*MS*, p.176). Londres's questions make the interpreter choke (*MS*, p.177).The whole set-piece has grown increasingly comic. The climax comes when Londres is lent Zhang's bulletproof automobile, bristling with armed guards, to take him back to his hotel: 'Je fends, tyran à mon tour, Moukden terrifié' (*MS*, p.179).

In a romantic interlude (the only one in all of his writings), a brief encounter, Londres listens attentively to the poignant life-story of a beautiful, blonde Russian lady. She has fled the Bolshevik Revolution, and landed up in China, where she has been treated as a Russian spy, robbed and assaulted. With no details, she and Londres spend the night together (*MS*, pp.180–90). This romantic stopover makes a refreshing change from the usual discomforts and frustrations of often primitive travel, which Londres, besides, always endures with great forebearance.

Peking Londres finds in a state of total anarchy: no-one in charge, nobody paid, everything up for sale (*MS*, p.199). The police-chief is hounded by his men for wages (*MS*, p.204). Peking offers the spectacle of a desperate free-for-all that has still to be paid for: 'La plus échevelée foire d'empoigne des temps anciens et modernes est ouverte' (*MS*, p.198).

For all his temperamental anarchism, Londres can never celebrate it in practice, though he does marvel at life going on pretty smoothly in the absence of effective government; as (notoriously) with fascism, the trains run on time. To his repeated question – is China a republic or an empire? – he receives only mystified or evasive answers (cf. the French

idiom 'réponse de Normand'), except for the suggestion that he should think of the situation as a Chaplin film. Do not ask impossible questions; swallow it whole (*MS*, p.213). At a meal with Chinese journalists, Londres seeks to avoid eating any of the dubious dishes by stoking up elsewhere beforehand and talking non-stop. Like many a Western ear, Londres's can register Chinese singers and instruments only as emitting screeches. Those pressmen eulogise the anarchic state of China, and ask who needs interfering governments (*MS*, p.229). Bigwigs in general keep telling Londres that they know no more than he does of what is going on in China, beyond their immediate area. Stoically, one comments that, at least, 'nous nous déchirons, mais en famille' (*MS*, pp.273–4). Even this would-be consolation is undermined, however, by the non-family foreign intruders long establsihed in the Chinese homeland.

Londres rebaptises as Gnafron (a stock shoemaker figure from the Lyon *guignol*) his interpreter, the well-named Pou, except that he is grossly fat. Provided by the French embassy, Pou tries to persuade Londres to move to safety in a hotel in the legation district, but the intrepid Albert refuses (*MS,* pp.217–218). In his function, Pou attempts to act as a blocker, or at least postponer, of awkward questions from the foreigner. He explains that 'il ne faut tout de même pas froisser le lotus' (*MS*, p.251). In effect, he carries a die loaded on all faces, for naturally he wants to survive any struggle for power. He is covering his very ample rear.

As in all his writings, Londres gladly falls back on humour of various types in order to lower the tension of fraught encounters with people or situations. In a cab encrusted with dirt like much of China, on his way to interviewing Zhang Zuolin, he describes the fleas as playing Follow-my-leader. He watches the locals go in for explosive nose-clearing: 'Chaque Chinois prenant ses narines pour une mitrailleuse, pressant sur la gâchette, mitraille l'horizon' (*MS*, p.174). Sardonically, he notes a reeking stream misnamed 'Rivière des Parfums' (*MS*, p.234). On his travels, his nose thus stays on permanent alert for smells bad and good; they are a key element in his conveying of local colour. He is alive also to sounds, for example a Buddhist ritual, compared by cross-overs to an animal cacophony: 'Ceux qui représentaient les rhinocéros bramaient comme des cerfs […] les cerfs glapissaient comme un chacal affamé. Les boeufs piaillaient comme des moineaux insouciants. Quant

aux démons ils avaient la voix des anges' (*MS*, p.214). This list ends not with a sting in the tail, but a pat on the back.

In addition to his one-night stand with the Russian beauty, Londres enjoys another escapade in Peking, when he goes with three French marines on the razzle. Non-judgmenetally, he records their none too bright reactions to things Chinese, but he cannot resist some Swiftian irony. He tells one of them that in China

> il était nécessaire que d'abord les enfants mourussent en masse, qu'ensuite des grandes personnes fussent saignées à périodes régulières, autrement les Chinois seraient trop nombreux, il n'y aurait plus assez de riz et cela amènerait des difficultés (*MS*, p.237).

This is a pseudo-Malthusian gloss on the overall situation. After the four men on a spree locate the Korean courtesans they are seeking, who sing them melancholy songs, Londres (very unusually for him) nostalgically recalls the streets of Paris (*MS*, pp.238–9). At this point the narrative breaks off, and presumably the quartet slake their sexual thirst with the prostitutes.[9]

With the aim of getting a close-up on the imminent battle between the armies of Zhang Zuolin and Wu Peifu, Londres moves on to Tientsin (Tianjin), where another general, Tang Shaoyi, lusting to become President of the Republic, has installed himself in the Japanese concession. The reinstated President of the Council, Liang-Che-Ji, has taken refuge in yet another alien enclave, the French concession. While in terms of politics he campaigns to oust the foreign devils, empirically he exploits their protection (*MS*, p.250). Londres finds Shanghai, largely autonomous but effectively under British, American and French rule, totally given over to the coining of pelf. Saving up the barb for the end, he characterises it as 'une exposition permanente des races, des moeurs et des tares du globe' (*MS*, p.259). Gambling, in casinos or on stock markets, is ubiquitous. In its train come widespread protection rackets and the drug trade, which Londres was reportedly investigating in his last weeks on terra firma. Craziness reigns, as all over China and as promised in his title. Like Malraux in *La Condition humaine* of eight years later, Londres sets down the death throes of the high life, the decline of the West and all it represents, in a sarcastic account of a plush

9 Compare the visit to the brothel in *Le Chemin de Buenos Aires*, in Chapter 6.

fancy-dress function in a luxury hotel just before hostilities begin. Panic underlies the frenetic festivities (*MS*, p.262). Multitudes flee to the haven of the white man's pockets of territory, which are bursting at the seams. Like a latterday Fabrice at Waterloo in Stendhal's *La Chartreuse de Parme*, Londres bustles about, eagerly trying to pinpoint the unfindable battle, but witnessing only sporadic firefights (*MS*, pp. 283–90).

Amidst all the dispersed mayhem, he re-meets his old friend, the English journalist Ward Price. The tone of the passage listing other colleagues is elegiac:

> Cependant, la destinée voulait que parmi tous – et je pense à vous, mes vieilles mouettes qui vous appelez Henri Béraud, Edouard Helsey, René Puaux, Jean Vignaud, – et qui t'appelais André Tudesq, nous fussions, Ward Price et moi, particulièrement voués à la même catastrophe (*MS*, p.294).

This is the sea-bird motif I cited earlier. Ward Price and he have known each other so long that they have little need to say anything about the anarchy of China which Londres has just observed and which the Englishman is setting off to see for himself. The finale, then, is throwaway. All Londres can (feign to) say to his old comrade is 'La Chine, mon ami…' (*MS*, p.296). The rest, no doubt, is the book we have just read.

With the benefit of the historian's hindsight and specialised knowledge, Jack Gray can offer obviously a more balanced picture of China in the period in which Londres visited it, though Gray is in fact generalising about the long span 1912–1938:

> Every poor harvest, every military campaign, every local depression of the market for handicraft products, every local abuse of taxation, claimed its permanent victims, squeezed out of the rural economy with little chance to return. Such conditions might be local and irregular in their occurrence, might only be negative exceptions to generally positive changes; but they created a destitute and alienated mass of people roughly equal to the entire population of the British Isles, and of course the beggars and the vagrants were more conspicuous than the majority of peasants who were being undramatically a little better fed, clothed and housed every year.[10]

10 Jack Gray: *Rebellions and Revolutions: China from the 1800s to the 1980s.* Oxford University Press, 1990, p.64. Gray also provides interesting evidence to suggest

'Undramatically': the undramatic is rarely newsworthy, and Londres did get the chaos at the top and at street level right; that was his main subject. As for his own wish-list, in *La Chine en folie* Londres swings between astonishment at such fragmented and rarely legitimised governance and an unsatisfied search for a full-blown anarchist utopia: 'Je cherchais le pays sans maître, la ville chimérique de l'anarchie totale. Dieu m'a comblé. Je la tiens. C'est Pékin!' (*MS*, p.198). Is this ironic? The trouble with that wonderful weapon, irony, is that sometimes it can be so concealed as to be unfindable with any certainty. As political correctness never gagged Londres, he is throughout unafraid of depicting China and the Chinese as loco and ridiculous. Linda Lowe says intriguingly if pedantically of Western writers on China:

> The desires shaping their texts were inscribed by the very terms they wished to escape; for the wish to exceed western binary systems is a desire that is itself structured by the opposition between the location of one's writing – within structure – and the place of the transcendent other – beyond structure.

She reminds us that the 'Orient' came to be seen 'no longer as colonized but as utopian'.[11] Londres's sense of proportion, mediated by his humour, prevented him from toppling into that dreamland.

'Mourir pour Shanghaï' (1932)

Uncollected into a book before Londres's death, the 26 related articles on China in 1932, his last visit, were edited by Francis Lacassin, under the above title, in the same volume as *La Chine en folie*.[12] In them, Londres came full circle back to his founding experience in journalism,

that foreign implantation was in many ways less profitable to the running-dog capitalists than to the general Chinese economy (pp.152, 167).

11 Linda Lowe: *Critical Terrains. French and British Orientalisms*. Ithaca, N.Y.: Cornell University Press, 1991, pp.138, 188.

12 After failing to convince Elie-Joseph Bois, the director of *Le Petit Parisien*, of the necessity of a journey to China on an unspecified mission, Londres resigned from the paper where he had stayed longest, and signed up with *Le Journal*, where the 26 articles appeared. He secured permission also to write for the right-wing weekly, *Gringoire*, but published nothing there.

as war correspondent. Between the two series of texts on China, war had evolved from civil hostilities to an international conflict with China's near, bellicose, and imperialistic neighbour, Japan.

In early 1932, after some months of fighting in Manchuria, Japan, without declaring war, in effect invaded Shanghai, on the pretext that Japanese goods were being boycotted on the orders of the Chinese government, such as it was. The Japanese forces targeted especially the foreign concessions in the international zone of the city, which were as before bolt-holes for large numbers of citizens, and which had their own troops and police-forces. To familiarise readers with this distant locale, Londres asks them to imagine a map of Paris: the Japanese have landed on the banks of the Seine between the Bastille and the Hôtel de Ville, and are aiming to seize the Gare du Nord. They are temporarily stalled in the Rue de Rivoli (*MS*, p.20). Fleeing in panic, the civilian population converge on the legation district. Londres makes no attempt to present this tide of humanity as a humanitarian disaster creating a refugee-problem. Quickly, the Chinese vastly outnumber the foreigners in the concessions. What Chinese troops there are are unreliable, rarely paid, and with little sense of defending 'China'. In theory, the battle will not spread to the concessions, though shells continuously land there. As in *Chez les fous*, Londres noses out madness everywhere, even on the streets, in particular a convoy of asylum inmates weaving its way through the general chaos: 'Que devaient-ils penser des gens tenus pour sensés?' (*MS*, p.34). It is a very good question.

Unsmiling Japanese soldiers, in contrast with the ill-disciplined, tattered Chinese troops, are motivated by a sense of unquestioning duty: 'L'inspiration n'est pas son fait; il reste où le chef le met, et, sur la petite place qu'il occupe, nimbé de sa dignité, il se comporte comme l'envoyé spécial du Soleil-Levant' (*MS*, p.41). The Japanese presence on this foreign soil, insolent, if curiously suave in its formality, recalls irresistibly to my mind the delectably racist lines of Ogden Nash:

> How courteous is the Japanese;
> He always says, 'Excuse it, please'.
> He climbs into his neighbour's garden,
> And smiles, and says, 'I beg your pardon';

He bows and grins a friendly grin,
And calls his hungry family in;
He grins, and bows a friendly bow;
'So sorry, this my garden now'.[13]

For his own part, scurrying about the devastated streets in the midst of murderous exchanges of gunfire, Londres takes the useless but automatic precaution of turning up his coat-collar, as during comparable barrages in the 1914–18 War. Also reminiscent of the Great War is the fact that the conflict in Shanghai is very largely, despite the costly street-fighting, a matter of marking time. Perhaps all wars are primarily waiting games. Londres is reminded of the digging-in at the Dardanelles, and the 'gardeners of Salonika' (*MS*, p.88). This battle, says Londres, is a 'comédie tragique' (*MS*, p.76). Even on the Chinese side of the barricades, Chiang Kai-Shek, the leader of the nationalist Kuomintang, on the way from Nanking (Nanjing), is fighting his own war of attrition, against (variously) the warlords, the Chinese communists (whom he wants to disarm), and the Japanese intruders.[14] Shanghai has only a shambolic army to defend it: 'C'est une horde de mendiants en armes. Ce ne sont que défroques sur défroques' (*MS*, p.87). It relies on the deployment of many snipers (the French equivalent, *francs-tireurs*, bears also the connotation of anarchists, mavericks). In the wider picture, the British, based in Hong Kong, and the Americans (in Manila) remain deeply concerned about any further Japanese inroads into China, which is of course *their* territory.

As always, Londres is highly aware of the huge costs of war, not only for the military, but especially for ordinary civilians: 'Lors de la dernière guerre, les hôpitaux étaient réservés aux combattants. Aujourd'hui, on doit en ouvrir au moins autant pour les civils. Où les progrès de l'humanité s'arrêteront-ils?' he asks ironically (*MS*, p.102). He also sees very sell how much silly but deep-rooted reflexes inflect, and indeed dictate, the course of battles: 'Pour l'avenir de leurs espérances, la face est aussi nécessaire à l'un que la victoire est à l'autre' (*MS*, p.121). Face, and the saving of it. Much more brutally at issue is the fact that many soldiers and citizens

13 Ogden Nash: 'The Japanese'. In: J.M. Cohen (ed.) *The Penguin Book of Comic and Curious Verse.* Harmondsworth: Penguin, 1954, p.87.

14 Malraux's *La Condition humaine* is, fragmentarily, the classic fictional version of this complex struggle.

have lost theirs for good, as the result of shells, grenades, bullets, or shrapnel.

What else did Londres observe before he left China? Partial clues, suppositions, and myths abound. Nobody knows for sure. One reliable fact is his relationship with Reggie d'Auxion de Ruffé.[15] This man, a lawyer and a correspondent for *Le Matin*, lived in Shanghai, knew China very well, and often helped visiting journalists with inside information. Londres was welcomed by him in 1922 and again in 1932. In a letter of March 1932, de Ruffé mentioned, without specifying their nature, the difficulties encountered by Londres and his colleague Andrée Viollis, in their separate investigations. Londres also met in Shanghai Georges-Marie Haardt, director-general of Citroën and co-leader of the Central-Asia Citroën expedition, also known as the 'Croisière jaune', using off-road caterpillar vehicles. Haardt and Comandant Pecquer related their terrifying journey across war-torn China, roamed by huge lawless mobs. Londres's curt comment was; 'Le peuple le plus bête de la terre'.

Londres's last, and lost, reportage has given rise to intense speculation and fabulation. What seems likely is that it was centred on the international opium and heroin trade based in China, and its probable connexions with French arms-sales in the Far East, involving leading French firms and politicians. It has also been suggested by Mousset that Londres was bringing back irrefutable evidence of the tentacular spread of Bolshevism in the Orient.[16] This, of course, was hardly a scoop in 1932. The journalist Pierre Herbart, trekking through China with Andrée Viollis, who was researching her book *SOS Indochine*, relates how he and she were due to embark on the same ship as Londres, the *Georges-Philippar*, when Viollis fell ill and had to be hospitalised. As a result, both of them were saved by her illness from premature death.[17]

In the area of doominess, Londres had unconsciously prophesied his own demise in a text 'Cinq Pirates de la mer Egée', when he volunteered the idea that he always brought bad luck to all vessels he

15 The following account is indebted to Micheline Dupuy: *Le Petit Parisien*. Paris: Plon, 1989, pp.190, 229–30, 230–1.

16 Mousset: *Albert Londres*, p.357.

17 Pierre Herbart: *La Ligne de force*. Paris: Gallimard, 1958, p.53.

sailed in. To his daughter Florise, after jocoseriously contrasting himself with a sailor, even though he too was by profession 'au long cours' (ocean-going), he confessed his envy of the mariner:

> Un jour ou l'autre, ils finissent toujours par faire un trou dans l'eau quelque part. On ne les enterre pas comme des gens ... Ils sont libres de leur carcasse pour l'éternité [...] Tu comprends ... voilà la vérité ... faire un trou dans l'eau et éternellement promener sa vieille âme.[18]

Thus even the posthumous Londres would circumnavigate the globe. He used much the same terms to the historian Jacques Bainville, who interviewed him for *Candide*: 'Quant à moi, je sais bien qu'à force de naviguer j'irai dormir par plusieurs brasses de fond'.[19] Full fathom five. As a war correspondent, he naturally avoided death by the skin of his teeth on many occasions. For example, in the ruins of Cambrai, in the company of an English officer, he came across a grand piano in the street. Not able to play himself, he left the officer to perform a Beethoven sonata. Walking slowly away, he heard and saw the piano and the man blow to smithereens. The instrument had been boobytrapped.[20]

The new sadness amid the perennial jokiness so poignantly noticed by his daughter during his last months on earth may have been due to his feeling that he could not go on travelling forever. If he stayed put, how could he apply his journalistic gifts to the France that he thought he understood too well to feel challenged by the prospect of writing on and in it? Was a slippered comfort and cosily parochial reporting all that was left for him? On a less melancholy level, he began not very successfully to learn English, and he entertained the idea of a first trip to the United States. He might settle in Toulon (a port...) with the woman he thought of marrying, on his return from China.

As it happened he spent most of his time on the *Georges-Philippar* writing up his detective-work in China, though he dined frequently with the Lang-Willar couple he had previously met in Argentina, and who were also acquaintances of de Ruffé. When the ship caught fire, the crew were unable to rescue him, nor was he able to save himself. The

18 Florise Londres: *Mon Père*, pp.47–8.
19 Jacques Bainville (under the collective pseudonym 'Candide'): *Candide*, 26 May 1932, quoted in Assouline: *Albert Londres*, p.566.
20 Florise Londres: *Mon Père*, pp.119–120.

four probable scenarios of his end are: burned to death, asphyxiated, drowned, or eaten by Red Sea sharks. The ship sank on 16 May 1932. Forty other pasengers perished. There have been suspicions that the fire was not an accident, but official enquiries did not corroborate this hypothesis. Londres's letters to his mother, the current ones of which might have cast light on what he had succeeded in finding out in China, were buried with her in her coffin. The Lang-Willar couple were due to provide *Excelsior* with a report on the disaster, and some clues as to Londres's findings, but their return plane crashed near Rome, the result of sabotage, in Assouline's view.[21] In the Londres Archives can be found several reports on the unspecified strange behaviour of the couple, on the ship and subsequently.[22]

As for ensuing legends, in 1999 appeared a curious scenario, which has not been filmed, *Shanghaï, dernières nouvelles: la mort d'Albert Londres*, by Régis Debray, whose glory days saw him in the wake of a Guevarist guerrilla in the Bolivian jungle, and who has since mutated into a pundit on and theorist of the media.[23] From the outset of the plot, various enigmatic figures tail the protagonists in Marseilles, Hong Kong and Shanghai. The tone is romantic and melodramatic. Londres has a sexual affair with an Italian aristocrat, Antonella (presumably the actual Russian lady of 1922), and both proceed to Shanghai by train. Maryse's fiancé, Egal, is seemingly caught up in the drug-trade, until it becomes clear that he has been ordered to infiltrate the Bande Verte, or drug mafia. He finds that it has plants in French headquarters, and has corrupted police, diplomats and the military. Egal is caught between two fires. Various murders in Shanghai and Hong Kong lead up to the sabotage of a boat; Egal is decapitated (whereas Martinet lived to marry Florise). There is a machine-gun attack on Londres's life. He has been told by Loriot that raw materials (poppies) for opium production have to

21 Assouline: *Albert Londres*, pp. 587–8.
22 Archives, 76/AS/14. Robert Lang-Willar, the couple's son, informed me in a letter of 11 June 2003 that he had received a letter from his father, alarmed at the global-conquest ambitions of the Japanese Right (the 'Tanaka Plan'). It is likely that Londres also dreaded such manic expansionism.
23 Régis Debray: *Shanghaï, dernières nouvelles: la mort d'Albert Londres*. Paris: Arléa, 1999. Among the real-life people whose names are changed are; Florise (Maryse), the editor Bois (Dubois), the daughter's fiancé, André Martinet (Egal), and Londres's informant, Charles Laurent (Loriot).

be imported from China to Indochina, in order to serve French business interests there. Antonella, deeply immersed in all the murky crimes, and who earlier begs Londres, in the middle of sexual ecstasy, to throttle her, is strangled by her cuckolded husband.

As in hamfisted detective-stories, the police-chief Bertini ties up the loose ends, narrative and criminal. The Bande Verte is not confined to Shanghai, but also operates in Saigon, Marseilles, Paris, Rome, Berlin; in Italy and Germany, it helps to finance fascist movements. Bertini himself is murdered in Saigon, after informing Londres that both of them were meant to be bumped off at a banquet during which the French consul was poisoned. When fire breaks out on the Europe-bound boat, Londres finds that he has been deliberately locked into his cabin. The final scene of this extravagant tale shows a Minister in Paris, shedding crocodile tears over Londres's untimely disappearance, and promising to ensure a national gong for him. He then phones the Italian embassy; the Lang-Willar's plane crashes near Rome.[24]

I try to believe that there is a kind of poetic justice when an investigative reporter like Albert Londres, of necessity exploitative, is capitalised on in his turn. After all, as we have seen in earlier chapters, Londres profited for his despatches from wars, earthquakes and fires on ships. I think, however, that his obdurate sense of humour would have made him smile over those two farfetched spin-offs.

The most important feature of the whole business is that, despite any sadness in his last years, he was still enthusiastically writing, enviably, up to his last breath.

24 Two years before Debray's scenario, a strip-cartoon was published, text by Olivier Neuray and illustrations by Yann Lepennetier, entitled *T5. Shangaï, Nuit Blanche.* Grenoble: Glénat, 1997. It covers, with no collusion, I was assured by its author, some of the same territory as Debray's scenario: the shenanigans of triads, the criminal involvement of French colonial officials in shady deals centred on Shanghai, etc.

Chapter 8
Journalism: the Wider Picture

Cet acte abominable et voluptueux qui s'appelle *lire le journal*
Proust[1]

Muckraking and Investigative Reporting

Among other consumable items, the consumer society consumes, like Proust in the epigraph above, newsprint, and often in a comparable spirit of complaint, mock or genuine. (Notice the oxymoronic adjectives in the quotation, and the oxymoronic polarity of the text's title itself). Readers, if not generous or sycophantic, are very largely ungrateful for their daily fare. When it is a matter of investigative journalism (though some would maintain that all journalism is or should be this), the degree of ingratitude increases. According to the director of France's most intelligent and prestigious journal, *Le Monde*, Jean-Marie Colombani, at least two-thirds of reader mail after a major investigation is hostile. This reaction results from a widespread assumption in France that the news media 'are working on behalf of covert interests', and so any revelations they make are rarely to be trusted.[2] The same press analyst, Mark Hunter, considers Londres 'comme un précurseur du "nouveau journalisme" et également, comme un avatar du *muckraking*'.[3]

1 Marcel Proust: 'Sentiments filiaux d'un parricide'. In: *Pastiches et mélanges*. Paris: Gallimard, 1935, pp.217–18.

2 Mark Hunter: 'The Rise of the Fouille-Merdes'. *Columbia Journalism Review*, November/December, 1995, p.3.

3 Mark Hunter: *Le Journalisme d'investigation aux Etats-Unis et en France*. Paris: PUF, 1997, p.65. The 'new journalism' he refers to was the reborn investigative journalism in the USA in the 1960s and 1970s, especially at the time of Watergate, but also the Vietnam crisis, civil rights agitation, antiracism demonstrations, and green politics.

When president Theodore Roosevelt gave currency to the word 'muck-rake' in a speech on 14 April 1906, taking it from the 'Man with the Muckrake' episode in John Bunyan's *Pilgrim's Progress*, he invested it with a strongly pejorative intention.[4] 'Muckraker' had, however, always been a dubious term; among its meanings was 'a prurient inquirer into private morals; a writer of pornography' (*OED*). In the Bunyan text itself, the act of muckraking was an emblem of absorption in the pursuit of worldly gain: 'The men with the muck-rakes are often indispensable to the well-being of society, but only if they know when to stop raking the muck', declared Roosevelt, who in his attack on contemporary journalists clearly distorted the sense of the original Bunyan anti-materialistic text. In self-defence, he stressed that 'some persons are sincerely incapable of understanding that to denounce mudslinging does not mean the endorsement of whitewashing'. He was in effect protesting, by ostensibly going over the top, the lurid untruthfulness of the press's lunatic fringe. Given its tenor, 'muckraking' has, appropriately, always been since Roosevelt's day a smear word on the lips of the powerful, as when Lyndon Johnson on 21 October 1964 likened it to 'slanderous comment or mudslinging'. In this perspective, muckrakers are simply troublemakers, and their plentiful opponents would echo the populist US slogan: 'USA – love it or leave it!' A less mindless interpretation of the word would ally it to crusading or public-interest journalism.[5] More widely, Harrison and Stein suggest that 'it bears closest resemblance to investigative journalism; less to advocacy journalism. It has a decent relation to sensationalistic and to yellow journalism'.[6]

The best known American practitioner of muckraking was Lincoln Steffens, who strangely denied that he was an investigator.[7] By this he meant that he was almost totally reliant on highly informed insiders, ready to spill the beans to him: par for the journalistic course. Compared with the principally urbane if not suave Londres, Steffens sounds, from his own self-estimate, and despite his deep immersion in tracking

4 The speech was reported in the *Cincinnati Enquirer* of 15 April 1906. John Bunyan: *Pilgrim's Progress*. Oxford: Clarendon, 1960, pp.202–2.

5 John M. Harrison and Harry H. Stein (eds): *Muckraking, Past, Present and Future*. University Park, PA: Pennsylvania State University Press, 1973, pp.11–12.

6 Harrison and Stein: *Muckraking*, p.14.

7 Lincoln Steffens: *The Autobiography of Lincoln Steffens*. New York: Harcourt, Brace, 1931, p.400. Subsequent references are in brackets in the text.

murky urban politicking, deeply naïve. His gift was for striking, graphic simplicity. When about to blow the gaff on Pittsburgh, he arranged for a painter to capture its baroque industrial skies. Steffens called this illustration 'Pittsburgh as Hell with the Lid off' (p.401). He viewed his function as that of an (honourable) blackmailer, holding city halls to ransom with his evidence of graft (p.405). If S.S. McClure, owner of the influential *McClure's Magazine*, considered such graft and corruption exceptional, local and criminal, Steffens believed that, if similar malpractices occurred everywhere in the same form, they could not be an accidental consequence of human wickedness, but the impersonal result of natural causes, which it might be possible to identify and deal with, without hating or punishing any individual (p.407). This variant Social Darwinism sounds like a futile attempt to flog the elements. Much of the corruption he located and revealed centred on the railroads, and his imagery is appropriately mechanistic (e.g. party 'machines'). This is of course the social area of least interest to Londres, perhaps because he sensed that reform would not work on such entrenched interests, which could be countered only at the ballot-box. Steffens himself, in his autobiography, eventually came to see the muckraking tradition he had done much to foster as dead, and a mistake in whose delusions he had shared.

Views on this phenomenon have always differed violently. Walter Lippmann, though a convinced conservative, recognised that 'muckraking is full of the voices of the beaten, of the bewildered, and then again it is shot through with some fine anticipation'.[8] There is little consensus on the concrete reforms achieved by muckraking journalism, much of it published in magazines. This journalism took off in a youngish country that was still in the process of discovering and defining itself. Londres wrote on and out of an old world. He could take much more as read, and, often, feel less sanguine about the likely practical impact of disclosures. American muckrakers wrote mainly out of disappointment over their nation's failure to meet its own great potential and its fine written standards. They wrote out of injured, angry idealism. A contemporary English critic commented (and his remarks remain relevant today):

8 Walter Lippmann: 'The Themes of Muckraking', in *Drift and Mastery: An Attempt to Diagnose the Current Unrest*. New York: Mitchell Kennerley, 1914, p.20.

They do not see that most of the evils they attack are inevitable results of the national creed of individualism. They lack either the insight or the courage to admit that some form of collectivism is the only permanent check upon the enslavement of the people by the most amazing plutocracy the world has ever seen.[9]

The tradition most certainly was parochial: home affairs diagnosed for home consumption. The notorious Yankee incuriosity about foreign matters and countries, added to the fact that remoter parts of the vast North American land mass *are* foreign to the rest of the population, ensure that foreign = alien. As today, in the heyday of muckraking, 'the corporate sector usually received the lion's share of the blame'.[10] Individual acquiescence in the practices of big business attracted meagre attention.

Some purists believe that the mere publishing of leaks from government or other agencies, in the style of Steffens, is not true investigative reporting, presumably because it smacks too much of passivity, of simple transmission of others' efforts to broadcast the truth. Such whistle-blowers providing privileged gen might well have to remain anonymous, like, at the time of Watergate, 'Deep Throat' and his/her variants: Shallow Throat, Muffled Throat, etc. Crime and vice have been a staple fare of all newspapers since their inception. Muck-raking simply transferred such informants from the dangerous classes to the top dogs. The commercial progeny of the exposure press, it has been held, are the blockbuster novels, focussed on the Mafia, Hollywood, or various major industries, which proliferated throughout the twentieth century, though the common denominator of such fictional exposés has most often been the sex-lives and the glamourous life-styles rather than the guilt of those involved.[11] In terms of impact, the danger is that readers grow sick of the sensationalism which ensues when less talented or more purely mercenary writers jump on the bandwagon. The result is compassion-fatigue, compounded by the perennial foe of concern: escapism, mental and moral laziness. For its part, this world remains an

9 William Archer, quoted in John Chamberlain: 'The Muck-rake Pack', in *Farewell to Reform*. New York: John Day, 1933, p.122.

10 David L. Protress, et al. (eds): *The Journalism of Outrage*. New York: Guilford Press, 1991, p.37.

11 John G. Cawelti: 'Blockbusters and Muckraking', in Harrison and Stein: *Muck-raking*, pp.87–9.

Augean stable. No sooner has someone cleaned out the muck than a new load lands. Muckraking can only ever be a cyclical endeavour; the job is never done. In a nice twist on the Bunyan reference, Upton Sinclair wrote: 'The Muckrake Man suffers only from an embarrassment of riches'.[12] He can rake it in in another sense, for many such journalists, including Londres, have made good money by lifting lids off. This, naturally, does not turn them into champagne socialists.

A singular exponent of the tradition is the fascinating figure of Benji the Binman (Benjamin Pell), rubbish-recycler extraordinary. He scrapes a comfortable living from rifling through the dustbins of significant people, in search of thrown-away documents that he can sell to the press as a scoop. He is a human pooper-scooper. Literally and metaphorically, he gets his hands dirty. Some think that he suffers from an obsessive-compulsive disorder, yet, if he did not exist, it would be imperative to invent him He is the unearther, then the conduit, for involuntary leaks, or Freudian slips. He is proactive, unlike many mainly reactive journalists. Is he merely parasitic? Only as much as the rest of us, who, when we can get away with it, annex other people's goods, ideas or cast-offs. Pell won a case gainst a con-man who diddled him out of his savings with the promise to film his life-story. The fraudster had introduced him to a 'producer', who was in fact a hairdresser, and thus robbed the robber.[13]

There is a very considerable overlap between muckraking and investigative journalism in general. The latter relies too on roving reporters and first-hand observation *(de visu)*. Since, if not before, the Atrides, heralds have frequently been held responsible for the news they bring, despite their implicit entreaty: 'Don't shoot the messenger'. Some fainthearts think that all news is bad news. One journalist has freely admitted that 'investigative journalism very properly looks for the worst case'.[14] Another, Loretta Tofani, explains that she is 'not interested so much in individual acts of wrongdoing as systemwide problems – how a

12 Upton Sinclair: 'The Muckrake Man', *The Independent*, September 1908, pp.517,
 quoted in H. Shapiro: *The Muckrakers and America*, p.3.
13 See the *Guardian,* 19 March and 21 March 2001, p.3, for some of this material.
14 David Lloyd, in an interview in February 1998 with Hugo de Burgh (ed.)
 Investigative Journalism. London: Routledge, 2000, p.309.

system breaks down'.[15] (Far fewer journalists, it is no surprise, are drawn to examining how a system prospers). Shock-value is clearly essential, but never enough. Any campaign must go on working over time, and at increasing depth and pointedness. The joint appeal goes obviously to the reading public, as voters and pressurisers, and to those who exercise the power to introduce reforms.

Upton Sinclair's *The Jungle*, centred on large-scale malpractices in the Chicago meat-packing industry, poses the conundrum: can a novel achieve more than a press crusade? Novelists, clearly, have much more time in which to document themselves and to organise plausibility. The conditions of reading fiction, amid home comforts, free from distraction, and the whole magic of taking off into an invented but real-seeming universe, give novelists a big advantage. Yet, for both reporter and novelist, the challenge, the facts of life, are the same. Is not writing of any kind, including letters, a message in a bottle launched from a desert island? Neither can ever feel sure of the destination or the reception. This situation is tellingly expressed by Annie Kriegel, when she was both a history professor at the Sorbonne and a regular columnist on *Le Figaro*:

> Personnellement, je me comporte à l'égard du journalisme et de l'enseignement de la même manière; ce sont pour moi des bouteilles à la mer que je fabrique avec la plus grande conscience mais dont je suis totalement incapable de dire si elles ont servi jamais à quelque chose. Et je n'ai pas les moyens de mesurer et de vérifier qui éventuellement les a repêchées.[16]

The wider enemy of any attempt at forcing attention in fiction or press is human beings' short-term memory, and even more that eternal ailment: compassion-fatigue. The more local enemy is obviously governments and other power-bases such as industry, the armed forces, churches and so on, none of which, very understandably, welcomes a freethinking, watchdog press. Bernard Ingham, one-time chief press-secretary to Margaret Thatcher, defined investigative journalism as ruled by 'the conviction that 'government is inevitably, irrevocably and chronically up to no good, not to be trusted and conspiratorial'.[17]

15 Loretta Tofani, quoted in T.L. Glasser: *Custodians of Conscience: Investigative Journalism and Public Virtue*. New York: Columbia University Press, 1998, p.5.
16 Annie Kriegel, in Marc Martin (ed.): *Histoire et médias: Journalisme et journalistes français 1950–1990*. Paris: Albin Michel, 1991, p.190.
17 Bernard Ingham: *Kill the Messenger*. London: HarperCollins, 1991, p.363.

Given these opponents and obstacles, it remains a mystery to all precisely how desirable socio-political change ever comes about. Maybe it is fear of public opinion rather than any overt manifestation of public outrage that causes the powers that be to modify their policies and practices. If so, the fear must stem, in 'democratic' regimes at least, from a longer-term sense that, come the next election, the citizenry might remember a government's accumulated misdoings, kept in the public eye by the press, and vote them out of office. This impact might be a drawn-out process, not an immediate, measurable event. Whistle-blowers need to preach to the unconverted. While the more customary appeal to those already persuaded has its undeniable uses – as a boost to morale, a Pied Piper strategy, or as a hammering reminder – preaching to the unconverted increases the chance of concrete action. The governing bodies need to be forcefully channelled into new thinking on most issues, as they rarely lead the dance of change. One commentator, Protress, concludes judiciously that 'investigative reporting will continue to be a catalyst for policy reform without necessarily being a vehicle for mass public mobilization or enlightenment'. The same observer, however, sounds the sobering historical note: 'To the left, investigative reporting created the false illusion that the United States was truly a democratic society whose serious ills could be addressed by merely disclosing its symptoms'.[18] The fact remains that all journalists are, in a low-level way, at least, investigative reporters, doing their homework, though we can all recall the amount of selling short or downright cheating prevalent in much homework.

Londres operated at the turning-point, the gradual transformation in France of a mainly sectarian to a news-centred press, not that these two were ever in watertight compartments. In 1914, France had the highest *per capita* consumption of newsprint in Europe. By 1939, it lagged way behind that of several industrialised nations. Usual generalisations as to the reasons for this loss of confidence in the press embrace the wide-spread 'bourrage de crâne' it practised in the First World War, the perceived and actual venality of much of the press in the interwar years, and, a little later, of course, the collaborationist press of the Occupation. In economic terms, the French press has never benefited from the levels of advertising revenue enjoyed by its counterparts in the USA, Britain,

18 Protress: *Journalism of Outrage*, pp.254, 3.

Germany, or Scandinavia. Despite these weighty factors, the paper that Londres served handsomely and the longest (eight years), *Le Petit Parisien*, had in 1928 the largest circulation of any daily in the world. Its editor-in-chief, Elie-Joseph Bois, had given Londres his first journalistic leg-up, before the Great War, on *Le Salut public*. On *Le Petit Parisien*, Bois gave his top reporters wide freedom, and very rarely doctored their copy. Londres filled the niche vacated by Henri Béraud. When he left it, it was as a result of a disagreement over expenses, about which Londres was always supremely cavalier.

The French Version

A French commentator quotes an American correspondent in Paris on the French press: 'Chaque article est un éditorial'.[19] The traditional polarised attitudes towards the press in France are, firstly, that to write for it should be beneath a proper writer's dignity, as he would acquire bad habits and vulgarise himself. But, secondly, that journalism provides a highly beneficial apprenticeship for a novelist (this was Zola's firm conviction), and, at the least, would serve as financial back-up for 'serious' writing. The French preference for regarding at least certain types of journalists as intellectuals suggests a mandarinesque view of reporters. A French novelist/dramatist with long experience of the press world, Jean Giraudoux, approaches the question of function and status in a pose of false mateyness: 'L'écrivain doit devenir, dans le travail du pays, un élément toujours présent, mobilisable chaque jour, un ouvrier de toute heure, un journalier, c'est-à-dire un journaliste'.[20] This passage deserves Claude-Edmonde Magny's mockingly punning title for her book on him: *Précieux Giraudoux*, for it displays not genuine, pointed wordplay, but a condescending toying with serious things.

Although the adversarial mode is commonly thought to be typical of French legal practice, it has only intermittently been that of the French

19 Jean G. Padideau: 'Le Journalisme politique à la française: Regards étrangers'. *Esprit*, 2, 1983, p.148.
20 Jean Giraudoux: 'L'Ecrivain journaliste', *Marianne*, 14 February 1934.

press. Of course, there have always been firebrands, such as Léon Daudet, for whom 'la polémique est l'âme du journalisme'.[21] Like Péguy, he cries non-stop 'Vae tepidis', which he renders as 'Je vomis les tièdes' (p.80). A more regularly occurring opinion is that the French press over its life-span has most often been more of a tribune press, top-down, than one offering any kind of interactive dialogue or forum; readers' letters play a reduced role.

In the period from the 1830s to the 1920s, Jean Chalaby argues, journalism was primarily an Anglo-American invention, for the following reasons. American and British newspapers contained more pages than French dailies and, because of more advanced newsgathering services, more news and faster. This information was more neutrally conveyed, less politically inflected: more factual, less opinionated. Even though British and American journalists no doubt have often had hidden or even transparent political agendas, they have tended to deny any overt allegiances. Perhaps the French were both more venal and more above aboard. The Anglo-American press enjoyed more resources, especially advertising revenue, which enabled it to maintain permanent corres-pondents abroad, to control news agencies, and to send larger numbers of special correspondents to the scene of events all over the globe.

Until well into the 1930s, endemic corruption prospered in the French press. Many press stories before the Second World War were compiled in order to blackmail or to smear their targets with cooked-up scandals. Arthur Raffalovitch, a Paris-based secret adviser to the Soviet Minister of Finances, and a respected economist, published in 1931, with the support of Boris Souvarine, *'L'Abominable Vénalité de la presse' dans les documents des archives russes*, in which he indicted the majority of French papers of the day. Though the communist *L'Humanité* featured his campaign, a good number of the documents had to wait seven years before publication in the above book. Bribes, frequently of considerable amounts, poured in to the papers from politicians, financiers and foreign governments, in order to distort or conceal inconvenient news. The ready acceptance of such bribery was a

21 Léon Daudet: *Bréviaire du journalisme*. Paris: Gallimard, 1936, p.79.

partial consequence of lower advertising receipts.[22] In these decisive circumstances, it is hardly surprising that the practice of truly investigative, confrontational journalism took far longer to develop in France.

Yet 'there is a cliché we have to kill – the Paris correspondent's joke that French investigative reporting is a contradiction in terms'. Hunter then proceeds to counter that cliché, but not before extensively analysing its well-foundedness:

> The refusal of of France's leaders to share information with their people was first noticed by Julius Caesar, and French bureaucrats still dread being quoted on even innocuous matters. Official secrecy in France covers a huge area of documents. There are no transcriptions or open-evidence files in court cases, and public access laws are weak and loophole-ridden. This explains why Paris's new investigative reporters tend to work [...] by cadging leads and classified documents from anonymous sources. Given such constraints, it is startling what these reporters have achieved.

By contrast, in the USA, the Freedom of Information Act provides ready-made material, legally, for enquirers. In Hunter's view, 'the top ranks of the profession in France are ignorant of or hostile to investigation, because they would rather be colleagues and confidants of the powers that be'. The tendency is still to use contacts, and the key equipment is the address-book. On the financial level, the French news industy is dependent on government support for survival. In an average year, these subsidies are equal to nearly one-fifth of the total advertising revenues of the French press. In legal terms, any would-be honest investigative reporter faces the risk of being sanctioned for receiving purloined documents or violating secrets. Nor can they count on support from colleagues. 'As recently as 1987 the popular review *Autrement* compared investigative reporting to *délation*, which during the Occupation meant denouncing your neighbour to the Nazis. Even today, the familiar term for an investigative reporter in Paris is fouille-merde, or "shit-digger"'.[23] Jean-François Lacan bitterly recounts his and his team's failed attempt to found an honestly investigative paper, at the time of the

22 Jean Chalaby: 'Journalism as an Anglo-American Invention: A Comparison of the Development of French and Anglo-American Journalism, 1830s–1920s'. *European Journal of Communication*. 11, 3, 1996, pp.305–6, 321.

23 I am very much indebted for much of the above to Mark Hunter's article, 'The Rise of the Fouille-Merdes', pp.1–6.

Gulf War, free from adverts, and aiming to be 'court, dense et acerbe'. As he puts it tellingly, 'les fouille-merde devenaient chercheurs d'or'.[24] Lest it be thought that repressive governments are a monopoly of the right, it is surely the case that all governments, of right or left, pressurise the press, and expect favours which they rarely return. French practices appear both shabby and controlled from above. A healthier alternative puts the stress on a more guarded and mistrustful interaction:

> The whole relationship of reporter and politician resembles a bad marriage. They cannot live without each other, nor can they live without hostility. It is also like the relationship between athletic teams that are part of the same league. It is a conflict within a shared system.[25]

Here symbiosis looks more like a dogfight.

I have examined throughout this book numerous instances of Londres's variety of investigative journalism, and thus of his place in the preceding great debate. I would add that he seldom attacks *ad hominem*. Instead of individualising, he generalises, and criticises the institution, the system, the government, or the history and geography of a country. He thus suggests that anyone might end up as guilty as the scoundrel he sketches for us. As a moralist, he inclines to the latitudinarian, the non-doctrinaire. Temperamentally, he was an amiable anarchist, always more drawn to heterodoxy than to orthodoxy. Furthermore, if, as some observers maintain, French citizens, allegedly more sociable than 'Anglo-Saxons', get much of their information from word-of-mouth or rumour, then Londres's brand of fact-finding journalism filled a niche, as there could be little hearsay about far-flung places and events, his chosen areas of enquiry. In his day, though more rarely nowadays, star reporters could still be more independent-minded and (obviously) freer in movement than the papers they wrote for, who gave them a freeish rein because their reportages sold more copies of the paper. The fact remains,

24 Jean-François Lacan et al.: *Les Journalistes: stars, scribes et scribouillards*. Paris: Syros, 1994, p.50.

25 I. De Sola Pool: 'Newsmen and Statesmen: Adversaries or cronies?' In: M.J. Nyhan and W.L. Rivers: *Aspen Notebook on Government in the Media*. New York: Praeger, 1973, p.15.

however, that, in the words of A.J. Liebling, 'the freedom of the press is guaranteed only to those who own one'.[26] Even if the concept of a truly free press was and is a pipe-dream, an unintimidated press whose chief reporters at least speak their minds is always a goal worth reaching for and supporting.

Popular Press

It is over-easy to dichotomise the press into popular and serious, tabloid and broadsheet, for there are areas in which the one is the other. 'Tabloid' was originally the name for a drug sold in tablet form (and the Catholic *The Tablet* is still being downed). By extension, 'tabloid' has come to mean a compressed publication (and *comprimé* is the alternative French word for a pill). Already in 1931, but it was hardly news then, an observer, Archambault, was keenly bemoaning the industrialisation, commercialisation and standardisation (e.g. syndicated articles) of the US press, and fearing what these portended for the French press. He jibbed at the awful sameness of the end-product, the implacable rewriting of reporters' copy by faceless editorial staff.[27] Any visitor to the USA – a huge and endlessly varied country topographically, indeed many countries rolled into one – can vouch for this drear uniformity, this continent-wide sense of *déjà vu*, when you open a local newspaper. Today, with the ferocious competition from radio and television, is the old-style 'grand reporter' an endangered, even extinct, species? He/she was always costly to employ, and technological advance has reduced human initiative in so many walks of life. Londres was often operating in virgin territory, or at least (which is impossible in other forms of life) semi-virgin. He too had to compete against the equivalent in his day of the tabloid press, its alternate inflation and puncturing of public figures, its sensationalism and scandalmongering about often short-lived celebrities. Did it but know Latin, the popular press's motto might be

26 A.J. Liebling: *The Press.* New York: Ballantine, 1961, p.30.
27 G.H. Archambault: 'Le Journal français de demain'. *Mercure de France*, 231, 1931, pp.554–572, *passim*.

'Aedificabo et destruam'.[28] It appeals to the vengeful side of human instincts, which needs no encouraging, by bringing the mighty down to the lowest common denominator. As such, it acts not as a democratic leveller, which might still respect the right to privacy and the choice of difference, but as a negating spoilsport, like the child who stamps on his/her own sandcastle, or somebody else's.

Training

Still today there is no obligatory training for journalists; schools of journalism produce only a minority of professionals. Partly as a result of this lack of formation, it is notable how many journalists 'end up' in the profession. Such fortuitous routes of access do not, of course, rule out full motivation once in the job. Equally, the reporter who learns the trade *in situ* makes him- or herself 'qualified' to speak, inform, guide thinking, incite emotional reactions, by their own efforts: travel, investigation of data, cross-checking and so on. In short, they have to legitimise themselves in others' eyes. Clearly, journalists do not have to work solely on themselves, but also to win over a readership, and to cultivate networks of informants. Opportunism, serendipity, lucky coincidences, all have a major part to play. As Chalaby points out, 'French reporters had to wait until the inter-war period (1918–1939) before acquiring the journalistic legitimacy and the social recognition of their Anglo-American colleagues'.[29] Londres never showed much interest in the preparatory aspects, the schooling of journalists: unions, statutes, legal status, collective negotiations over severance pay or pensions, diplomas or other qualifications. Though he enjoyed warm relationships with other pressmen and women, from several countries, his own inveterate individualism would not stretch to embrace such organised, bread-and-

28 This is the tag that Proudhon the constructive anarchist turned round to 'Destruam et aedificabo', for he aimed at reconstruction after ground-clearing. He used it as an epigraph to his *Système des contradictions économiques ou Philosophie de la misère* (1846).
30 Chalaby: 'Journalism', p.309.

butter or merely formal issues. Léon Daudet, similarly, thought the very idea of a school for journalists as incongruous as that of an academy for parliamentarians.[30]

Ways and Means

On his travels, Londres did not have to lug about all the presentday accoutrements and impedimenta of the roving reporter: laptops, satellite-phones, video-links, nor coordinate a team of ancillary staff. He rarely had to pool information doled out by its possessors. In those pre-cassette days, he relied on a pencil for notes, and a steel-nib pen for their transcription. His extant notebooks bear no trace of any shorthand, apart from the makeshift, common-or-garden variety of which any of us is capable. I mentioned earlier the photos he took for *Terre d'ébène*. He often carried an ordinary camera with him for such recording of what he witnessed. The resulting snaps were largely utilitarian. He seems not to have exploited that ability of the camera to tell lies, which, perversely, led to the growth in its popularity in the nineteenth century.[31] If he had had at his disposal current journalistic dodges such as the 'sting' (setting up a targeted figure), or bugging devices, he probably would not have used them. On the other hand, he did exploit traditional tactics like infiltration (e.g. for *Chez les fous*), impersonation, or other forms of undercover work. He intended to sneak into Mecca in disguise. All the same his wriggling into forbidden areas never quite matched the zany resourcefulness, the mad devotion to duty, of a reporter on *Détective* who, with special equipment, carried out an underwater drag when searching for the corpse of a missing child.[32]

Many journalists today are sedentary, and spend long hours before computer screens in order to mug up an area of enquiry via electronic retrieval of data-bases. Such practices have largely replaced the time-honoured (for some) self-immersion in libraries, cuttings-collections or

30 Léon Daudet: *Bréviaire du journalisme*, p.132.
31 Susan Sontag: *On Photography*. Harmondsworth: Penguin, 1979, p.86.
32 See Delporte: *Les Journalistes en France*, p.236.

archives. Londres was a hunter-gatherer. As such, he could feel free of much of the servitude and harassment suffered by hacks working in headquarters: the distracting hubbub of open-plan offices, the constant interference by editors or proprietors. Londres greatly enjoyed the status and the *carte blanche* of foreign reporting; the exoticism of the locales visited, the myth of adventure, the opportunity to look beyond the confines of your own backyard. No doubt there is an element of travelogue in all *grands reportages*, which (many feel) our contemporary TV images have made somewhat redundant. His position was a cross between a correspondent stationed somewhere abroad for some considerable time and an unofficial special envoy making a flying visit, parachuting into a distant spot. As I said at the outset, his portable home was a warm travel-rug and a single, battered pigskin suitcase covered in numerous labels. Of such lightly-laden nomads as himself, he once joked that they looked more like burglars with their loot than voyagers.[33]

Sources and Interviews

Among any reporter's sources are: anecdotes, gossip, rumour, documents, briefings, interviews, swotting up backgrounds, and, inevitably, concoction or imagination which fill in and embroider on a few details. No doubt many journalists suffer to some degree from false-memory syndrome. No doubt, also, that a high number are only too conscious of the *jour* in *journaliste*, and so think of their work mainly as piece-work and short-term. Within the calling occurs much picking of colleagues' brains or copy, aka plagiarism, though much of this is surely piecemeal, jackdaw-fashion – the way most of us squirrel much of what passes for our knowledge. In Londres's day, few newspapers employed local stringers, and foreign reporters like him tended to go right to the top in order to gain insights. The trouble with mainly intuitive journalists in the Londres mould is that they spend less than enough time on documentation. Defiantly, he counted heavily if not exclusively on guesstimates, 'le pifomètre' or snoutometer, especially as regards statistics. In many

33 Londres: review of Andrée Viollis: *Seule en Russie* (*DA*, p.283).

places (Salonika, the Middle East, Vietnam), he could have recourse to local French-language newspapers, for he had no foreign languages to speak of. Stamina or brazenness gained him access to influential people, or experienced victims such as prisoners, prostitutes, soldiers, etc. All in all, he combines the proactive and the reactive in his efforts to get the gen from the horse's mouth. He uses both *vox populi* and powermongers.

'The interview was not a common practice among French journalists until the interwar period', according to Chalaby.[34] In general, Londres engineered audiences, face-to-face interviews, rather than relying on press-conferences. In them he ran up against more stone-walling than deliberate obfuscation or other attempts to slant reporting. Some of the notables that he beards in their dens have an answer for everything, even if it is not to the question asked. Even though they were not, in his day, usually playing to the camera or the microphone, his interlocutors indubitably knew they were on stage and acting a part in front of an alien observer. Londres is ever conscious of this fact of life. In French, *comédie* betokens both playacting and risibility, hence the amused tone of Londres's reportages. He is continuously aware that any locals, of whatever standing, whom he sounds out have their own priorities, agendas and different cultural expectations, and no God-given respect for a foreigner's demands. When he failed to be granted an interview with the Supreme Pontiff, Londres commented, wryly: 'Mais lui, j'ai le temps. Il est éternel'.[35] When he did successfully penetrate the smokescreen and extract useful information, this was probably due to his persistence, his bonhomie, his mother-wit and ability to think on his feet. His practice is to play off different versions of the facts from varied conversations, and by such cross-checking is able to arrive at more plausible knowledge. Sometimes, his fame, doggedness or charm opened doors and loosened tongues, though at others those very qualities made people clam up. No doubt many felt that if this renowned reporter had stirred up hornet's nests elsewhere, the same might happen here again. Going to the top was not invariably illuminating. His stance and mode of behaviour when trying to pump interlocutors must have been (though we have only his presentation to go on) genial, reasonable, never incandescent with outrage nor fuelled by threats of blackmail or other forms

34 Chalaby: 'Journalism', p.312.
35 Londres, quoted in Mousset: *Albert Londres*, p.315.

of browbeating. Trust was obviously paramount. Would he abuse the information? Would the donor suffer for supplying it? Humour, and good humour, have a major part to play in all such exchanges.

Interviews are to a large extent two-way. The interviewee wants to glean from the questioner what the wider world will make of his actions or inactions. In addition, as the roving reporter may well have covered more ground and met more ordinary or extraordinary people than the interviewee, the latter might learn things to his advantage, as well as imparting information or disinformation. The audience is thus a tit-for-tat, giff-gaff.

Interpreters are rarely mentioned by journalists, who in the main want to appear to have had direct access to their source. This particular phenomenon is particularly laughable on television, where we see and hear a reporter ask a question in English, then listen to an answer, with no apparent intervention by a go-between, in Pushtu or Swahili. Londres does credit his interpreters in Africa, Depui in Arabia, Pou in China, on whom he had to lean heavily, as he spoke only 'l'étranger', and mime has its limits. Good-humouredly, Londres tends to make light of translation problems. Of Stambouliiski in Bulgaria he writes: 'Il ne parle que le bulgare. Ça ne fait rien. Pas de salamalec, pas de sourire en coin. Il semble dire: "Vous là, moi là, l'interprète là et roulons"' (*CR*, p.535). Londres may well be intimating that actually speaking the local language may make the exchange too cosy, too complicitous.

If we turn the tables and put Londres himself on the spot, we find him, in his rare interviews, elusive and digressive. 'M'interviewer? Vous venez pour ça? Mais je n'ai rien à dire. J'ai tout dit. Vous savez tout [...] Un reporter ne devrait jamais avoir quelque chose à dire sur lui. Son rôle est d'enregistrer, de traduire'.[36] The boot is on the other foot. Londres, besides, was always allergic to metadiscourses, and so, even if he had been born much later, he would not have been a suitable case for postmodernist analysis. He had a profound distaste for mediation, for distancing, except that of humour. In an article after Londres's death, Berthier stretches the idea that Londres had little or nothing to say when interviewed (an inaccurate view, besides) to the claim that he left on his factfinding tours with no preconceptions: 'Un Albert Londres quand il

36 Pierre Humbourg: 'Avec Albert Londres explorateur'. *La Liberté*, 15 February 1929. In: *Le Juif errant est arrivé*, p.282.

partait à Biribi, à Cayenne, à Rosario, ne savait pas d'avance ce qu'il en rapporterait'.[37] On the contrary, Londres had his suspicions, more or less well-founded, that he was ready to revise on the spot. He was ever ready to be taken aback.

Like any journalist worth his salt, he was an excellent eye-witness, but equally, like Louis Guilloux, an *ear*-witness, and an imagination, a sensibility, and a heart.[38] All the experiences that through long absences he went without at home he lived to the full on the move, abroad. Dialogue, or simply listening patiently, was a key element of that foreign but familiar experience.

> Chez Londres [in the words of the historian Henri Amouroux], l'oeil 'écoute' [...] Unis par la même chaîne de misère, le bagnard Roussenq ne parle pas comme le bagnard Hespel [...] Chez Albert Londres, la première qualité – beaucoup devraient s'en souvenir aujourd'hui – a été celle de l'écoute des voix, des douleurs, des différences.[39]

Londres was also a good listener in that, in the days before portable sound-recorders, he took care to render sound-effects, in his efforts to present a rounded account of a scene (cf. Malraux in *La Condition humaine*).

The dangers of being receptive in this way are well illustrated by Joseph Kessel's ingenuous admission that he lived vicariously through, nay identified with, the powerful and exotic personalities he interviewed:

> Mais la peur du gendarme et l'étau des principes acquis dès l'enfance m'empêchaient de plonger jusqu'au fond. Eux, mes compagnons des grands chemins, des ports, des guerres, des sables perdus, ils avaient le courage, entier, terrible, de leurs exigences effrénées. Par leur truchement, je vivais celle que je n'osais, moi-même, affronter. C'est pourquoi je suis allé à eux avec tant d'ardeur et de persévérance.[40]

37 Pierre-Valentin Berthier: 'Nous n'avons pas le droit d'oublier Albert Londres'. *Le Libertaire*, 25 April 1952. In above, p.303.

38 See my *Louis Guilloux: Ear-Witness*. Amsterdam: Rodopi, 1998.

39 Henri Amouroux: 'Ce livre a une histoire...' In: *Grand Reportage: Les Héritiers d'Albert Londres*. Paris: Florent Massot Présente, 2001, p.10.

40 Joseph Kessel, foreword to *Tous n'étaient pas des anges*. Paris: Plon, 1963, p.8. On 1 November 1933, Kessel was one of the founding members of the prix Albert-Londres, together with Andrée Viollis, Louis Roubaud, Henri Béraud, Edouard Helsey, Roland Dorgelès, Ludovic Naudeau, Pierre Mille, and others.

Any kind of objectivity seems unlikely with such an attitude towards sources. Allegedly, 'in America we want facts'. In the home of perfected spin-doctoring and lethal euphemisms? Joseph Pulitzer, the donor of the principal prize for journalism in the USA, went on to say: 'Who cares about the philosophical speculations of our correspondents?' In contrast, 'in French newspapers, the organizing principle of many articles', comments Chalaby, 'was the mediating subjectivity of the journalist'.[41] In all journalism, however, too many 'hard facts' turn out to be as floppy as quiffs. Walter Lippmann cites some classic research on the untrustworthiness even of eye-witness reporting:

> The eye-witness brings something to the scene which later he takes away from it; oftener than not what he imagines to be the account of an event is really a transfiguration of it [...] For the most part, we do not first see, and then define, we define first and then see.[42]

Pedelty speaks of 'the obfuscational idiom of neutrality, independence, and objectivity'.[43] The model American journalist attempts to be a one-person non-aligned nation. It is self-evident that the call for and cult of objectivity is an ideology in itself. Even, or especially, scientists, hard as much as soft, cannot be objective, for so often their working hypotheses contain in embryonic form the later result; the conclusion antedates the foreword and the main body. The unavoidable reason for the failure of impartiality is that human beings are passionate creatures who pay allegiance to certain values as against other values held dear by other people. Facts themselves are rarely neutral, or even establishable. What we think of as natural, as Barthes has shown time and again, is what suits us, or what we rarely stop to question. For Roselyne Koren, a consequence of the privileging of objectivity, the finding of ambiguity, popularly known as 'sitting on the fence', produces a press which readers are inclined to mistrust:

> La légitimation de l'écriture de presse par l'opinion publique pourrait sortir de l'impasse où l'a conduite l'apologie de l'Ambiguïté et l'art de montrer simultané-

41 Joseph Pulitzer, quoted in Chalaby: 'Journalism as an Anglo-American Invention', p.311. Chalaby's statement, p.312.
42 Walter Lippmann: *Public Opinion*. New York: Macmillan, 1947 [1922], pp.80–81.
43 Mark Pedelty: *War Stories: The Culture of Foreign Correspondents*. New York: Routledge, 1995, p.7.

ment 'qu'on en est' et 'qu'on n'en est pas', si les journalistes concernés cessaient de prétendre qu'ils sont des médiateurs absents de leurs propres dires...[44]

How open-minded was Londres? Did he travel with a congealed mind-set? Obviously, he was moulded to some degree, like all of us, by family, school, work and leisure environments, on his home-patch. But he could and did think outside (in both senses) France. Speaking of visiting Syria in 1925, he writes: 'Je n'ai visé qu'un but dans ce travail: l'impartialité. Aussi ai-je eu soin, en quittant Marseille, de ne pas oublier l'une de mes oreilles, voulant entendre aussi bien du côté droit que du côté gauche' (*PP*, p.237). Through the habitual levity, it is palpable that Londres does not mean dispassionate neutrality so much as a readiness to listen to conflicting versions of the situation. Listening needs two ears, and is inherently political (right/left). In him, the two drives, towards tolerance and towards indignation, result less in ambivalence or imbalance than in fruitful tension. There is between them a continuum rather than a sterile stand-off.

Politics

Politics, certainly in the form of national party politics, was largely a non-event or non-starter in Londres' eyes, though he knew that all public matters, and a good many private ones, are inherently political. He had, besides, a way with non-events. When any initiative failed to produce the desired goods, he persevered in writing at some length about it. As Assouline says tartly; 'Londres a l'échec bavard'. Indeed, quite a number of Londres's reportages went unfinished; he did not always follow up initial efforts.[45] It is, however, to his credit that he more often includes damp squibs than he lends credence to or inflates pseudo-events, a common fault in the press. There is a very long tradition of doctoring or

44 Roselyne Koren: 'Quand informer, c'est dire le blanc et le noir: Quelques effets de l'oscillation binaire'. In: Paul Bogaards, et al. (eds). *Quitte ou double sens: Articles sur l'ambiguïté offerts à Ronald Landheer*. Amsterdam: Rodopi. 2002, pp.199–200.

46 Assouline: *Albert Londres*, pp.229, 232.

frankly making up news and, further, of provoking or exacerbating already dangerous situations, in order to make them seem newsworthy. This can go to the lengths of faking photographs, or reenacting scenes with hired help. Londres was more addicted rather to writing up (recording/escalating) what he had fragmentarily collected. In addition, many journalists have been tempted to copy the 'moutons de Panurge' (i.e. to act as lemmings), and to let themselves be swept along in covering non- or pseudo-events. Londres at least selected his own foci, whatever difficulties he subsequently encountered in pursuing his quarries.

However much we might be seduced into trying, we cannot get away from politics, or delete it from general or particular life. It is even more the case for the investigative journalist that, like rats, politics makes its home everywhere. To write in the public interest, you have first to interest the public. To that end, the journalist has to use every weapon in his/her armoury, to engage readers in what they tend to believe they have little time or inclination for: politics. This side of the tomb, it is surely impossible to forego a viewpoint, a stance, a moral choice, as soon as we venture words on any topic. As is well known, there is a monarchist way of reporting on a road accident. Ettema and Glasser make the judicious distinction between 'Conservative' and 'conservative':

> Even if [investigative] journalism is not a witless apologist for dominant values, its essential moral vision is a culturally *conservative* vision in the most fundamental sense of the term – that is to say, committed to the conservation of such values as fair play, common decency, and individual liberty.[46]

In other words, the journalist should not lose faith in his beliefs, for 'the best cure for the evils of democracy is more democracy'.[47]

Is there a difference between social responsibility and political commitment? Certainly, honest investigative journalists act under the compulsion of a sense of responsibility towards society and its often ill-treated individual members. This is civic virtue, at a higher level than the picking up of litter.

46 Ettema and Glasser: *Custodians of Conscience*, p.114.
47 Louis Filler: *The Muckrakers*. University Park, PA: Pennsylvania State University Press, 1976, p.5.

The term 'salvationist' is sometimes mockingly used to describe crusading journalism. As it happens, one Salvation Army officer, Charles Péan, continued the good work initiated by Londres in order to better the lot of convicts in Cayenne. Though modesty has not much say in such areas, journalists with a mission may not often loudly call for change but hope for it. If they have done their job properly, some readers will draw their own conclusions, and apply pressure where they see fit and are able. At least, journalists must implicitly rely on such an impact, for why else campaign at all? The urge to translate texts into actions embraces not only some room-bound creative writers, but also roving (and sedentary) reporters. Londres's attempts at provoking a political assassination in Greece and sabotage in Soviet Russia were over-the-top variants of such activism. Such melodramatic excesses remained few. In general, how well Londres understands political, military and diplomatic waiting-games. To be honest and comprehensive, news reporting cannot be all high drama.

Londres's years of mainly tedious parliamentary reporting explain why, in his later career, he barely took any interest in French party politics. He had done his bit, as a cub reporter. Assouline overstates somewhat when he writes that 'il est ainsi, Londres. Aux antipodes des préoccupations les plus immédiates de ses compatriotes'.[48] As we will shortly see, Londres did focus on the cost of living. It is true, however, that the more humdrum or arid aspects of French political life seemed to leave him cold, or tepid at best. Among reasons for this specific non-engagement was the fact that he faced less competition on foreign than on home ground; the call of elsewhere, exotic or not; and a greater freedom for his interpretation of events when playing away.

Against the charge of largely ignoring his own country Londres could counter-attack by criticising the French lack of curiosity about foreign parts and events: 'La France se réveillera peut-être de sa torpeur', he wrote while in Portugal. 'Peut-être pourrons-nous enfin faire comprendre à nos compatriotes que l'on ne vit plus aux époques anciennes, où chacun vivait chez soi dans une bienheureuse ignorance du reste du monde' (*CR*, pp.792–3). Whereas, in the old days, it was poets who sought refuge in an ivory tower,

48 Assouline: *Albert Londres*, p.221.

c'est chaque Français qui monte à sa tour, s'y installe, et n'en bouge plus. Il regarde ses frontières. C'est déjà quelque chose. Mais, au delà, il ne veut rien voir [...] Le monde peut gronder, tempêter, menacer, cela ne fera pas frémir ses doigts de pieds dans ses pantoufles (*CR*, p.793).

Having recently been to Japan and Vietnam, he feels justified in saying:

les couleurs de nos anciennes gloires pâlissent aux yeux des peuples en formation. Ces peuples, il faut les connaître. Il faut voir en quoi ils nous sont supérieurs, en quoi nous les dépassons. Ce qu'ils devraient apprendre de nous, ce que nous aurions besoin d'apprendre d'eux (ibid).

This view accommodates both a continuing colonialism and a broad-minded pragmatism. To the still large agricultural population of France he addresses the call to action: 'Les océans ne sont plus des déserts: ce sont des boulevards chaque jour de plus en plus sillonnés. Vous labourez votre champ, c'est bien, mais pensez qu'on laboure aussi la mer' (*CR*, p.794).

After his long trek around the Far East and India, Londres came home for a spell and decided to renew himself by quitting *Excelsior*. He joined the team of the newly-founded left-wing daily, *Le Quotidien*, in February 1923. Entrusted with a reportage for once in France, Londres felt ill-at-ease. After a brief reportage for *L'Eclair* on the Ruhr, he was deemed not to be on the wavelength of *Le Quotidien*, and moved on to *Le Petit Parisien*, where he would enjoy great elbow-room for several years.

In the short run of reports on France for *Le Quotidien*, Londres concentrated on interviewing the mayors of three major cities: Marseilles, Toulouse, and Bordeaux. The first, a self-proclaimed collectivist, expressed himself horrified by speculating sharks and the very high cost of living. Yet, when he tried to persuade the municipality to sell goods more cheaply than trade prices, he was informed that would be illegal (*CR*, pp.677–8). The Mayor of Toulouse's option, because of stagnation in the central government's policies, had been to campaign against the low French birth-rate, and also to work to enhance the image of France in Latin countries (ibid.). Thirdly, the mayor of Bordeaux also fought against the rocketing food-prices, and was in addition the first French mayor to crusade for a minimum wage (*CR*, p.679). While Londres had obviously no hand in any of these initiatives, at least he reported them,

and so could not be accused of lacking some interest in the concrete lives of his fellow-countrymen. He presents all of these platforms with virtually no comment, though he clearly approves of them, while recognising the great difficulty of introducing any break of habits against the wishes of entrenched interest-groups. Rather laboriously, he jokes about one such operator, Henri Chéron, whose decrees had put up by 26% the cost of meat and cereals entering France. Londres feigns amazement that Chéron should be a god to some sectors of the economy – traders, for instance – for this was a protectionist measure, whereas ordinary citizens all over the Hexagon want simply to string him up (*CR*, pp. 679–682). When the Finance Minister, de Lasteyrie, puts up income tax by 20%, commercial people simply double the prices of goods. Thus the taxpayer is hit by a double whammy (*CR*, p.682). Laws are bent to protect speculators or overcharging traders: 'C'est le volé qui a payé pour voir acquitter ses voleurs!' (*CR*, p.683).

The most positive of Londres's reports praises Edouard Herriot, mayor of Lyons (Londres's home town), for his readiness to take risks, while France as a whole treads water, falls behind on exports, and so on. Herriot has instigated major works: abattoirs, a stadium, a hospital, a hostel for students, cheap housing, and a home for unmarried mothers (*CR*, p.684). As for the rest of France, 'le spéculateur a tué la spéculation de l'esprit' (*CR*, p.687). The winners are the *mercantis*, the profiteers, in this occidental bazaar. The articles, it must be said, are preponderantly drab, harping, and lack all lift-off. In terms of coverage of French home affairs, they have, however, to be placed in the context of his wider and deeper investigations into French prisons, asylums, the vice-trade, and the Tour de France.

If Londres was not very political in a narrow sense, except briefly, about his own country, this relative *dégagement* or lack of inspiration chimed with the decrease in political partisanship and affiliation among newspaper readers in his period, after a long tradition of 'la presse d'opinion', often extremely violent in tone. Despite this marked decline in a doctrinal press, it is not necessarily justified to talk of depoliti-cisation, for the weekly press and periodicals took over and expanded the former polemical daily press. Thus, Londres's instinctive refusal of an overtly political stance coincided with a general evolution. Much violence, of course, hung on and in. François Mauriac, looking back over the period, saw this vehemence as a form of public divertissement:

C'était la distraction du petit déjeuner, le guignol des grandes personnes…, les victimes elles-mêmes ne protestaient pas. Il semblait entendu que les honneurs de la politique et de la littérature n'allaient pas sans la bastonnade quotidienne de Polichinelle […] La passion de la corrida […] est au fond commune à tous les hommes.[49]

In our own time, papers offer a medley of news, opinionating, picture magazines, how-to columns, and entertainment. Depoliticisation (always a relative phenomenon) has made room for diversification. Journalists no longer need to be suborned or doctored in any blatant fashion. Rather, they are taken on board, often literally (campaign buses, presidential aircraft or motorcades), and are in this way buttered up and compromised through over-proximity to those they should be questioning and judging, those they should keep their distance from. On the question of employer/employee relationships, Philippe Simonnot aptly describes French presentday journalists as '"des eunuques tutoyés". S'ils sont admis dans le sérail, n'est-ce pas grâce à leur impuissance congénitale ou acquise?'[50]

Perhaps journalists can be, at best, only knockers-up, not policemen with powers of arrest, not judges and juries with the authority to convict and sentence, nor, least of all, benevolent or malignant tyrants who can effect change by diktat. The favoured images are canine: watchdog, news-hound, *limier* (sleuth), bloodhound. Journalists bring to our attention, like guide-dogs for the blind or the deaf, awaken us to the untoward, and remind us that it is time to get up off our arses, if only in our heads.

Journalists afflicted with a lowish self-image are unlikely to harbour great expectations, or scruples, about their work. While it is no doubt a dangerous ally, in that it can inflate to cocksureness, confidence is surely essential for good reporting. Confidence, in turn, must ride on the back of status, of a belief that what they write matters. What strikes

49 François Mauriac: *Le Figaro*, 4 January 1945.
50 Philippe Simonnot: *'Le Monde' et le pouvoir*. Paris: Les Presses d'Aujourd'hui, 1977, p.163. The phrase about eunuchs is borrowed from Bertrand Poirot-Delpech: *Finie la comédie*. Paris: Gallimard, 1969, p.94. Simmonot, *Le Monde's* specialist on oil matters, was sacked for revealing the government's underhand practices in this area. It was widely believed that his distinguished paper yielded cravenly to official pressure over this affair.

the reader most about about Londres's journalism is precisely the stance and tone of confidence. Not brashness. But rather an unmistakable sense that, after doing his homework and fieldwork as thoroughly and imaginatively as possible, he is in a position to speak with some authority. Even as a foreign devil or intruder, he has earned the right of entry and speech rights. Perseverance and audacity, often brass-necked cheek, must be the indispensable attributes of any professional investigative reporter. It is the difference between the tabloid reporter's stereotypical coda, when suddenly finding himself out of his depth: 'I made my excuses and left', and 'I simply could not walk out on this situation'. Londres did not apologise, and stayed. Despite his lust, as with all journalists of any ambition, for full-frontal exposure on the front page, Londres managed to tread the very fine line between cynicism and healthy scepticism. Undoubtedly, long exposure to difficult and dangerous situations leads to a toughening-up process. 'A fréquenter de trop près la politique, la finance, les coulisses de la Justice […], il faut se bronzer pour ne pas se briser, se blesser pour éviter d'être dupe'.[51] *Se bronzer*, here, does not mean to get a tan but to steel oneself. Overcoming the ever-present temptation to skimming, to quickfire superficiality in order to meet deadlines, the journalist proper has to know when to be improper, and to keep in mind non-stop that to be respected you often have to be disrespectful. Above all, the journalist has to learn to live with the built-in obsolescence of press writing. No doubt, all wish that the old Latin tag were true: 'Verba volant, scripta manent'.

We will look next at Londres's various strategies for achieving some kind of permanence.

51 Bernard Voyenne: *Les Journalistes français; D'où viennent-ils? Que sont-ils? Que font-ils?* Paris: CFPJ–Retz, 1985, p.252.

Chapter 9
Doing Things with Words

Literature?

I want to treat at more length in this chapter questions of style and rhetoric, which so far have cropped up in scattered form. It may be thought that the study of such matters is more relevant to literature than to journalism, especially given the dubious reputation of journalism for many observers, for whom the press is at best the half-breed or illegitimate brother of literature. If I choose to place a consideration of the stylistic and rhetorical underpinning of what I believe to be Londres's brand of literature in this last chapter before the conclusion, it is, firstly, because this is the most natural home for it. Secondly, this decision will bring the book full circle back to its beginning, which dealt with Londres's first steps in literary creation, as a poet and would-be dramatist.

To link up with a major part of the preceding chapter, I would adduce Harrison and Stein:

> At no time in American history has the relationship between literature and politics been so close as it was during the period when muckraking was at its height. Many of the most active muckrakers crossed the line between the two with some regularity.[1]

As we have shown time and again, where America led, Europe and in particular France, followed on. One result of this cross-over is the form of writing connoted by the term 'faction': a mixture of recorded factual data and invention. More generally, writing for the papers has traditionally been a stage on the way to an independent literary career, or, equally, a source of more or less superior moonlighting income. Journalism can offer a sort of security. When installed, journalists, unless

1 Harrison and Stein: *Muckraking,* p.81.

their articles are spiked, have at least a sure outlet for their productions; they are commissioned. Life is more uncertain for solely creative writers, who have to live off what their works eventually earn by way of royalties, that splendidly regal misnomer for rations.

What are the possible links, the common practices, between the two modes? Like novelists, some kinds of poets, dramatists, and all of us in everyday life, journalists tell stories (in both the honourable and the suspect senses of that expression). Narrative is the stock-in-trade. As Hayden White says of historians,

> historical events are made into a story by the suppression or subordination of certain of them and the highlighting of others, by characterisation, motific repetition, variation of tone and point of view, alternative descriptive strategies, and the like – in short, all of the techniques that we would normally expect to find in the emplotment of a novel or play.[2]

At the very least, journalists are embryonic, or short-order, historians. For a long time now, we have had to get used to the generalisation that everything is fiction: history, political discourse, even scientific narratives (which are often highly metaphorical), and indeed our daily representations of each other. Even at its worst, journalism is bastard or mongrel literature.

More particularly, in France *grands reportages* or *grandes enquêtes* were in many ways the natural successors to the *romans-feuilletons* (serial novels) which magnetised readers of the press in the nineteenth and early twentieth century. From a different angle, for Chalaby 'the emergence of the journalistic field was a long struggle of independence not only from the sphere of politics but also from the literary field'.[3] Wherever we place the stress, the fact is that, in the 1920s, publishers as varied as Albin Michel, Editions de France, Editions de la Nouvelle Critique, Baudinière, Grasset, and Gallimard, all published *grands reportages* in book form. Londres's *Au Bagne* played a major role in this development. Within newspapers, such *grands reporters* became the

2 Hayden White: *The Tropics of Discourse: Essays in Cultural Criticism.* Baltimore: Johns Hopkins University Press, 1978, p.84.

3 Chalaby: 'Journalism as an Anglo-American Invention', p.313. For Tocqueville, it was the other way round: French politics were thoroughly permeated by literature. See Alexis de Tocqueville: *L'Ancien Régime et la Révolution.* Ed. J.P. Mayer. Paris: Gallimard, 1967, p.240.

stars, well-paid, and with their names in big print as a come-on. Yet a journalist's production, if he/she were to attain true fame and some durability, had to appear in book form. Traditions in the French press had been deeply literary from the start. Either writers wrote some journalism, or journalists aped writers, and often aspired to literary consecration, symbolised by book publication, the winning of literary prizes, or election to academies. As we have seen earlier, despite the undoubtedly heavy influence of American and British journalistic models, the French version of *grands reportages* is distinguished by its emphasis on commentary rather than facts, and by the reporter's insistent, unmistakable presence in the copy.

Among the important writers of Londres's era who earned a significant part of their income from journalism were: Colette, Pierre Mac Orlan, Francis Carco, Roland Dorgelès, Joseph Kessel, Blaise Cendrars, Jean Giraudoux, Georges Simenon, and Henri Béraud. In the 1930s, *Paris-Soir* employed no fewer than 29 accredited literary writers over a two-year period.[4] The review *Détective*, which enjoyed huge sales over a long period, promised in its first editorial (November 1928): '*Détective* sera romancier: il vous fera participer à des épopées merveilleuses'.[5] A major reason for all this give-and-take between journalism and literature was that the novel was seen by some to be, then as at other times stretching over a century, in a state of crisis. It was terminally ill, it was dying, it is dead. What is supposed, at differing historical junctures, to have displaced it includes the theatre, travel literature, reportages, history, and so on. Later would come cinema, then radio and television, videos, Internet chat-rooms. Michel Raimond asks rhetorically: 'A quoi bon lire des aventures imaginaires quand les besoins d'émotion étaient assouvis par le récit d'aventures véritables?' In the Twenties and Thirties, 'une obsession de la vie saisie dans son caractère de tout-venant et de faits divers attirait les esprits hors des voies du roman'.[6]

Asked by an interviewer in 1929 whether he would ever write a novel, Londres replied: 'Je ne songe pas à cela. Pour être romancier, il

4 Chalaby: 'Journalism', p.313.
5 Londres thought of contributing, like Carco, Kessel or Simenon, but in fact did not.
6 Michel Raimond: *La Crise du roman, des lendemains du Naturalisme aux années vingt.* Paris: José Corti, 1966, p.160.

faut le temps de méditer et d'écrire, cela suppose qu'on s'arrête un moment, et j'ai bien peur de ne m'arrêter jamais'.[7] Thus, despite several leisurely sea-journeys, for Londres travel precluded writing a novel. The fact remains that the often extended periods he lived in foreign parts, the plentiful time at his disposal on voyages out and back, indicate that his usual writing practice was indeed more akin to that of a novelist or essayist than to the archetypal journalist harried and hog-tied by deadlines. Just like serialised novelists who later publish in book form the chopped-up parts of their fiction, Londres's ability to give his journalism greater survival chances by collecting it in volumes gave readers a second bite at the cherry, the opportunity to savour the despatches as an ensemble.

He was in fact badgered to do a Kessel, but refused: 'Je n'ai pas l'intention de répondre aux innombrables revues françaises et étrangères qui se figurent que je n'ai rien de mieux à faire qu'à écrire des romans sur mon enquête', he wrote to his parents. Yet, at another moment he told them: 'Jusqu'au 4 mai je vais travailler au roman qui s'appellera "La Grand'Route"'.[8] He was tempted, then. Nothing has, however, ever been found of such a fiction. After his years spent finding out how to set a memorable scene, tell an engrossing and pointed story, coordinate or invent dialogues, the writing of a novel would not have been a totally new experience or challenge for Londres. To a greater extent than pure novelists, of course, Londres found his characters, his plots, his exchanges of ideas, and the physical context for all of these, ready-made wherever he went. Equally obvious is the fact that he reshaped, and embellished, this far from raw material – just like a novelist proper. Not all of his employers relished his literary skills. During the 1914–18 War, when Londres asked to be transferred to the Dardanelles from the Western Front, the editor of *Le Matin* helped him on his way with this cutting remark: 'Adieu donc, bon voyage, nous nous passerons de vous. Vous avez du reste introduit au *Matin* le microbe de la littérature'.[9] It was something other than a slip of the pen or mind that made several

7 Ambrière: 'Au Pays des grands reporters', p.289.
8 Letters to his parents of 29 May and 15 April, with no year indicated. (In Archives).
9 Florise Londres: *Mon Père*, p.86.

reviewers of Londres's books of reportage refer to them as *romans*. Charensol sums up, rather too neatly:

> [Albert Londres] avait inventé une forme très personnelle de reportages. Il les concevait comme une suite de courtes nouvelles dont les personnages étaient bien réels, satisfaisant le goût du lecteur pour le document vécu autant que son appétit de romanesque.[10]

At the very least, a decent percentage of journalism must be closer to true literature than the bulk of fiction, pulp and pulpable, published in any given year in any country.

Londres's long-time friend, the journalist/novelist Henri Béraud, turns the usual hierarchy upside-down when he speaks of 'ce mépris de l'amateur pour le professionnel'. This was in the course of a well-practised attack on André Gide, this time in his avatar as a reporter on the Rouen Assizes. 'Ces impressions, rédigées à loisir, publiées avec de longs retards et mille repentirs, étaient de tout point inférieures aux "physionomies" que les journalistes doivent rédiger dans la fièvre et le brouhaha des audiences'. Perhaps, Béraud suggests provocatively, the old-style novel is defunct, and should yield to reportage. It is outdated, 'un espèce de coche, de diligence, de l'esprit', whereas the press offers 'la chose vue, le récit véridique, tout chaud, prolongeant dans les phrases les palpitations mêmes de la vie'.[11] If Londres ever needed to console himself for not achieving a novel, he could well have made his own Béraud's pungent opinions on the relative value of journalism and fiction.

Londres, in many ways, is ambiguous and mysterious, the mark perhaps of the true writer. Zola is inimitable, and he talked obsessively about his investigative methods. Without furnishing any such details, Londres too is *sui generis*. When approached by a young man up from the provinces, Zola advised him to hurl himself into journalism. Describing this encounter, Zola sketches in advance the young Londres on his arrival in Paris:

10 Georges Charensol: *D'une Rive à l'autre*. Paris: Mercure de France, 1973, p.22.
11 Henri Béraud: *Le Flâneur salarié*. Paris: Union Générale d'Editions, 1985, pp.16–17.

Il a vingt ans, il ignore l'existence, il ignore Paris surtout: que voulez-vous qu'il fasse? S'enfermer dans la chambre d'un faubourg, rimer des vers plagiés de quelque maître, mâcher en vain le vide de ses rêves? Il en sortira au bout de cinq ou six années aussi ignorant de la vie, ayant encore tout à apprendre, l'intelligence malade de son inaction.

For such a youth, journalism would be a 'bain de force'. Wisely, Zola allows for the innate, the verbal silver spoon, as well as the existentially acquired, for 'la presse ne donne de style à personne, seulement elle est l'épreuve de feu pour ceux qui apportent un style'.[12] Zola is the often unknown or unacknowledged fount for later (especially American) manuals of journalism, 'style-books', that are forced on pubescent reporters, too many of whom, however, settle for the skeleton of this credo rather than its tough core.

Style

Londres gradually helped to make the *grand reportage*, previously the apanage of academicians or diplomats, into a more democratic mode, though only eclectically conveyed in the demotic. Though I am convinced that style and composition are inescapably ethical matters – there is no innocent language – for the purposes of exposition I will need to treat them separately. I reject totally the elitist proposition of Delmond: 'Le journalisme n'a rien à voir avec la rhétorique. Le niveau moyen du public n'est pas élevé: le style doit être simple'.[13] Simplicity is no more natural than complication, and so it is a form of rhetoric. It aims to persuade us of its virtues, its rightness. We need only recall the craftiness of the understated style of Hemingway, or of the Camus of

12 Emile Zola, in *Les Annales politiques et littéraires*, 22 July 1894, cited in Lacan: *Les Journalistes: stars, scribes et scribouillards*, pp.221–2.

13 A. Delmond: *Albert Londres*. Thèse de troisième cycle. Université de Paris IV, 1976, p.162.

L'Etranger. As Montaigne said long ago, if you want to hear the whole range of rhetorical devices, listen to your maid's chatter.[14]

Not simplicity, then, but concision certainly (which for many people is surprisingly hard to swallow). It has been mooted that the large quantity of monosyllabic words in English (e.g. the jacks-of-all-trades *get*, *put*, *set*, and all their extensions) make for a more condensed mode of expression, though of course short words used in quantity can hardly produce brevity. Even so, the famous snappiness of journalistic language should never delude us into overlooking the fillers, the padding, which also feature. In addition, in reading a paper it is often hard to distinguish between 'fleshing out' a story and freewheeling additions. Nevertheless, in Londres's case, we see a palpable care and ear for economy, and for a variety of rhythms, attack, punch-lines, ellipses. It is less a question of reading between his lines than of keeping up with him. We can take it on trust, because he wins it, that he says what he means, and means what he says. There are few revisions or corrections on his manuscripts. He must have believed that his first thoughts were usually his best. The result is an exuberant and natural prose, whereas so many journalistic idiolects are spoken by noone in their right mind, even if they are widely written.

There are many dialogues in Londres's narratives. Assimilating rapidly information and experiences, he remodels what he has taken in, for he is a born fabulist. Either he has a fantastic memory, or he embroiders and reshapes. The dialogues are superbly faked, and all the more persuasive for that, for example in *Au Bagne*, when the penal administration speaks in the tones of a brothel madam. His notebooks contain only the barest, driest notations of interviews. It is as if he wanted to internalise what he had heard, instead of recording it verbatim. In reporting dialogues, he is ventriloquising, inserting the discourse he wished had taken place. As in novels, his dialogues are very frequently concocted as a means of dramatising situations, which he composes in writerly fashion. In *Au Bagne*, the rough convicts speak in correctly structured sentences, use the past historic tense in their narratives, and take off at times on short flights of lyricism. There is no Balzac-type, elephantine attempt to match what was probably, on the spot, sub-standard French. A prisoner recounts an escape from the settlement; the

14 Michel de Montaigne: *Essais*. Ed. M. Rat. Paris: Garnier, 1962, livre 1, chapitre 51, p.340.

small boat is caught in a violent storm: 'La barque vola sur la mer comme un pélican. Au matin on vit la terre' (*AB*, p.24). No doubt the convicts' lingo was picturesque, and Londres supplies a stylish counterpart, which is one way of refusing to belittle or stereotype the outcasts. In the same account:

> Dans Trinidad, Monsieur, il n'y a que policiers et voleurs. Un grand Noir me frappa sur l'épaule et dit: 'Au nom du roi, je vous arrête!' Il n'avait même pas le bâton du roi, ce macaque-là! Mais un morceau de canne à sucre à la main. Ces Noirs touchent trois dollars par forçat qu'ils ramènent (*AB*, p.24).

It is easy to imagine Londres listening to this colourful tale, revelling in the comedy and pathos of the situation, and then sitting down to rewrite it, but striving to keep to the spirit, if not the letter, of the original.

One of Londres's masters, Joseph Conrad, described thus his task as a writer: 'By the power of the written word to make you hear, to make you feel – it is, before all, to make you *see*. That – and no more, and it is everything'.[15] No doubt this is an etymological tautology, but Londres is a graphic writer. Traditionally, and especially for many readers, descriptions, whether in novels or reportages, have had a bad press. It is commonly felt that descriptions of places or objects slow and clutter up the main thrust of the narrative. For the less avid reader, descriptions are what you skip. As a result, in many writers, if descriptions feature at all, they are often perfunctory. How pictorial did Londres aim to be? He was writing in the age before the phenomenal rise of the daily *Paris-Soir* with its profusion of photos.

In Darien's *Biribi*, a pathfinder for Londres's *Dante n'avait rien vu*, the hero Froissard refuses to describe the North African locales except in derisory form, for instance a Tunisian town seen from afar and exclusively in terms of edibles: 'Une dégringolade de fromage blanc entre des murailles en nougat: le tout dominé par une pièce montée sur laquelle il aurait plu de la crème fouettée. On en mangerait'. This joke use of exoticism, the travelogue's recourse to local colour, has its more practical and pointed side. Needing to extract money for essentials from a cousin back home, Froissard hits on the device of sending flowery pen-portraits of North Africa, which he rightly imagines will feed the

15 Joseph Conrad: Preface to *The Nigger of the Narcissus*. In: Conrad's *Prefaces to his Works*. London: Dent, 1937, p.52.

stereotypical expectations of the recipient, and, putably, the readers of Darien's novel. Froissard ironically sums up his exploitation of cliché in this singing for his supper: 'Je sens, je vois, je vois même très bien; et la preuve, c'est que je vois absolument comme ceux qui ont vu avant moi'.[16] Indeed, reading descriptions of places, how often have we felt that the author was reinventing the wheel? Darien's aggressively rueful admission of the unreliability (or excessive reliability) of description repeats the earlier lesson of Cervantes and Flaubert, and the later one of Barthes: we see what we have read. I will analyse later Londres's use of and resistance to cliché.

His own descriptions can hover over the precious, while remaining touching, as in this scene of gulls watched from a torpedo-boat:

> Un soleil de première communiante, pâle et recueilli, peut juste éblouir une langue de mer. Des mouettes, dont voici un parc, font dans ses rayons des effets de cuirasse. Elles veulent fêter sans doute le spectateur [...] On va peut-être leur expliquer pourquoi elles ne vivent plus en paix et quel est ce bruit qui leur fait dresser le bec. Le spectateur, mouettes blanches et grises, n'a pas le don de parler aux oiseaux, il ne pourra pas vous payer vos belles fantaisies dans le soleil (*CR*, pp.47–8).

More economically, he can hit the target, as in this description of King Constantine preparing to depart: 'Il s'était, avant de sortir, maquillé d'amabilité' (*CR*, p.221). He personalises places, as after the departure of the monarch: 'Après cinq heures, subitement, la physionomie de la ville est retournée. On la voit pâlir comme un vrai visage: la ville sait' (*CR*, p.223). While no doubt Londres hoped, by his writings, to foster understanding, above all he wanted readers to picture what he had seen, even when he had no magic explanation to offer.

The role of metaphor in description is primordial, as the pulling together of different referents creates new images. Throughout, I have quoted many examples of Londres's uses of metaphor. A frequent habit, logical for a foreign correspondent, is to refer back to France, and especially Paris, that is to what is familiar to his readers, enabling them to grasp the distant via the familiar. As he deals principally with often very different cultures and scenes, and unusual sets of events, such a bridging of the gap (the very essence of metaphor: 'to carry across') is

16 Georges Darien: *Biribi*. Paris: Union Générale d'Editions, 1970, pp.78, 284–5.

clearly necessary. At the same time, trying to communicate the strange (which so often is translated as the 'funny'), he seldom privileges the home reference. Nor, à la Voltaire, does he venture abroad in order to slate domestic practices. A regular variant of this tactic is to bring together on the same level the two elements he is comparing, as a means of satirical cutting down to size, as when he remarks casually that T.E. Lawrence is as much a colonel as Londres himself. Or the Chinese warlord, who as a child hunted herbs to sell: 'Ce fut sa première vocation, devenant vétérinaire comme d'autres s'installent rebouteux': the future dictator starting out as horse-doctor (*MS*, p.160). With no mocking intent, he creates an extended image structuring a whole passage, as in the lengthy *métaphore filée* on the Greek maze (*CR*, pp.105–7).

Londres's reportages are indeed in general artfully structured, a sign of a convinced literary rhetorician. The structure can be largely static, as in texts such as *Au Bagne*, *Dante n'avait rien vu* or *Chez les fous*, where the penal situation itself dictates a running (commentary) on the spot. In addition, many of his wartime despatches deal with and reflect stalemates. Thus his writing on the move, which gives my book its title, makes much room for concentrated attention on circumscribed areas. Only the Tour de France is constantly in motion. Though *Pêcheurs de perles* houses a great deal of travel around the Near East, its final focus falls on the mainly stationary and hemmed-in, if yoyo, activities of the divers. Their lives consist of near-automated ups and downs. In French rhetoric, repetition plays a major part; it goes with this culture's taste for theme-and-variations. A large percentage of Londres's experience, in wars, revolutions, prisons, asylums, or even in tailing the cyclists of the Tour de France, consists of the witnessing and undergoing of repetition: reiterated horrors, enforced habits, the treadmill existence of various kinds of sufferers. Whether immobile or peripatetic, Londres's concern is ever to 'cadencer une phrase'.[17] This can give rise to quite intricate structures, for Londres never subscribed to the puritanical view that sentences which hold you up and compel you to reread them should be recast. Such a practice would ban second thoughts, mental back-flips, and other joys of the living intellect. After all, if we read too flowingly, we fall into a sort of uncritical trance.

17 Mousset: *Albert Londres*, p.323.

It is not surprising that film-makers and stage-adapters have been drawn to his journalism, for it has many affinities with screen and boards: rapid cutting from one scene or theme to another, staccato commentary, swift panning. In such graphic writing, the visual and the written coalesce. Often an apparently offhand verb suffices to encapsulate a drawn-out event: 'En six heures, notre train *liquida* le Liban' (*PP*, p.165, my italics). All the same, Assouline overstates when he writes that Londres 'n'explique pas, il montre. Ne démontre pas, mais raconte. C'est sa force'.[18] Though it is true that 'journalists do not write articles. They write stories. A story has structure, direction, point, viewpoint', Londres's stories are not those of the popular press.[19] The popular press is almost all narrative, anecdotes, gossip, with a minimum of invitations to readers to think for themselves: all is predigested. Such papers do not relish being quarrelled with, and few have serious columns devoted to readers' letters. The working assumption is that the paper's staff are in tune already with everybody's ideas and feelings, and so there is no need for further refinement, questioning or discussion. The tone is that of unadulterated dogmatism, in the best (and worst) bar-room lawyer/taxi-driver mode.

Like Jules Vallès, Londres favours plenty of short jabs rather than haymakers. This was his way, too, of 'aerating' his text. Remember the dense mass of print in newspapers up to the Second World War. Vallès needed such oxygen (spacing, breathing-points) in order to combat asphyxiation, either of self or of reader. For him the goal of a journalist proper was 'l'allure ferme, sobre, sans bavures […] Chaque paragraphe doit contenir sa balle propre'.[20] Such a preference led to often telegraphic structures, typographically isolated and thus foregrounded segments of text, punchy sentences, the bloating of often minor details for comic or rhetorical effect, and in general the search for drama even in the supposedly humdrum. Similarly, the often staccato rhythm of Londres's sentences recalls Vallès's syncopations. In both cases, this is a way of paying due homage to chaos, or at least to bittiness and mess – the very stuff of life. Sartre's *La Nausée* offers a potent critique of our insistent

18 Assouline: *Albert Londres*, p. 356.
19 Allan Bell: *The Language of News Media*. Oxford: Blackwell, 1991, p.147.
20 Jules Vallès, in: A. Callet: 'Lettres inédites de Jules Vallès'. *Revue indépendante*, April 1885, pp.473ff.

and misleading retrospective ordering of experience in anecdotes and funny stories. As with Vallès, discontinuities in Londres are still a means to shaping that involves deletions, highlighting, underplaying, overstating: choice. It is a new order, not an absence of order. Like Vallès and as a result of journalistic habits of headlining, Londres often gives readers the gist, the main news, ahead of the details; he jumps the gun. If anything, such a device adds to rather than destroys suspense and tension.

In both cases, holding in (irony, reserve, litotes) alternates with expansion (indignation, hyperbole, lyricism). It is the rhythm of breathing itself. It is the accumulation, juxtaposition and intensity of the scenes evoked that gives each writer's work whatever unity it possesses. The sketches pile up into whole pictures. Vallès, and Londres, keep a sharp eye open for the salient, revelatory feature or gesture, the special silhouette each of us has. People are on parade, but the two journalists are generally tolerant sergeant-majors. Both knew in their bones that journalistic style has to be mainly lapidary. Not only constraints of space and time, but also the need to spare readers unnecessary brain-fag or eye-strain, lead to foreshortened texts, – except of course that the notorious brevity of wit can be ultimately fatiguing to the recipient. Journalism has to grab the attention of readers, for newspapers are by no means invariably scanned in the domestic tranquillity of an armchair, but so often in noisy cafés, bars, or in crowded commuter transport.

Clichés

Two founding clichés or stock metaphors about journalism (and that which founds is self-evidently essential) concern firstly glass: lens, focus, window on the world, reflection of public opinion; and secondly excavation: probing, exposing, unearthing. Journalists should radiate what they bring to light. The very term 'mind-set' calls up images of jelly, custard, concrete, or other solidifications of the loosely packed. Clichés are fixed, which is to say dead, though some are dead right, spot-on. In a farewell speech to Fleet Street in 1945, James Bone said: 'To make a cliché is to make a classic'. The ambivalence of cliché, its

variable wrongness or rightness, helps to ensure longevity. Using them, as we all do all the time, we slump towards automatism, verbal tics or hiccups. In this state, we have words before thoughts, and put carts before horses.

Your style is no doubt your personal hallmark, but also 'le style fait la prison'.[21] Having a style to call your own necessitates a certain amount of self-parody. Londres could not help but be himself incorrigibly; he could never escape his own bounds, the perimeter and parameter of his cognitive and linguistic potentialities.

As Bernard Voyenne, after a lifetime spent studying and teaching the French press sums up stoically: 'Tout, ou presque, a changé dans la presse sauf les idées qu'on s'en fait: celles-ci n'ont guère varié depuis le XVllle siècle'.[22] The same grievances, recriminations and stereotypes recur over the decades. Inside the profession, automatic pilots long predated the aeroplane age, as Balzac, in his own terms, noted over a century and a half ago: 'Quiconque a trempé dans le journalisme, […], à la longue […], les gonds de la banalité s'usent et tournent d'eux-mêmes'.[23] His own clichés about the press can turn Romantic and melodramatic: 'Le journalisme est un enfer, un abîme d'iniquités, de mensonges, de trahisons, que l'on ne peut traverser et d'où l'on ne peut sortir pur'.[24] But even Balzac the great over-reacher cannot surpass Kierkegaard: 'If Christ were to appear in the world today, he would, so help me God, take aim not at the high priests, but at the journalists!'[25] Nearer to our own day, we find still exaggerated but more moderately phrased verdicts: 'Quelques vieux rédacteurs de province persistent à croire que le journal est une tribune et le journalisme un sacerdoce': something of a headily mixed metaphor – politician/priest.[26] For Henri

21 André Suarès: *Trois Hommes*. Paris: Nouvelle Revue Française, 1913, section 1.
22 Voyenne: *Les Journalistes français*, p.155.
23 Honoré de Balzac: *Splendeurs et misères des courtisanes*. (*La Comédie humaine*, vol. 6). Eds. P-G. Castex et al. Paris: Gallimard, 1977, p.437. The metaphor is less efficient than intended, for what is worn out does not turn easily. In general, Balzac sneered at journalists as a sub-genre of the man of letters.
24 Balzac: *Illusions perdues*. Ed. A. Adam. Paris: Garnier, 1956, p.250.
25 Sören Kierkegaard, quoted in Karl Kraus: 'Ecrasez l'infâme!' *No Compromise: Selected Writings*. Ed. F. Ungar. New York: Frederick Ungar, 1977, p.92.
26 Archambault: 'Le Journal français de demain', p.558.

Béraud, a reporter 'tient à la fois du diplomate et du détective'.[27] In the early twentieth century, a regular foreigner's cliché about the French press was that it was much inferior to the American or British press as regards garnering or establishing facts or collecting news on the spot, but that it possessed 'typically' French qualities of literary style, wit, and general cultural *savoir-faire*.

A frequent dismissive image is of the journalist as hack. Journalist hacks are a major subdivision of the hackneyed, along with nags and strumpets, (and the same conjunction reoccurs in the French derivation, *haquenée*). In detail: journalists are venal, boozy, unscrupulous, devious, self-boosting, anarchistic, lazy, libellous, brash, and so on. At the other extreme, they are portrayed as folk-heroes, crusaders or knight-errants. Most of these images, pejorative or laudatory, stem from a great many (mainly) Hollywood films, or American plays and novels, with their dramatic refrain of 'Stop the presses!' or 'Hold the front page!' Woodward and Bernstein's investigation of the Watergate scandal provided a high-point in the heroisation of the profession, especially when embodied on screen by Robert Redford and Dustin Hoffman, though Woodward, like many another young subversive, found later that it paid better to cosy up to the Establishment. The trite images also arise from non-journalists' disdain or envy, above all on the score of alleged racy living. A frequent tag is of the reporter as intrusive dabbler, snooper, dilettante. A particular stock idea, for which Londres had some sympathy, is that no special training is necessary in order to pursue this calling: you learn on the job, by rich or bitter experience, or absorb the recipe lessons of old stagers. One commonplace promoted both by journalists and consumers of newsprint concerns the supposedly essential quality of impartiality. As if men, or women, could function like unfeeling robots, or recording angels. We see the censoring value of cliché when we recall officialdom's persistent attempt to deflect reporters away from battlefields, away from the awkward or brutal truth, by reason of the reputed untrustworthiness of the hacks. Perhaps, to purloin the argument occasionally used to still criticism of the Catholic Church because of its sometimes fallible, indeed criminal, priests, we might plead against the indicters of journalists that blanket attacks on the

27 Béraud: *Le Flâneur salarié*, p.14. More sombrely: 'Il écrit pour l'oubli' (p.111).

whole profession are not justified by the existence of some rogue pressmen.

Apart from Londres, two of the most famous reporters in French culture are both fictional: Rouletabille and Tintin. Rouletabille (rolling stone) was a figure created by the bestselling crime writer, Gaston Leroux. He is a perspicacious, delving reporter, who solves mainly crime enigmas. Leroux provides a neat summary of the journalist's basic function: 'Voir, savoir, savoir faire, faire savoir'.[28] Hergé, the inventor of the strip-cartoon, ageless, boy-hero Tintin, acknowledges that the lad, in his avatar as an ace newshound, was inspired by 'grands reporters' such as Londres, Kessel and Hemingway.[29] Damelincourt comments that this mythical, highly proficient but ever cub reporter 'ne prend quasiment jamais de notes et ne fréquentera que rarement les locaux de son journal. Archétype de la presse dans la bande dessinée, Tintin apparaît ainsi bien plus comme un aventurier que comme un journaliste'.[30] Much the same was often believed of Albert Londres.

Whether the style be high style or the demotic, many unimaginative journalists fall into aping it. As a public medium, perhaps inevitably, its operators try to be all things to all people, and thus land up in cliché. 'The press is the last refuge of clichés'.[31] A standard term for a journalistic or a French schoolchild's text is 'copy'/*copie*. The journalist would thus be a copyist, a stenographer for others. According to the veteran journalist/novelist/playwright Keith Waterhouse,

> for a good forty years, the popular press was to speak in a strange, celluloid-collar English. In those penny-a-lining days, policemen were upholders of the law, criminals were denizens of the underworld, goalkeepers were custodians of the citadel – and journalists were gentlemen of the press. They wrote like counting-house clerks forging their own references.[32]

28 Gaston Leroux, quoted in Le Bohec: *Les Mythes professionnels des journalistes*, p.144.

29 Hergé, quoted by Benjamin Damelincourt: 'BD: Enquête sur la disparition d'un mythe'. *Presse-Actualité*, February 1984, p.29.

30 Ibid, p.30. Clark Kent in the Superman series is more of a feeble antihero in his everyday journalist mode, as a contrast with his miraculous flights when suitably uniformed.

31 Guillermo Cabrera Infante: *Infante's Inferno*. London: Faber, 1985, p.359.

32 Keith Waterhouse: *On Newspaper Style*. London: Viking, 1989, p.25.

In the puristic view, it is when journalists ache to move beyond recording and to make a splash that clichés begin to proliferate:

> It is best [claims Lerner] to regard cliché as an attitude to one's language, rather than the use of individual objectionable phrases: to speak of cliché, and not clichés. And we may define it as the use of commonplaces with sensational intent – the purple cliché.[33]

On the face of it, this opinion is puzzling, for it would seem hard to captivate anyone with worn-out devices. Do not greedy or blasé publics implicitly demand 'Surprise us!'? Lerner's notion presupposes that much clichéic, sensationalist discourse carries a still potent mesmeric charge. The fact that journalists generally steer clear of abstraction and seek to use metaphors profusely promotes the myth of the press's colourful writing as against cooler forms of language. Of course, a great deal of anyone's speech or writing is metaphorical, because idiomatic. It is only when such forms are unexamined, knee-jerk, that they slump into automatism.

For their part, headlines are often compact clichés, because shortage of space limits vocabulary and the complexity of what can be conveyed. The identikit/photofit picture (*portrait-robot* in French), much used by the police and reproduced by the press in its crime-busting mode, in many ways sums up the pen-portraits of non- or less criminal people covered in the main body of the paper. In these, human beings are shrunk, simplified, to the easily recognisable. The other extreme, but extremes meet, is hyping. Walter Lippmann wittily relocates the word 'ideal' in his analysis of journalistic hyperbole: 'Our repertoire of fixed impressions [...] contains ideal swindlers, ideal Tammany [town-hall] politicians, ideal jingoes, ideal agitators, ideal enemies'. Furthermore, 'we do not like qualifying adverbs. They clutter up sentences, they interfere with irresistible feeling. We prefer most to more, least to less [...] In our free moments everything tends to behave absolutely – one hundred percent, everywhere, forever'. On a less over-the-top level, 'without standardisation, without stereotypes, without routine judgments, without a fairly ruthless disregard of subtlety, the editor would soon die of excitement'.[34]

33 L.D. Lerner: 'Cliché and Commonplace'. *Essays in Criticism*, VI, 3, 1956, p.254.
34 Lippmann: *Public Opinion*, pp.104, 156, 352.

Where does Londres stand on the wide spectrum of clichédom? First of all, he was himself a living, and then a dead, cliché or archetype of the 'grand reporter', and he proudly lived up to his status and myth. Like the classic screen reporter, he always, in photos at least, except when in Arab mufti, wore his trilby, a symbol no doubt of out-and-aboutness. In his prose, as well as working hard to modify or destroy the clichés of others (about convicts, the mad, prostitutes, or whole countries), he also had to work on his own previously unenlightened preconceptions, for instance about colonies or Jews. He did not always succeed. French colonies were, in his frozen view, long past their heroic, pioneering stage of development. He was comparing a reality with a bookish invention. If at times, he seems to veer close to antisemitic prejudices in his report on Soviet Russia, we must recall that he could hardly avoid mentioning the numbers of Jews in positions of power there, for many were, and he had no particular criticism to make of their performance. Inflexible anti-Bolshevism was another matter, but he believed he had produced enough evidence to justify it, and his indictment did not depend on race. In general, he recognises how serviceable many set expressions are, for example the common old threat to misbehaving children: 'Si tu continues, tu iras casser des cailloux sur les routes de Guyane' (*AB*, p.34.) The irony, of course, as we have seen, is that there was little or no road in that poorly developed settlement for the grown-up delinquents to work on.

Londres picks the perfect antidote to hackneyed exoticism, when he writes of the Dardanelles in 1915:

> C'est là! Les Dardanelles! Elles étaient les portes dorées qui conduisaient les voyageurs vers la cité enchanteresse. Parler d'elles, c'était déjà sourire au fond de soi à toutes les somptuosités de l'Orient. Elles étaient le mot qu'il semblait suffisant de prononcer pour que l'on vît aussitôt à travers les voiles, les visages de femmes mystérieuses de ce pays. Leur nom était si joli qu'en les approchant on était tout prêt à entendre tintinnabuler les clochettes d'argent. Et c'est le canon qui va parler! (*CR*, p.96).

Here, Londres both handsomely admits the seductiveness of the Orientalist cliché, and subverts it with the facts of contemporary life. Though he never acted the part of that other journalistic cliché, the crime-buster, he certainly took the lid off many an unsavoury, or indeed nauseating, stewpan, and helped to reverse the course of injustice for

several groups or individuals. Even though, in their spirited anthology of invented but plausible journalistic cliché, Burnier and Rambaud place Londres in the midst of literary giants like Flaubert, Maupassant, Hugo, Valéry and Gide, and say that none of these ever used the hackneyed phrases their book encapsulates, it is not entirely true that Londres, let alone his august company, is a cliché-free zone.[35] Who, on earth, is?

Indeed, why single out journalists, when many an official hand-out, government spokespersons' sound-bites, citizens doorstepped on the street, or anybody's mentally lazy reactions to what we read, see or hear, are replete with clichés? Many of our most spontaneous utterances or unspoken thoughts are clichés; we prefer reflexes to reflexions. Change, or the possibility of it, occurs only if we consciously resist cliché, and ask: 'Is this necessarily so?' 'What does that mean, exactly?'

As for journalists, the need to comply with a house-style tends to iron out individual phrasing or any provocative asperities. Rewriting engenders anonymous copy. 'The rules are never spelled out but are understood and internalised, and the system becomes self-regulating, through anticipatory self-censorship'.[36] We can never justifiably blame the 'system', for we have helped to make it what it is. Big Brother *depends* on Winston Smith. The miracle, always under threat of cancellation, is that the best journalists, such as Londres, whether working on quality or tabloid newpapers, can at times buck the system, and function as more successful Winston Smiths in the general derealising, uniformising environment, by their resistance to thought-control from above, below, or even from their own worse selves.

35 Michel-Antoine Burnier and Patrick Rambaud: *Le Journalisme sans peine*. Paris: Plon, 1997, p.13.

36 Bob Hodge and Roger Fowler: 'Orwellian Linguistics', in: Roger Fowler, et al. (eds): *Language as Control*. London: Routledge & Kegan Paul, 1979, p.17.

Readers

Though anyone can fabricate a hostile stereotype of readers – lazy, gullible, passive, forgetful, and so on – in fact no general image is possible. Journalists are difficult enough to typify as a body. We have, however, their texts to go by. With readers, we have to rely on nothing but guesswork, for they are the great unseen. We can, all the same, imagine them, and we can talk about Londres's designs on the reader, detectable from his writing practices.

What can a journalist take for granted and count on? This, of course, is every human being's essential problem: what do we share, and what can we accurately know of each other? A journalist must appeal to some form of consensus, moral standard, common decency, or common sense. The risks involved in configuring readers are those of dumbing-down, condescension, or reliance on the lowest common denominator.

Londres clearly wants to involve his readers in thinking about issues that governments or other agencies would prefer them to forget about or be ignorant of. Just as Gandhi wisely and wittily replied to the question : 'What is democracy?' by saying that it would be a good idea, good investigative journalists are there to remind us, either by implication or by direct address, and against all nay-sayers, of what remains a good idea. This is true conservatism, and true public relations, and not in its debased presentday sense. For many readers, all vigorous resistance to authority is bad because disruptive, except for the actions of reactionary forces against unpopular underdogs, which are of course conducive to public order. Against such conservatism, in its limited sense, thoughtful journalists need to demystify, or at least demist, readers, by corralling their maverick notions, shaping and focussing them, by homing in on the gist of a question and sidelining irrelevant aspects. Even so, an effective journalist does not attempt to predigest everything. He/she leaves some work, for example cross-referencing or other critical checks and balances, to the reader assumed to be thoughtful, if not yet properly informed. A colleague of Londres, on the question of journalistic exposure, takes the Pope line ('What oft was though but ne'er so well expressed'): 'Il y a tant de colères tassées dans une conscience d'honnête

homme. Et voici que ces colères écatent par la voix de cet inconnu'.[37] Ay, there's the rub. How many *honnêtes hommes*, or *honnêtes femmes*, are there in the population at large? It is a matter of trust or of pious hope that they form a significant number. Another commentator asks the crunch-question: 'Les lecteurs ont-ils le même imaginaire que les journalistes?'[38]

As a roving reporter for much of his life, Londres faced particular problems over his relationship with readers. Unlike Proust's Françoise, the epitome of the old peasantry of France, and an artist, like him, in her own field (culinary artisanry), most people are imaginably more concerned by the news of their locality or country than by geographically remote dramas.[39] A journalist's job is to lift us out of our terrible parochialism, our picayune backwaters, though the majority of readers inevitably focus on international news only when it directly impinges on and threatens national or local life. One solution is to try to bring abroad home, to familiarise the foreign. Seeking to evoke a Polish city, to make it real and recognisable to French readers, Londres writes:

> Ici, je dois vous montrer comment la ville est faite. En haut, le Belvédère, qui serait notre Arc de Triomphe: les allées Uyastowska, qui sont les Champs-Elysées; puis la place Saint-Alexandre, qui est la Concorde. Pilsudski est place Saint-Alexandre (*DA*, p.129).

This panning shot, homing in on the focus for his visit, the Polish leader, would naturally be of less use to readers in a village of the Cévennes. Another ploy is to turn the tables: 'Vous êtes loin, et vous savez peut-être les raisons de la survie de Monastir. Nous, nous sommes sur les lieux et nous ignorons tout' (*CR*, p.127). Paradoxically, the envoy may enjoy less comprehensive news-coverage than the stay-at-home. The reader might feel flattered, before remembering that he has not shelled out in order to read an admission of ignorance.

When discussing Londres's reports from China, I quoted his wry awareness that he had to surmount relative apathy among his French audience for such foreign news. Reports from the colonies, on the other

37 Alexis Danan: *L'Epée du scandale*. Paris: Laffont, 1961, p.247.
38 Lacan: *Les Journalistes*, p.52.
39 Françoise blinkers herself to the nearby pains of her pregnant kitchen-maid, while waxing distraught over far-flung catastrophes.

hand, held some intrinsic interest, because many French families had offspring in colonial administrations or overseas armed forces. In addition, a good number of even small-time French investors owned stocks and shares in colonial enterprises. Above all, the colonies benefited, and suffered, from their status as exotic places for metropolitan readers. *Le Journal des voyages* and *Le Tour du monde*, popular illustrated magazines, and *L'Illustration*, targeted at the bourgeoisie, fed such a taste for alien hothouses. No doubt they simultaneously or alternately opened up horizons and cemented stereotypes about foreign parts, denizens and customs. Finally, as well as being transported to locales and briefly living in them by proxy, readers can experience live encounters with famous figures as if they themselves were present. Delmond employs a usefully polysemous verb when he writes of Londres's 'désir de dépayser ses lecteurs'.[40] *Dépayser*: to disorient, to give a change of scenery to, to make strange.

Journalists have some right to consider themselves as providers of an extension to the normal lives of readers. In all his campaigns, Londres could never delude himself tht he was preaching to the converted; he had no readymade, sympathetic audience. He had to create one. One tactic was to put putative readers on their honour by assuming that they remembered what they had read earlier. Reporting from Salonika in May 1916, he says: 'Vous vous souvenez que [Salonique] fut très agitée il y a quelque cinq mois' (*CR*, p.160). Frequently, he addresses the reader directly in this way, though usually from a certain distance of politeness. He eschews the chummy mode so often let loose in the English press. Very French is his unabashed use of cultural allusions, as in the title *Dante n'avait rien vu*, or his casual recycling of Montesquieu's ironic 'Comment peut-on être Persan?' when he lends this to a Malagasy soldier encountering for the first time an Oriental one: 'A-t-on idée d'être Annamite?' (*CR*, p.190).

The relationship of reader to journalist is lastingly curious and ambivalent. While we follow a reporter's guide through a labyrinth, it is perhaps as we regard an unreliable narrator leading us through a fictional maze. We want to believe him, but we feel mistrust. How much does the reporter really know? Is the text slanted by some hidden agenda? In their turn, of course, journalists and editors have to use material fed to them

40 Delmond: *Albert Londres*, p.108.

by governments or businesses, while remaining sceptical about the hand-out. In efficiently repressive regimes, the press is permanently on parole. If a government concludes that it is misbehaving, it can be silenced, or driven underground. In a less efficiently repressive regime, as Delmond points out, 'celui envers qui [Londes] a réellement des devoirs, c'est le public, non le rédacteur en chef'.[41]

On many of the pages of this book, we have seen Londres writing ironically. In presenting human affairs as a variant form of theatre, such a writer might be thought to reinforce a passive response in readers. After all, theatre can be discounted: you don't have to go there, or read it. An apparently cynical text might encourage actual cynicism among readers. Humour is a tricky business.

Humour

If you pooh-pooh play, you forget that you were ever a child, or you were a mutilated or very dull child, a parody adult before your time. If you think that play concerns only children, you have not properly grown up. Play, and therefore humour, is as primordial and essential as work. Play *is* work – though for far too many people work is not play. In these pages, I have repeatedly stressed Londres's humour, and logically so. It is a constant, an organic part of his world-view and his ways of writing. It cannot be ignored or underestimated without amputating his totality.

Probably the very best cliché is that many a true word is spoken in jest. As well as being dangerous, but so can be humour, cliché has ineluctable connexions with comedy. An American term for cliché, 'bromide', in Britain traditionally denotes a means of keeping a soldier's pecker down: clichés as sedatives and detumescents. The American humourist Gelett Burgess exploits the word both for persons who do 'their thinking by syndicate', and for what emerges then on their lips or pages.[42] Bromides speak 'bromidioms', totally predictable remarks.

41 Delmond: *Albert Londres*, p.105.
42 Cf. my earlier remark about the large amount of syndicated material in the US press.

The opposing term, 'Sulphites', hardly gets rid of the bad smell, for 'bromide', etymologically, means stench. Unfortunately, like many a jobbing journalist, Burgess shrinks back from the full implications of his founding idea, and settles for and back on the comforting bosom of orthodoxy.[43]

The sidestepping of cliché, the resistance to its hegemony, relies on fresh thinking, vital use of language via twists, and an overriding sense of humour. Marc Kravetz hits the nail on the head, the blockhead, when he detects in Londres's and his own profession 'un engagement dans notre métier poussé à l'obsession en même temps qu'une conscience suraiguë de sa dérision'.[44] Gravity desperately needs its antonym, levity. We can die, it is proved every day across the whole world, of over-seriousness. Probably the only consistent and genuine investigative journalism in France has been, since its inception in 1916, the satirical weekly, *Le Canard enchaîné*. If that is accepted, it would prove that humour, thoughtfully targeted and deployed, is a fine way of responding honestly and effectively to the multiple challenges of reality. Some of Londres's portraits of dignitaries (e.g. in the First World War), are caricatures, potentially a variant form of reductionist sterotyping unless accurately aimed. We should remember the large role played by subversive cartoons in the war, or rather the anti-war, effort.

As I have offered numerous instances of Londres's jokes, twists, puns and so forth, in all the chapters so far, I want to use this section for more general speculation on his humour. For starters, nonetheless, here is one very nicely judged witticism. It concerns the Syrian desert tribes who, around 1920, were being egged on by the British to display overt hostility to the French administration in Syria: 'Crier aux armes à des hommes dont le plus clair du métier fut toujours d'attendre l'occasion, fusil à l'épaule, n'était pas *prêcher dans le désert*' (*PP*, pp.222–3, my italics). This rejuvenates an antique idiom ('preaching in the wilderness', addressing a non-existent congregation), very appositely, and indeed presciently: he could be referring to presentday Afghanistan.

Londres interested himself not merely in his own prowess as a humourist, but also partly judged those he encountered on his travels

43 Gelett Burgess: *Are you a Bromide?* New York: Huebsch, 1908, esp. pp.17, 21–2.
44 Marc Kravetz: 'Profession: correspondant de guerre'. *Magazine littéraire*, 378, 199, p.100.

along the same lines. Just as he found the laughter of convicts in the hell-hole of Cayenne to be close to *le rictus* (a kind of death's head or grinning skull), so in Soviet Russia, to his sorrow, *le râle* (death-rattle, but also corncrake) had replaced *le rire* (*DA*, p.208). As Delmond says, 'il n'y a pas [chez Londres] d'humour gratuit'.[45] It always works its passage. Even his 'objectivity', which I have argued is an undefendable hypothesis, is pointed. As Assouline notes, 'il est capable, d'un même tour de phrase, de moquer une des idées qui lui paraissent inconcevables, tout en donnant la parole à leurs sectateurs pour qu'ils les expriment'. In other words; give them their head, but let the comic response show through. In Assouline's view, Londres's *La Chine en folie* reveals 'un Londres gouailleur et picaresque dont le vaudeville était peut-être la véritable vocation'. Thus Assouline hovers, or havers, between belittling Londres as fundamentally unserious, and only partly recognising the crucial omnipresence of his humour. Modulating between *humeur* and *humour* (both from the same root; 'humour' in English is dual-purpose), he nevertheless accurately describes Londres as 'définitivement plus journaliste d'humeur que d'analyse'.[46] The moods, however, were many and various; and they were more often provoked by events than self-generated complacently. Assouline hardly allows for the necessity of humour in a journalist's make-up, whether it be a matter of entertaining the public – Londres wrote mainly for popular papers – or as a way of keeping himself sane amid the numerous horrors he witnessed. This is not to deny that on occasion he could steer close to joining what Waterhouse calls disparagingly 'the Third Form of the Fourth Estate' (especially production-line punning, and a generally joshing tone).[47] It is certainly the case that Londres would not have relished for his epitaph the emended graffito 'Killjoy was here'.

The French, naturally, believe that they have cornered the market in irony, that driest, suavest, most controlled and subtlest incarnation of humour. It is deadpan, smart, and, as such, the slipperiest item of rhetoric to pin down or to employ adroitly. Yet it cannot be invisible, just

45 Delmond: *Albert Londres*, p.122.
46 Assouline: *Albert Londres*, pp.181, 250, 356.
47 Waterhouse: *On Newspaper Style*, p.25.

discreet. Indeed, it can put on stage, at least for those who have eyes to see or brains to deduce, a writer's or speaker's camouflage. Ironic writers want both to withhold and to give away. Lack of irony is often a sign not only of a prosaic mind, but of an obfuscating one which, to be combatted, needs the counter-mystification furnished by irony. Furthermore, irony can be diamond-cut-diamond, a retaliation against hostile actions or speech, as well as, of course, an underlining of the myriad of ironies of life itself, the bloody-mindedness of existence. Though oblique in approach, it has the power to be one of the most targeted, pointed modes of humour and of critical thinking. As it does not appear to be explicitly moralising, it can be used in the finally futile pursuit of objectivity. Directed inwards, self-irony offers a way of getting in first with indictment, before others only too willingly oblige (the tactic of 'Mine Own Executioner').

For his part, the regularly ironic Londres can sound, in the Voltairean mould, pseudo-callous. On the massive sufferings of the citizens of St. Petersburg in 1920, he writes: 'C'est le typhus qui, passant par là et découvrant ces trois cent mille [habitants] recroquevillés sous la faim et le froid, s'est mis à jouer avec eux. Il en a abattu sans fatigue quatre-vingt mille par mois' (*DA*, p.178). An effortless massacre. This is irony as understatement of an event too vast to be otherwise described. While ostensibly the opposite of irony, exaggeration can pursue its own more blatant ironic trajectory. Of course, it is sane to remember that hyperbole can be merely also exclamation, or 'shriek marks', as it is called in the trade.[48] I have provided many examples of Londres's very pointed and comic use of hyperbole. The exacerbation of irony, sarcasm (savaging, as against simulated ignorance) can of course strike a reader as obtrusive. Sporadically, Londres remembers to ease up on his sarcasm and to allow facts, which can be as eloquent as any argument, to speak for themselves.

Ettema and Glasser pinpoint the drawbacks of journalistic irony:

> Irony transfigures the conventions of journalistic objectivity into a morally charged vocabulary for condemnation of the villains to whom we have foolishly entrusted our public affairs. Irony always threatens further irony, however; as a means of moral discourse, irony threatens to undermine its own moral ends.

48 Francis Wheen: *Guardian*, 16 November, 1994, p.5.

They go on: 'Progressive journalism presents the irony of a more enlightened yet less active electorate'.[49] In their view, irony can usefully comfort, or be much too comfortable.

Because it is indirect, irony can seem to suggest that it need not be taken altogether seriously. And, of course, if it goes undetected, its words can appear to give succour to the very enemy at which it is aimed. Even when it is spotted by recipients, these often feel ill-at-ease, unsure of the text's real intentions or secret agenda. Clearly, the receiver of irony has to be ready for and alive to it. The great postmodernist passe-partout, irony, can, naturally, ironically play the game of those seeking to disinform us. It can breed an attitude of unearned knowingness based, all too often, on ignorance or fallacy. Has irony ever reformed anyone or anything? It can be the would-be superior person's consolation or substitute for *not* participating in change.

Black humour, a major potentiality of irony (as in Swift's famous advice to the starving Irish to eat their babies) acutely encapsulates the ambivalence central to all humour. For what seems brave sport to some seems to others merely heartless indifference. Surely, however, black humour, like irony, can emphasise, and not trivialise, the seriousness of suffering. Without levity there is no true gravity, and overcoming gravity has been a persistent and now (intergalactically) realisable dream of humankind. Humour is not just 'comic relief', but often makes a joke out of pain, as in much Jewish humour. For a Londres, a sense of humour is as aboriginal as a tragic sense of life, and each can house the other, not cosily, but in a productive tension. Though humour can sidetrack our moral sense, or switch it off temporarily, it can also force us to see, feel and judge from a different angle than the one we first thought of. It can rub our noses in the mess of life, often more effectively than solemn preaching can.

Occasionally, like all of us, Londres emits failed jokes, as when he says of Dieudonné: 'De même que pendant la guerre on sucrait son café avec de la saccharine, il adoucit son regard d'une profonde amertume' (*HS*, p.212). How can bitterness sweeten anything? Saccharin is artificial, bitterness presumably authentic. In general, however, despite his fixation

49 Ettema and Glasser: *Custodians of Conscience*, pp.12, 109.

on all forms of imprisonment, Londres's humour rarely falls into that trap so well described by Jules Vallès, that of becoming 'le forçat du bon mot', dispensing factitious gaiety.[50] Vallès said of Henri Rochefort, an arch-practitioner in his day of this semi-automatic wit: 'Votre talent peut s'user à appointer les épigrammes, comme la meule du rémouleur s'use à appointer les aiguilles'.[51] Vallès called this style of journalist 'allusionniste' – punning no doubt in his habitual way on 'illusionniste' – and swore that he was himself unfitted for such shifty practices. Although, in colloquial French, 'faire l'article' means to indulge in puffery, to plug something, as if selling an image were central to journalism, there was little room in Vallès's dynamic articles for that buried publicity, that hidden persuasion, that graphic *claque*, which were so prevalent in the nineteenth-century French press, and later. He had less fishy things to fry, or, as French has it, other cats to whip. Like Vallès, Londres's humour arises from what he is discussing. It is not forcibly imported and superimposed upon on it. He sees the joke *in* the material, the suspect or dangerous disparity that calls for highlighting and mockery. Like Vallès again, if he valued personal sovereignty, he ridicules delusions of grandeur, including his own. Like Vallès, Londres did not howl, or croon, with the wolves. Each was his own man, though temperamentally Vallès was much more of a *barker* than Londres. They both had unconcealably telltale styles.

Londres understood very thoroughly that humour can be, in the right hands, the very best, the aptest, reaction to an experience or a situation, in that not only does it help with bearing the unbearable (the horrific, the sandbaggingly boring, the infuriatingly impenetrable), but also is the only honest response to those various provocations. A sense of humour is a sense of perspective, and thus indispensable. I recall reading a newspaper report in the 1990s, about peasant dissidents in an Indian state, who decided that the most effective counter to official lies and brainwashing was, quite simply, to laugh out loud and en masse at all such pronouncements. It is tempting to imagine that, while they would be worried by public anger, politicians or company panjandrums would be even more disconcerted and humbled by collective mockery

50 Jules Vallès: *Oeuvres complètes*. Ed. R. Bellet. Paris: Gallimard, 1975, vol.1, p.799.
51 Ibid,. p.1052. I take the point, but the needles will wear out first.

expressed in laughter. It would be like actors on stage getting a concerted raspberry from the audience. How could the officials respond, except by standing clumsily on their remnants of dignity, which would then invite yet more derision? If they tried to retaliate with humour themselves, their target would be so diffuse that it would hit nobody in particular. Londres was, in effect, a one-man crowd responding like those subcontinental peasant humourists. All the same, even so staunch a champion as I of humour as a necessity for a proper life is given pause for thought by the title and the text of Neil Postman's book: *Amusing Ourselves to Death*.[52]

Tailpiece

Most of the time, Londres plays his cards on the table; even his irony speaks volumes. He was not an *allusionniste*, nor an elitist who favours the top-down approach. He is one of the least 'objective' of journalists, which is probably why he is one of the best. Can self-cancelling ever produce anything that provokes thought, grabs attention to important concerns, or illuminates murk? Mousset speaks of 'cette impartialité frémissante qui est sa marque'.[53] He is sensationalist only in the sense that, as with Vallès, his reactions are based on his senses, sensations, sensibility. Both are highly metaphorical writers. (In the jargon of the printed word, a 'literal' is an error. To be unrelievedly literal is certainly a mistake). Style, like humour, is a second skin, a second nature: it is the man or the woman him/herself.

With jesting sincerity, Don Marquis held that 'the art of newspaper paragraphing is to stroke a platitude until it purrs like an epigram'.[54] This suggests, however, a certain amount of leisureliness. On the move, Londres had to find freshness more urgently. His colleague, and a fine

52 I have omitted any further consideration of the regular punning in Londres's reportages, as I have already given plenteous instances of it and evaluated it throughout each chapter. I wanted in them to study their exploitation *in situ*, rather than in a decontextualised march-past in this largely generalising chapter.

53 Mousset: *Albert Londres*, p.156.

54 Don Marquis, quoted in E. Anthony: *O Rare Don Marquis*. New York: Doubleday, 1962, p.354.

reporter herself, Andrée Viollis, sums up perceptively Londres's variegated ways with words:

> Des articles d'un dessin précis et sans bavures, aux ombres et aux lumières violentes. Tout cela, par le plus étrange des contrastes, baignant dans je ne sais quelle atmosphère de fantaisie légère et cocasse, de nonchalant je m'en fichisme. Le plus savoureux des mélanges.[55]

Such a medley is as good a way as any other of keeping sane and of encouraging others to think and act sanely for a change.

Londres, of course, wrote in a golden, or gold-plated, age of journalism, which knew fewer restrictions on space or time for top reporters, who could on occasion see their campaigns have concrete repercussions. They don't write like that anymore, in our world of house-styles, rewriting, and pseudo-neutrality. His style is much less bedevilled than most by that literariness, that excessive recourse to cultural passwords and catch-phrases, so prevalent in French journalism, then as now.

55 Andrée Viollis: 'Albert Londres, prince des reporters'. *Les Nouvelles littéraires*, 5 September 1926, p.1. In the 1930s, women formed only 2% of French journalists. Reviewing Viollis's *Seule en Russie* in 1927, Londres over-gallantly claimed that she had scooped him and his male consorts everywhere, and that in her book she had covered the whole of Russia. He did not add that Soviet Russia was in a far less chaotic state when Viollis visited it than when he had. He clearly admires her sanity and self-sufficiency.

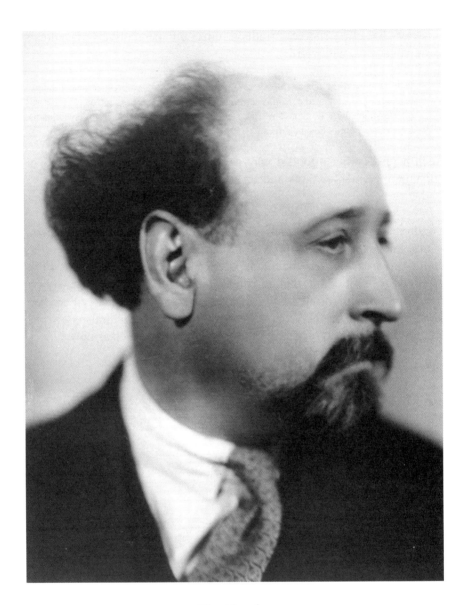

Albert Londres

Conclusion

The life of a journalist is poor, nasty, brutish and short. So is his style.[1]
Stella Gibbons

I use this epigraph by antiphrasis, or counter-factually, in relation to Albert Londres, for only the 'short' is true of his life. We have just seen what can be thought of his style.

Despite his undoubted hankering for stardom, he would not have thanked anyone of us for a hagiographical approach to his lifelong performance. How could someone as natively irreverent as he welcome reverence? Nowadays, very many journalists spend much of their time glued to that secondary goggle-box, the computer screen, whence they trudge or hop along the information highways and byways of the Internet, rather than hoofing it abroad. As with us television viewers, the world comes to them filtered. Londres belonged to a more direct-action, time-consuming era. Self-evidently, there is no inherent virtue in this fact of timing and accident of birth. His achievements in that different context, however, call out to be evaluated and saluted graciously, if critically.

So far, we have watched him mainly out of the house and out of his native land, a rolling stone, who of course gathered moss and barnacles, on land and sea. Obviously, there was also a more domestic Londres, a family man. 'They used to say that a man's life was a closed book. So it is but it's an open newspaper'.[2] While this gag remains somewhat gnomic, I take it that 'closed book' refers to the mystery we so often are to each other, and our consequent reliance on guesstimates; and 'open newspaper' concerns the more public actions of each of us, on display

1 Stella Gibbons: *Cold Comfort Farm*. Harmondsworth: Penguin, 1938 [1932], p.7. Her emebedded quotation is from Thomas Hobbes: *Leviathan*, 1651, pt.1, chap.13.
2 Finlay Peter Dunne: 'Newspaper Publicity', *Observations by Mr. Dooley*. New York: R.H. Russell, 1902, p.63.

for anyone to see. At all events, *reading* is not a part-time occupation, but an omnipresent necessity in learning to know others.

For much of his adult life, Londres's parents had largely to depend on reading his letters home in order to stay in touch with him. His constant habit of keeping them informed in this way about his experiences away from them undoubtedly acted as a brake on his journalistic excesses, so tempting when readers are otherwise anonymous. This practice ensured that he kept a foot on common ground. It was also a rehearsal. How he structured and dressed his narratives for a readymade private audience inflected how he wrote for the large-scale, public one. From time to time, he had to remind his parents, naturally anxious to see him, that absence was unavoidable. In 1920, on the eve of his departure to Soviet Russia, he explains, as so many times before, why he cannot get to them in Vichy: 'Vous ne pouvez tout de même vous désoler de mon succès'.

In his daughter's memoirs, he is presented as a man with a love for practical jokes and for fabulation. He had a decidedly rough way of bringing up a child. Reminiscent of Rousseau's *Emile*, where the devoted tutor, in order to teach his charge courage, dresses up as a ghost, moaning horribly, Londres one night plonked his little girl in her nightie on a dark landing.[3] Florise Londres nonetheless palpably loved her father absolutely, and she addresses much of her text directly to him. She relates his elaborate games, for instance making out in public that she was his sister, imaginably out of a distaste for being taken for old. He could be boyishly egotistic. On the publication of his first book, *Au Bagne*, he ordered Florise to buy a copy while he looked on, in order to savour the process of seeing his 'new-born' purchased at a near distance.[4] As a person, he could often be infuriatingly delightful.

According to both Assouline and Mousset, he had an inexhaustible supply of eager women. For Mousset, 'il n'aurait tenu qu'à lui de se constituer un harem brillant'. According to Assouline, 'jusqu'à la fin, sa vie sentimentale sera peuplée de maîtresses séduisantes, de compagnes de passage et de créatures aussi éphémères qu'un gouvernement en Europe Centrale', which wittily marries one of Londres's major

3 Florise Londres, p.20.
4 Ibid, pp.158–9.

stamping-grounds and his bed.[5] Shortly before his death, he was seriously thinking of remarriage, after a gap of thirty years. There is no need to intrude further. Londres himself had a good sense of respectful distances: 'Ses interlocuteurs le croient distant quand il n'est qu'en retrait'.[6]

As to the image of Londres in general, he remains a key-reference-point, indeed an exemplar, for a good many present-day journalists and thoughtful readers of the press, either professional or paying customers, to the extent that some of his obiter dicta are trotted out like mantras. On the Internet, an extensive website devoted to him juxtaposes people all over the globe discovering him for the first time, finding him relevant to their own particular concerns, and wanting to share their enthusiasm with unseen others. Noting this posthumous fame, Charon expresses some reservations. In their current state of reduced morale, even disarray, and given the shortage of reliable yardsticks, for many journalists

> il y a cette référence lancinante à une sorte d'âge d'or, aux grands anciens, aux modèles en partie idéalisés, d'Albert Londres à Beuve-Méry. Est-il vraiment possible de penser les solutions en termes de sursaut et d'appel incantatoire à la vertu?[7]

While I do not believe that any Golden Age ever existed, even in Eden, if we refuse to learn from predecessors we run the danger of becoming only pragmatic, and that way cynicism lurks.

After extolling the dogged courage of pioneering roving reporters, Pierre Mac Orlan concludes sadly:

> Les correspondants des grands journaux se mêlent aux éléments mêmes du cataclysme. L'habitude professionnelle les préserve, cependant, contre un certain dégoût de l'homme. Ce n'est qu'en vieillissant que le souvenir des spectacles qu'ils ont vus leur remontera du coeur aux lèvres, en nausées.[8]

5 Mousset: *Albert Londres*, p.317 and Assouline: *Albert Londres*, p.350.
6 Assouline: *Albert Londres*, p.349.
7 Jean-Marie Charon: *Cartes de presse: Enquête sur les journalistes*. Paris: Stock, 1993, pp.309–10. Hubert Beuve-Méry directed *Le Monde* for twenty-five years, and significantly helped to make it what it stands for today.
8 Pierre Mac Orlan: 'Les Compagnons de l'aventure: correspondants de guerre et grands reporters'. In: *Le Mystère de la mallette no. 1*. Ed. F. Lacassin. Paris: Union Générale d'Editions, 1984, p.234.

In other words the globetrotter suffers from world-weariness. In Assouline's view, Londres 'est un cynique à géométrie variable'.[9] This image of the swing-wing aircraft, highly adaptable to different challenges, captures both Londres's variety of moods, and his dynamism. Framed between an uninspired, indeed corny, début and what is reported to have been a frequently saddened but still excited finale, Londres's life did not replicate the dominannt patterns of his best writing. He does not add up to a cynic, but rather a sceptical freethinker. The very best lesson that journalists worth their salt like him can pass on to us readers is: never take anyone or anything as read, least of all as gospel.

In my Preview, I mentioned Paul Nizan, whose writing life embraced fiction, essays and a good deal of journalism. In his *Chronique de septembre*, on the Munich Crisis, Nizan stated that foreign correspondents must try to act like historians, although the tempo of research is obviously vastly accelerated. If journalism, and within its corps Albert Londres, are parasitic by their very nature, because journalism has a tighter and more urgent tie-up with everyday reality than literature normally has, then we should remind ourselves vigorously that so are life, the universe, and everything. Nizan therefore admitted, and welcomed, the strong element of risk-taking, of gambling on being right, as well as of possible distortion. Londres was often not only politically incorrect, but also politically plain wrong. Even when getting it wrong, however, journalists' analysis of complex situations remain historical facts. If some of Londres's texts have dated, this is inevitable. But, in general, does history date? Nizan was fully alive to the corporate nature of much press information. Like novels or poems, journalists feed off each other in a kind of existential plagiarism. A combination of psychological insight, detective-work, and the magical powers of Lesage's prying demon would be the ideal equipment, but at least the reporter should know when he is over-simplifying or cheating. In all, only a genuine flexible mind could hope to cope with the discontinuities of present history.[10]

Apart from in war situations, Londres suffered very little from censorship, or even from the rewriting of his despatches by staff editors. He enjoyed great freedom of manoeuvre and of expression. A realist all the same, he frequently resorted to self-censorship, in that he calculated

9 Assouline: *Albert Londres*, p.198.
10 Paul Nizan: *Chronique de septembre*. Paris: Gallimard, 1939, p.10.

what would pass, not only with his superiors but also with readers, what he could or could not get away with. This is a crucial aspect of responsible journalism, as well as a reminder that no journalist can get away with murder.

Londres was not an intellectual giant, and he was no saint, but, at his best, he was that rarish thing: a journalist who honoured his profession, and exemplified many of its better features. Like all of us non-monoliths, he was a mixed bag. It should be blindingly obvious that his total output houses a good amount of dross. Much of any journalist's copy is purely functional, or pleonastic. So is our everyday discourse. We do not, any of us, live or speak in purple patches. It is no wonder that the saying 'famous last words' has long since been usable only ironically or ruefully. Playing on the idea of automotive misfiring, Clément Vautel exclaims: 'Des ratés! Le journalisme en a beaucoup, comme un vieux moteur'.[11] A different kind of misfiring recurred in Londres's relationships with a succession of employers. It was, for Assouline, his unshakable pride and his sense of his own worth that gave rise to the 'crises de démissionite aiguës qui le frapperont à de nombreuses reprises en dix-sept ans'.[12] Londres, however, never called on union help. It was in fact after his death that in March 1935 a new law brought in a 'conscience clause', which allowed journalists to break their contract with their employer, while retaining the right to indemnification, so long as their departure was justified by changes in the nature or the direction of the publication for which they worked, if such changes damaged the honour, reputation and moral interests of the employee.

What justifies the publication and the study of resurrected journalism, supposedly the most ephemeral of all forms of paid written communication? If, as we are often urged, we must not be allowed to forget Hitler, the Alamo, or Original Sin, we should feel obliged to recognise the ongoing relevance of journalism's past for the present. Rarely does Londres seem irretrievably superannuated. His alert writings open up many closed spaces: prisons, asylums, brothels, terrorist organisations, sporting coteries, and indeed whole countries

11 Clément Vautel: *Mon Film: souvenirs d'un journaliste*. Paris: Albin Michel, 1941, p.289.
12 Assouline: *Albert Londres*, p.349.

largely blocked off from Western readers: Japan, China, Arabia, Central Africa. Like infants' first books, like the logos of public lavatories, like lecturing with visual aids, television privileges pictures and sidelines words. An earlier breed of journalist such as Londres, or as we have seen, a novelist such as Conrad, relies on the power of words to evoke scenes, to make readers see what the writer has seen, or imagined. Not long before setting off on his final journey, to China, Londres persuaded an old friend from Vichy to drive him to Holland, where the unique highspot was the opportunity to fulfil a thirty-year-old dream: sitting for ages in front of Rembrandt's *The Nightwatch*. Londres, who whenever possible slept lengthily like a log, was bowled over by Rembrandt's vigilant stay-ups. His own life had been a keenly observant day-watch. Londres was not a nightwatchman, guarding the status quo, but a knocker-up, unwelcome but indispensable.

As they themselves often lugubriously acknowledge, journalists are seen by many as being about as trustworthy as estate-agents (all that puffery...), or prostitutes (venality). Albert Londres helped mightily to contribute or restore, to a profession long held in disrepute, dignity, credibility, and stylishness. The chief editor of *Le Monde*, and himself one of the finest investigative reporters in contemporary France, Edwy Plenel, urges his readers to 'lire, relire Albert Londres, le plus actuel des journalistes'. He goes on to claim. 'Le plus célèbre des journalistes français, statufié en grand ancien de la profession, en est l'un des spécimens les plus encombrants et les moins apaisés', and to quote the German journalist, Kurt Tucholsky, who opposed 'le reportage horizontal, promenade blasée à la surface des choses' to 'le journalisme vertical'[13] Londres never paddled in the gutter press. He belonged to the far smaller community of the sidewalk press: taking his time, keeping his eyes and his ears skinned. Even within this smaller fraternity, he stands somewhat apart. 'De tous les envoyés spéciaux', writes Assouline, 'Albert Londres reste probablement un des plus individualistes, marginal par goût, rêveur par tempérament. Un personnage tout à fait atypique'.[14] Odd man out, like the Vallès, Darien, Nizan, Queneau and

13 Edwy Plenel: 'Albert Londres, journaliste vertical'. *Le Monde des livres*, 19 June 1992, pp.22, 33.
14 Assouline: *Albert Londres*, p.566.

Guilloux I have brought in at various junctures. A lone wolf in what today looks increasingly like a pack.

His books have been translated into German, Dutch, English, Spanish, Italian, and several other languages. Despite his unmistakable French roots and cultural baggage, he is indeed eminently translatable, transferable. He appeals widely. He travelled the world, and speaks to much of it. His writing on the move moves readers' emotions, and moves readers to think.

Bibliography

I indicate in square brackets which editions I have consulted, and the abbreviation used for each after quotations in the text.

Collections

Oeuvres complètes. Ed. H. Amouroux. Paris: Arléa, 1992. (This contains all of Londres's books published during his lifetime).
Câbles et Reportages. Ed. F. Lacassin. Paris: Arléa, 1993. (This is the invaluable source for a high percentage of Londres's articles, collected or uncollected). [*CR*].
Histoires des Grands Chemins. Paris: Albin Michel, 1932. (Selected articles).

In addition, virtually all of Londres's books and a selection of his articles have been reprinted in recent years by Arléa or Le Serpent à Plumes, Paris, in separate volumes, but with few or no notes.

Poems

Suivant les heures. Imprimerie parisienne, 1904.
L'Ame qui vibre. Paris: Sansot, 1908.
Le Poème effréné 1: Lointaine. Paris: Sansot, 1909.
Le Poème effréné 2: La Marche à l'étoile. Paris: Sansot, 1910.

Books

Au bagne. Paris: Albin Michel, 1924. [Republished, edited with notes by F. Lacassin, together with *L'Homme qui s'évada.* Paris: Union Générale d'Editions, 1975]. [*AB*].

Dante n'avait rien vu (Biribi). Paris: Albin Michel, 1924. [Republished, edited with notes by F. Lacassin, together with *Chez les fous.* Paris: Union Générale d'Editions, 1975]. [*DN*].

Chez les fous. Paris: Albin Michel, 1925. [See above] [*CF*].

La Chine en folie. Paris: Albin Michel, 1925. [Republished, with later articles on China, as *Mourir pour Shanghaï,* edited with notes by F. Lacassin. Paris: Union Générale d'Editions, 1984]. [*MS*].

Marseille porte du Sud. Paris: Editions de France, 1927. [Republished by Arléa, 1999]. [*MPS*].

Le Chemin de Buenos Aires (La Traite des Blanches). Paris: Albin Michel, 1927. [Republished, together with *Terre d'ébène (La Traite des Noirs),* under the title of *La Traite des Blanches, La Traite des Noirs,* edited with notes by F. Lacassin. Paris: Union Générale d'Editions, 1984]. [*TB*].

L'Homme qui s'évada. Paris: Editions de France, 1928, and, as *Adieu Cayenne!,* 1932. [See above]. [*HS*].

Terre d'ébène. Paris: Editions de France, 1929. [See above]. [*TN*].

Le Juif errant est arrivé. Paris: Albin Michel, 1930. [Republished, edited with notes by F. Lacassin. Paris: Union Générale d'Editions, 1975]. [*JE*].

Pêcheurs de perles. Paris: Albin Michel, 1930. [Republished, together with Londres's articles on Syria, 1915–17, edited with notes by F. Lacassin. Paris: Union Générale d'Editions, 1975. [*PP*].

Les Comitadjis (Le Terrorisme dans les Balkans). Paris: Albin Michel, 1932. [Republished, edited with notes by F. Lacassin. Paris: Christian Bourgois,1989]. [*C*].

Other editions used

D'Annunzio, conquérant de Fiume. Ed. F. Lacassin. Paris: Julliard, 1990. [Londres's articles on D'Annunzio, and those on Soviet Russia]. [*DA*].

Contre le bourrage de crâne. Paris: Arléa, 1993. [Londres's war journalism, 1917–18]. [*CBC*].

Les Forçats de la route. Paris: Arléa, 1996. [Londres's articles on the Tour de France]. [*FR*].

Si je t'oublie Constantinople. Ed. F. Lacassin. Paris: Union Générale d'Editions, 1989. [Londres's articles on the Dardanelles, 1915–17. Same text as in *Câbles et Reportages*, see above, but with Lacassin's preface and notes].

Archives

Archives Nationales, Paris: 27 dossiers (76/AS/1…). 1–19: Typescripts of articles, collected or uncollected; letters to family and others; photographs. The remainder concern his daughter, Florise, and the prix Albert Londres.

Philby Collection, St. Antony's College, Oxford.

Translations (with prefaces)

The Road to Buenos Ayres. Tr. E. Sutton. Introduction by Theodore Dreiser. London: Constable, 1928.

Terror in the Balkans. Tr. with appendix by Leonide Zarine. London: Constable, 1935.

El Camino de Buenos Aires. Tr. and foreword by Bernardo Kordon. Buenos Aires: Legasa, 1991.

Stage and Screen

Albert Londres (film). Director Marc Besson. Julianne Films / La Cinquiè-me, 1996.

La Planète Londres. Devised and produced by Vincent Colin. Performed in various Paris and regional theatres in 1998–9.

Books and Articles on Londres

[Several of the articles are reprinted in *Le Juif errant est arrivé* [*JE*]].

ANON: Review of P. Assouline: *Albert Londres. L'Histoire*, 120, 1989, pp.62–3.

ANON: 'En Guyane, dans les pas d'Albert Londres, entretien avec Henri Amouroux'. *Historia*, 630, 1999, pp.18–19.

ANON: *Grand Reportage: les héritiers d'Albert Londres.* Paris: Florent Massot Présente, 2001.

Assouline, Pierre: *Albert Londres: vie et mort d'un grand reporter.* Paris: Gallimard, 1990 [1989: Balland].

Bauer, Gérard: 'Un Grand Journaliste'. *Le Courrier de l'Allier*, 15 June 1932.

Béraud, Henri: *Rendez-vous européens.* Paris: Editions de France, 1928.

Béraud, Henri: 'Vie et mort d'Albert Londres'. *Gringoire*, 22 June 1932, p.5. [In *JE*].

—— *Qu'as-tu fait de ta jeunesse?* Paris: Editions de France, 1941.

—— *Les Derniers Beaux Jours.* Paris: Plon, 1953.

—— *Le Flâneur salarié.* Paris: Union Générale d'Editions, 1985 [1927].

Berthier, Pierre-Valentin: 'Il y a vingt ans…lors de la catastrophe du *Georges-Philippar*'. *Le Libertaire*, 25 April 1952. [In *JE*].

Bois, Elie-Joseph: 'Pauvre Albert Londres'. *Le Petit Parisien*, 6 June 1932. [In *JE*].

Bonardi, Pierre: 'Routes et relais d'Albert Londres, voyageur baude-lairien'. *La Tribune des Nations*, 29 November 1934. [In *JE*].

'Candide' (Jacques Bainville): 'Albert Londres'. *Candide*, 26 May 1932.

Carbillet, Captain G.: *Au Djebel Druze*. Preface by Albert Londres. Paris: Argo, 1929.

Chardonnet, Gaston: 'Albert Londres'. *Bulletin de la Société d'Histoire et d'Archéologie de Vichy et des environs*. 43, 1950, pp.232–252.

Charpentier, André: 'Albert Londres poète, chef de l'Ecole effréniste'. *Les Nouvelles littéraires*, 20 August 1932, p.5.

Coquet, James de: 'Les Premières: *Au Bagne*' Le Figaro, 1 July 1929, p.5.

Dan, Uri: 'Albert Londres: The Zionist from Vichy'. *Quesher*, 17 May 1995, p.25e.

David, Catherine: 'Un Familier de l'atroce'. *Le Nouvel Observateur*, 18 September 1975, p.49.

Debray, Régis: *Shanghaï, dernières nouvelles: la mort d'Albert Londres*. Paris: Arléa, 1999.

Delacourt, Xavier: 'Un Grand Reporter'. *La Quinzaine littéraire*, 526, 1989, p.9.

Delmond, A. *Albert Londres*. Thèse de 3e cycle, Université de Paris IV, 1976.

De Lucca, Erri: 'Albert Londres, l'uomo che profetizzò l'Olocausto'. *Corriere della Sera*, 21 July 1997, p.25.

Dieudonné, Eugène: *La Vie des forçats*. Preface by Albert Londres. Paris: Gallimard, 1930.

Dieudonné, Eugène: 'Eugène Dieudonné, le forçat innocent arraché au bagne, nous parle du grand journaliste disparu'. *Paris-Soir*, 9 June 1932. [In *JE*].

Doré, Francis: *Albert Londres n'a rien vu*. Paris: Figuière, 1930.

Ducros, Emmanuelle: *Sur les traces d'Albert Londres* (1884–1932). Mémoire de maîtrise, Université Pierre Mendès-France, 1996–7.

Dufresne, Claude: 'Dieudonné, l'ébéniste du bagne, finit sur les planches'. *L'Histoire*, 612, 1997, pp.68–70.

Folléas, Didier: *Putain d'Afrique! Albert Londres en terre d'ébène*. Paris: Arléa, 1998.

Griffo, Maurizio: 'John Reed e Albert Londres, le due verità sui Soviet'. *Ideazione*, 4, 1998, pp.1–4.

Harang, Jean-Baptiste: 'Ici Londres, tu as le bonjour d'Albert'. *Libération*, 6 August 1992, pp.27–8.

Helsey, Edouard: Preface to Londres: *Histoires des Grands Chemins* [Also in *JE*].

—— *Envoyé spécial*. Paris: Fayard, 1955.

Humbourg, Pierre: 'Avec Albert Londres, explorateur'. *La Liberté*, 15 February 1929. [In *JE*].

Juin, Hubert: 'Le Fer dans la plaie'. *Le Monde des livres*, 29 August 1975, p.11.

Lacassin, Francis: *Albert Londres et le grand reportage*. Mairie de Paris, 1982.

Lapaire, Hugues: *Le Petit Logis: souvenirs d'un homme de lettres*. Moulins: Crépin-Leblond, 1946.

Lepennetier, Yann: *Nuit blanche*. Ill. By O. Neuray. Grenoble: Glénat, 1997.

Londres, Florise: *Mon Père*. Paris: Le Serpent à Plumes. 2000 [1934].

—— 'Mon Père Albert Londres'. *Cahiers bourbonnais*, 9, 1959, pp.301–6. [Contains some unpublished poems].

Marchetti-Leca, Pascal: 'Albert Londres, le pionnier des grands reporters'. *Historia mensuel*, 1 November 2000, pp.70–3.

Merki, Charles: 'La Chine en folie'. *Mercure de France*, 15 November 1926, pp.192–6.

Morelle, Paul: 'Albert Londres: de la poésie au journalisme'. *Le Monde des livres*, 23 May 1970, pp.iv–v.

Mousset, Paul: *Albert Londres: l'aventure du grand reportage*. Paris: Grasset, 1970.

Naud, François: 'Le Grand Reporter, Albert Londres'. *Presse-Actualité*, 110, 1976, pp.38–47.

Paisant, Chantal: 'Images du pouvoir blanc dans le reportage d'Albert Londres en Afrique noire'. In: J.L. Cabanès and Ch.-G. Dubois (eds): *Images européennes du pouvoir*. Bordeaux: Editions Universitaires du Sud, 1996, pp.407–17.

Plenel, Edwy: 'Albert Londres, journaliste vertical'. *Le Monde des livres*, 19 June 1992, pp.22, 23.

Rabaut, Jean: 'Albert Londres, grand reporter'. *L'Histoire*, 70, 1984, pp.74–9.

Redfern, Walter: 'Among the Alienated'. *Times Literary Supplement*, 10 October 1975, p.1202.

Rigaux, Philippe: *L'Image de l'ennemi chez Albert Londres: Représentation symbolique et vérité du texte*. Mémoire de licence, Université de Lausanne, 1995.

Rinaldi, Angelo: 'Les Réquisitoires d'Albert Londres'. *L'Express*, 16–22 June 1975, pp.34–6.

Sautter, Gilles: 'Notes sur la construction du chemin de fer Congo-Océan (1921–1934)'. *Cahiers d'études africaines*, 7, 1967, pp.219–299.

Simon, Simone: 'Albert Londres: sa vie, son oeuvre'. *Petite Bibliothèque des Amis des Archives de la Haute-Garonne*, 51, n.d., pp.1–10.

Soriente, Mariel: 'La Ciudad de la traición: Gombrowicz/Albert Londres: trayectos y apropiaciones en la construcción del espacio urbano porteño'.
http://www.filo.uba.ar/Departamentos/letras/teolit/Teolit11/soriente.htm

Vazquez Rial, Horacio: 'Albert Londres, padre del periodismo de investigación'. *El País*, 30 March 1993, p.30.

Viollis, Andrée: 'Albert Londres, prince des reporters'. *Les Nouvelles littéraires,* 5 September 1925, p.1 [also in *JE*].

Voilley, Pascale: 'Albert Londres and Sports Writing in the 1920s'. *Dog Days*, 2, 2, 1997, 23pp.

West, James L.W. 111: 'Dreiser and The Road to Buenos Ayres'. *Dreiser Studies*, 25, 2, 1994, pp.3–22.

Wider Dimensions

Albert, Pierre and Fernand Terrou: *Histoire de la presse*. Paris: PUF, 1985.

Albert, Pierre: *La Presse française*. La Documentation française, 1998.

Amaury, Francine: *Histoire du plus grand quotidien de la IIIe République: 'Le Petit Parisien', 1876–1944.* 2 vols. Paris: PUF, 1972.

Amouroux, Henri (ed.): *Grands Reportages: 43 prix Albert Londres, 1946–1989.* Paris: Seuil, 1989.

Anderson, David and Peter Benjaminson: *Investigative Reporting*. Bloomington: Indiana University Press, 1976.

Andrew, Christopher M. and A.S. Kanya-Forstner: *France Overseas: The Great War and the Climax of French Imperial Expansion*. London: Thames & Hudson, 1981.

Antoine, Gérald: *Paul Claudel, ou le génie de la gloire*. Paris: Laffont, 1988.

Arbellot, Simon: *La Fin du boulevard*. Paris: Flammarion, 1965.

Archambault, G.-H.: 'Le Journal français de demain'. *Mercure de France*, 231, 1931, pp.554–72.

Arnaud, Lucien: *Charles Dullin*. Paris: L'Arche, 1952.

Arnoux, Alexandre: *Charles Dullin, portrait brisé*. Paris: Emile-Paul, 1951.

Assouline, Pierre and Pierre Dampenon: *De nos Envoyés spéciaux: Les Coulisses du reportage*. Paris: J.C. Simoën, 1977.

Audoin-Rouzeau, Stéphane: '"Bourrage de crâne" et information en France en 1915–18'. In: Becker, Jean-Jacques and Stéphane Audoin-Rouzeau (eds): *Les Sociétés européennes et la Guerre de 1914–1918*. Université de Paris X–Nanterre, 1990, pp.163–74.

Baines, Roger W.: *'Inquiétude' in the Work of Pierre Mac Orlan*. Amsterdam: Rodopi, 2000.

Balle, Francis: *Les Journaux quotidiens et les journalistes français: Sociologie d'un marché et d'une profession*. Thèse de doctorat d'Etat ès lettres, Université de Paris V. 3 vols, 1986.

Barly, Henry: *Avec l'Armée serbe: de l'ultimatum autrichien à l'invasion de la Serbie*. Paris: Albin Michel, 1918.

Barré, Jean-Luc: Philippe Berthelot: *L'Eminence grise, 1866–1934*. Paris: Plon, 1988.

Barrillon, Raymond: *Le Cas Paris-Soir*. Paris: Colin, 1950.

Barris, Alex: *Stop the Presses! The Newspaperman in American Films*. South Brunswick: A.S. Barnes, 1976.

Barthes, Roland: 'Le Tour de France comme épopée'. *Mythologies*. Paris: Seuil, 1957.

Barzini, Luigi: *Vita vagabonda*. Milan: Rizzoli, 1948.

Bell, Allen: *The Language of News Media*. Oxford: Blackwell, 1991.

Bellanger, Claude et al. (eds): *Histoire générale de la presse française. Vol.3: de 1871–1940*. Paris: PUF, 1972.

Belorgey, J.-M.: 'Voyageurs français en Afrique Noire'. *Afrique littéraire et artistique*, 1969, pp.3–17.

Bertrand, F.: *La Presse francophone de tranchée au front belge, 1914–1918*. Brussels: Musée Royal de l'Armée et d'Histoire Militaire, 1971.

Biarnès, Pierre: *Les Francais en Afrique noire, de Richelieu à Mitterrand*. Paris: Colin, 1987.

Billy, André and Jean Piot: *Le Monde des journaux: Tableau de la presse française contemporaine.* Paris: G. Crès, 1924.

Blondin, Antoine: *Sur le Tour de France.* Paris: Mazarine, 1979.

Brincourt, Christian and Michel Le Blanc: *Les Reporters.* Paris: Laffont, 1970.

Brunn, Julien (ed.): 'Encore un été dopé'. *Le Monde des débats*, 7, October 1999, pp.1–6.

Buitenhuis, Peter: *The Great War of Words: Literature as Propaganda, 1914–18 and after.* London: Batsford, 1989.

Burgh, Hugo de (ed.): *Investigative Journalism.* London: Routledge, 2000.

Burnier, Michel-Antoine and Patrick Rambaud: *Le Journalisme sans peine.* Paris: Plon, 1977.

Butin, Jean: *De la Gerbe d'or au pain noir: La Longue Marche d'Henri Béraud.* Roanne: Horvath, 1979.

Carbuccia, Horace de: *Le Massacre de la victoire.* 2 vols. Paris: Plon, 1973.

Carruthers, Susan L.: *The Media at War.* Basingstoke: Macmillan, 2000.

Catroux, General Diomède: *Deux Missions en Orient, 1919–1922.* Paris: Plon, 1958.

Cendrars, Blaise: *Du Monde entier au coeur du monde / Anthologie nègre.* Paris: Denoël, 1963 [1921].

Chalaby, Jean: 'Journalism as an Anglo-American Invention: A Comparison of the Development of French and Anglo-American Journalism'. *European Journal of Communication*, 11, 3, 1996, pp.303–26.

—— *The Invention of Journalism.* Basingstoke: Macmillan, 1998.

Chambure, A. de: *Quelques Guides de l'opinion en France pendant la Grande Guerre.* Paris: Celin/Mary/Elen, 1918.

Charensol, Georges: *D'une Rive à l'autre.* Paris: Mercure de France, 1973.

Charon, Jean-Marie: *La Presse en France de 1945 à nos jours.* Paris: Seuil, 1991.

— *Cartes de presse: Enquête sur les journalistes.* Paris: Stock, 1993.

Charpentier, André: *La Chasse aux nouvelles: Exploits et ruses des reporters.* Paris: Editions du Croissant, 1926.

Charreton, Pierre: *Le Sport, l'ascèse, le plaisir.* Saint-Etienne: Université Jean-Monnet, 1990.

Chiclet, Christophe: 'Macedonia Risks Falling Apart' *Le Monde diplomatique*, 13 January 1999.

Claudel, Paul: *Journal 1*. Paris: Gallimard, 1968.

Clogg, Richard: *A Concise History of Greece*. Cambridge University Press, 1992.

Cooper, Nicola: *France in Indochina: Colonial Encounters*. Oxford: Berg, 2001.

Coquery-Vidrovitch, Catherine and Henri Moniot: *L'Afrique noire de 1800 à nos jours*. Paris: PUF, 1974.

Courrière, Yves: *Joseph Kessel, ou sur la piste du lion*. Paris: Plon, 1985.

Cumming, Henry H.: *Franco-British Rivalry in the Post-War Near East: The Decline of French Influence*. London: Oxford University Press, 1938.

Damelincourt, Benjamin: 'Enquête sur la disparition d'un mythe'. *Presse-Actualité*, February 1984, pp.29–33.

Danan, Alexis: *Cayenne*. Paris: Fayard, 1934.

—— *L'Epée du scandale*. Paris: Laffont, 1961.

Darien, Georges: *Biribi, discipline militaire*. Paris: Union Générale d'Editions, 1966 [1890].

Darlix, Paul: *La Nouvelle Route de Buenos Aires*. Paris: Baudinière, 1931.

—— *Avec les 'Durs' de Buenos Aires à Caracas*. Paris: Baudinière, 1932.

Daudet, Léon: *Bréviaire du journalisme*. Paris: Gallimard, 1936.

Dauzat, Albert: *Légendes, prophéties et superstitions de la guerre*. Paris: La Renaissance du Livre, 1919.

Davis, Richard Harding: *With the French in France and Salonika*. London: Duckworth, 1916.

De la Haye, Yves: *Journalisme, mode d'emploi: des manières d'écrire l'actualité*. Grenoble: La Pensée sauvage, 1985.

Delporte, Christian: *Les Journalistes en France, 1880–1950: Naissance et construction d'une profession*. Paris: Seuil, 1999.

Desmond, Robert W.: *The Press and World Affairs*. New York/London: Appleton-Century, 1937.

Devèze, Michel: *Cayenne: déportés et bagnards*. Paris: Julliard, 1965.

Dhur, Jacques: *Visions de bagne*. Paris: Ferenczi, 1925.

Donet-Vincent, Danielle: *La Fin du bagne (1923–1953)*. Rennes: Editions Ouest-France, 1992.

Douglas, Allen: *War, Memory and the Politics of Humor: The 'Canard Enchaîné' and World War 1*. Berkeley: University of California Press, 2002.

Dullin, Charles: *Souvenirs et notes de travail d'un acteur.* Paris: Odette Lieutier, 1946.

Dupray, Micheline: *Roland Dorgelès: un siècle de vie littéraire française.* Paris: Presses de la Renaissance, 1986.

Dupuy, Micheline: *'Le Petit Parisien'.* Paris: Plon, 1989.

Dutourd, Jean: *Ça bouge dans le prêt-à-porter: traité du journalisme.* Paris: Flammarion, 1989.

Dygert, James H.: *The Investigative Journalist: Folk Heroes of a New Era.* Englewood Cliffs, NJ: Prentice-Hall, 1976.

Estier, Claude: *La Gauche hebdomadaire.* Paris: Colin, 1962.

Ettema, J.S. and T.L. Glasser: *Custodians of Conscience: Investigative Journalism and Public Virtue.* New York: Columbia University Press, 1998.

Fanoudh-Siefer, Léon: *Le Mythe du Nègre et de l'Afrique noire dans la littérature française de 1800 à la deuxième Guerre Mondiale.* Paris: Klincksieck, 1968.

Ferenczi, Thomas: *L'Invention du journalisme en France: Naissance de la presse moderne à la fin du XIXe siècle.* Paris: Plon, 1993.

Ferro, Marc: *La Grande Guerre, 1914–1918.* Paris: Gallimard, 1969.

Feuerhahn, Nelly (ed.): 'Humour et politique'. *Humoresques*, 5, 1994.

Filler, Louis: *The Muckrakers.* University Park, PA: Pennsylvania State University Press, 1976.

Flapan, Simha: *Zionism and the Palestinians.* London: Croom Helm, 1979.

Fowler, Roger: *Language in the News: Discourse and Ideology in the Press.* London: Routledge, 1991.

Frédérix, Pierre: *Un Siècle de chasse aux nouvelles, de l'Agence d'information Havas à l'Agence France-Presse, 1865–1957.* Paris: Flammarion, 1959.

Freiburg, J.W.: *The French Press: Class, State and Ideology.* New York: Praeger, 1981.

Fussell, Paul: *The Great War and Modern Memory.* London: Oxford University Press, 1977.

Gaboriau, Philippe: *Le Tour de France et le vélo: Histoire sociale d'une épopée contemporaine.* Paris: L'Harmattan, 1995.

Gabriel-Robinet, Louis: *Journaux et journalistes hier et aujourd'hui.* Paris: Hachette, 1962.

Galtier-Boissière, Jean: *Mémoires d'un parisien*. 3 vols. Paris: La Table Ronde, 1961-3.

Gide, André: *Voyage au Congo*. Paris: Gallimard, 1927.

Girardet, Raoul: *L'Idée coloniale en France de 1871 à 1962*. Paris: La Table Ronde, 1972.

Glenny, Misha: *The Balkans, 1804–1999*. London: Granta, 1999.

Gray, Jack: *Rebellions and Revolutions: China from the 1800s to the 1980s*. London: Oxford University Press, 1990.

Guéry, Louis: *Visages de la presse: la présentation des journaux des origines à nos jours*. Paris: Editions du CFPJ, 1997.

Guillaume, Yves: *La Presse en France*. Paris: La Découverte, 1990.

Guillebaud, Jean-Claude: 'Le Journalisme d'avant les soupçons'. *L'Histoire*, 70, 1984, p.1.

—— 'Les Média contre le journalisme'. *Le Débat*, May–August 1990, pp.149–52.

Guitard-Auviste, Ginette: *Paul Morand*. Paris: Hachette, 1981.

Guy, Donna J.: *Sex and Danger in Buenos Aires*. Lincoln and London: University of Nebraska Press, 1991.

Harrison, John M. and Harry H. Stein (eds): *Muckraking, Past, Present and Future*. University Park, PA: Pennsylvania State University Press, 1973.

Hayes, Carlton J.H.: *France: A Nation of Patriots*. New York: Columbia University Press, 1930.

Helsey, Edouard: *Les Aventures de l'Armée d'Orient*. Paris: La Renaissance du Livre, 1920.

—— *Au Pays de la monnaie de singe (Voyages en Allemagne)*. Paris: Albin Michel, 1924.

—— *L'An dernier à Jérusalem*. Paris: Editions de France, 1930.

Herbart, Pierre: *La Ligne de force*. Paris: Gallimard, 1958.

Herr, Michael: *Dispatches*. London: Picador, 1979.

Holman, Valerie and Debra Kelly (eds): *France at War in the Twentieth Century: Propaganda, Myth and Metaphor*. New York/Oxford: Berghahn, 2000.

Holt, Richard: *Sport and Society in Modern France*. London: Macmillan, 1981.

Horne, John and Alan Kramer: *German Atrocities, 1914: A History of Denial*. New Haven: Yale University Press, 2001.

Hunter, Mark: 'The Rise of the Fouille-merdes'. *Columbia Journalism Review*, November/December 1995, pp.1–6.

—— *Le Journalisme d'investigation aux Etats-Unis et en France*. Paris: PUF, 1997.

Inglis, Fred: *People's Witness: The Journalist in Modern Politics*. New Haven: Yale University Press, 2002.

Jacob, Madeleine: *Quarante Ans de journalisme*. Paris: Julliard, 1970.

Jouvenel, Robert de: *Le Journalisme en 20 leçons*. Paris: Payot, 1920.

Jullian, Philippe: *d'Annunzio*. Tr. S. Hardman. London: Pall Mall, 1972.

Kessel, Joseph: *Marchés d'esclaves*, suivi de *L'Irlande révolutionnaire*. Paris: Union Générale d'Editions, 1984.

Kipling, Rudyard: *France at War*. London: Macmillan, 1915.

Knecht, Edgar: *Le Mythe du Juif errant*. Presses Universitaires de Grenoble, 1977.

Knightley, Philip: *The First Casualty: From the Crimea to Vietnam: The War Correspondent as Hero, Propagandist, and Myth Maker*. London: André Deutsch, 1975.

Kravetz, Marc: 'Profession: correspondant de guerre'. *Magazine littéraire*, 378, 1999, pp.98–102.

Kuhn, Raymond and Erik Neveu (eds): *Political Journalism: New Challenges, New Practices*. London: Routledge, 2002.

Kupferman, Fred: *Au Pays des Soviets: le voyage français en Union Soviétique, 1917–1939*. Paris: Gallimard/Julliard, 1979.

Lacan, Jean-François et al. (eds): *Les Journalistes: Stars, scribes et scribouillards*. Paris: Syros, 1994.

La Guérivière, Jean: *Les Fous d'Afrique: Histoire d'une passion française*. Paris: Seuil, 2001.

Larcher, Commandant Maurice: *La Grande Guerre dans les Balkans*. Paris: Payot, 1929.

Larès, Maurice: *T.E. Lawrence, la France et les Français*. 2 vols. Université de Lille III: Service de reproduction des thèses, 1979.

Larique, Marius: *Les Hommes punis*. Paris: Gallimard, 1933.

Laure, Pierre: *Le Dopage*. Paris: PUF, 1995.

Laurens, Henry: *Lawrence en Arabie*. Paris: Gallimard, 1992.

Lauzanne, Stéphane: *Sa Majesté la Presse*. Paris: Fayard, 1925.

Lawrence, T.E.: *The Seven Pillars of Wisdom*. Harmondsworth: Penguin, 2000 [1926].

Léautaud, Paul: *Journal littéraire 1*. Paris: Mercure de France, 1986.

Le Bohec, Jacques: *Les Mythes professionnels des journalistes: L'Etat des lieux en France*. Paris: L'Harmattan, 2000.

Leclerc, Christophe: *Avec T.E. Lawrence en Arabie: La Mission militaire française au Hedjaz, 1916–1920*. Paris: L'Harmattan, 1998.

Leclère, Marcel: *La Vie quotidienne dans les bagnes*. Paris: Hachette, 1973.

Ledeen, Michael A.: *The First Duce: D'Annunzio at Fiume*. Baltimore: Johns Hopkins University Press, 1977.

Le Fèvre, Georges: *Bagnards et chercheurs d'or*. Paris: Ferenczi, 1925.

Leiris, Michel: *L'Afrique fantôme* (1931). In: *Le Miroir de l'Afrique*. Ed. J. Jamin. Paris: Gallimard, 1996.

Lepape, Pierre: *La Presse*. Paris: Denoël, 1972.

Little, Roger: *Between Totem and Taboo: Black Men White Women in Francographic Literature*. University of Exeter Press, 2001.

Lodi, Luigi: *Giornalisti*. Bari: Laterza, 1930.

Longrigg, Stephen Hemsley: *Syria and Lebanon under French Mandate*. London: Oxford University Press, 1958.

Mac Orlan, Pierre: *Le Bataillon de la mauvaise chance*. In: *Oeuvres complètes*, vol.xvi. Geneva: Edito-Service, 1970.

—— *Le Mystère de la malle no. 1*. Paris: Union Générale d'Editions, 1984.

Manevy, Raymond: *La Presse de la Troisième République*. Paris: Foret, 1955.

Manor,Yohanan: *Naissance du sionisme politique*. Paris: Archives Gallimard/Julliard, 1981.

Marchetti, Dominique: 'Les Révélations du "journalisme d'investigation"'. *Actes de la Recherche en Sciences Sociales*. 131/2, 2000, pp.30–40.

Maroger, Mireille: *Bagne*. Paris: Denoël, 1937.

Martin, Laurent: *'Le Canard Enchaîné', ou les fortunes de la vertu*. Paris: Flammarion, 2001.

Martin, Marc (ed.): *Histoire et médias: Journalisme et journalistes francais, 1950–1990*. Paris: Albin Michel, 1991.

—— *Médias et journalistes de la République*. Paris: Odile Jacob, 1997.

Martin-Lagardette, Jean-Luc: *Les Secrets de l'écriture journalistique*. Paris: Syros, 1987.

Mazedier, René: *Histoire de la presse parisienne de Théophraste Renaudot à la IVe République, 1631–1945.* Paris: Editions du Pavois, 1945.

Mesclon, Antoine: *Comment j'ai subi quinze ans de bagne.* Paris: Mesclon, 1931.

Miraldi, Robert: *Muckraking and Objectivity: Journalism's Colliding Traditions.* New York: Greenwood, 1990.

Mitford, Jessica: *Poisoned Penmanship: The Gentle Art of Muckraking.* New York: Knopf, 1979.

Monier, Frédéric: *Henri Béraud: Homme de presse.* Mémoire de maîtrise, Université de Paris IV–Sorbonne, 1987.

Monroe, Elizabeth: *Philby of Arabia.* London: Faber, 1973.

Montagnon, Marcel: *La France coloniale: La Gloire de l'empire.* Paris: Pygmalion/Gérard Watelet, 1988.

Montaron, Marcel: *Ciel de cafard.* Paris: Gallimard, 1932.

Morand, Paul: *Paris Tomboctou.* Paris: Flammarion, 1928.

Morin, Violette: *L'Ecriture de presse.* Paris/The Hague: Mouton, 1969.

Naud, Francois: *Des Envoyés spéciaux aux grands reporters: La Reconnaissance d'une profession (1920–1930).* 2 vols. Thèse pour le doctorat en histoire, Ecole des Hautes Etudes en Sciences Sociales, 1996.

Naudeau, Ludovic: *En Prison sous la Terreur russe.* Paris: Hachette, 1920.

Nevakiki, Jukka: *Britain, France and the Arab Middle East, 1914–1920.* London: Athlone, 1969.

Nicholson, Geoffrey: *The Great Bike Race.* London: Hodder and Stoughton, 1977.

Nye, Edward (ed.): *A Bicyclette.* Paris: Les Belles Lettres, 2000.

Paillet, Marc: *Le Journalisme: Fonctions et langages du quatrième pouvoir.* Paris: Denoël, 1974.

Palmer, Alan: *The Gardeners of Salonika.* London: Deutsch, 1965.

Palmer, Michael B.: *Des Petits Journaux aux grandes agences.* Paris: Aubier, 1983.

Pascal, Pierre: *Mon Journal de Russie.* Lausanne: L'Age d'homme, 1975.

Péan, Charles: *Conquêtes en terre de bagne.* Paris: Altis, 1948.

Pedelty, Mark: *War Stories: The Culture of Foreign Correspondents.* New York/London: Routledge, 1995.

Philby, Harry St John Bridger: *Arabian Days.* London: Robert Hale, 1948.

Pierre, Michel: *La Terre de la grande punition: Histoire des bagnes de Guyane.* Paris: Ramsay, 1982.

Plenel, Edwy: *La Part d'ombre.* Paris: Stock, 1992.

—— 'La Plume dans la plaie'. *Le Débat*, 90, 1996, pp.169–192.

Ponsonby, Arthur: *Falsehood in War-Time.* New York: E.P. Dutton, 1928.

Postel, Jacques and Claude Quétel (eds): *Nouvelle Histoire de la psychiatrie.* Toulouse: Privat, 1983.

Price, George Ward: *The Story of the Salonika Army.* London: Hodder and Stoughton, 1918.

Priou, Guillaume: *Le Tour de France cycliste dans la presse nationale de l'entre-deux-guerres: Naissance d'un phénomène social.* Maîtrise d'histoire contemporaine, Université de Paris X–Nanterre, 1996–7.

Protress, David L. et al.: *The Journalism of Outrage.* New York: Guilford Press, 1991.

Rabaut, Jean: 'Le Grand Reportage n'est plus ce qu'il était' *L'Histoire*, 41, 1982, pp.92–5.

Raffalovitch, Arthur: *'L'Abominable Vénalité de la presse' ... d'après les documents des archives russes.* Paris: Librairie du Travail, 1931.

Ransome, Arthur: *Six Weeks in Russia in 1919.* London: George Allen & Unwin, 1919.

Rearick, Charles: *The French in Love and War: Popular Culture in the Era of the World Wars.* New Haven: Yale University Press, 1997.

Reddaway, W.F. et al. (eds): *The Cambridge History of Poland.* Cambridge University Press, 1941.

Reed, John: *Ten Days that Shook the World.* London: Lawrence & Wishart, 1961 [1919].

Rieffel, Rémy: *L'Elite des journalistes.* Paris: PUF, 1984.

Rosenstone, Robert A.: *Romantic Revolutionary: A Biography of John Reed.* New York: Vintage, 1981.

Roubaud, Louis: *Le Voleur et le sphinx.* Paris: Grasset, 1926.

Roucaute, Yves: *Splendeurs et misères des journalistes.* Paris: Calmann-Lévy, 1991.

Roussenq, Paul: *L'Enfer du bagne.* Vichy: Pucheu, 1957.

Ruellen, Denis: 'Reporters: les disciples de Zola'. *Médiaspouvoirs*, 25, 1992, pp.5–11.

—— *Le Professionalisme du flou: Identité et savoir-faire des journalistes francais.* Presses Universitaires de Grenoble, 1993.

Said, Edward: *Orientalism.* Harmondsworth: Penguin, 1985.

Sarrail, General Maurice: *Mon Commandement en Orient, 1916–1918.* Paris: Flammarion, 1920.

Sauerwein, Jules: *Trente Ans à la une.* Paris: Plon, 1962.

Sauvage, Christian: *Journaliste: Une Passion, des métiers.* Paris: CFPJ, 1988.

Schneidermann, Daniel: *Du Journalisme après Bourdieu.* Paris: Fayard, 1999.

Schrecker, John E.: *The Chinese Revolution in Historical Perspective.* New York: Praeger, 1991.

Schwob, Maurice: *Moeurs des diurnales: Traité du journalisme.* Paris: Editions des Cendres, 1985.

Seidler, Edouard: *Le Sport et la presse.* Paris: Colin, 1964.

Shapiro, Herbert (ed.): *The Muckrakers and American Society.* Lexington, Mass.: D.C. Heath, 1968.

Simpson, John: *Strange Places, Questionable People.* Basingstoke: Macmillan, 1998.

Sitwell, Osbert: *Noble Essences or Courteous Revelations.* London: Macmillan, 1950.

Sous le Brassard vert. Paris: Editions de la Sirène, 1919.

Steffens, Lincoln: *The Autobiography of Lincoln Steffens.* New York: Harcourt Brace, 1931.

Tannenbaum, Jan Karl: *General Maurice Sarrail, 1856–1929.* Chapel Hill: University of North Carolina Press, 1974.

Tharaud, Jean and Jérôme: *L'An prochain à Jérusalem.* Paris: Plon, 1924.

—— *Grands Reportages.* Ed. A. Doysié. Paris: Corrêa, 1946.

Thogmartin, Clyde: *The National Daily Press of France.* Birmingham, AL: Summa, 1998.

Touzot, Jean and Alain Cresciucci (eds): *L'Ecrivain journaliste.* Paris: Klincksieck, 1998.

Tristani-Potteaux, Françoise: *L'Information malade de ses stars: Comment la personnalisation de l'information se fait instrument de pouvoir.* Paris: Pauvert, 1983.

Tuchman, Gaye: *Making News: A Study in the Construction of Reality.* New York: The Free Press, 1978.

Tudesq, André: *Les Compagnons de l'aventure.* Paris: Attinger frères, 1916.

Tudesq, André-Jean: *La Presse et l'événement.* Paris/The Hague: Mouton, 1973.

Tunstall, Jeremy: *Journalists at Work*. London: Constable, 1971.

Une Heure de ma carrière. Paris: Baudinière, 1926.

Varin d'Ainville, Madeleine: *La Presse en France: Genèse et évolution de ses fonctions psycho-sociales*. Paris: PUF, 1965.

Vautel, Clément: *'Mon Film'*. *Souvenirs d'un journaliste*. Paris: Albin Michel, 1941.

Vigarello, G.: 'Le Tour de France'. In: P. Nora (ed.): *Les Lieux de mémoire. III, Les France,2*. Paris: Gallimard, 1992, pp.886–925.

Viollis, Andrée: *Seule en Russie de la Baltique à la Caspienne*. Paris: Gallimard, 1927.

Voyenne, Bernard: *Les Journalistes français: D'où viennent-ils? Qui sont-ils? Que font-ils?* Paris: CPJF-Retz, 1985.

Waterhouse, Keith: *On Newspaper Style*. London: Viking, 1989.

Waugh, Evelyn: *Scoop*, and *Waugh in Abyssinia*. London: Methuen, 1984 [1936].

Weigle, Clifford F.: 'The Press in Paris from 1920 to 1940'. *Journalism Quarterly*, 18, 1941, pp.376–84.

Weill, Georges: *Le Journal*. Paris: Editions de la Renaissance du Livre, 1934.

Wilson, John: *Understanding Journalism*. London: Routledge, 1996.

Winter, Jay and Emmanuel Sivan (eds): *War and Remembrance in the Twentieth Century*. Cambridge University Press, 1999.

Wolsensinger, Jacques: *L'Histoire à la une: La Grande Aventure de la presse*. Paris: Gallimard/Découvertes, 1989.

Yapp, M.E.: *The Near East since the First World War*. 2nd edn. London: Longman, 1996.

—— The Making of the Modern Near East, 1792–1923. London: Longman, 1997.

262

Index

European Connections

edited by Peter Collier

'European Connections' is a new series which aims to publish studies in Comparative Literature. Most scholars would agree that no literary work or genre can fruitfully be studied in isolation from its context (whether formal or cultural). Nearly all literary works and genres arise in response to or at least in awareness of previous and contemporary writing, and are often illuminated by confrontation with neighbouring or contrasting works. The literature of Europe, in particular, is extraordinarily rich in this kind of cross-cultural fertilisation (one thinks of medieval drama, Romantic poetry, or the Realist novel, for instance). On a wider stage, the major currents of European philosophy and art have affected the different national literatures in varying and fascinating ways.

The masters of this comparative approach in our century have been thematic critics like F.R. Leavis, George Steiner, and Jean-Pierre Richard, or formalist critics like I.A. Richards, Northrop Frye, Gérard Genette and Tzvetan Todorov, but much of the writing about literature which we know under specific theoretical labels such as 'feminist' (Julia Kristeva, Judith Butler), 'marxist' (Georg Lukacs, Raymond Williams) or 'psychoanalytical' criticism (Charles Mauron, Jacques Lacan), for instance, also depends by definition on taking literary works from allegedly different national, generic or stylistic traditions and subjecting them to a new, comparative grid. The connections of European with non-European writing are also at issue—one only has to think of the impact of Indian mythology on Salman Rushdie or the cross-fertilisation at work between a Spanish writer like Juan Goytisolo and the Latin American genre of 'Magical Realism'. Although the series is fundamentally a collection of works dealing with literature, it intends to be open to interdisciplinary aspects, wherever music, art, history, philosophy, politics, or cinema come to affect the interplay between literary works.

Many European and North American university courses in literature nowadays teach and research literature in faculties of Comparative and General Literature. The series intends to tap the rich vein of such research. Initial volumes will look at the ways in which writers like Thackeray draw on French writing and history, the structure and strategies of Faulkner's fiction in the light of Proust and Joyce, Goethe's relation to the Spanish picaresque tradition, Victorian reactions to Eugène Sue, and George Mackay Brown's interest in Hopkins and Mann. Offers of contribution are welcome, whether

studies of specific writers and relationships, or wider theoretical investigations. Proposals from established scholars, as well as more recent doctoral students, are welcome. In the major European languages, the series will publish works, as far as possible, in the original language of the author.

The series editor, Peter Collier, is a Fellow of Sidney Sussex College, and Senior Lecturer in French at the University of Cambridge. He has translated Pierre Bourdieu (*Homo Academicus,* Polity Press, 1988), Emile Zola (*Germinal,* Oxford World's Classics, 1993), and Marcel Proust (*The Fugitive,* Penguin, 2002), has edited several collections of essays on European literature and culture (including *Visions and Blueprints,* with Edward Timms, Manchester University Press, 1988, *Modernism and the European Unconscious,* with Judy Davies, Polity Press, 1990, *Critical Theory Today,* with Helga Geyer-Ryan, Polity Press, 1990, and *Artistic Relations,* with Robert Lethbridge, Yale University Press, 1994), and has written a study of Proust and art (*Mosaici proustiani,* Il Mulino, 1986). He is a member of the British branch of the International Comparative Literature Association.

Guy de Maupassant

A Further Selection of the *Chroniques* of Guy de Maupassant

Edited with an Introduction and Notes by Adrian C. Ritchie

Oxford, Bern, Berlin, Bruxelles, Frankfurt/M., New York, Oxford, Wien, 2003. 252 pp.
ISBN 3-03910-153-6 / US-ISBN 0-8204-6963-7 pb.
sFr. 70.– / € 47.70 / €** 44.60 / £ 29.– / US-$ 44.95*
* includes VAT – only valid for Germany and Austria ** does not include VAT

This second selection of Maupassant's *chroniques*, edited in their original French version, includes articles on a wide range of subjects. Many are on literary, artistic or social themes, some are inspired by political events of the day. In general, some of the lighter pieces have been chosen, but in all of them Maupassant has something important to say.

Maupassant often uses his *chroniques* to rehearse themes and topics to be developed later in short stories or novels. It is true that he never sought to re-publish them after their initial appearance in *Le Gaulois*, *Gil Blas*, or *Le Figaro*, but this is not to say that he did not reveal much about his inner self in these writings. Though he sometimes referred to them disparagingly as an irksome weekly obligation, he continued to offer his *chroniques* to the Parisian dailies when fame and fortune ensured that he had little need of the extra income they brought in. He wrote almost as many *chroniques* as short stories – indeed the distinction between the two genres is not always clear – and, whether the tone is facetious, serious or ironic, one can sense that Maupassant enjoys this dialogue with a regular readership. Readers or critics who ignore the journalism deprive themselves of a significant part of his overall output. This second selection shows once again that Maupassant the short-story writer and novelist was also an entertaining and observant chronicler of events in the France of his day.

Contents: A selection of Maupassant's *chroniques* published in the French press in the 1880s – Notes explaining references and allusions – A short introduction to the *chroniques* with an evaluation of the importance of the journalistic writings – A bibliography of critical works relating to Maupassant's writings in the press.

The Editor: Adrian C. Ritchie is Head of French (Department of Modern Languages), at the University of Wales, Bangor. He has written extensively on Maupassant, and is the editor of *Guy de Maupassant: A Selection of the Political Journalism* (1999) and of *Guy de Maupassant: A Selection of the 'Chroniques' (1881–87)* (2002), both published by Peter Lang.

PETER LANG
Bern · Berlin · Bruxelles · Frankfurt/M. · New York · Oxford · Wien

Berry Palmer Chevasco

Mysterymania

The Reception of Eugène Sue in Britain 1838–1860

Oxford, Bern, Berlin, Bruxelles, Frankfurt/M., New York, Wien, 2003. 284 pp.
European Connections. Vol. 6
Edited by Peter Collier
ISBN 3-906769-78-X / US-ISBN 0-8204-5915-1 pb.
sFr. 79.– / € 54.40 / €** 50.80 / £ 33.– / US-$ 50.95*

* includes VAT – only valid for Germany and Austria ** does not include VAT

Mysterymania examines the reception in Britain of the French author Eugène Sue from 1838 to 1860 with the aim of furthering understanding of the intellectual and cultural dialogue between France and Britain and the effect of that dialogue on British fiction during the Victorian period. Sue's novels were widely read throughout the western world during the 1840s, especially amongst the newly literate of the poor and working classes. His success with these new readers helped to feed the controversies of the period surrounding the influence of fiction on public morality. The study of Sue's reception in Britain offers insight into these controversies as well as adding to the awareness of the concerns of an important period in the history of English literature. Because of his widespread success, Sue's effect on popular culture and fiction is easily recognized. *Mysterymania* explores the more problematic relationship of Sue's fiction with contemporary British works which now form part of the established canon. Particular attention is paid to the relationship Sue's novels bear to some of the most studied figures of English literature, notably Dickens and Thackeray. *Mysterymania* seeks to advance the appreciation of a nineteenth-century author whose works were significant to his time but whose importance has been largely ignored since.

Contents: 'Roi du Roman Feuilleton': life and works of Eugène Sue – 'The moral epidemic': critical response to Sue in the British press 1838-1857 – 'Mysterymania': an historical examination of the effect of G.W.M. Reynolds's *The Mysteries of London* and *Les Mystères de Paris* – Response to Sue's fiction in the papers and works of key Victorian authors, Dickens, Thackeray, Elizabeth Gaskell, Disraeli, Elizabeth Barrett Browning, George Eliot and Charles Kingsley – 'Social problem novels' and the poor fallen woman: Sue's legacy on Victorian English fiction.

The Author: After taking a degree in English literature from the University of California at Berkeley, Berry Palmer Chevasco studied French literature at the Sorbonne and, as a postgraduate, International Relations at INSEAD in Fontainebleau. Later postgraduate study led to a PhD from University College London focusing on the cultural cross-currents significant in the nineteenth century, particularly those at play between French and Anglo-Saxon cultures. Articles published include studies of Elizabeth Barrett Browning's reception of French literature and a comparison of Eugène Sue with G.W.M. Reynolds.

 PETER LANG

Bern · Berlin · Bruxelles · Frankfurt/M. · New York · Oxford · Wien

Patricia O'Flaherty

Henry de Montherlant (1895–1972)

A Philosophy of Failure

Oxford, Bern, Berlin, Bruxelles, Frankfurt/M., New York, Wien, 2003. 256 pp.
Modern French Identities. Vol. 22
Edited by Peter Collier
ISBN 3-03910-013-0 / US-ISBN 0-8204-6282-9 pb.
sFr. 70.– / € 47.70 / €** 44.60 / £ 29.– / US-$ 44.95*
* includes VAT – only valid for Germany and Austria ** does not include VAT

Montherlant – worthless amoral aesthete – or sensitive literary philosopher? This book takes a brand new look at his work and system of values. The author places Montherlant in the context of French twentieth-century literature and thought, with reference to the literary and philosophical movements of the century. She further describes the legacy of this prolific writer, whose literary standing is contested by some but whose importance in French twentieth-century literature and philosophy is beyond dispute. The stage for an analysis of Montherlant's œuvre is set through an examination of his essays and notebooks, in relation to the writings of Plato, an important source. Montherlant, like many other writers of his generation, sought an ideal of heroism, explored in his early novels, which was destroyed by the horrific wars of the twentieth century. Through subtle argument and detailed textual analysis, this book demonstrates the complex and contradictory nature of a philosophy which advocates pleasure and *joie de vivre*, while espousing a nihilistic vision.

Contents: Montherlant's System of Values as expressed by the *Carnets* and *Essais* – Heroism – The Death of Heroism – Humanist Existentialism - Action or Contemplation – The Ideal - *Les Garçons* and *Thrasylle* – Travel Writings – Stoicism and Nihilism.

The Author: Patricia O'Flaherty (1952) is at present Lecturer in French at Dublin City University, having spent fifteen years at the University of Zimbabwe. Her interests include literary theory and the French twentieth-century novel and she has published widely on the work of Henry de Montherlant.

PETER LANG
Bern · Berlin · Bruxelles · Frankfurt/M. · New York · Oxford · Wien